ISSUE 1

DIRECTOR'S FOREWORD

In 1921 composer Edgard Varèse and musician Carlos Salzedo wrote: "The composer is the only one of the creators of today who is denied direct contact with the public. When his work is done he is thrust aside, and the interpreter enters, not to try to understand the composition but to impertinently judge it.... The International Composers' Guild [which was founded with its home at the Whitney Studio Club, the forerunner of the Whitney Museum of American Art] disapproves of all 'isms'; denies the existence of schools; recognizes only the individual."[1] It is in this spirit and tradition that the Whitney Museum, nearly ninety years later, is presenting *Christian Marclay: Festival*.

In the days leading up to the founding of the Whitney Museum of American Art, Juliana Force, Gertrude Vanderbilt Whitney's assistant who would become the Museum's first director, recognized the importance of supporting progressive artists of all disciplines. Accordingly, she offered a home for the International Composers' Guild at the Studio Club; the Guild presented new works by composers ranging from Carl Ruggles and Henry Cowell to Erik Satie, Alban Berg, and Igor Stravinsky. However, equally important, as Varèse and Salzedo attest in the quote above, is that the Guild and the Whitney recognized the changing relationship between the composer and the audience, between music and the visual arts. The idea that the composer was not invisible but played an active role with the audience was a radical one and one that is very much in evidence in *Christian Marclay: Festival*. And, the unity and interaction of various artistic disciplines is tacitly acknowledged by the idea that the Studio Club was thought to be an appropriate home for the Guild. This cross-fertilization of the visual and the aural is fundamental to the work of Marclay as well.

The notion that the Guild prized individual, democratic expression above and beyond the concept of group movements is pointed in the above quote. This idea was equally embraced and promulgated by both Whitney and Force. In 1931 the former wrote: "The American public cannot be fooled for very long. It is made up of straight thinking, independent minded people who once given the opportunity, judge for themselves just as much as any other public. Art needs the layman, it needs his opinions, his backing and his criticism. Expert advice is good but it is not enough."[2] This sense of trust in the individual—the audience member and the musician, the layman and the professional—is at the heart of Marclay's work. The viewer participation in the artist's new piece, *Chalkboard* (2010), reveals a profound respect

for the individual and democratic creation. This freedom also extends itself to the approximately fifty musicians who will perform the works. As Marclay proposes in his interview with Russell Ferguson in this volume, "[The musicians] are playing their music not mine." He goes on to say "the loss of control in music is actually what interests me the most."[3] Marclay acknowledges the shared responsibility of artist, performer, and audience as well as the infinite variations of artistic expression.

The belief that art creates community was a founding principle of the Whitney and is a tenet of Marclay's work today. The Whitney Studio Club was as much, if not more so, a gathering space for the artist community as an exhibition space. The Studio Club had a library, billiards room, and also offered a locus for meetings, discussion, and sketching sessions. It was a crucible for artistic creation—not a place of passive experience. In *Christian Marclay: Festival*, the audience is a critical part of the art itself. "Music is the most social of all the arts, and not just for the musicians," Marclay says. "The audience plays its role—their presence adds a dynamic element to the event . . . it is always social and unpredictable."[4] The Whitney continues its fervent commitment to community and the active engagement of the viewer. Indeed, it's worth noting here that *Christian Marclay: Festival* is the second in a series instituted at the Whitney in 2008 with *Paul McCarthy: Central Symmetrical Rotation Movement—Three Installations, Two Films*. Going beyond traditional notions of retrospective, survey, or project, this initiative invites an artist to take an entire floor of the Museum and explore a concept or idea that, heretofore, has resulted in presentations both focused and open-ended.

Marclay's "exhibition," however, doesn't simply mirror the activities of the Guild and the Studio Club. His art is about a synthesis: a synthesis of the roles of curator, artist, and composer, and a synthesis of the senses whereby one can "see" sounds and "hear" form and color. In his 1997 exhibition for the Whitney Museum at Philip Morris *Pictures at an Exhibition: An Installation by Christian Marclay*, the title of which is taken from the composition written by Modest Mussorgsky, Marclay selected and installed nearly fifty prints, drawings, photographs, and paintings, which visually address or evoke music and sound. Benches were set up in rows as if to position the audience to see and "hear" the works. It was an installation composed and conducted—a visual concert, silent but heard. Just as Marclay notes that "music doesn't need to be blind,"[5] neither does visual art

need to be silent. *Christian Marclay: Festival* is the flip side of *Pictures at an Exhibition*. It is a feast, a riotous celebration of sights and sounds, projections, collages, installations, prints, vinyl records, found objects, and performances by artists including Elliott Sharp, Lee Ranaldo, Alan Licht, and Nicolas Collins. Marclay takes the viewer to a place and provides an experience that defies category and singularity. It is synesthetic. It is art.

Organizing an exhibition and events of this complexity, variability, and unpredictability are no easy task even for an artist who lives complexity, variability, and unpredictability. We are profoundly grateful to Christian Marclay for his trust, patience, and, above all, his integrity. His exacting commitment to creating the finest possible exhibition has been inspiring to us, and we hope it will be for the public. Curator David Kiehl's love of Marclay's work has made it possible for the artist and the Whitney to realize a passionate and richly nuanced exhibition. My great gratitude also goes to Limor Tomer, Adjunct Curator of Performing Arts, who has worked to provide a marathon schedule of performances in collaboration with the artist. And, as always, the entire staff of the Whitney Museum has spared no effort in bringing Marclay's vision to fruition.

The Whitney is extremely grateful to Bloomberg and Keds for their sponsorship of *Christian Marclay: Festival*. We are also grateful to the National Committee of the Whitney Museum of American Art, the Steven A. and Alexandra M. Cohen Foundation, and Jill and Peter Kraus for their generous support and to Bentley Meeker Lighting & Staging, Inc. for their in-kind support. The commitment of Steven Johnson and Walter Sudol and several anonymous donors was crucial to making this innovative catalogue a reality. We appreciate the contributions of those noted above and share their enthusiasm for the pioneering work and practice of Christian Marclay.

—Adam D. Weinberg
Alice Pratt Brown Director

ENDNOTES
1 Louise Varèse, *Varèse: A Looking-Glass Diary*, vol. 1 (New York: W. W. Norton, 1972), pp. 166–67, quoted in Avis Berman, *Rebels on Eighth Street* (New York: Atheneum, 1990), p. 174.
2 Gertrude Vanderbilt Whitney, quoted in Evelyn Hankins, "En/Gendering the Whitney's Collection of American Art," in *Acts of Possession*, ed. Leah Dilworth (New Brunswick: Rutgers University Press, 2003), pp. 169–70.
3 See pages 66 and 68 in this volume.
4 See page 68 in this volume.
5 See page 69 in this volume.

FESTIVAL

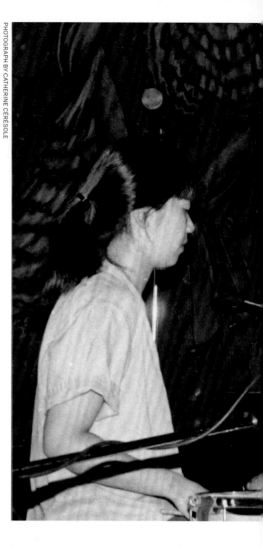

PHOTOGRAPH BY CATHERINE CERESOLE

This publication was created on the occasion of the exhibition *Christian Marclay: Festival* curated by David Kiehl, curator, and Limor Tomer, adjunct curator of performing arts, at the Whitney Museum of American Art, New York.

Whitney Museum of American Art, New York, July 1–September 26, 2010

Christian Marclay: Festival

Sponsored by **Bloomberg** and **Keds**

Generous support is provided by the National Committee of the Whitney Museum of American Art, the Steven A. and Alexandra M. Cohen Foundation, and Jill and Peter Kraus. Significant support for the catalogue is provided by Steven Johnson and Walter Sudol and several anonymous donors.

Lighting and audio by

**BEN·
TLEY
MEE·
KER.**

WHITNEY
Whitney Museum of American Art
945 Madison Avenue
New York, NY 10021
whitney.org

Yale
Trade edition distributed by
Yale University Press
302 Temple Street
P.O. Box 209040
New Haven, CT 06520
yalebooks.com

This publication was produced by the publications department at the Whitney Museum of American Art, New York: Rachel de W. Wixom, head of publications; Beth Huseman, editor; Beth Turk, associate editor; Anita Duquette, rights and reproductions manager; Kiowa Hammons, rights and reproductions assistant; Brian Reese, publications assistant.

Creative Director: Christian Marclay
Editor: Claire Barliant
Designer: Garrick Gott
Design Assistant: Eric Nylund
Production: The Production Department
Printer: The Studley Press
Typefaces: Mercury, by Radim Pesko and Adobe Plantin

Cataloging-in-Publication Data is on file with the Library of Congress.

ISBN 978-0-300-16900-3

Printed and bound in the United States.
10 9 8 7 6 5 4 3 2 1

Unless otherwise indicated, all photos © Christian Marclay.

Cover: *Record Players*, The Kitchen, New York, 1982. Courtesy the artist. © Christian Marclay. Photograph © Paula Court.

Page 1: *The Bachelors, even*, 1980. Performance at the Massachusetts College of Art, Boston. Photograph by P. Noel.

Pages 2–3: *Ghost (I don't live today)*, 1985. Performance at the Kitchen, New York, March 9, 1985. Courtesy the artist. Photograph by Fred de Vos.

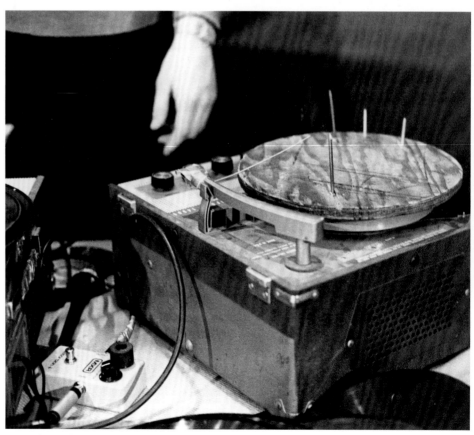

A modified turntable (phonodrum) used by Christian Marclay performing as The Bachelors, even (with Kurt Henry). Performance at St. Marks Church, New York, 1980.

4

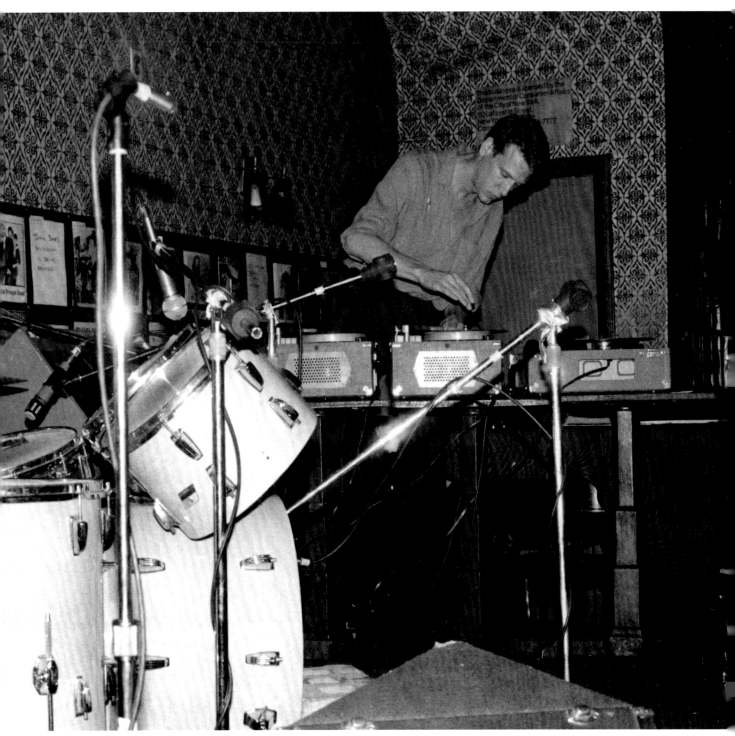

Christian Marclay and Ikue Mori performing at Folk City, New York, August 24, 1983.

FROM THE CURATOR

If I were to pinpoint the exact moment that initiated the process of bringing *Christian Marclay: Festival* to fruition, it would be the acquisition four years ago of the artist's graphic score, *Graffiti Composition* (1996–2002). This score originated in the summer of 1996, when Marclay pasted five thousand sheets of blank staff paper throughout Berlin. Passersby eagerly took up the challenge of this urban intervention and covered the sheets with doodles, scratches, and sometimes musical notes. These everyday, anonymous responses were extensively documented and a selection of images were made into the aforementioned score in 2002. Since then, this score has been interpreted by numerous musicians as a formal musical work.

In the colophon for *Graffiti Composition*, Marclay instructs musicians to freely select from and interpret the images. The decision to put together *Christian Marclay: Festival* stems from the realization that while previous museum exhibitions have highlighted the material aspects of Marclay's oeuvre, there has never been a close examination of the artist's scores and their continuing interpretation. As art historian Liz Kotz notes elsewhere in this publication, with the advent of modern music, and the innovations of John Cage in particular, the score becomes a text that initiates the work, setting it in motion. Marclay pushes this dictum further. He sees the score as an inspiration for a new work with each performance.

Christian Marclay: Festival brings Marclay's scores together for the first time, and includes some thirty years of an exceptional body of work that has pioneered new approaches in both visual and sound art. It also challenges the normative of museum exhibition practice. In effect, the Whitney's fourth floor functions as a stage. The largest gallery area is devoted to the projected scores and an ongoing series of performances of the scores themselves. Adjustable curtains allow for more intimate settings for some of the performances. The graphic scores, two-dimensional collages, and unconventional instruments are on display in a second gallery-*cum*–music cabinet, where these objects are displayed when not in use. Smaller galleries feature documentation of Marclay's earlier performances and serve as a listening room for past recordings. As a pioneer turntablist, Marclay has performed with many of the foremost experimental musicians of our time. A lot of these artists are participating in the exhibition; on any given day, they will be performing and rehearsing in the galleries.

Conceived in the same improvisatory, spontaneous spirit as the exhibition, this volume is the first of three separate "magazines" issued during the run of the exhibition. The magazine format reflects the spontaneity of the music and the musicians and allows a more immediate response to the evolution of the exhibition over time. This format enables documentation of the many performances, as well as the ever-changing, ephemeral piece *Chalkboard* (2010), in which an accumulation of marks made by visitors will generate additional interpretations by the musicians.

By approaching Marclay's practice from this particular angle, viewers will be able to reach a new appreciation for an artist who has long been known for his ability to unite the visual and the aural. *Christian Marclay: Festival* explores a relatively under-recognized dimension to the artist's work, one that stresses process over product and participation over spectatorship. In short, it is a rare opportunity to experience Marclay's radical reformulation of musical notation.

—David Kiehl

Footsteps, 1989 (installation view, Shedhalle, Zurich).

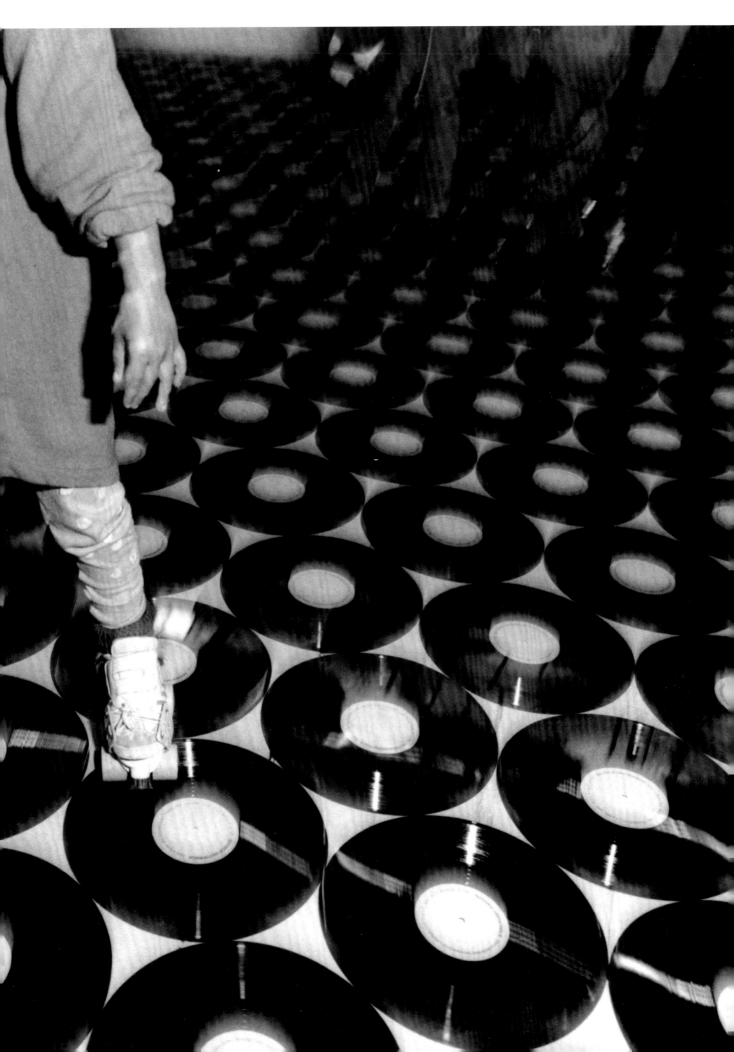

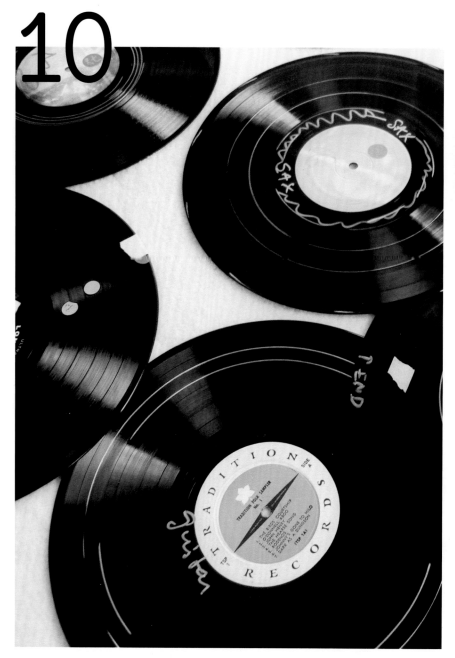

10

22

28

CONTENTS
Festival
Issue 1

34

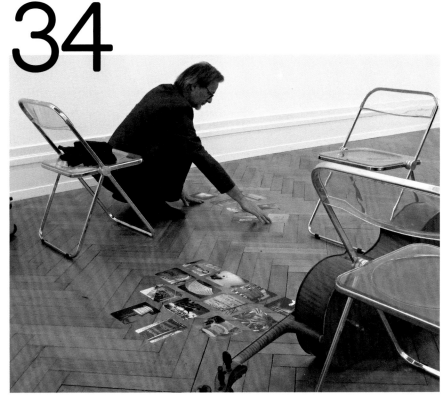

44

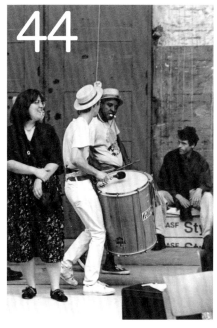

54

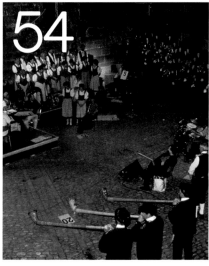

40

64

MARKED RECORDS/ PROGRAM FOR ACTIVITY

Liz Kotz

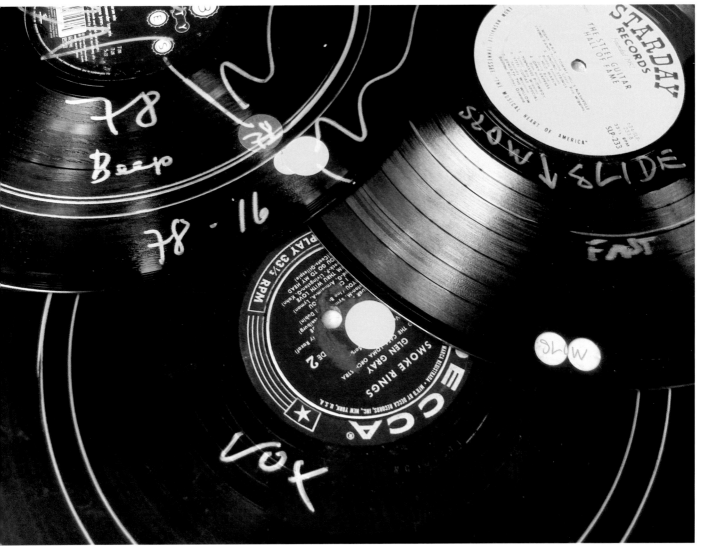

Performance records, c. 1980s– .

12

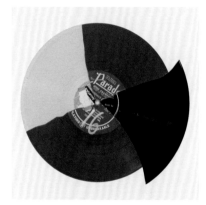

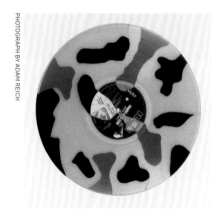

Recycled Records, 1981–85. Collaged vinyl records, dimensions variable.

Christian Marclay has performed with turntables and records since 1979. To prepare for these largely improvised performances, Marclay often alters and marks the discs he plans to use—sticking tape and stickers on them to show where segments start and stop, indicating tracks with arrows and dots, and so forth. Many records are scrawled with brief annotations in marker—"strings," "sax," "slow start," "last end"—indicating the sound materials and providing quick instructions.

Unlike Marclay's brightly colored and laboriously collaged *Recycled Records* from the 1980s, these "marked records" are not considered works of art but tools for performance, made to be used. These visually compelling objects reveal an essential aspect of Marclay's practice: the profound interpenetration of instrument and score, of object and inscription, in which a text can become a score, a notation a drawing, an object a realizable composition. It is a practice in which a form of inscription (a record) can be used as an object, and diverse objects (from scavenged scraps of paper and drawings to printed pastry tins to items of clothing) can be employed as materials to generate performances.

Quite famously, Marclay does not consider himself a composer, and was not trained as a musician; he does not "read music," in the sense of performing from conventional musical notation. From the outset, the instruments he played were turntables and records. As music critic Philip Sherburne notes, this choice rendered "the history of recorded music as a vast, endlessly remixable archive."[1] If the record has turned music into an object, for Marclay, records provide a limitless field of readymades. And, as others have proposed, his turntable performances answer Laszlo Moholy-Nagy's exhortation to "change the gramophone from a reproductive instrument to a productive one"[2] by using readily available consumer objects to generate jarring and lyrical new performances structured by accident and interference—slipping the apparently fixed object back into the temporal contingency of interpretation and performance.

But what does it mean to use a vinyl record—a storage device, a means of inscription—as an instrument? And then, when playing these records, to write on them, to annotate and "prepare" them—in effect, using them both as an instrument (a sound source) and as a form of notation? By systematically adapting, misusing, and destroying musical and non-musical materials, in strategies developed over more than thirty years, Marclay explores the permeable boundary between notation and instrument, between music as a set of materials and sound sources and music as a form of writing.

Of course, to describe a marked record as a form of musical notation is to situate it in relation to the widespread mutation and crisis in the function of the musical score in twentieth-century experimental music. From earlier figures like Henry Cowell and Edgard Varèse to the group of post-WWII composers known as the New York School, the intimate relation between unconventional sound sources and reimagined notational forms spurred an array of unorthodox notations, graphic scores, and kit-like scores. Already in the 1940s, John Cage assembled boxes of screws, felt, and other miscellany to be placed between piano strings in his prepared piano pieces, distributing these materials and carefully diagrammed and measured "tables of preparations" among the more conventional-looking musical scores.[3] By the late 1950s, Cage's scores for indeterminate compositions like *Fontana Mix* (1958) consisted of unbound sheets of graphic materials—pages covered with curved lines, and transparent sheets of randomly placed points—that performers could use to generate a playable score, according to the work's lengthy instructions. In a similar vein, by the early 1960s, La Monte Young was drafting calligraphic swirls and lines on cards, based on an awareness that a line or drawing was "something you could play."[4]

In this new game of music, notation relinquishes its previous historical function of representing the work and determining its structure. After Cage et al, the score is no longer a representation of the work, but a text that initiates it, that sets it in motion. In quite crucial ways, the work now resides in the realization.[5] If, in the Western classical tradition, notation was understood as "any graphic means of representing sounds, either by symbolizing them, or by providing instructions for producing them physically,"[6] Marclay's work explores the sheer perceptual impossibility of symbolizing sound, or representing it in textual or graphic forms.

Historically, we understand this crisis of the score not only as a breakdown of the classical tradition, but also as a mark of how technologies of sound recording, production, and reproduction have challenged and supplanted the score's function to register, preserve, and transmit musical practice. Unlike the precision and relentless repetition of the phonograph recording, the score provides an incomplete schema, one that generates unlimited new realizations. As the philosopher Roman Ingarden argued in 1928, "it was precisely the certain imperfections of this system . . . namely, the incomplete determination of the work by the score, that

has this advantage over preserving the work by recording: that it reveals the essential structure of the work, that is to say, that on the one hand the 'fixed' relatively invariant schema, and on the other hand, the multiplicity of possible various profiles through which a work may manifest itself."[7] While this notion of an integral "essential structure" no longer holds for much modern music, the productivity of this "incomplete determination" offers a compelling rationale for diverse forms of graphic, written, and event object-based notations.

A visual artist as well as a turntablist, Marclay explores the complex materiality of industrially produced music: "Recording technology has turned music into an object, and a lot of my work is about that object as much as it's about the music."[8] While every reading is in some sense a writing, an interpretation that rewrites the source, Marclay's diverse projects constantly test the limits of bound static objects and contingent temporal performance, and the limits of what can be made readable as music.

In various interviews, Marclay has recounted his initial shock, upon moving to the U.S., that a record, rather than being "this object to be respected, collected and stored for posterity," was now "just a cheap commodity to be used and abused."[9]

13

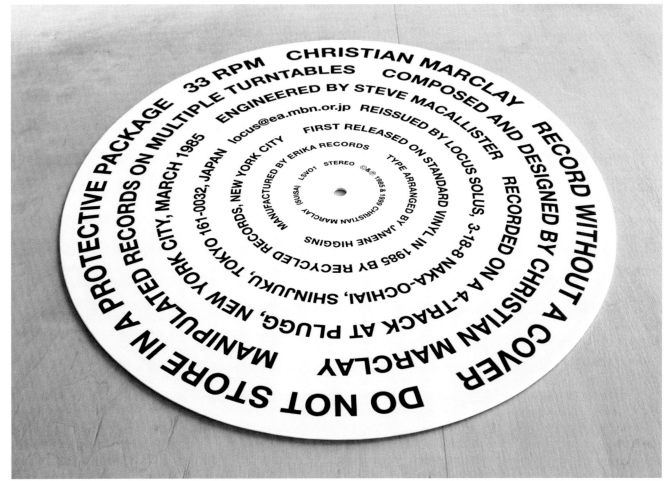

Record Without a Cover, 1985/1999. 12 inch picture-disc reissues 1985 recording. Published by Locus Solus, Japan.

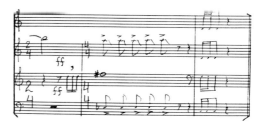

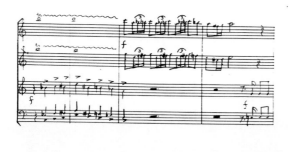

Through the Looking Glass (detail), 1985. Ten photocopied pages, each 14 x 8 ½ in.

The very cheapness and ubiquity of the thrift-store record allow it to become material for reuse and rewriting, turning it into another kind of ephemera, a surface, like paper, that could be used for new markings. Of course, it is not only the ubiquity but the fragility of records that lend themselves to this treatment. Embedded in an inherently fragile form of storage and inscription, phonograph grooves are altered with every pass of the stylus. As Thomas Levin notes, "every playing of any gramophone record is also a scratching, a defacement, a particularization of the multiple."[10]

This intermingling of object, instrument, and notation is manifested in Marclay's *Record Without a Cover* (1985), as the embossed surface on one side of the record informed buyers "do not store in a protective package." Theodor Adorno described the gramophone record as "the first means of musical presentation that can be possessed as a thing."[11] *Record Without a Cover* opens this "thing" to constant change and alteration. Accidental scratches and abrasions accumulate on its surface—rendering it "the perfect record" in Marclay's words: "a living record . . . revealing the musical properties that the record has built into itself."[12] The object is both an instrument and a set of instructions for a performance.

Played on a turntable, the record gradually shifts from static and dust to surface pops and noise to recognizable sound. This collision or layering of real-time and recorded traces leaves us unable to distinguish between original recordings and surface damage. Marclay has described how, when making the edition, "I didn't want to publish a finished composition but rather one open to changes, to accidents."[13]

What links a notational scheme and instrumentation is a shared archive of possible sounds—like the way the piano is tuned to comprise discrete notes that can be rendered in conventional grand-staff notation. Experimental music has a long history of musicians and composers creating their own instruments, from Cage's prepared pianos to Harry Partch's handmade microtonal instruments. Like a notation, an instrument proposes a set of rules, which can then also be altered, with a limited set of sound sources, techniques, and possible combinations that can be used to generate a grammar. In *Wind Up Guitar* (1994), Marclay has attached old-fashioned windup music-box mechanisms to a guitar, adding prerecorded melodies to its possible repertoire of sounds—creating an altered instrument that requires new ways of being played. In Marclay's expanded idea of what a score is, he may

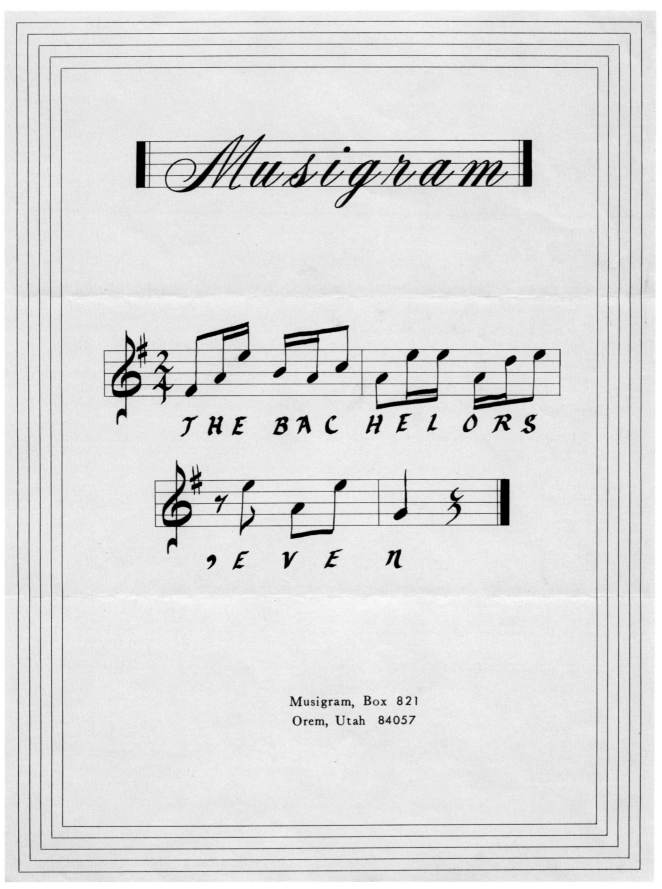

Musigram, 1979. Ink on paper, 11 x 8 ½ in.

16

Graffiti Composition, 1996–2002. Mixed media, dimensions variable.

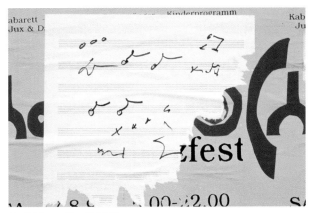

Graffiti Composition, 1996–2002.

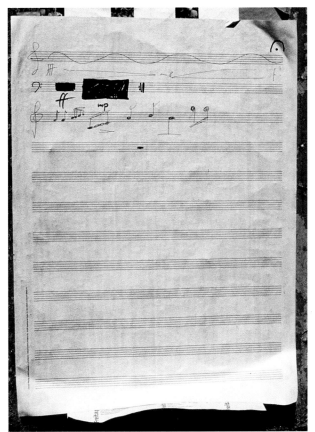

Graffiti Composition, 1996–2002.

provide a sound archive, or set of materials, for musicians to use—typically quite open structures within which anything can happen. Using materials like cards or scraps of paper that can be selected and rearranged, this practice recalls the graphic scores and "open form" scores of the 1950s and 1960s. Marclay's model is both more social, grounded in concrete models of performance practice, and more visual, focused on these score materials as objects, with a physical and tactile immediacy that need not subordinate them to their use in performance.

Since Marclay does not write music, his first actual "scores" were made through delegated writing. *Musigram* (1979) was made by submitting the band's name, "Bachelors, even," to a firm—discovered in an advertisement in the back of a magazine—that would translate words into musical notation; the ornately calligraphed *Musigram* is more a visual and conceptual object than an actual score. And, in *Through the Looking Glass* (1985), Marclay had a complex sonic collage of prerecorded brass music transcribed into grand-staff notation, a gesture that challenges the linear constraints of notation by asking it to translate a sound collage. Understood more as a record or transcription than a plan for live performance, the resulting score was performed only once, at Roulette in New York in 1985.

Paradoxically, it was working with virtuoso musicians, through his involvement with John Zorn's early 1980s *Game Pieces* for instance, that opened up Marclay's sense of what types of materials could be played or interpreted to yield a performance. In a 2002 interview, he recalls, "I was able to put my technique, my way of making music in the context of real musicians. That experience was really interesting . . . I learned how to improvise more, because I used to do more structured sets, I used to practice, to number my records and compositions . . . So I learned improvisation and . . . how to collaborate."[14]

Such uncontrolled collaborations became a pervasive thread in Marclay's work. The project *Graffiti Composition* (1996–2002) initially consisted of thousands of printed posters of staff lines that were pasted up all over Berlin in the summer of 1996. After these blank pages were marked on, torn, defaced, and used for all kinds of messages and signs, including actual musical notes, a selection was photographed and reproduced as an edition that is both a print multiple and a score. Marclay traces the project's development, noting that the work "was first a street installation for people to leave markings, now it's a score, and in the future there will be concerts and recordings by other people," adding, "I like these evolving structures where I eventually lose control."[15] In *Graffiti Composition*, whatever happens on the staff lines is potentially music, since the lines suggest a time structure and a possible pitch scale. Placed in the hands of performers, even a tear or squiggle or drawing is readable—and playable—albeit in completely unpredictable ways.

17

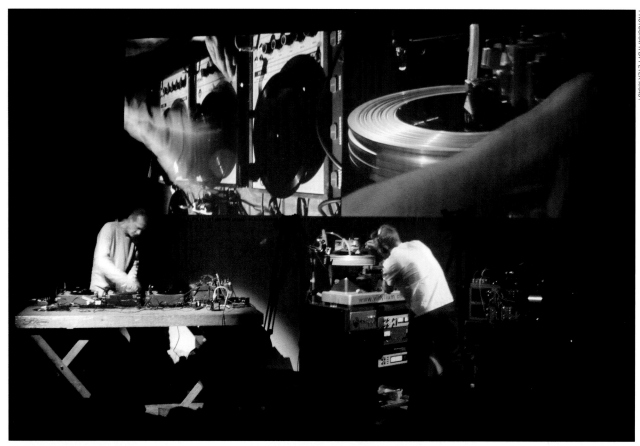

18

Christian Marclay and Florian Kaufmann performing *Tabula Rasa* at the Reithalle Dojo, Bern in 2004.

Ephemera (detail), 2009. Twenty-eight folios in slipcase, edition of 100. Published by mfc-Michèle Didier, Brussels.

Even as analogue recording has become supplanted by diverse digital technologies, Marclay has explored the material specificity and relevance of earlier technologies like records in the face of their disappearance. The process of generating playable traces through manipulating objects occurs even in the absence of a previously recorded surface. In *Tabula Rasa* (2003–2009), a series of live performances made with the Swiss artist, sound engineer, and vinyl-cutter Florian Kaufmann, Marclay used empty turntables, tapping the devices, manipulating the tone-arms, and creating feedback in order to generate sounds which were then recorded live onto a lacquer disc; once a platter was made, it was played back on Marclay's turntables, allowing the looping system to generate real-time layers of live and recorded sound. As Marclay notes, he isn't actually starting with nothing, since he is using the turntable, a device meant to read traces rather than generate them.[16] The technical set-up allowed both Marclay and Kaufmann to alter and manipulate inputs and add effects, creating a rich vocabulary of sound amid a complex cycle of documentation and transformation.

For years, Marclay has been obsessed with efforts to visually represent sound and the complete impossibility of doing so, collecting all kinds of objects and ephemera decorated or designed with musical notation (or bits of notation meant to simply signify "music") as well as an endless array of found onomatopoeias culled from comic books and candy wrappers, among other sources. Marclay explores the idea that diverse types of materials (including objects) can be played and used as notation. His video scores, onomatopoeia, and found objects circle around the instability of the musical sign, proposing "readings" of things that were never intended as writing. *Ephemera* (2009) presents scraps of materials collected over years. Re-examining these decorative motifs— found on cards, fliers, ads, and book and record covers—as actual performable music, *Ephemera* implicitly asks, how do you read a red silence versus a yellow field? What is the tonal difference between a dot and a squiggle? What does a city skyline superimposed over staff lines sound like? Accumulating materials never intended as compositions, these graphic works force us to reconsider what marks are musically meaningful.

By treating these cast-off pop-cultural materials as scores, Marclay perversely reinvigorates the historical project of graphic notation, a style that has gone out of favor as improvisers instead listen to recordings. As Marclay is well aware, it is precisely the translation required to realize a

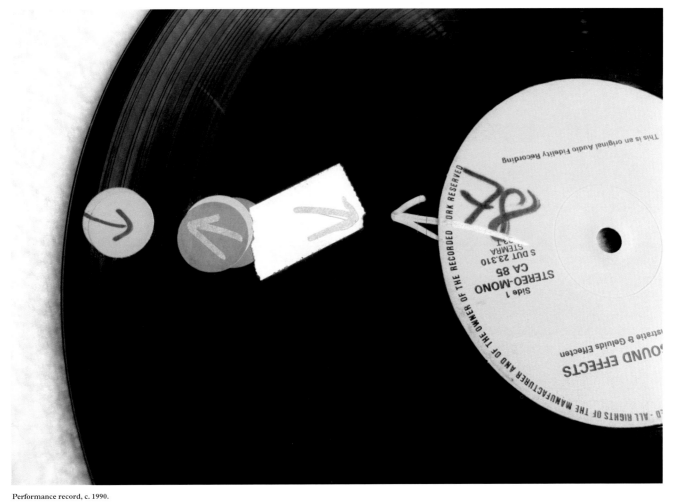

Performance record, c. 1990.

Shuffle (details), 2007. Deck of seventy-five offset printed cards. Published by Aperture, New York.

score, the room for interpretation, that generates new and unforeseen possibilities. And perhaps the more absurd the source material, the more interesting the demands it places on a performer. In *Boxed Set* (2008–2010), a collection of nested boxes decorated with musical motifs sets up a found notation. The structure of the containers sets up a time structure and an order, allowing performers to open them and realize it as a score, if a highly indeterminate one.

While many of these materials could seem merely spurs for improvisation, Marclay is clearly interested in efforts to make more literal readings. Yet he abstains from the lengthy supplemental annotation and verbal instruction that frequently accompany graphic and experimental scores. While the published edition of *Graffiti Composition* includes a descriptive text about how the project was made, the large format cards of *Shuffle* (2007), collecting visual depictions of musical signs, are accompanied by only sparse instructions and are designed to be very open, and the published folio *Ephemera* contains no text whatsoever. It is the very liminality of these materials—interchangeable as found object, visual art, and potential musical score—that is in play here.

This project has a complex and vital history. As the music-ologist Wiley Hitchcock noted, recalling the experiments of a previous generation: "Radical notations of a diversity that defies generalization arose out of the happenings, mixed-media events, and conceptual and performance art of the 1960s (as did a view of music as process and action as much as sound). Each work seemed to demand its own, unique graphic representation, which, no longer a score in any traditional sense, is simply a catalyst for action or a program for activity."[17] It is this matrix, where visual art, music, and performance interpenetrate and inform one another, that Marclay's work retrieves and reactivates in our own very different present. If happenings and early performance and event-based works have been understood largely as phenomenological experiences in the moment, Marclay's work attends to the curious materiality of all types of potentially musical artifacts, from cast-off records to printed posters, finding in this flotsam and jetsam of mass-produced culture models for a new practice between music and visual art. As David Tudor's legendary performances of compositions by Earle Brown, Christian Wolff, and Cage attest, anything is potentially playable. Similarly, Fluxus boxes and tactile objects suggest a new kind of score, in which words and objects can be used as notations to generate unanticipated realizations. In this spirit, Marclay explores musical and artistic practice and its potential to be continually crafted and transformed by its materials.

My thanks to Christian Marclay, Claire Barliant, and Mark So for their assistance with this essay.

Liz Kotz is a Los Angeles-based art historian and critic, and author of *Words to Be Looked At: Language in 1960s Art* (MIT Press, 2007).

Performance record, c. 1980.

21

ENDNOTES

1 Philip Sherburne, "Christian Marclay," *Interview* (May 2005) p 162.
2 Laszlo Moholy-Nagy, "Neo Plasticism in Music" (1923), *Broken Music* (Berlin: Berliner Künstlerprogram des DAAD and gelbe Musik Berline, 1989), p. 54.
3 Not surprisingly, it is this second "score," the graphic, grid-like table of preparations, that is more frequently reproduced as an "illustration" of the work, as the explicatory functions of annotation—historically, the province of quasi-parenthetical linguistic and mathematical instructions on how a score is to be performed—increasingly overtake the representational functions of musical notation proper. In its precise tabulation of measurements, materials, and methods of placement, the "table of preparations" exemplifies the shift toward notation as the specification of actions, objects, and procedures. According to Daniel Charles, a box of preparatory materials (screws, felt, pieces of wood, etc.) was sometimes included with prepared piano scores. In this context, Fluxus boxes collecting everyday objects, gadgets, and materials appear quite Cagean.
4 See John Holzaepfel, "La Monte Young and Marian Zazeela, New York City, July 25, 1999" (unpublished interview).
5 My thinking in this area is informed by the work of the composer Mark So, particularly his essay "text / composition—scores and structure after 4'33"," unpublished essay, 2010.
6 H. Wiley Hitchcock, "Notation," *The New Grove Dictionary of American Music*, vol. 3, ed. H. Wiley Hitchcock and Stanley Sadie (London and New York: Macmillan, 1986) p. 385.
7 Roman Ingarden, *The Work of Music and the Problem of Its Identity* [1928], trans. Adam Czerniawski, (Berkeley: University of California Press, 1986) p. 158.
8 "Interview Cut-up 1991–2004," *Christian Marclay* (London: Phaidon, 2005), p. 121.
9 Adorno, "The Form of the Record" (1934), trans. Thomas Y. Levin, *October* 55 (Winter, 1990), pp. 56-61.
10 "Interview Cut-up 1991–2004," p. 116.
11 Ibid.
12 "Christian Marclay and Yasanao Tone," *Sounds by Artists*, Dan Lander and Micah Lexier, eds. (Toronto: Art Metropole, 1990) p. 345. See also Douglas Kahn, "Christian Marclay's Early Years: An Interview," *Leonardo Music Journal* 13 (2003) pp. 17-21.
13 Thomas Y. Levin, "Indexicality Concrète: The Aesthetic Politics of Christian Marclay's Gramophonia," *Parkett* 56 (1999) p. 166.
14 "Christian Marclay Interview, Vol. 1," Sanematsu Akira, 28 March 2000, in Ginza, Japan. http://homepage1.nifty.com/A-ito/VOID2/marclay/marclay_eng_00.html (minor spelling errors corrected).
15 Jan Estep, "Words and Music: Interview with Christian Marclay," *New Art Examiner* (September-October 2001) p. 82.
16 "The premise for this performance, for *tabula rasa* is that I don't use prerecorded music. I don't use records, LPs that are ready-mades, but I am starting with nothing. But nothing isn't really the word, because I start with the turntable. So I have to create a grammar, a vocabulary using the turntable, and I start the performance by making sounds just using the turntable. Which then are recorded by Florian [Kaufmann] and then put on a disk, which he hands me and then I start, or I continue rather. So it is more about the turntable in a way, but it is hard to dissociate, because once I have a sound that it recorded, then I use it. But there is this interesting meshing of the two. So the turntable becomes the record, and the record gets manipulated and goes back into this loop system basically. But so if there is a tabula rasa it is the turntable, the empty turntable." Marclay in Björn Gottstein, "Interview with Christian Marclay," January 2008, Berlin. http://www.geraeuschen.de/9.html
17 Hitchcock, p. 396.

ALL THE WORLD'S A STAVE

Susan Tallman

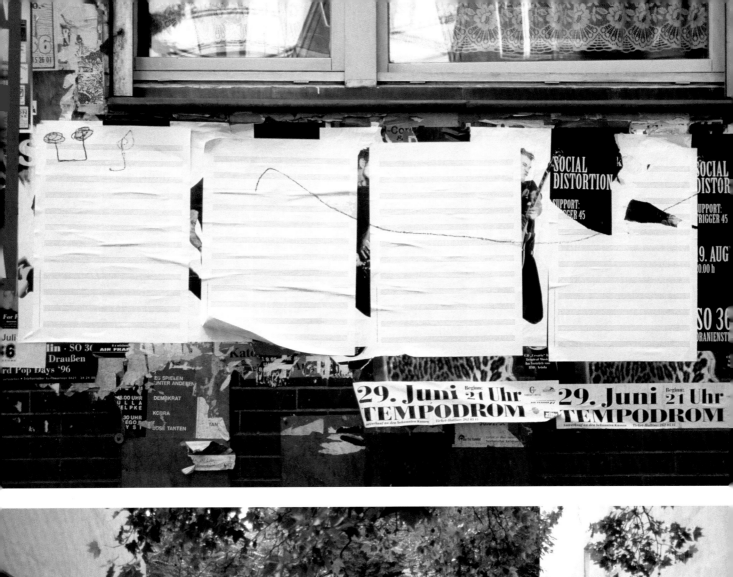

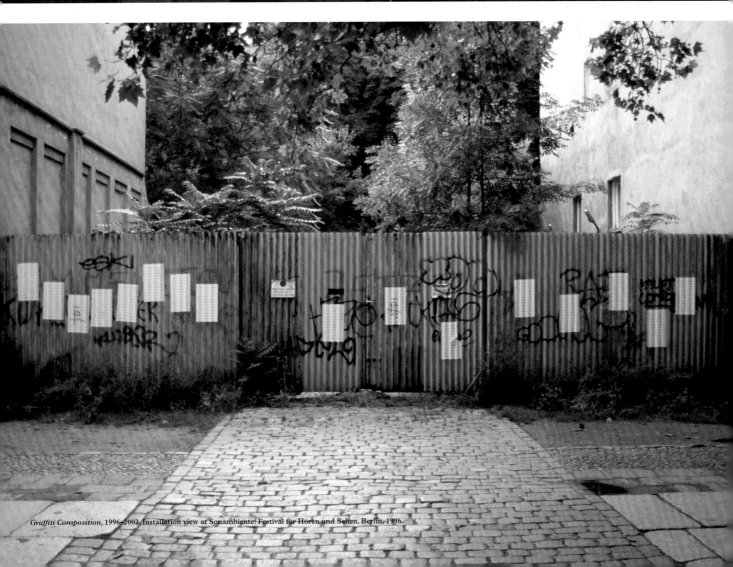

Graffiti Composition, 1996–2002. Installation view at Sonambiente: Festival für Hören und Sehen, Berlin, 1996.

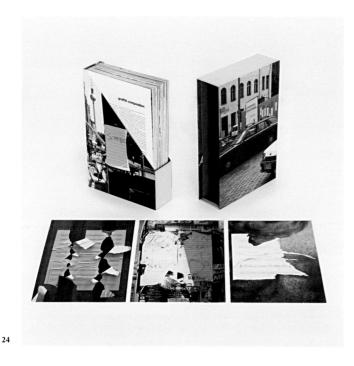

24

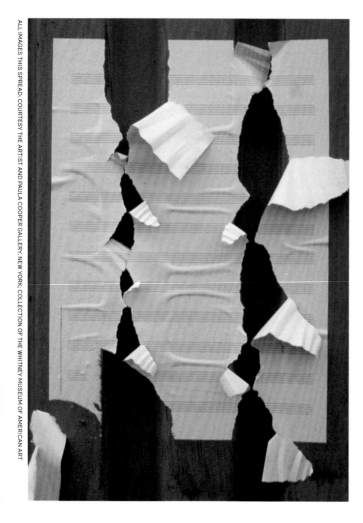

This spread: *Graffiti Composition*, 1996–2002. Portfolio of 150 digital prints, each 13 x 8 ½".
Printed by Muse X Editions, Los Angeles, published by Paula Cooper Gallery, New York.

Berlin is a musical town. Every corner seems to offer a cacophony of accordionists busking for change; violin scales waft from open windows; posters clamber for attention for rock gigs, open-air performances of the *Magic Flute*, or appearances by the Finnish Men's Shouting Chorus. In the summer of 1996, thousands of sheets of blank staff paper abruptly joined the fray: They offered no instructions, no explanation, no advertising, just twelve empty five-line staves. They were a momentary visual lull; white space in the midst of white noise.

People scribbled all over them.

The posters were part of *Graffiti Composition* (1996–2002), Christian Marclay's contribution to the Berlin sound-art festival Sonambiente. They had been designed as open invitations to passersby who could, Marclay wrote, "become composers as well as audience members." Every other night for a month, a crew dispersed throughout the city with posters and paste, while Marclay and his assistant, Rüdiger Lange, traveled around photographing the results. Most of the five thousand sheets disappeared instantly—blown away, torn down, or covered over. Still, hundreds remained to entice people to jot down a musical passage, scribble a doodle, or send, as someone wrote in tidy, quiet letters, "a message to the world." Marclay and Lange took some eight hundred photographs that summer, of which 150 were later editioned as a box set of digital prints by Muse X Editions. *Graffiti Composition* is an art object, a documentation of a transitory event, and a score, collaboratively (and sometimes unwittingly) created by dozens of people, a few insects, and the random hand of chance.

It is a radically "open" score: The work's performance premiere in 2001 featured wildly different interpretations by conductor Butch Morris, pianist Anthony Coleman, and singer Shelley Hirsch. Since then versions have been presented in London, New Orleans, the Netherlands, and New York, with perform-ance forces ranging from one to almost a dozen musicians. Most music is written to be interpreted by other people, but the degree to which composers have been willing to hand over the reins has varied enormously throughout history. John Cage, famously, saw compositional control as a philosophical, even spiritual, issue and, in doing so, built a bridge between music and visual art. It is the bridge on which Marclay has been camped for the greater part of his career.

Marclay's 1985 *Record Without a Cover* was a limited edition recording—largely the sounds of scratches and tics on other records—released with no protective jacket. Every time the record was picked up or slid between adjacent albums, new scratches, tics, and pops were acquired, so the very act of buying the record and carrying it home altered the piece you would hear when you got there. Incidental sound, recorded sound, recorded incidental sound, and recorded recorded sound were locked together in a counterpoint that confused the roles of composer and consumer, performer and audience.

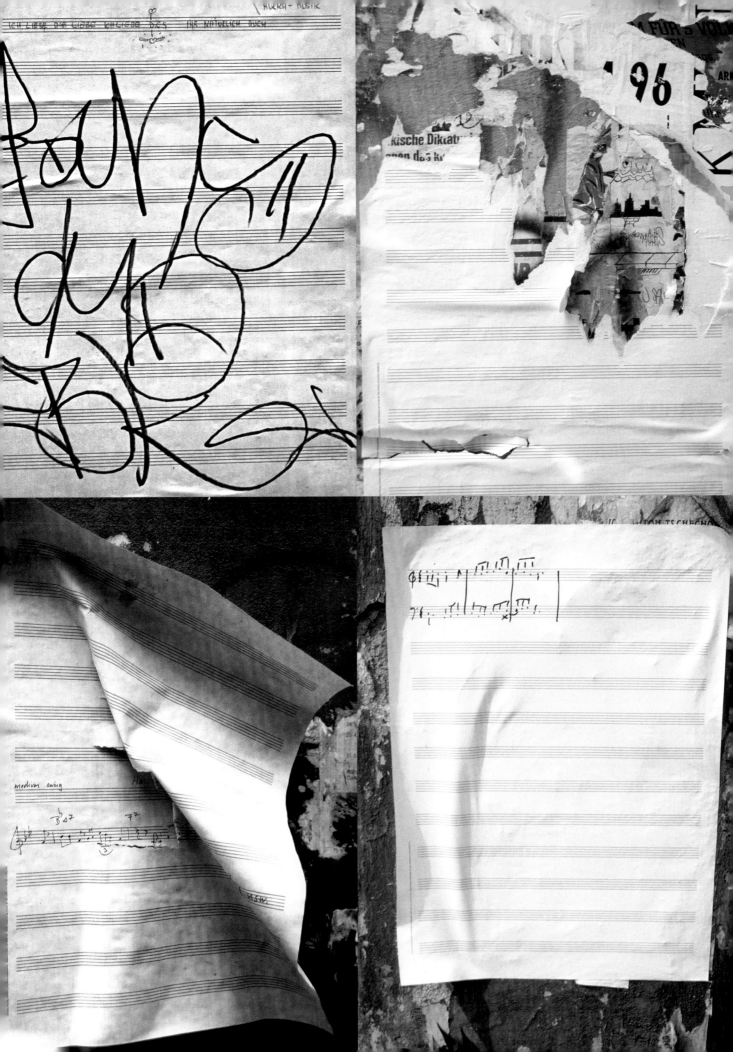

Graffiti Composition relies on a similar mix of visible musicality (all those staves), accident, and the musical contributions of anonymous donors. Though its 155 loose pages have no set order and often no musical notes, musical suggestion is everywhere: A sailboat floats on the staff, heels to port, turtles, and rights itself, proposing a looping melodic line. A mosquito squished between the top two lines becomes a treble-clef E. Splattered ink becomes harmony. Words stand in for music left unwritten: One person simply scribed, "Some dumb tune that stays in your mind all day." Some of the most beautiful images document the remains of posters that have been covered up or torn down, sheets punched through with holes or torn in soaring arcs. Even these look playable—one can imagine the loud vertical rips (tenor saxophone) through the prim staff lines (violin).

There is also an astonishing amount of scripted music, fully dressed, with the proper accessories—key signatures and tempo notations and chord symbols across the top for any wandering guitarists. There are student exercises and Baroque divertimenti. One busy batch of notes attracted the frustrated complaint: *"immer dieses tüdeldidüt!"* (always this tooty-toot!) Sometimes there are just a few notes, the

beginnings of a tune, broken off by the arrival of a bus, or a boyfriend, or boredom. And in typical Berlin fashion much of this erudition is put into the service of vulgarity: There is both a "Klo Song" (toilet song) and a "Urinal Boogie."

The sheer mass of the material suggests something operatic in scope—an opera of fragmentary characters and incident, unencumbered by plot; the scattershot snapshot of a particular city at a particular point in time. It's all here: the flashy music posters with the awkward English ("The Nuggets, Your Hottest Band in Town"), the wit (*"Mir fehlen die Noten"*—notes fail me—reads a cascade of letters), the self-conscious love of high art, and the equally self-conscious love of lowlife; even the Prussian dourness that pervades more of the city than nonresidents might guess (the posters left blank, tightlipped and unyielding, speak as loudly about the character of Berlin as the lipstick besmirched "Roy woz 'ere! Cheers, Ladies!").

If any one image can summarize *Graffiti Composition*'s openness and site-specificity, it would be the notation sheet slapped up on a pane of wire-reinforced glass around which wrought-iron leaves curl and splay—a doorway to some once-elegant building. Written in a neat and graceful hand is a two-part *Valse Passante* in the key of D, marked fortississimo. But the sixteen bars of the waltz have no notes, just a half-note rest at the end. Silence—to be played as loudly as possible, in 3/4 time. It could be seen as a European take on John Cage's *4'33"*: a little fussier (key of D), a little funnier (fortississimo). But where Cage's work became, in effect, his signature piece, the silent waltz is offered up anonymously, identified only by place: Across the top, the same neat hand has written "In Berlin Mitte," in Arabic.

Vive la Tüdeldidüt.

Susan Tallman is an art historian and writer, specializing in prints, multiples, and questions of authenticity and reproduction. She has lived and worked in New York, Amsterdam, and Berlin and currently teaches at the School of the Art Institute of Chicago.

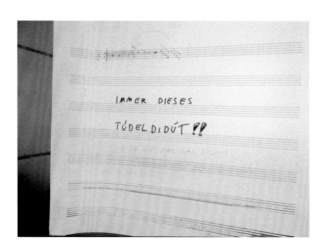

This spread: *Graffiti Composition*, 1996-2002. Portfolio of 150 digital prints, each 13 x 8 ½". Printed by Muse X Editions, Los Angeles, published by Paula Cooper Gallery, New York.

THE SOUNDS OF CHRISTMAS

Rob Young

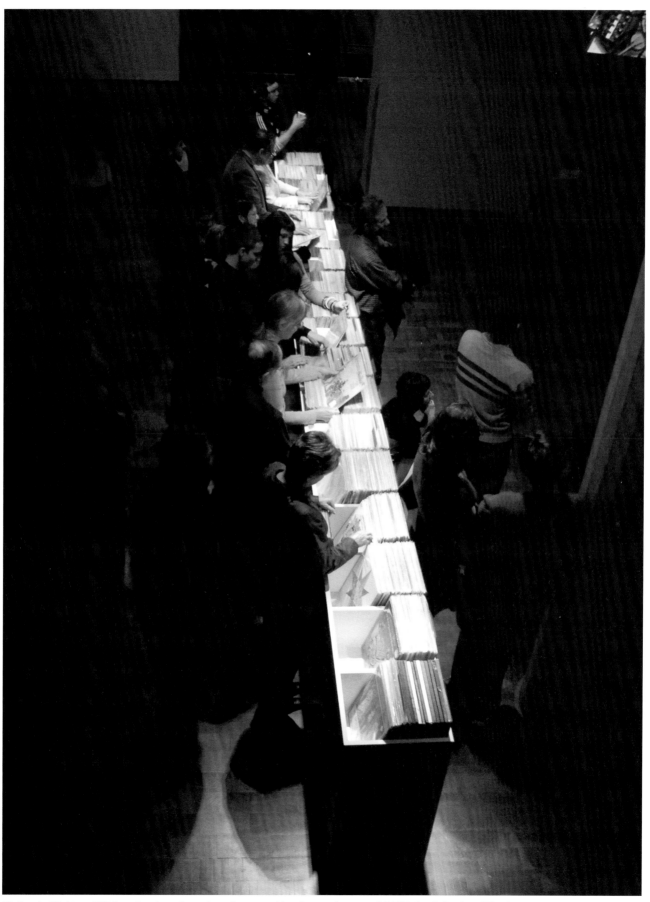

The Sounds of Christmas, 1999. Approximately one thousand records, two turntables, mixer, sound system, and six DVDs. Installation view at Milwaukee Art Museum, December 2005.

ondon, December 2004. Three waist-high crates are delivered to the pavilion on a freezing weekday. Levered open, they reveal their contents: more than a thousand vinyl records. This is Christian Marclay's collection of Christmas records, accumulated over several years, and which have traveled all over the world, flipped through by countless fingers. They have arrived at a temporary pavilion erected outside London's Tate Modern to be exhibited as *The Sounds of Christmas*, which Marclay installs every December at a designated location somewhere in the world. I was one of the curators involved in bringing this seasonal artwork to the U.K., and was fortunate enough to be standing among the crates as their contents were unpacked and placed between dividers on wooden racks constructed specifically for this event.

What does Christmas sound like? The festivities did not begin, my grandmother used to say, until she had heard the lone King's College choirboy trill the opening lines of "Once in Royal David's City," in the ceremony of Nine Lessons and Carols that is broadcast from Cambridge on British radio every Christmas Eve. Hipper households might throw on Phil Spector's *Christmas Gift for You* or Dean Martin singing "Frosty the Snowman": Yuletide through a cocktail glass. For others, it might be the Bach *Christmas Oratorio*, the sleigh bells that provide the icy leitmotif throughout Paul McCartney's "Wonderful Christmastime," or the angelic warble of Aled Jones singing "Walking in the Air." This kind of music is indelibly linked with the holiday festivities, conjuring the mood and setting the tone. But until you've leafed through *The Sounds of Christmas*, you simply have no idea how much choice is out there.

Christian Marclay began collecting Christmas LPs with artistic intent at the end of the 1990s. "I've always picked up cheap Christmas LPs," he tells me, "for when I was doing performances around the Christmas holidays. I wanted to be seasonal. I only started buying them seriously when I was on a residency in San Antonio, Texas, at Artpace in 1999. I developed this project in Texas and went hunting for records all over San Antonio and as far away as Austin." By the time *The Sounds of Christmas* was first realized in 1999 at Artpace, the collection consisted of nine hundred LPs. Now it stands at more than twelve hundred, and in the last decade has traveled to New York, San Francisco, Miami, Glasgow, London, Milwaukee, Geneva, Montreal, and Detroit. As an artwork, *The Sounds of Christmas* fulfills overlapping functions: It is a visual feast that encourages viewer interaction. Records are displayed in wooden browsers, as in a shop, and each flick of the racks reveals another variation on the seasonal theme. In the same space, all the record covers are projected in a random sequence on six video monitors, documenting the endless variety of cover designs.

Juxtaposed in this way, the LP packages tell their own story. Stick a plastic tree on a beach with the Sugar Loaf Mountain in the background: *Christmas in Rio*. Snow, pinecones, reindeer-drawn sleighs: *A Norwegian Christmas*. Christmas music rendered by Mormon, Pentecostal, Oxbridge, African tribal, Greek Orthodox, Welsh male, and Red Army choirs; Elvis, punk rockers, thrash metalers, opera stars, trad folkies, Vegas schmoozers, Japanese kotoists, cool-bop vibraphonists, Disney characters, Hawaiian guitarists, period instrumentalists, avant-garde improvisers, Swiss yodelers, gangsta rappers, soccer squads, military units, kindergarteners, Miami Bass DJs. Literary depictions of Christmas—Dylan Thomas, Dickens—read by Richard Burton and Paul Scofield. The Nativity rung on Cotswold church bells or harmonized by families pressing up recitals in private editions of ten. Everything and everybody, from the topmost to the crapmost of the music industry, seems to have wanted a slice of the Christmas pudding.

But this archive is not intended to be passively browsed. The installation directive calls for a small stage and sound system to be provided, plus a pair of DJ turntables

30

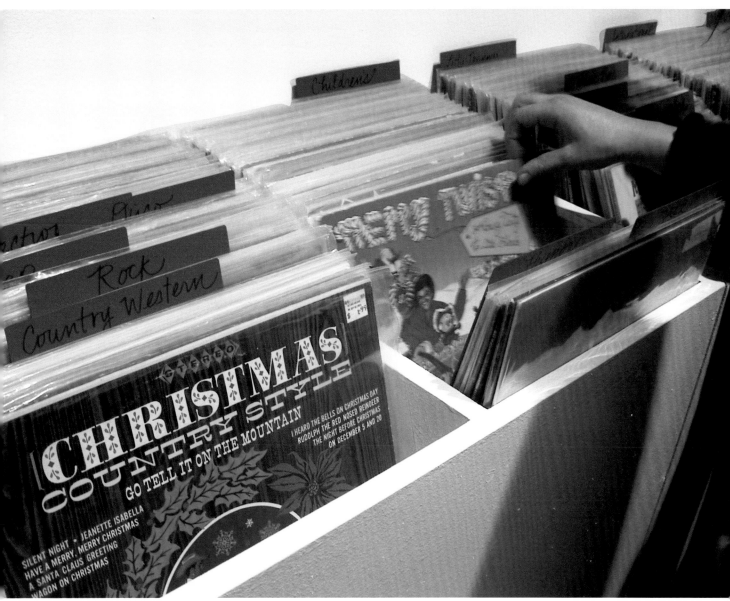

The Sounds of Christmas, 1999. Installation view at CCA – Centre for Contemporary Art, Glasgow, 2003.

and mixer. At each city, local DJs and musicians are commissioned to create unique, improvised mixes at live events, using only the Christmas albums as source material. They are permitted to sample the records and transform the sounds with any kind of effects pedal or processing software they want to bring, but the origin must be the music engraved in the grooves of the collection's LPs.

In this sense, *The Sounds of Christmas* is a working musical score and a giant readymade instrument. Its parameters are not a conventional written manuscript; the tools for activation are provided within the installation space. Among the rest of Marclay's work, it sits between one of his "accumulation"

pieces like *Wall Of Sound* (1997) and an open-ended, score-generating project like *Graffiti Composition* (1996–2002). It is a working demonstration of the recombinant art of the DJ, which now has its own history stretching back to late 1970s hip-hop and disco as well as the experimental turntable strategies pioneered by Marclay himself with his early group, The Bachelors, even. This legacy is reflected in the work's ad-hoc, "crate-digging" sourcing of materials as much as in the centrality of the DJs' performances.

There's a delight to be had in the infinite variations milked out of the idea of Christmas, and in the inventiveness of the musicians in further appropriating, recombining,

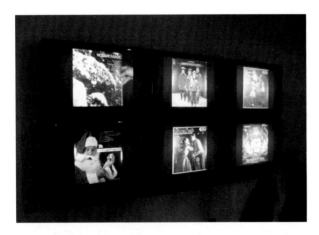

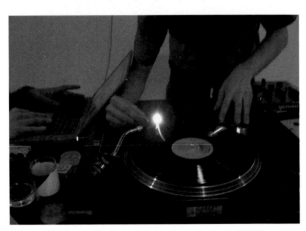

From top: *The Sounds of Christmas*, 1999. Installation views at DHC/ART Foundation for Contemporary Art, Montreal, 2008. Installation view at CCA – Centre for Contemporary Art, Glasgow, 2003.

and distorting the content. At the London iteration, the performances were wildly diverse. Ninja Tune DJs such as Coldcut's Matt Black and Strictly Kev accentuated the fun, funk, and kitsch elements. Experimental musicians the Bohman Brothers focused on the album sleeves, reading out excerpts from the liner notes while extracting noises from the cardboard itself. And turntablist Janek Schaefer created a hallucinatory, ringing soundscape of lushly elongated tones and angelic, caroling sonorities that suggested the ancient provenance of the Yuletide feast. Marclay himself tossed chopped-up portions of hymns and old-chestnut songs into a blender, modulating and transforming them with deft hands-on turntable manipulations and foot-switch effects.

Like Marclay's other LP collection-based work—*Incognita* and *Dictators* (both 1990), for example, which respectively highlight the unnamed female models used to sell albums and depict the male conductor as lonely hero—*The Sounds of Christmas* draws attention to patterns of representation in the packaging of these consumer objects. Instant signifiers of the season—tinsel and baubles, roaring fires, Santa hats, gift-wrapped parcels, pinecones, sleighs, stars, and shepherds—are systematically attached to artists who, for the rest of the year, would not dream of making any reference in their work to a Christian festival. Christmas, after all, is the center of gravity in the capitalist year—the shopping period that most affects retail profit margins. Many Christmas LPs are the product of nothing less than naked opportunism. Others, such as the handful of albums recorded by local choral societies, intended for sale among friends and relatives, are invested with love and pride. In between sit the hundreds of solo-artist Christmas celebrations—Henry Mancini, Liberace, Sting—calculated to humanize pop idols, reminding credulous fans that on December 25 they too will be opening presents and carving the ham. Or the myriad themed albums, from Hammond organ carols to Tijuana brass versions of "Winter Wonderland," which consumers might select to chime in with their own individual lifestyle aspirations. Marclay recognizes that records are more than just containers of music; they are cultural artifacts in their own right: They are repositories of memory, carriers of deep personal associations, and, in this case, bearers of entrenched cultural hegemony (surely no other world religious festival has generated so much audio product?).

Christmas LPs lie dormant for most of their lives—they're really only needed one or two days of the year. Experiencing *The Sounds of Christmas* feels like strolling round a charity shop, and in fact the piece performs an act of phonographic charity: Picking out these peripheral components of the domestic record collection, DJs dust them off and give them the gift of life.

Rob Young is an English writer and editor-at-large of *The Wire* magazine. In 2004 he cocurated Christian Marclay's *The Sounds of Christmas* at Tate Modern, London. His latest book is *Electric Eden: Unearthing Britain's Visionary Music*, published this summer by Faber and Faber.

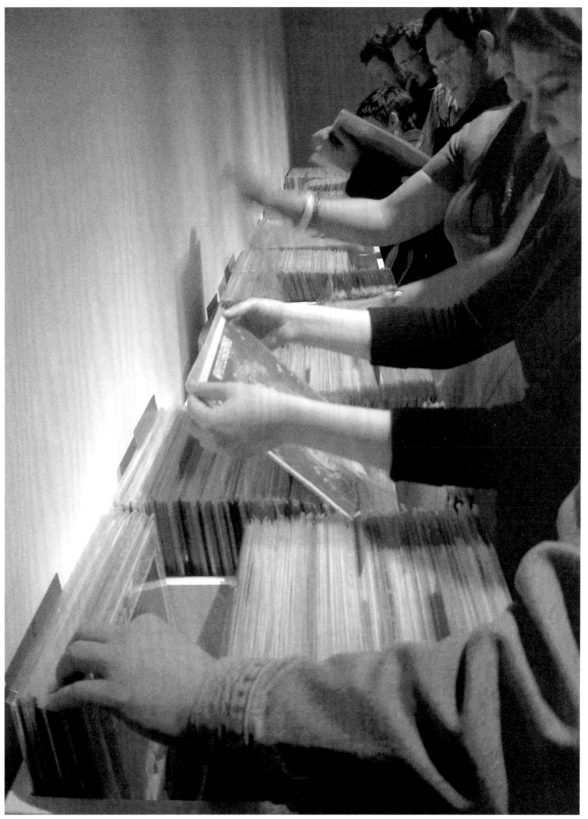

The Sounds of Christmas, 1999. Installation view at CCA – Centre for Contemporary Art, Glasgow, 2003.

SHUFFLE

Marclay has assiduously photographed musical notation found in everyday settings such as shop awnings, chocolate tins, T-shirts, underwear, and other places. These images are evidence of Marclay's keen eye for music inscribed throughout the urban landscape. All around us, it seems, are musical notes just waiting to be discovered and played. The box contains the following instructions:

This deck of cards can be used as a musical score.
Shuffle the deck and draw your cards.
Create a sequence using as many or as few of the cards as you wish.
Play alone or with others.
Invent your own rules.
Sounds may be generated or simply imagined.

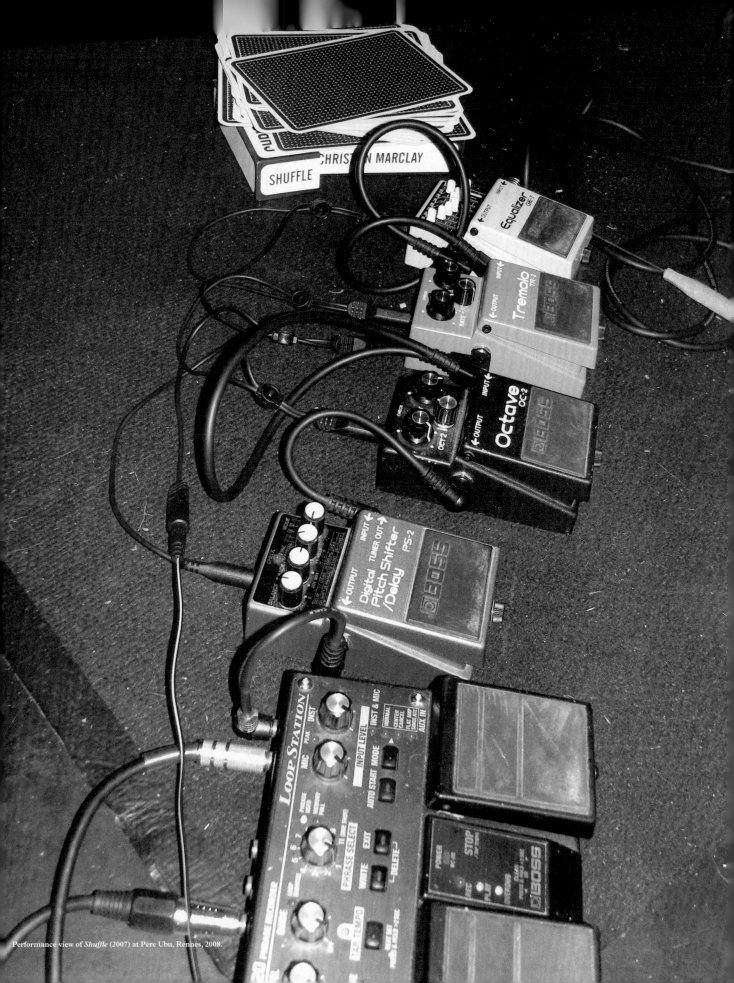

Performance view of *Shuffle* (2007) at Père Ubu, Rennes, 2008.

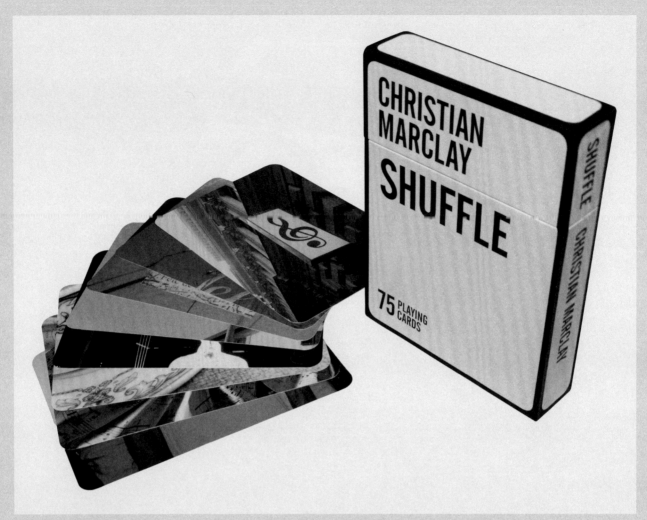

Shuffle, 2007, deck of seventy-five cards, printed in four-color on box and cards. Each card: 6¾ x 4¾ in. (16.5 x 12 cm), box: 7 x 5 x 1¼ in. (17.5 x 13 x 3 cm).
Published by Aperture, New York.

37

Shuffle (details), 2007. Deck of seventy-five offset printed cards. Published by Aperture, New York.

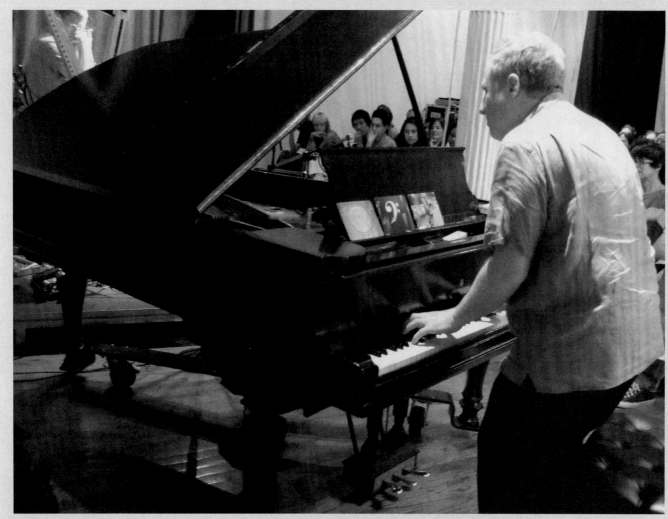

Anthony Coleman performing *Shuffle*, 2007, at Roulette, New York, June 2, 2007.

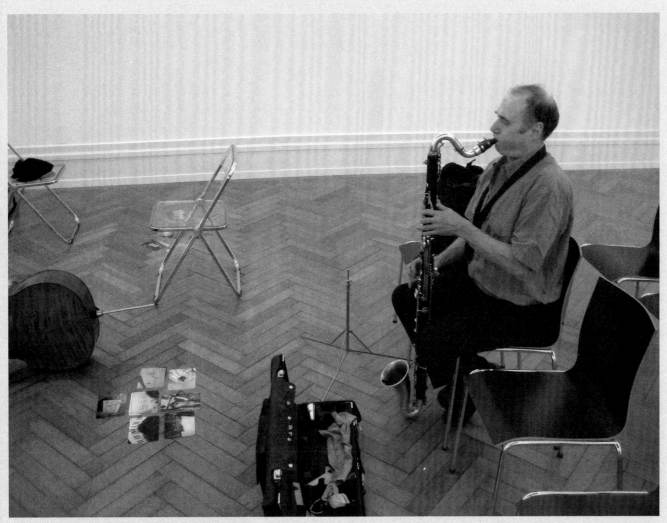

Hans Koch performing *Shuffle*, 2007, at Kunsthalle Bern, May 19, 2007.

Martin Schuetz performing *Shuffle*, 2007, at Kunsthalle Bern, May 19, 2007.

THE BACHELORS, EVEN

40

In 1979, while still a sculpture student at the Massachusetts College of Art in Boston, Christian Marclay cofounded his first band with fellow student and guitarist Kurt Henry. Their name paid homage to Duchamp's *The Bride Stripped Bare by Her Bachelors, Even* (1915–23). Influenced by punk music and 1970s performance art, the duo made music not only with guitar and voice, but by playing film loops, chopping wood, breaking mirrors, and smashing TV sets with bowling balls, among other actions. It was in this context that Marclay first started experimenting with turntables. From this point on music became central to Marclay's work as an artist. The band dissolved in 1980, after several appearances in San Francisco and New York.

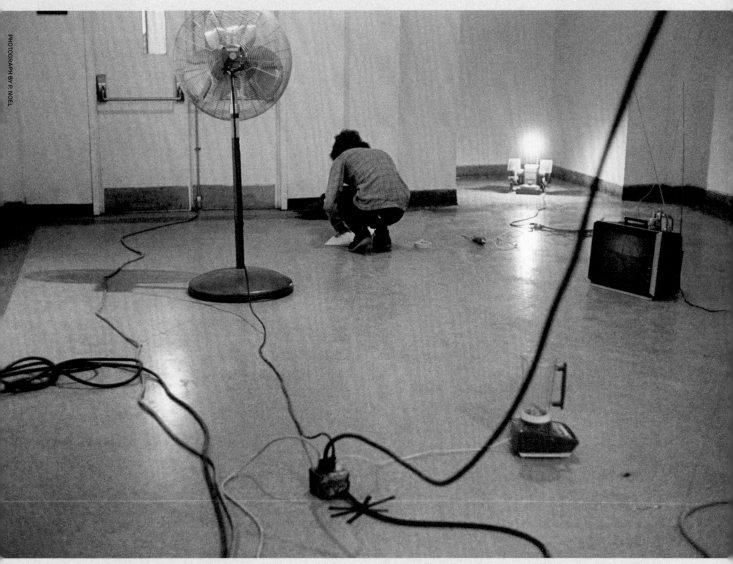

PHOTOGRAPH BY P. NOEL

Performance view from *The Bachelors, even*, Massachusetts College of Art, Boston, 1980.

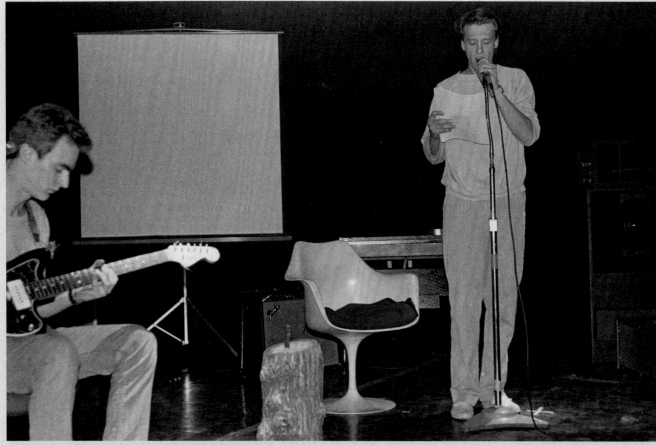

Christian Marclay and Kurt Henry performing as The Bachelors, even, at the Boston Film and Video Foundation, 1979.

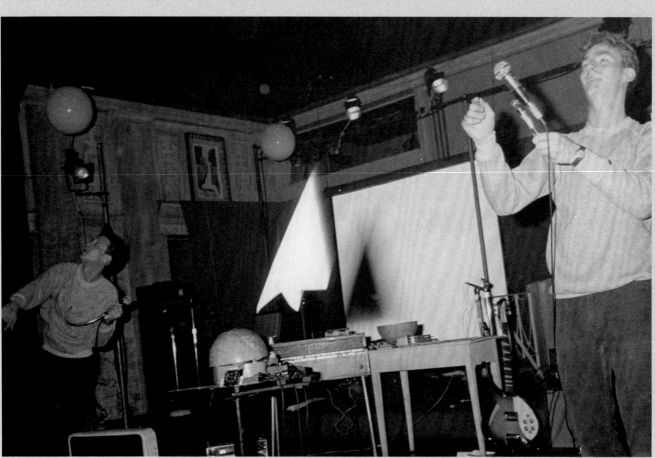

Above and opposite page: Christian Marclay and Kurt Henry performing as The Bachelors, even, at *Eventworks 80*, Boston, April 12, 1980.

42

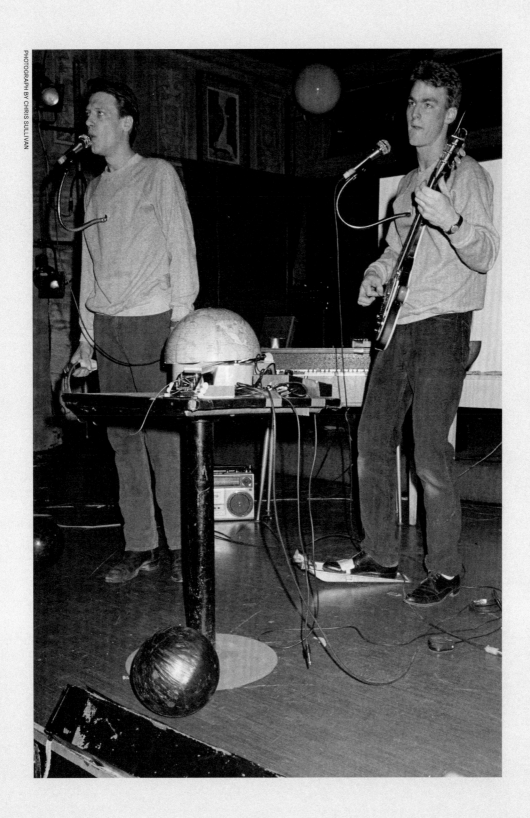

43

BERLIN MIX

As part of the programming celebrating the tenth anniversary of Berlin's Freunde Guter Musik, on July 24, 1993, Christian Marclay directed a simultaneous concert of more than 180 musicians at the Strassenbahndepot, a former streetcar facility in the city's Moabit district. Using large numbered signs to indicate when members of this diverse ensemble should start and stop performing, Marclay created a sweeping polyphonic tapestry—a "live mix"—of the profusion of musical genres enriching the cultural life of the German capital. Hip-hop and klezmer musicians, a classical string quartet and a samba group, accordionists and African drummers, oompah and funk bands, as well as opera singers, a choir, a barrel-organist, and many others, participated in this landmark event.

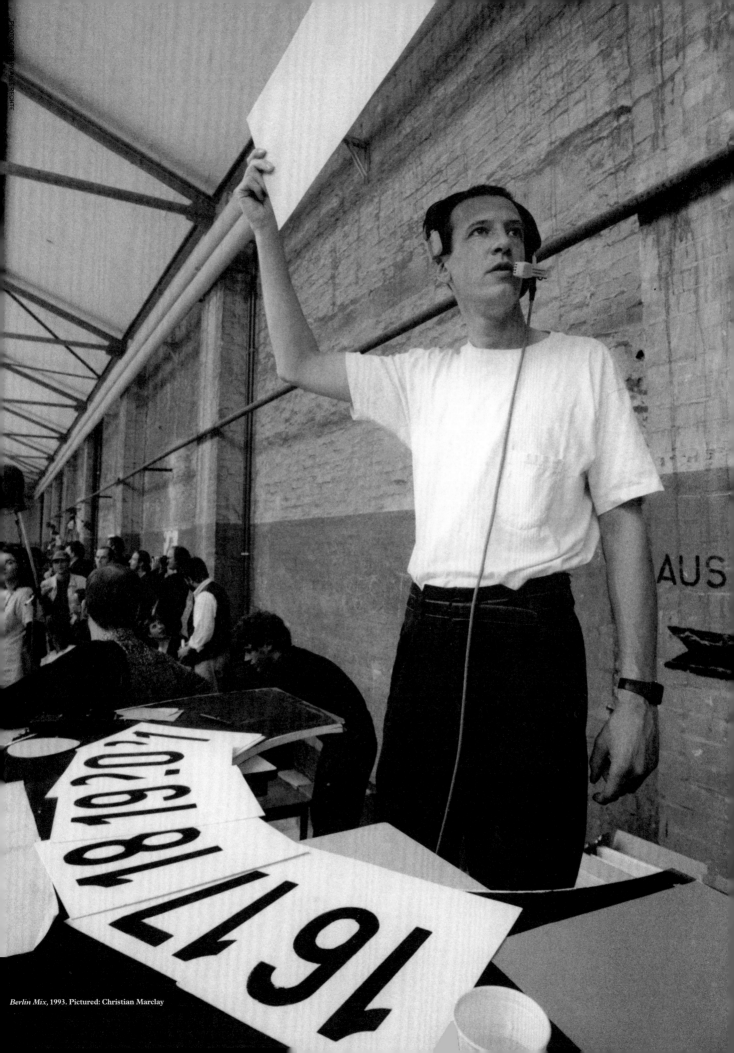

Berlin Mix, 1993. Pictured: Christian Marclay

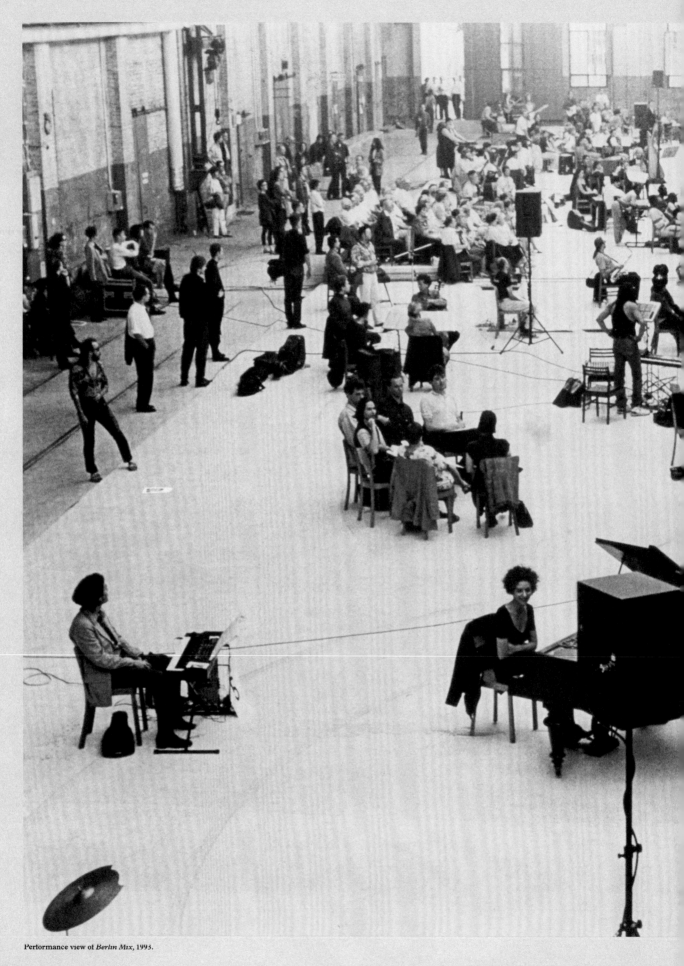

Performance view of *Berlin Mix*, 1993.

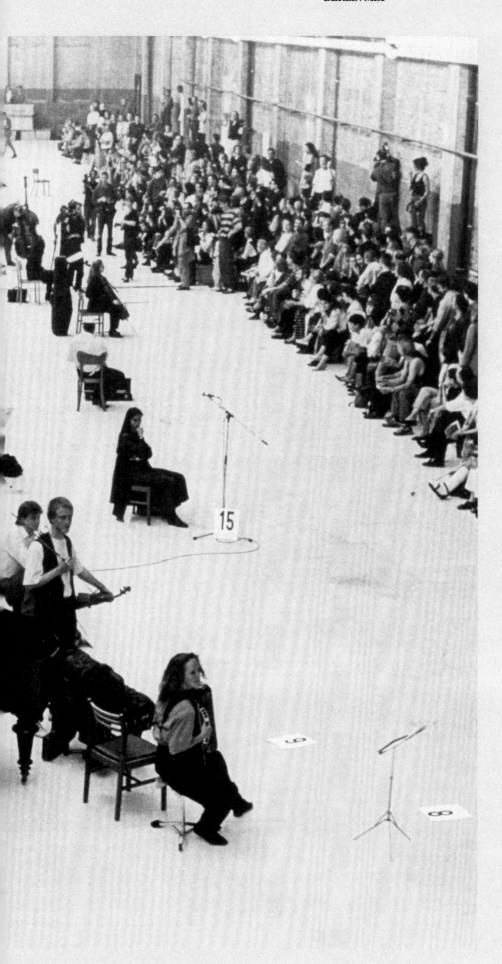

PHOTOGRAPH BY JÜGEN DIETRICH

48

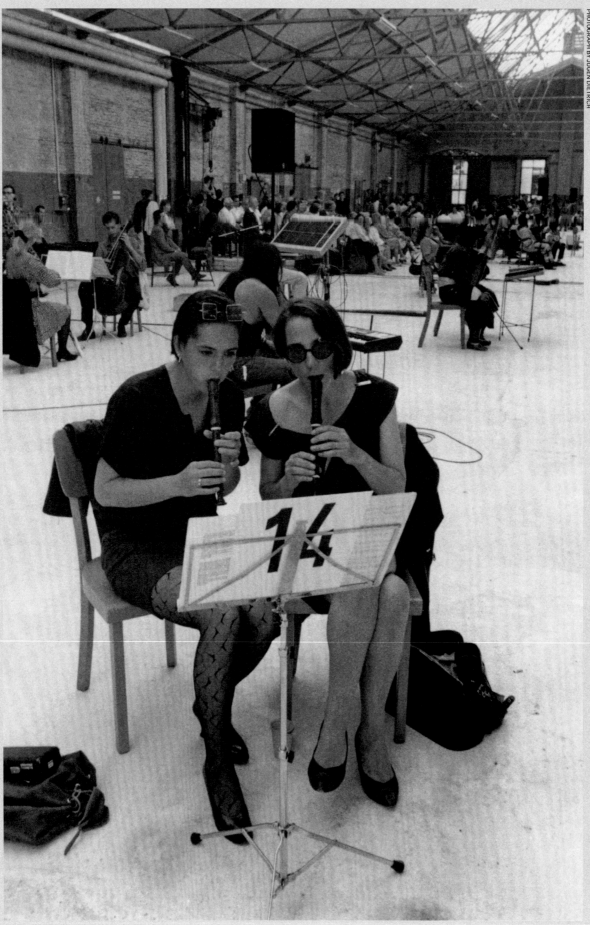

Henriette Knüpling and Christiane Seiffert.

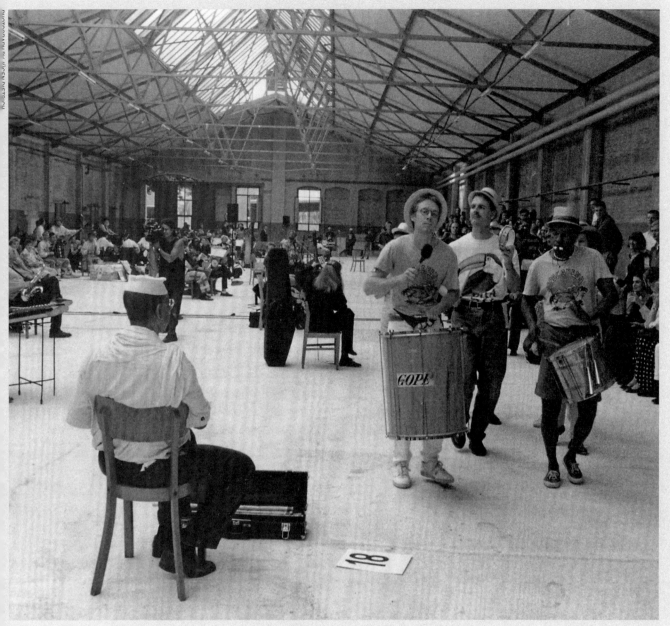

Mohamed Askari and Dr. Edel Samba band.

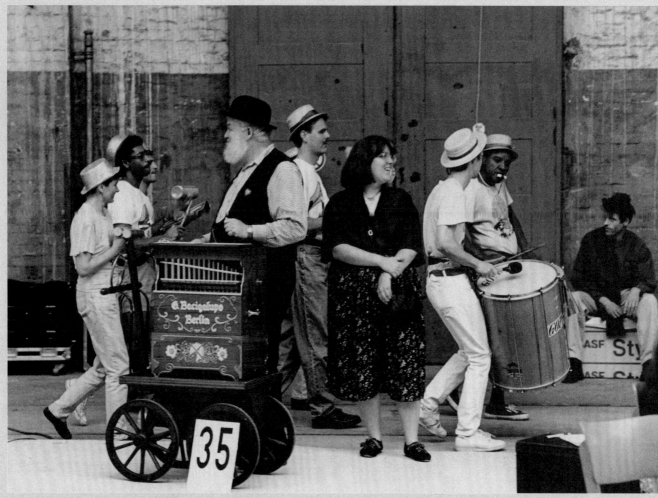

Wiemann and Rybczynski, Internationale Drehorgelfreunde Berlin e.V. and Dr. Edel Samba band.

Dimitrios Zacharis Duo and Russian Folk ensemble.

Amelia Cuni and Olivier Perrier.

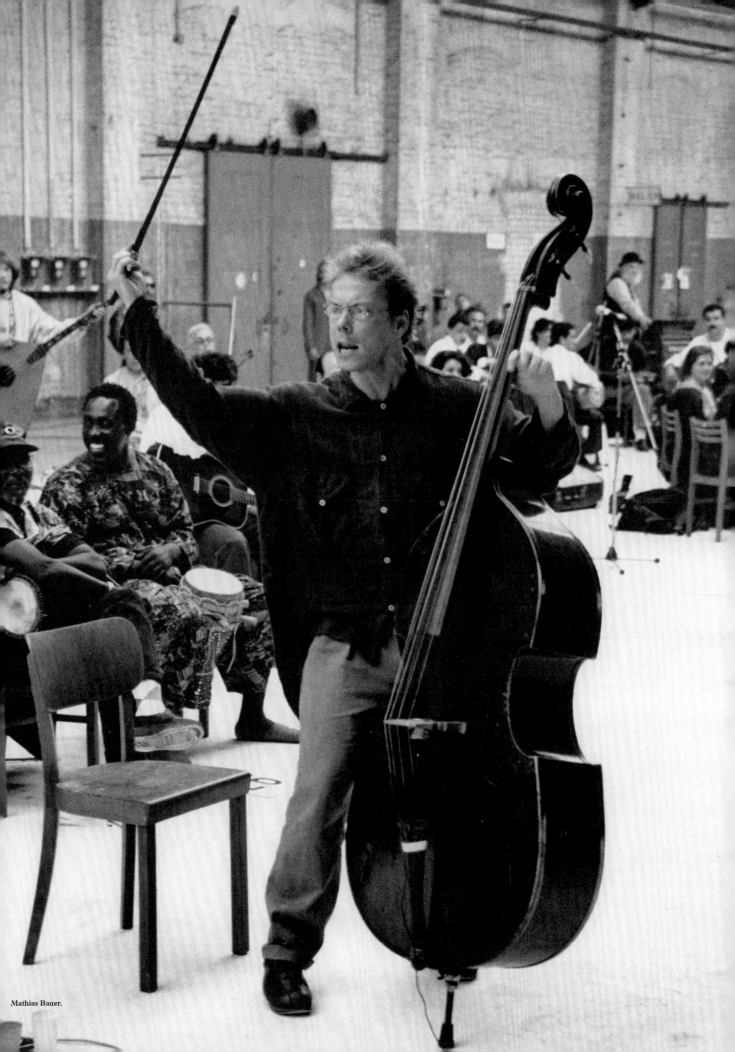

Mathias Bauer.

PHOTOGRAPH BY JÜGEN DIETRICH

52

21

Werner Durand.

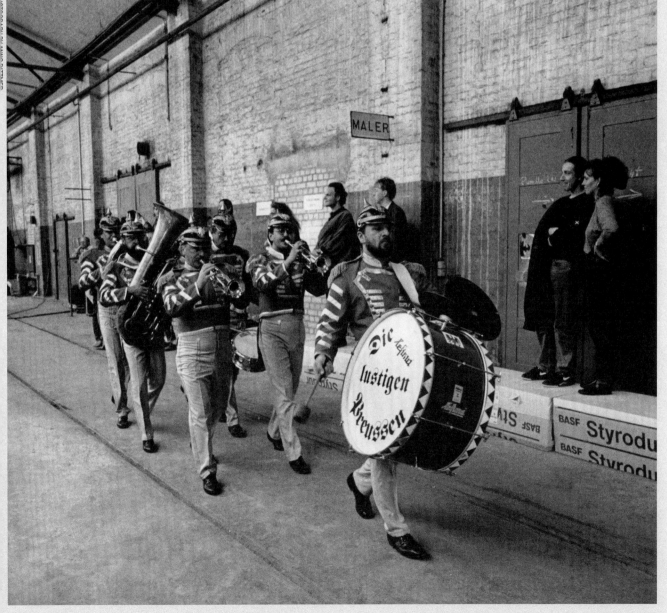

Die Lustigen Preussen.

SWISS MIX

On June 6, 1996, two hundred musicians from more than thirty groups representing the cantons of Switzerland gathered in the courtyard of medieval fortress Belluard Bollwerk in Fribourg during the annual international festival to participate in Christian Marclay's *Swiss Mix*. Using numbered signs, as he had three years earlier for *Berlin Mix*, Marclay conducted the ensemble in a multilayered mix of musical genres that captured the diversity of contemporary Swiss music, a broad range that included traditional folk as well as alternative genres.

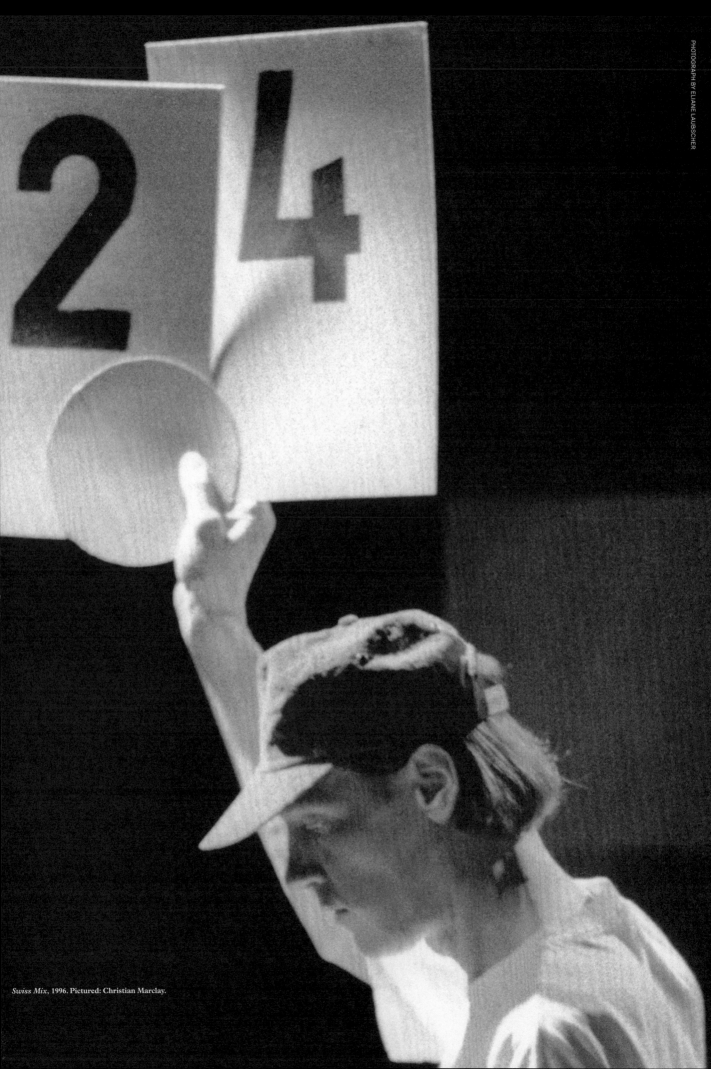

Swiss Mix, 1996. Pictured: Christian Marclay.

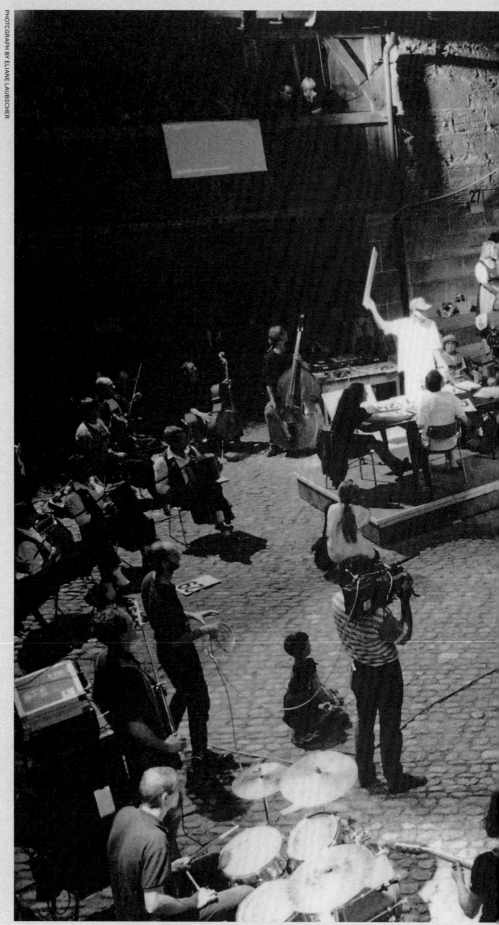

PHOTOGRAPH BY ELIANE LAUBSCHER

56

Performance view of *Swiss Mix*, 1996.

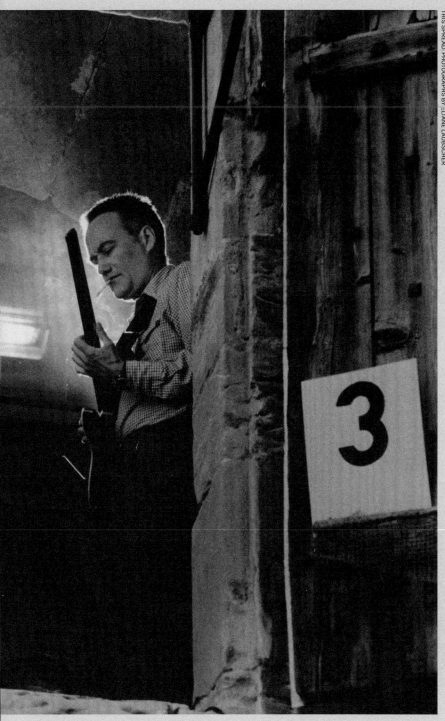

THIS SPREAD: PHOTOGRAPHS BY ELIANE LAUBSCHER

Stephan Wittwer.

THIS SPREAD: PHOTOGRAPHS BY ELIANE LAUBSCHER

60

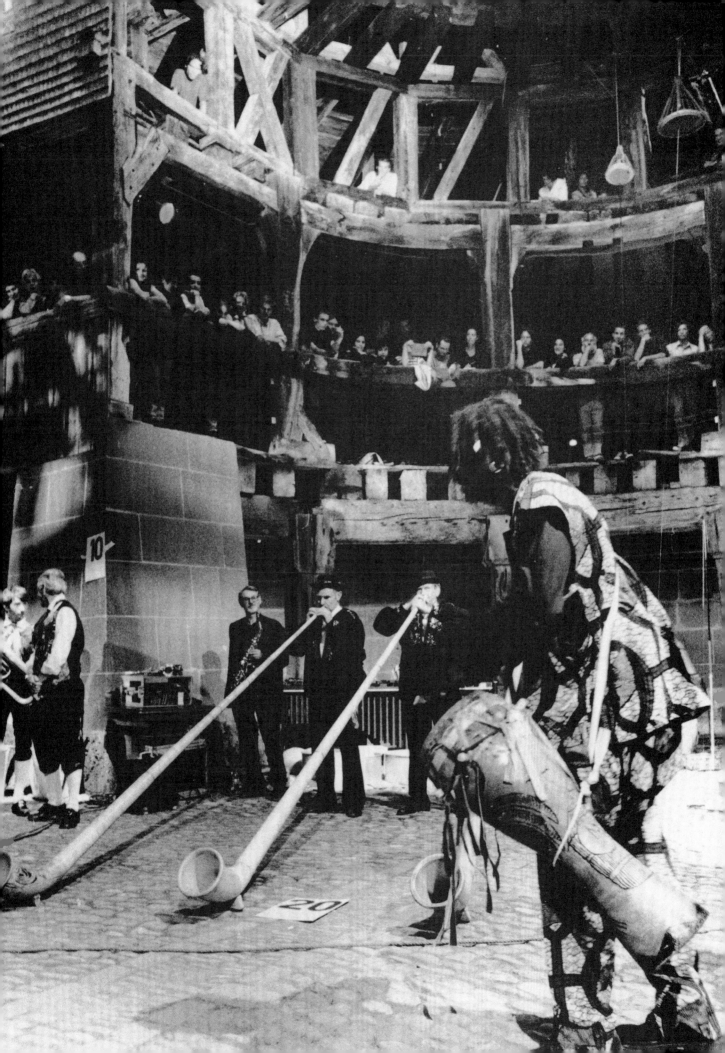

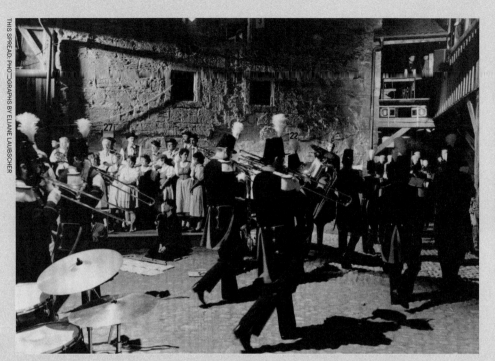

THIS SPREAD: PHOTOGRAPHS BY ELIANE LAUBSCHER

62

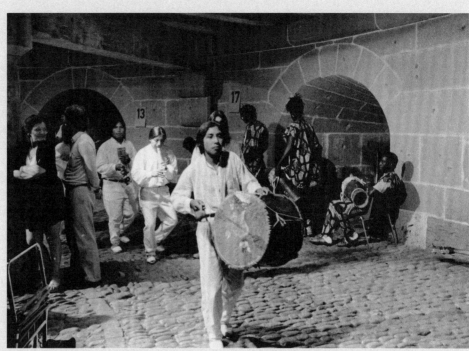

MANGA SCROLL

This 2010 vocal score consists of onomatopoeias found in manga cartoons originally published in Japan but translated for the U.S. market. These black-and-white serialized newsprint comics have been cut and collaged into a sixty-foot-long hand scroll. This type of scroll, which was invented in the eleventh century, is considered the antecedent of the contemporary Japanese graphic novel. Having been stripped of their dramatic context, the sound effects are strung together into one long composition meant for interpretation by voice.

PHOTOGRAPHS BY WILL LYTCH. COURTESY GRAPHICSTUDIO, TAMPA

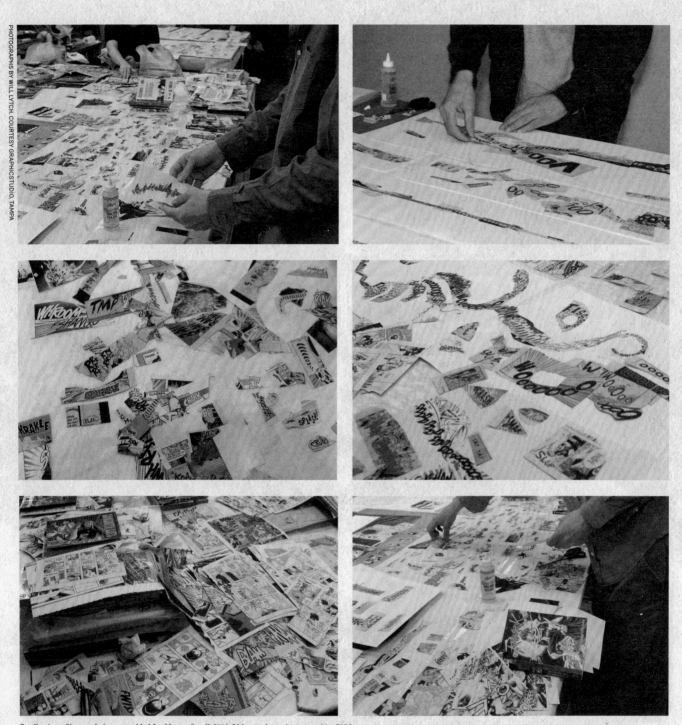

Studio view of images being assembled for *Manga Scroll*, 2010. Lithograph on rice paper, 16 x 712 in.
Published by Graphicstudio, University of South Florida, Tampa. Courtesy the artist.

NEVER THE SAME TWICE

Christian Marclay interviewed by
Russell Ferguson

For most of your career, your activities as an artist and as a musician have seemed to follow almost parallel tracks. This exhibition at the Whitney seems focused primarily on bringing your work as a composer into the space of the visual arts. I wonder whether you could say something about how these two tracks relate. Have you thought of them as separate, or have they always been aspects of one practice?

I have straddled these two fields since very early on, when I was still an art student in Boston in the late '70s. I started doing performance art and as a result got kicked out of the sculpture department. But when I started mixing records in performance, my work took a different turn. Music became central to my thinking. I don't really have two careers, because I make music the way a visual artist would. Sound and image are very closely intertwined in my work. Yet I feel more comfortable with the artist label than the composer label. I am not a composer. The only time I compose is when I perform or make a recording, or when I make an audiovisual composition with video. For a period in the early 1980s I stopped making art and focused on music. This was a very formative period for me. I was performing and touring a lot, collaborating with many musicians and learning so much from them. Many of these same musicians will be performing at the Whitney during the exhibition.

Who are some of those musicians? How were they important to you?

John Zorn introduced me to a lot of musicians when he invited me to perform in his "game pieces" in the early 1980s. These were group improvisations with rules such as in sports or strategy games. We were free to improvise within the precise guidelines determining our interaction, but not the specific sounds we made. Therefore the musical outcome was unpredictable. John was less concerned with the music than the structure of the pieces and the dynamic relation between the players. Because they were games, they were a lot of fun. The first Zorn piece I performed in was *Track and Field* in 1982, and later *Darts*, *Locus Solus*, *Rugby*, and *Cobra*, among others. There was a collage aspect to these fast-paced pieces, lots of jump-cut contrasts, and John liked the fact that I could conjure up the history of music at the drop of a needle, changing styles in an instant, from Braxton to Balinese. My first New York influence was punk and No Wave music, and it was interesting to see Zorn hire people like Arto Lindsay and Ikue Mori from the band DNA for his performances. Classical musicians, punks, and all kinds of eccentrics, we played together regardless of genre and background. That mixing spirit was very much in the air at the time.

Through these performances I met many musicians who had very idiosyncratic ways of playing. I had to keep up with all that exceptional talent. It was a crash course in music improvisation. David Moss asked me to perform with him. We ended up performing a lot together and toured Japan in 1987, playing almost daily for a month. All this playing sharpened my skills as an improviser. I had met Elliott Sharp in 1981 when he asked me for a one-minute piece for his compilation LP *State of the Union*, which was my first recording on vinyl, made at home on a cassette player. Elliott and I have collaborated on many projects since. Butch Morris is also someone I befriended in those days. There were so many fascinating players: Anthony Coleman, Zeena Parkins, Tom Cora, Wayne Horwitz, Shelley Hirsch, Jim Staley, Fred Frith, among many others.

I want to go back to your statement that you are "not a composer," and that the only time you compose is when you "perform or make a recording." Do you not regard your scores (that other people can perform) as compositions?

My scores are not finished works. Every time they are performed they generate something new. They will never sound the same twice. Composing implies a determination or at least a structure, an absolute model that won't change much with each performance. Most of my scores don't even specify the instrumentation. They are open to a multitude of interpretations. The musicians are asked to be very creative. They are playing their music, not mine. "Composer" also implies authorship; I prefer "collaborator." I am more like an instigator, who can disappear behind the score. I can hide in the audience and be surprised by what I hear. It is a very different experience than performing myself, or to be listening to someone else's music being performed. The music is unfamiliar, yet I know what prompted it, because I was involved in the process.

Opposite: Christian Marclay performing at the Kitchen, New York, 1985.

NEVER THE SAME TWICE

That's very modest. There are a lot of other composers whose scores incorporate aleatory elements, or at least elements that are very much up to the performers, and they still consider themselves the author of the work.

Maybe it is because of my visual-art background and my not having studied music in an academic way. If a fabricator makes an artwork for me, I direct him or her, and though there is an exchange of ideas, in the end I am the one who approves it or not. With my scores, I can't control the result. The music is not entirely mine. And even what generated the score is often not even mine; it is found, readymade music. The loss of control in music is actually what interests me the most. The struggle between control and loss of control is so much at the core of improvised music. Many artists have been interested in that threshold between determinacy and indeterminacy, and not just John Cage, but also Duchamp, Pollock, Burroughs, and others.

Why is it that in your visual art you need, or want, complete control over every detail, but in the scores you are willing to surrender control almost entirely?

I never have complete control over anything, even when I think I do, and that is why I enjoy making art. Live music allows me more freedom because it is time based. It is very much of the moment. I can't go back to make corrections. I have to accept the mistakes and be attentive to the accidents, as they are often the springboards for discoveries. All scores imply a translation, and in all translation there is a loss of information, but there is also a potential gain. Selecting the interpreters is often as important as the score itself. Musicians with whom I have an affinity and shared history may be more suited to perform my pieces, and I may want to highlight their unique abilities. I have a piece called *Zoom Zoom* (2008) that was designed with Shelley Hirsch in mind. Others can perform it, but her skills are ideal for this work. She is a unique improviser, and her wild imagination always surprises me.

Have you ever been taken aback or surprised by a performance of one of your scores? And would you say that there could be an illegitimate interpretation of them?

I have to accept that possibility. There have been performances that I did not like as much as others, mainly because the interpreter was trying to outsmart the score, coming up with some gimmick instead of making some interesting music. That's the danger of giving someone so much freedom. Maybe because my scores are so visual, musicians sometimes feel this is their chance to be visual, to make performance art or something more theatrical, and as a result the music suffers. The best performances are usually the ones that focus on the music. When I played in John Zorn's pieces there was always someone who would use some strategy to negate the music, because there were ways, while playing by the rules, to become a soloist, and decide to do nothing. The silence was a way to show off one's prowess, but it never served the music well.

For you as a musician, what are the main differences between free improvisation and performing someone else's score?

As a DJ I don't have the possibility of playing specific notes, so I am limited with respect to traditional notation. But I can enjoy the constraints of a score or the directions of a composer. It usually forces me to explore possibilities that I may not access on my own. In Butch Morris's "conductions" I was reacting to his directives, but it always remained an exchange, a collaboration in real time. We were all communicating at the same time, and his baton doesn't denote authority, but rather reflects and structures the group effort. In such structured improvisations the players bring a lot of their own skills and talent to the table. No one wants robots interpreting their music.

Collective free improvisation is never completely free because the musicians are reacting to one another, but one is not necessarily freer when improvising alone. I find playing with a group more interesting. Music is the most social of all the arts, and not just for the musicians. The audience plays its role—their presence adds a dynamic element to the event. That is what I like about live music, it is always social and unpredictable.

Is there on any level a political dimension to the implied collaboration between you and the performers of your scores?

You cannot create in a vacuum. I tend to base my work on realities we all share. I do not create from an imagination disconnected from everyday life. I'm less interested in dream or fantasy worlds, so of course the work will reflect the sociopolitical structures I live in, and sometimes be critical of it. My work with records is critical of the music industry, and it may sound rebellious to some, but luckily it is not only that, it is also a way for me to perform and enjoy the pleasure of collaboration with other musicians. Performing with records and turntables is less interesting to me today because vinyl records don't have the same cultural relevance they had in the 1980s. I have to remain conscious of the social implications of any of my works. Writing a traditional score implies a social hierarchy, which is not what I am trying to do here. I am not creating a composition out of sounds I imagined, organizing them in a structure for musicians to faithfully re-create. Instead I am providing a framework, a context in which sounds can develop freely through social interaction.

You suggested earlier that your scores are in some ways unfinished works. I'm interested in the point at which you might consider them completed. Are they complete in some sense when you yourself finish making them, or only after they have been performed? And to what extent do they exist as purely visual works?

69

The score is just a spark that triggers a reaction. It is a skeleton that needs the flesh and blood of the performer to come to life. A spark flickers for only an instant, so the idea of finished or unfinished is not really appropriate here. Some of my scores don't necessarily need to be performed to be appreciated. *Ephemera* (2009) or *Shuffle* (2007), for instance, bring attention to the ubiquitous presence of graphic music in our daily life. Maybe that's enough.

I'm interested in how something that is meaningless to one person can generate particular sounds for someone else. To a musician the visual stimuli result in action. Those sounds then create a bridge with an audience. This translation of the senses is fascinating. Not because there is a mystery there. On the contrary, the mystery is what I am trying to eliminate. I'm not interested in the mystery of the score, or its invisibility. I don't care so much for the mystique that occurs when the performer is the only one privy to the information of the score. In my video-scores such as *Screen Play* (2005) or *The Bell and the Glass* (2003), I alter the traditional dynamic between composer, performer, and listener, because the projection shows the listener what the musicians are responding to. And I also create a situation in which sound and image influence each other. Music doesn't need to be blind. This idea that music should remain pure and be listened to with eyes closed is outdated.

Do you think that pursuing both art and music has made it harder for people to get a complete sense of your work? To what extent do you have two separate audiences?

Music is performed in music spaces and art is presented in art spaces. This reinforces the divide. This exhibition will be a chance for a lot of people to see and, especially, to *hear* an aspect of my work that is less known. There has been so much talk about crossover between art and music, but in reality music is not taken seriously in the art world because it is less marketable. Also music in an exhibition gallery is less than ideal because of the bad acoustics. Maybe it is only an architectural problem? Yet an art audience comes with an openness often greater than in some academic music circles. When I make an audiovisual composition such as *Video Quartet* (2002), or *Crossfire* (2007), it is usually presented in an art context. The public reads it more in visual terms than musical ones, even though the work is really, for me, as much music as it is art. Each context comes with its limitations, and these video installations are technically too complex to present in a traditional music venue. But there is nothing wrong with having two audiences. As long as someone is affected by the work, I don't care who they are.

Russell Ferguson is chair of the department of art at UCLA and an adjunct curator at the Hammer Museum, Los Angeles. In 2003, he organized the first comprehensive exhibition of Christian Marclay's work, which was shown at the Hammer and at five other museums in the United States, England, France, and Switzerland.

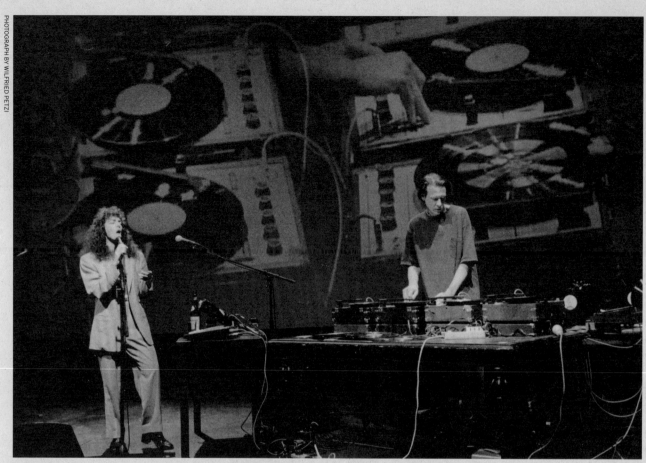

Shelley Hirsch and Christian Marclay performing at Marstall, Munich, April 26, 1987.

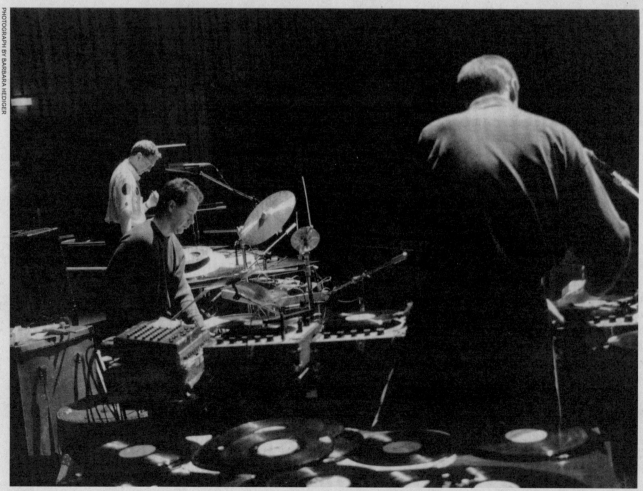

Christian Marclay, Günter Müller, and Steve Beresford performing during *Doubletake: Collective Memory and Current Art*, Kunsthalle Wien, Vienna, January 7, 1993.

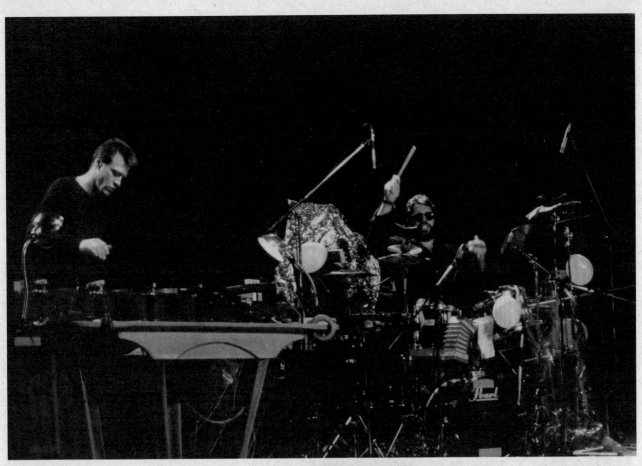

Christian Marclay and David Moss performing at the Actual Music Festival, Nikkatsu Studio, Tokyo, November 24, 1986.

PHOTOGRAPH BY CATHERINE CERÈSOLE

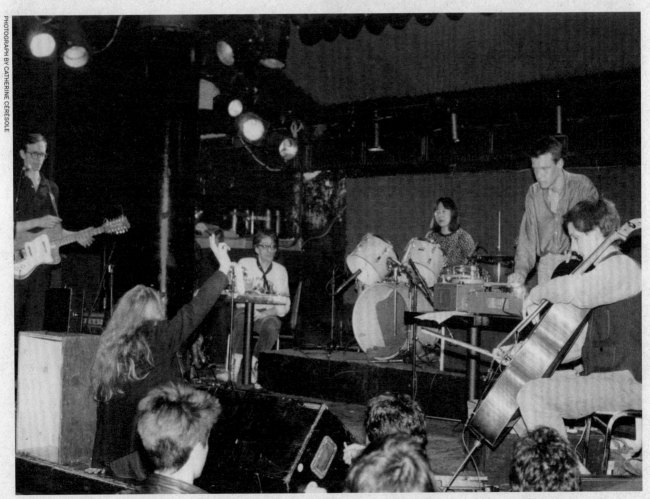

John Zorn's "Rugby" performed by Arto Lindsay, Zorn, Ikue Mori, Christian Marclay, and Tom Cora. Prompter: Robin Holcomb. Danceteria, New York, February 24, 1983.

PERFORMANCE SCHEDULE

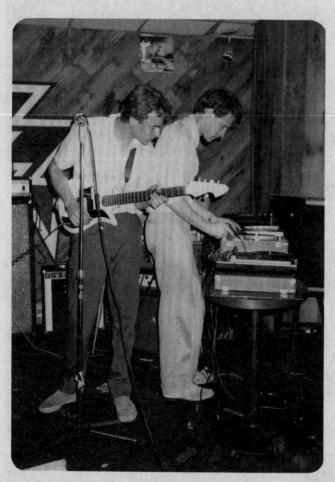

Christian Marclay and Kurt Henry performing at the Underground, Boston, 1979.

THURSDAY, JULY 1

1:00pm – Graffiti Composition
Min Xiao-Fen, Elliott Sharp

2:30pm – Box Set
Ulrich Krieger

4:00pm – Screen Play
Maria Chavez, Marina Rosenfeld,
special guest

FRIDAY, JULY 2

4:00pm – Screen Play
Maria Chavez, Min Xiao-Fen, Elliott Sharp

7:00pm – Screen Play
Text of Light (Ulrich Krieger, Alan Licht,
Lee Ranaldo)

SATURDAY, JULY 3

12:30pm – Ephemera
Sylvie Courvoisier, Mark Feldman

2:00pm – Screen Play
Maria Chavez, Min Xiao-Fen, Elliott Sharp

4:00pm – Screen Play
Text of Light (Ulrich Krieger, Alan Licht,
Lee Ranaldo)

SUNDAY, JULY 4

12:30pm – Ephemera
Sylvie Courvoisier, Mark Feldman

2:00pm – Graffiti Composition
Ulrich Krieger

4:00pm – Screen Play
Maria Chavez, Min Xiao-Fen, Ulrich Krieger

WEDNESDAY, JULY 7

2:00pm – Screen Play
Marina Rosenfeld, special guests

4:00pm – Sixty-four Bells and a Bow
Nicolas Collins

THURSDAY, JULY 8

1:00pm – Sixty-four Bells and a Bow
Nicolas Collins

4:00pm – Wind Up Guitar
Lee Ranaldo

FRIDAY, JULY 9

2:00pm – Sixty-four Bells and a Bow
Nicolas Collins

7:00pm – Screen Play
Maria Chavez, Marina Rosenfeld,
special guests

SATURDAY, JULY 10

1:00pm – Sixty-four Bells and a Bow
Nicolas Collins

4:00pm – Wind Up Guitar
Alan Licht

SUNDAY, JULY 11

1:00pm – Sixty-four Bells and a Bow
Nicolas Collins

4:00pm – Screen Play
Maria Chavez, Alan Licht, special guest

WEDNESDAY, JULY 14

4:00pm – Shuffle
John Butcher, Ned Rothenberg

THURSDAY, JULY 15

1:00pm – Wind Up Guitar
Lee Ranaldo

4:00pm – The Bell and the Glass
John Butcher, Ned Rothenberg

FRIDAY, JULY 16

2:00pm – Ephemera
John Butcher, Ned Rothenberg

7:00pm – Manga Scroll
Joan LaBarbara

SATURDAY, JULY 17

1:00pm – Screen Play
John Butcher, Alan Licht, Lee Ranaldo,
Ned Rothenberg

4:30pm – Zoom Zoom
Shelley Hirsch, Christian Marclay

SUNDAY, JULY 18

1:00pm – The Bell and the Glass
John Butcher, Ned Rothenberg

4:00pm – Wind Up Guitar
Alan Licht

WEDNESDAY, JULY 21

2:00pm – Screen Play
Sylvie Courvoisier, Mary Halvorson,
Ikue Mori

THURSDAY, JULY 22

1:00pm – Sixty-four Bells and a Bow
o.blaat

4:00pm – Wind Up Guitar
Mary Halvorson

FRIDAY, JULY 23

2:00pm – Sixty-four Bells and a Bow
o.blaat

7:00pm – Ephemera
Sylvie Courvoisier, Ikue Mori

SATURDAY, JULY 24

12:30pm – Screen Play
Sylvie Courvoisier, Mary Halvorson,
Ikue Mori

2:00pm – Ephemera
Sylvie Courvoisier, Ikue Mori

4:00pm – Wind Up Guitar
Mary Halvorson

SUNDAY, JULY 25

12:30 – Ephemera
Sylvie Courvoisier, Mary Halvorson

2:00pm – Sixty-four Bells and a Bow
Ikue Mori

4:00pm – Sixty-four Bells and a Bow
o.blaat

WEDNESDAY, JULY 28

1:00pm – Wind Up Guitar
Mary Halvorson

4:00pm – Sixty-four Bells and a Bow
Ikue Mori

THURSDAY, JULY 29

1:00pm – Shuffle and Ephemera
Sylvie Courvoisier

4:00pm – Graffiti Composition
Mary Halvorson, Ikue Mori

FRIDAY, JULY 30

2:00pm – Sixty-four Bells and a Bow
Ikue Mori, special guest

7:00pm – Screen Play
Ikue Mori, Zeena Parkins, special guest

SATURDAY, JULY 31

1:00pm – Sixty-four Bells and a Bow
Ikue Mori

4:00pm – Pret-à-Porter
Sylvie Courvoisier, Mary Halvorson,
special guests

SUNDAY, AUGUST 1

1:00pm – Ephemera
Sylvie Courvoisier, Ikue Mori

4:00pm – Wind Up Guitar
Mary Halvorson

73

PERFORMER BIOS

John Butcher
John Butcher's work encompasses improvisation, composition, and explorations with feedback and extreme acoustics. Since leaving academia in 1982, he has collaborated with hundreds of musicians—including Derek Bailey, John Stevens, Gerry Hemingway, Polwechsel, John Edwards, Toshimaru Nakamura, Eddie Prevost, John Tilbury, and Steve Beresford. His compositions include pieces for Elision and Rova Quartet, and "somethingtobesaid" for his own septet.

Maria Chavez
Born in Peru, avant-turntablist Maria Chavez lives in Brooklyn, New York. She creates electro-acoustic sound pieces using vinyl and needle. She has collaborated with Merce Cunningham, Otomo Yoshihide, and Pauline Oliveros. She was recently awarded the Jerome Emerging Artist grant and is a Van Lier Fellow.

Nicolas Collins
New York born and raised, Nicolas Collins studied with Alvin Lucier, worked with David Tudor, and has collaborated with numerous other musicians. He has been Visiting Artistic Director of STEIM (Amsterdam) and a DAAD composer-in-residence in Berlin, and currently teaches in the Department of Sound at the School of the Art Institute of Chicago.

Sylvie Courvoisier
Swiss-born composer-improviser Sylvie Courvoisier is one of the most creative and imaginative pianists in new music. A frequent collaborator with Mark Feldman, Ikue Mori, and John Zorn, she is a member of Mephista, co-leads the Sylvie Courvoisier/ Mark Feldman Quartet, and is the leader of her own quintet, Lonelyville, and the trio Abaton. Since 1997, she also performs regularly solo.

Ulrich Krieger
Ulrich Krieger is a composer, performer, and improviser living in California. He has studied saxophone, composition, and electronic music. Krieger has developed an "acoustic electronics" approach to playing saxophone and composition. He works in experimental and electronic music, noise, improvisation, rock, and metal, collaborating with Lou Reed, Lee Ranaldo, Thomas Köner, Phill Niblock, Radu Malfatti, and others. He teaches composition at the California Institute for the Arts.

Mary Halvorson
Mary Halvorson's eclectic body of work spans the worlds of chamber-folk, experimental rock, and avant-garde jazz. Known as "the freshest, busiest, most critically acclaimed guitar-slinger out of downtown Manhattan/ Brooklyn right now" (Howard Mandel, *Jazz Beyond Jazz*), she can be heard with her own bands and with such frequent collaborators as Jessica Pavone, Kevin Shea, and the iconic Anthony Braxton.

Shelley Hirsch
A native New Yorker, Shelley Hirsch has been deemed "an unorthodox, extraordinary fusion of vocalist, composer, and performance artist" by composer Anne LeBaron. Her work encompasses storytelling, staged performances, compositions, improvisations, collaborations, installations, and radio plays that have been presented on five continents.

Joan La Barbara
Joan La Barbara, composer/performer/ sound artist, has created a unique vocabulary of experimental and extended vocal techniques—multiphonics, circular singing, ululation, glottal clicks—her "signature sounds." Awards include a Guggenheim Fellowship, a DAAD Fellowship in Berlin, an NEA grant, numerous commissions for multiple voices, chamber ensemble, music theater, orchestra, and interactive technology. La Barbara is composing a new opera exploring the interior dialogue and sounds within the mind.

Alan Licht
Alan Licht is a New York–based guitarist, writer, and curator. Recent activities include performances with the newly reconstructed Luigi Russolo *intonarumori* (noise instruments) by Text of Light, the group he cofounded with Sonic Youth's Lee Ranaldo, and creating *On Deaf Ears*, a sound installation at Audio Visual Arts gallery in Manhattan. He is the author of *Sound Art: Beyond Music, Between Categories* (Rizzoli, 2007).

Min Xiao-Fen

Pipa player and composer Min Xiao-Fen transcends borders with cutting-edge music. A breathtaking virtuoso, Min blends ancient Chinese music and her own compositions, diverse musical influences including Chinese folk music and regional operas, Taoist music, American jazz, and bluegrass. She was honored with an award from the Asian Cultural Council. Min is also the founder of Blue Pipa, Inc.

Ikue Mori

Ikue Mori moved from Tokyo to New York in 1977. She started playing drums and soon formed the seminal No Wave band DNA with Arto Lindsay. Since the 1990s she has collaborated with numerous improvisers throughout the U.S., Europe, and Asia, while continuing to produce and record her own music. Mori won the Distinctive Award for Prix Ars Electronics Digital Music category in 1999. In 2000 Mori started using laptop computers to expand her vocabulary, not only performing sounds with them but creating visual work as well.

o.blaat (Keiko Uenishi)

Sound artist, social composer, and core member of SHARE, o.blaat (Keiko Uenishi) is known for her works formed through experiments in restructuring and analyzing one's relationship with sounds in sociological, cultural, and psychological context. Exploring aural space, o.blaat created *Car décalé (légèrement)* utilizing audio feedback, and installed *SOUNDLEAK: TheROOM* at Medien Kultur Haus, Wels, Austria.

Zeena Parkins

Zeena Parkins is a composer and improviser who works with sound as a solo performer, installation artist, and collaborator with fellow musicians, choreographers, filmmakers, and light composers. Known as a pioneer of the electric harp, Parkins has expanded the language of the acoustic harp with the inventive use of unusual playing techniques, preparations, and processing. She has received commissions from all over the world as well as numerous awards, including three Bessie Awards and fellowships from the Foundation for Contemporary Arts, NYFA, NYSCA, and the Rockefeller Foundation.

Lee Ranaldo

Lee Ranaldo is a musician, visual artist, writer, and founding member of the New York City group Sonic Youth. Their most recent record is *The Eternal*, released in 2009. An extensive touring museum exhibition, *Sonic Youth, etc: Sensational Fix*, opened in June 2008 at LIFE, St. Nazaire, France, and continues to tour Europe through 2010. Ranaldo's visual and sound works have been shown most recently in the solo show *A Random Collection of Cells*, at Hogar Collection in Brooklyn, New York. His latest collection of writings, *Against Refusing*, enlists Internet spam as a springboard for poetry. Recent solo recordings include *Afternoon Saints: The Shirley Jangle* (with Christian Marclay, Gunter Muller, David Watson); *We'll Know Where When We Get There* (with Leah Singer), and *Maelstrom from Drift*.

Marina Rosenfeld

Marina Rosenfeld is a composer and artist based in New York. Her work has been widely presented in Europe and North America by festivals, museums, and organizations including the Whitney Museum (Biennials 2002 and 2008), Stedelijk Museum, Tate Modern, Creative Time, Holland Festival, Performa Biennial, Merce Cunningham Dance Company, and many others. She is also co-chair of Bard College's graduate program in Music/Sound.

Ned Rothenberg

Composer-performer Ned Rothenberg is internationally acclaimed for both his solo and his ensemble music, presented for the past thirty years in North and South America, Europe and Asia. He performs primarily on the alto saxophone, clarinet, bass clarinet, and the shakuhachi—an endblown Japanese bamboo flute. He leads the trio Sync, with Jerome Harris on guitar and Samir Chatterjee on tabla. Recent recordings include Sync's *Harbinger, Intervals*, a double CD of solo work; *Live at Roulette* with Evan Parker; and *Are You Be* and *The Fell Clutch* on the label Animul. Chamber music releases include *Inner Diaspora*, *Ghost Stories*, and *Power Lines*. Other collaborators have included Sainkho Namchylak, Paul Dresher, John Zorn, Marc Ribot, and Yuji Takahashi.

Elliott Sharp

A central figure in the avant-garde for more than thirty years, Elliott Sharp leads Orchestra Carbon, Tectonics, and Terraplane and has pioneered ways of applying fractal geometry, chaos theory, and genetics to musical composition and interaction. His work has been featured in the Venice Biennale and the Hessischer Rundfunk Klangbiennale, with the premiere of "On Corlear's Hook" for the Radio-Sinfonie Frankfurt.

WORKS IN THE
EXHIBITION

Dimensions are in inches, followed by centimeters;
height precedes width precedes depth.

Mixed Reviews (American Sign Language), 1999–2001

Mixed Reviews, 1999–2010

The Bell and the Glass, 2003

Screen Play, 2005

SCORES

Through the Looking Glass, 1985
Score for a brass quartet
Ten pages photocopy
Collection of the artist;
courtesy Paula Cooper Gallery, New York

Mixed Reviews (American Sign Language),
1999–2001
Single-channel color video, silent; 30 min.
Collection of the artist;
courtesy Paula Cooper Gallery, New York

Mixed Reviews, 1999–2010
Vinyl letters on wall
Site-specific installation
Collection of the artist;
courtesy Paula Cooper Gallery, New York

Graffiti Composition, 1996–2002
Portfolio of 150 Indigo prints printed from
digital file; ed. 12/25
[sheet] 13 x 8 ½ in. (33 x 21.5 cm)
Printed by Muse X Editions, Los Angeles,
Star Link Company, Inc., Torrance, California
and Meridian Printing, East Greenwich,
Rhode Island; box assembled by Portfolio
Box, Inc., Pawtucket, Rhode Island;
published by Paula Cooper Gallery,
New York; Whitney Museum of American Art,
New York; gift of Steven Johnson and Walter
Sudol 2006.51.1

The Bell and the Glass, 2003
Two synchronized video projection loops,
color and black and white, with sound; 22 min.
Collection of Pamela and Richard Kramlich;
Exhibition copy courtesy Paula Cooper
Gallery, New York

Screen Play, 2005
Single-channel video projection,
black and white with color, silent; 29 min.
Made possible with support from
Eyebeam's Moving Image Foundation.
Collection of the artist; courtesy
Paula Cooper Gallery, New York

Shuffle, 2007
Deck of seventy-five color offset printed cards,
[card] 6¾ x 4¾ in (16.5 x 12 cm).
[box] 7 x 5 x 1 ¼ in. (17.5 x 13 x 3 cm).
Published by Aperture Foundation, New York
Frances Mulhall Achilles Library, Archives,
Whitney Museum of American Art, New York;
gift of David Kiehl, 2007

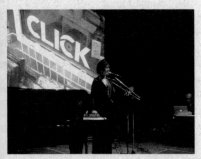
Zoom Zoom, 2007–2009. Performance with Shelley Hirsch.
Theatre du Grutli, Geneva.

Ephemera, 2009

Record Without a Cover, 1985

Box Set, 2008–2010

Zoom Zoom, 2007–2009
Digital slide projection, color, silent;
time duration variable
Collection of the artist; courtesy
Paula Cooper Gallery, New York

Ephemera, 2009
Portfolio; color offset lithograph, set of
twenty-eight folios; with slipcase; ed. 8/90
[folio] 15 ¾ x 23 ¾ in. (40 x 60 cm) each
Printed by Patrick Laurensis, Arte-Print,
Brussels; published by mfc-Michèle Didier,
Brussels
Whitney Museum of American Art; purchase,
with funds from the Print Committee
T.2010.386

Manga Scroll, 2010
Lithograph; HC copy
[sheet] 16 x 720 in. (40 x 1828 cm)
Printed and published by Graphicstudio/
University of South Florida, Tampa
Collection of Graphicstudio/University of
South Florida,Tampa

Chalkboard, 2010
Interactive wall installation
[wall] 17 ½ x 87 ft.
Made possible with support from the
Whitney Museum of American Art, New York
Collection of the artist; courtesy Paula
Cooper Gallery, New York

Covers, 2007–2010
Thirty 12-inch found record covers
[each] 12 ¼ x 12 ¼ in. (31 x 31 cm)
Collection of the artist; courtesy
Paula Cooper Gallery, New York

Box Set, 2008–2010
Commercially printed tin, plastic,
and cardboard boxes
Dimensions variable
Collection of the artist; courtesy
Paula Cooper Gallery, New York

Sixty-four Bells and a Bow, 2010
Sixty-four glass, porcelain, and metal
hand bells, and a violin bow
Dimensions variable
Collection of the artist; courtesy
Paula Cooper Gallery, New York

Prêt-à-Porter, 2010
Found garments and accessories,
a bottle of single-malt whisky, glasses
Dimensions variable
Collection of the artist; courtesy
Paula Cooper Gallery, New York

DRAWINGS/OBJECTS

Recycled Records, 1980–1986
Collaged vinyl records
[each] 12 in. (29.8 cm) diameter
Collection of the artist; courtesy
Paula Cooper Gallery, New York

Record Without a Cover, 1985
Vinyl record
12 in. (29.8 cm) diameter
Published by Recycled Records, New York
Courtesy Paula Cooper Gallery, New York

Vocal Score, 1989
Collage on music-score sheet
[sheet] 18 x 12 in. (45.7 x 30.5 cm)
Collection of the artist; courtesy
Paula Cooper Gallery, New York

BZAAM, 1989
Acrylic on paper
[sheet] 10 ¼ x 6 ¾ in. (26 x 16.8 cm)
Collection of the artist; courtesy
Paula Cooper Gallery, New York

**RATATATATATATATATATATATATA, VIP,
VIP, BWEEEE, BLAMMM**, 1989
Acrylic on paper
[sheet] 10 ¼ x 6 ½ in. (25.7 x 16.5 cm)
Collection of the artist; courtesy
Paula Cooper Gallery, New York

POP, RRUMBLE, 1989
Acrylic on paper
[sheet] 10 ¼ x 6 ¾ in. (25.7 x 16.8 cm)
Collection of the artist; courtesy
Paula Cooper Gallery, New York

BYOOW! TATATAT! POW!, 1989
Acrylic on paper
[sheet] 10 ¼ x 6 ¾ in. (25.7 x 16.8 cm)
Collection of the artist; courtesy
Paula Cooper Gallery,New York

77

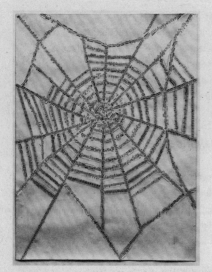
Spiderweb, 1992

Wind Up Guitar, 1994

Aaaaahhh, 2006

Zzzz, 2006

GRRROWR! SNAP! GNARL! VROOOOM!,
1989
Acrylic on paper
[sheet] 10 ¼ x 6 ½ in. (25.7 x 16.5 cm)
Collection of the artist; courtesy
Paula Cooper Gallery, New York

KZAAAAAT! BADOOOMMM, 1989
Acrylic on paper
[sheet] 10 ¼ x 6 ¾ in. (26 x 16.8 cm)
Collection of the artist; courtesy
Paula Cooper Gallery, New York

Untitled, 1991
Collage, acrylic on paper
[sheet] 13 ¼ x 21 ¼ in. (33.5 x 54 cm)
Collection of the artist; courtesy
Paula Cooper Gallery, New York

Spiderweb, 1992
Collage on paper
[sheet] 34 x 26 ¼ in. (86.4 x 66.4 cm)
Collection of Linda and James Gansman,
New York

Wind Up Guitar, 1994
Lacquered six-string guitar,
twelve eighteen-note
Reuge music-box mechanisms; ed. 5
35 x 12 ¾ x 4 in. (89 x 32.4 x 10 cm)
Published by Carl Solway, Cincinnati
Collection of the artist; courtesy
Paula Cooper Gallery, New York

Aaaaahhh, 2006
Color inkjet, printed from digital files;
ed. AP 2/2
[sheet] 30 x 85 ½ in. (76.2 x 217.2 cm)
Printed by Laumont Editions, New York;
published by White Cube, London
Collection of the artist; courtesy
Paula Cooper Gallery, New York

Click Click, 2006
Color inkjet, printed from digital files;
ed. AP 2/2
[sheet] 43 ¼ x 56 ½ in. (110 x 143.5 cm)
Printed by Laumont Editions, New York;
published by White Cube, London
Collection of the artist; courtesy
Paula Cooper Gallery, New York

Conk, 2006
Color inkjet, printed from digital files;
ed. 5/5
[sheet] 43 ¼ x 48 ¾ in. (110 x 124 cm)
Printed by Laumont Editions, New York;
published by White Cube, London
Whitney Museum of American Art;
gift of Kim and David Schrader 2009.68

Shtoom, 2006
Color inkjet, printed from digital files;
ed. AP 2/2
[sheet] 43 ¼ x 44 ¾ in. (110 x 112 cm)
Printed by Laumont Editions, New York;
published by White Cube, London
Collection of the artist; courtesy
Paula Cooper Gallery, New York

Visshh!, 2006
Color inkjet, printed from digital files;
ed. AP 2/2
[sheet] 39 ½ x 105 ½ in. (100 x 268 cm)
Printed by Laumont Editions, New York;
published by White Cube, London
Collection of the artist; courtesy
White Cube, London

Whomp, 2006
Color inkjet, printed from digital files;
ed. AP 1/2
[sheet] 43 ¼ x 57 ¼ in. (109.9 x 145 cm)
Printed by Laumont Editions, New York;
published by White Cube, London
Collection of the artist; courtesy
White Cube, London

Zzzz, 2006
Color inkjet, printed from digital files;
ed. AP 1/2
[sheet] 42 x 42 ¾ in. (106.7 x 108.6 cm)
Printed by Laumont Editions, New York;
published by White Cube, London
Collection of the artist; courtesy
White Cube, London

Original material collected for **Ephemera**
Found commercially printed matter
Dimensions variable
Collection of the artist; courtesy
Paula Cooper Gallery, New York

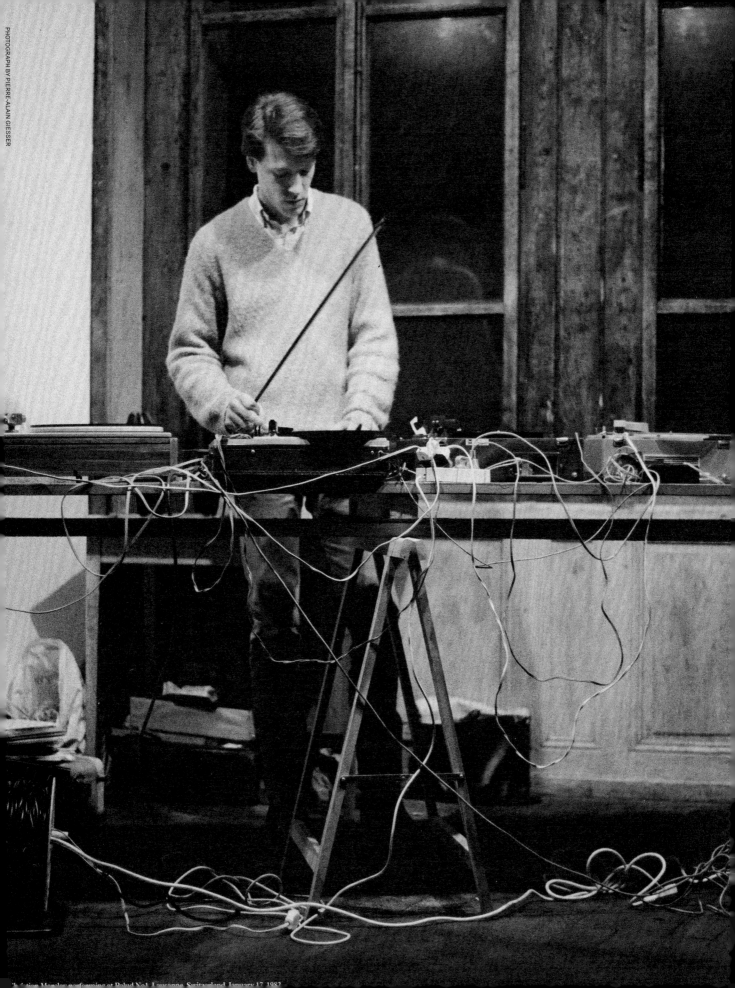

Christian Marclay performing at Balud No1, Lausanne, Switzerland, January 17, 1982

tear out this page while listening attentively
listen and crumple the page into a small ball
you can repeat these sounds with other pages
save the ball(s) discard the book.

Christian Marclay, 1995

Christian Marclay: Festival

ISSUE

Whitney Museum of American Art, New York

FROM THE
CURATOR

PHOTOGRAPH © PAULA COURT

I had been working on *Christian Marclay: Festival* for a year when it opened on July 1, 2010. And even though I was intimately familiar with every detail of the exhibition—on paper, at least—I was completely unprepared for what I walked into on the first day. As the elevator doors opened and I stepped into the gallery, I was immediately disoriented. What is this? Is it a gallery? A theater? A concert hall? Am I backstage or onstage? There are theatrical curtains concealing and revealing parts of the space, theatrical lighting, a nine-foot Yamaha piano, looping video images on what seemed like individual side-stages, and musicians warming up, rehearsing, performing. As it turns out, *Christian Marclay: Festival* is all of the above: an exhibition, yes, but also a stage, a backstage, a theater, and a concert hall.

As this second issue of the catalogue goes to press, we are about halfway through the run of the exhibition. To date, several dozen performers have given radically different reads of the scores. For me the show is a cross between a family reunion and a vindication: I have worked with most of the performers in this show for years, in a variety of venues and contexts, from downtown gallery spaces to the Brooklyn Academy of Music, and have fought for the resources and bandwidth to present their work to the public. To have these extraordinary artists gather at the Whitney and perform for thousands of visitors, most of whom are hearing them for the first time, is as good as it gets for a curator with a crusader's mentality. In the process of enlisting performers, I also got to meet and fall in love with a few artists I was not familiar with, and in turn was able to introduce Christian Marclay to some artists who were unknown to him. This artistic matchmaking is what I am good at and most enjoy. One result of this matchmaking will be a performance of *Manga Scroll* (2010) by vocalist Theo Bleckmann, a set that is being added to the schedule even as I type, which promises to be phenomenal and very different from the other versions we will hear from Joan La Barbara, Shelley Hirsch, David Moss, and Kate Valk.

During opening day, pianist Rob Schwimmer (whose work I have supported for a decade, but who was new to Christian) overwhelmed the audience with an astonishingly virtuosic rendition of *Chalkboard* (2010), a score created by visitors scribbling with chalk on an eighty-seven-foot-long chalkboard at the Whitney. His colossal imagination is matched only by Christian's, who conceived the piece. Rob's genius was his ability to tap into Christian's subtle but ever-present humor and transform the living score—sometimes even as it was still being marked up—into a beautiful musical narrative with internal cohesion and structure. Humor was also a key part of the pas-de-deux Christian performed with Shelley Hirsch on July 18, in an unforgettable performance of *Zoom Zoom* (2007–09). Created specifically for Shelley, *Zoom Zoom*'s visual and verbal puns were popping everywhere as Christian and Shelley played aural-visual ping-pong. Shelley's right brain–centric monologues were egged on, subverted, supported, and distorted by Christian's images. *Zoom Zoom* is only going to be performed once more (September 22, at 4:30pm). Don't miss it.

We have a veritable Who's Who of improvising musicians joining us during this exhibition. But we also have you, the visitor, and you are perhaps the single most important collaborating artist. Therefore I encourage you to return again and again. Take advantage of Christian's trust in you. Pick up the chalk, or the eraser, or both.

—Limor Tomer, Adjunct Curator, Performing Arts

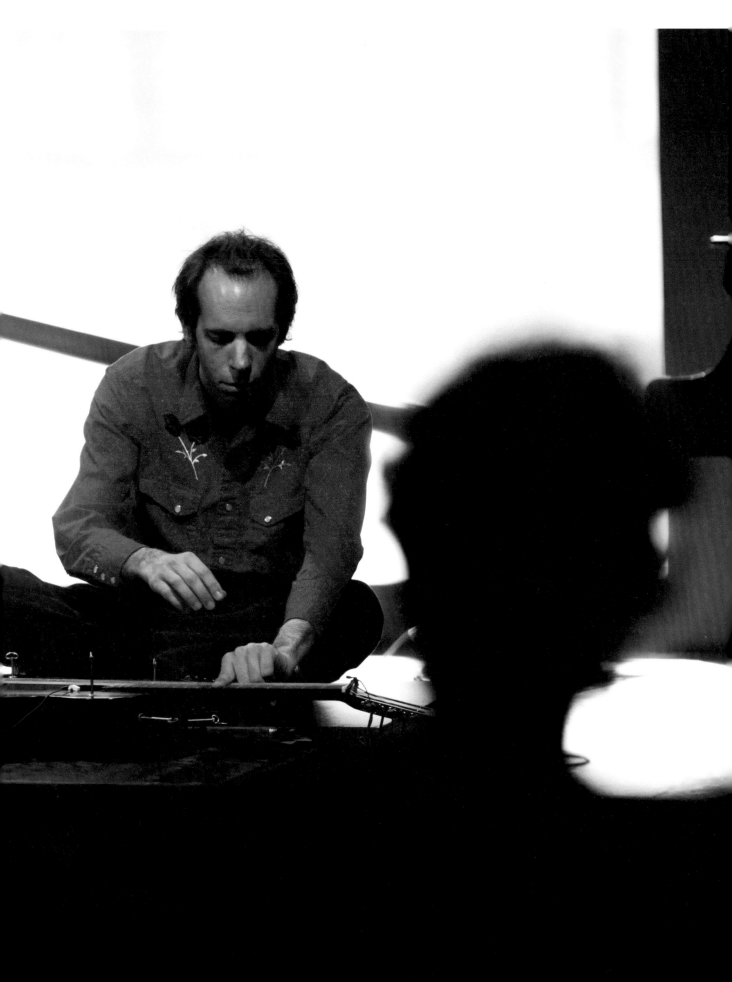

Alan Licht performing with *Wind Up Guitar*, July 8, 2010, at the Whitney Museum of American Art, New York.

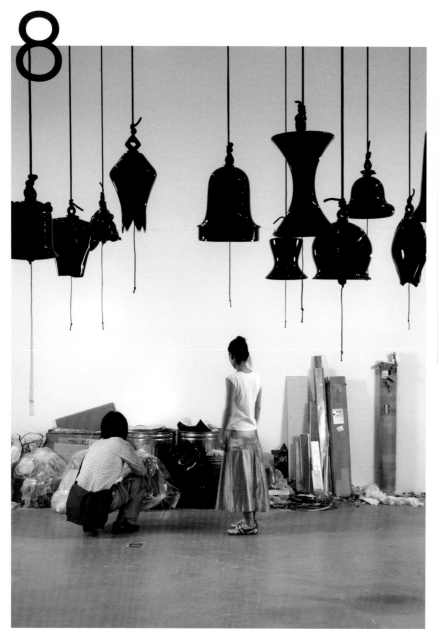

8

6

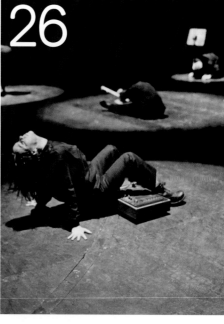

26

40

CONTENTS

Festival
Issue 2

34

52

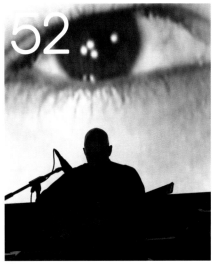

44

48

ENSEMBLE
ENCORE

Ingrid Schaffner

Installation view of *Ensemble*, September 7–December 16, 2007, at the Institute of Contemporary Art, University of Pennsylvania.

This spread: Installation views of *Ensemble*, September 7–December 16, 2007, at the Institute of Contemporary Art, University of Pennsylvania.

Very much a piece of his work, even though none was in it, *Ensemble* was a group show organized by Christian Marclay, who drew on his credentials as an artist, musician, and deejay to engage others in a project they might have resisted in the hands of most curators. Because, as the title suggests, the exhibition was conceived as a composition to which each work contributed some sound. Not that we in the post-retinal field of contemporary art necessarily lack the ear; it's more a question of trust. "Sound artists routinely see their work relegated to the lobby, elevator, toilet, and basement, or simply put outdoors," Marclay observed.[1] He knew from experience. Indeed, it was the opportunity to counteract this tendency of museums to isolate the act of listening from that of looking at art that prompted him to accept an invitation from the Institute of Contemporary Art (ICA) at the University of Pennsylvania (Penn), and conceive this exhibition in the first place.[2]

Under the guise of "guest curator," Marclay operated more along the lines of "generator-arbitrator." This is the term Marcel Duchamp coined to describe his own role as an artist making exhibitions (which he routinely did) by compelling peers to contribute to a collaboratively constructed tableau. Any reference to Duchamp taps deep into the roots of Marclay's practice, from the name of the experimental band—The Bachelors, even—that he performed with during the 1980s, to a more recent installation of empty museum crates outfitted with

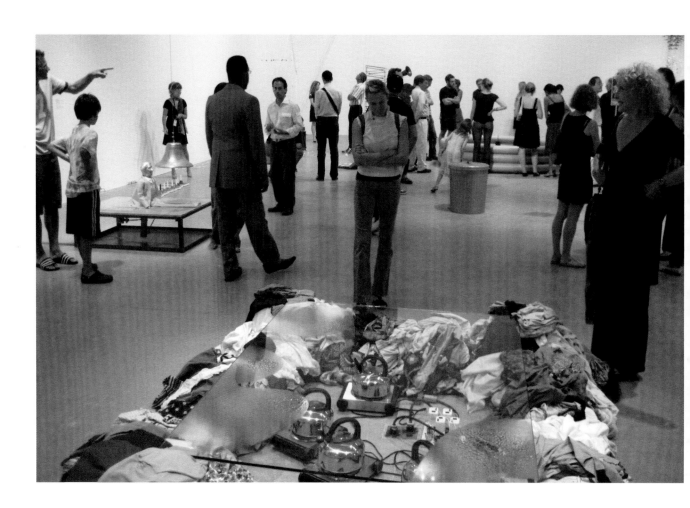

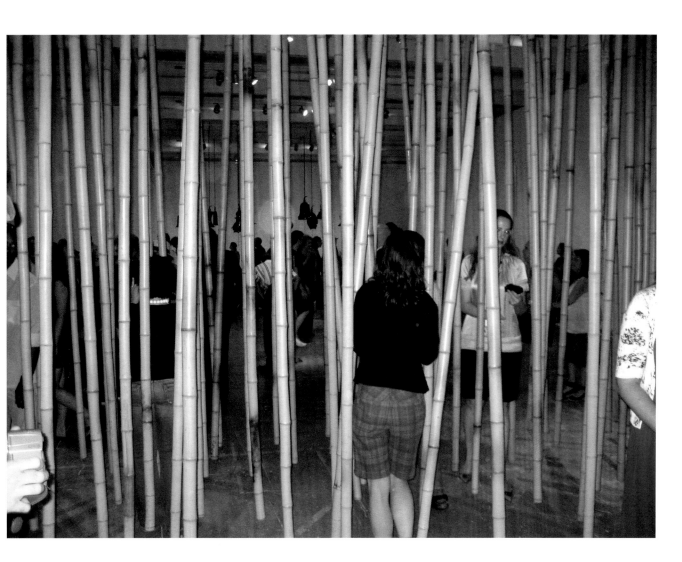

music boxes that played like so much hidden noise (*Music Boxes [from Crossings]*, 1999), to the very Duchampian sense of agency that allows Marclay, as a conceptual artist, to move freely between making objects and music. Nor is *Ensemble* the first museum exhibition Marclay has organized in his career; there is a strain of shows, starting in 1995 at the Musée d'Art et d'Histoire in Geneva, in which he has drawn aural images and objects from historic collections to create installations that perform like silent concerts, filling the viewer's mind with pictures of unheard melodies.

However, *Ensemble* is the first time Marclay made an exhibition with works borrowed from his contemporaries. In this case, Duchamp's approach proved most conducive. Acting as an agent among peers, Marclay made *Ensemble* not only to illustrate his solidarity with sound artists, he also neatly sidestepped issues of authority and submission that would otherwise have loomed large in the creation of a show in which each work was selected as an instrument that would complement the others and culminate in an overarching composition. No artist wants his or her work to be instrumentalized by a curator, but who doesn't want to be part of a cool band?

Ensemble was not just curated, it was orchestrated. Using both eye and ear, Marclay selected twenty-seven works by as many artists that made some kind of acoustical or natural sound (i.e., not amplified). Mineko Grimmer's giant bamboo curtain was set rattling as soon as one entered the gallery, which was filled with bright and shimmering noises: there were bells gonging, pieces of china clinking, a teapot whistling, metronomes clicking, music-box tines pinging. Not everything played at once: Some works, like Dennis Oppenheim's *Attempt to Raise Hell* (1969) and Michelangelo Pistoletto's *Orchestra of Rags* (1968) were on timers; others, like Martin Kersels's *Creakers* (2007) and Katja Kölle's *Staccato (americano)* (2004/2007) required viewer interaction. Motion detectors set Carolee Schneemann's *War Mop* (1983) a-beating and Fia Backström's *Visitor Chime* (1996) a-chiming. Sometimes the show ticked and hummed like a nervous cabinet of curiosities. There were the constant clinks of Céleste Boursier-Mougenot's thirty-one bowls floating in a plastic inflatable swimming pool and the regular flap of Darren Almond's monumental flip-clock. Other times the exhibition erupted into urban din. Lift the lid of *The Alarming Trashcan* (c. 1987), by Yoshi Wada, for an alarm bell–deafening din. Occasionally the phone would ring. I was in the gallery the day that two little boys got to talk to their

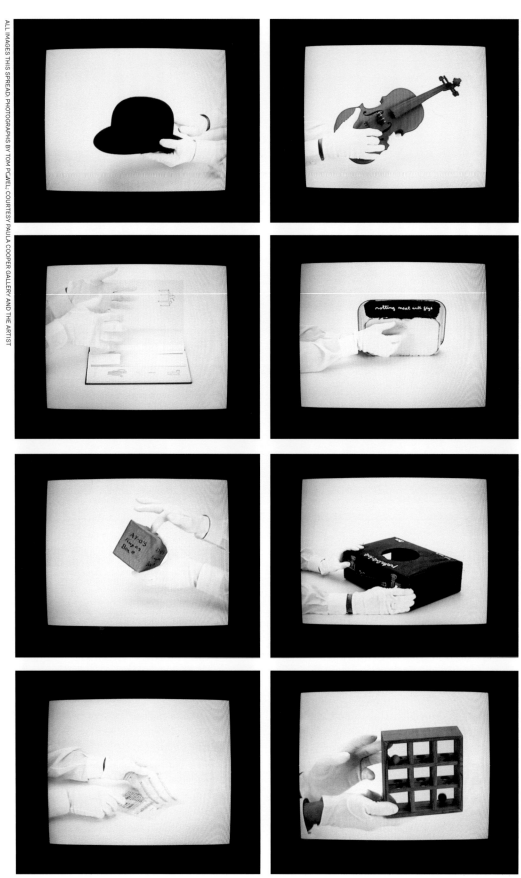

ALL IMAGES THIS SPREAD: PHOTOGRAPHS BY TOM POWEL; COURTESY PAULA COOPER GALLERY AND THE ARTIST

12

Stills from *Shake Rattle and Roll (Fluxmix)*, 2004. 16 DVDs, 16 monitors, 10–15 minutes (variable), dimensions variable.

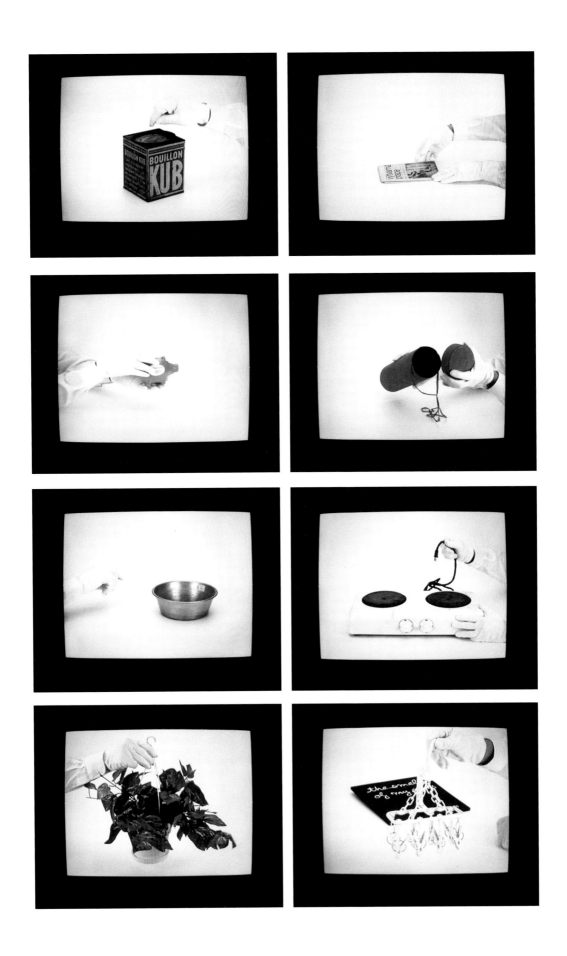

13

father's favorite artist, Yoko Ono. More often, Ono would reach the gallery guard Linda Harris, and they would have a quick chat.

Overall, as Ono's *Telephone Piece* (1997) might intone, *Ensemble* was very Fluxus in feeling, in terms of both the ordinary and readymade nature of the objects on view, and the flow of chance and happenstance that brought the show to life every day. Echoes of the historical movement that emerged during the 1960s turn into clear sound when one considers the exhibition in light of Marclay's 2004 video installation *Shake Rattle and Roll (Fluxmix)*, in which he handles objects from the Walker Art Center's formidable collection of Fluxus art like tiny instruments to produce a matrix of sounds.

As playful as *Ensemble* was, it also contained the specter that haunts all kinetic art: When it's not moving, it's dead. Enter the Accompanists. Marclay invited eight musicians and performance artists to add their own sounds to the exhibition and interact with it. The vocalist Shelley Hirsch gave throat to works in the show; electronic musicians o.blaat (Keiko Uenishi), Aki Onda, and Alan Licht sampled and produced feedback for themselves to loop and play and drone back into; sculptor Terry Adkins beat jazz percussion from the more instrumental objects. One of the original Fluxus artists, Alison Knowles, performed with her own accompanist, a

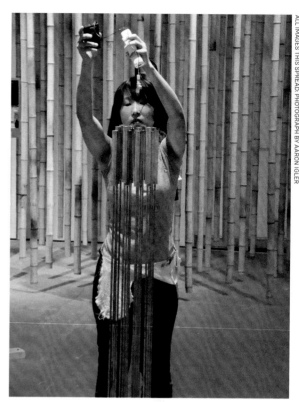

ALL IMAGES THIS SPREAD: PHOTOGRAPH BY AARON IGLER

o.blaat (Keiko Uenishi) performing on October 3, 2007, during *Ensemble* at the Institute of Contemporary Art, University of Pennsylvania.

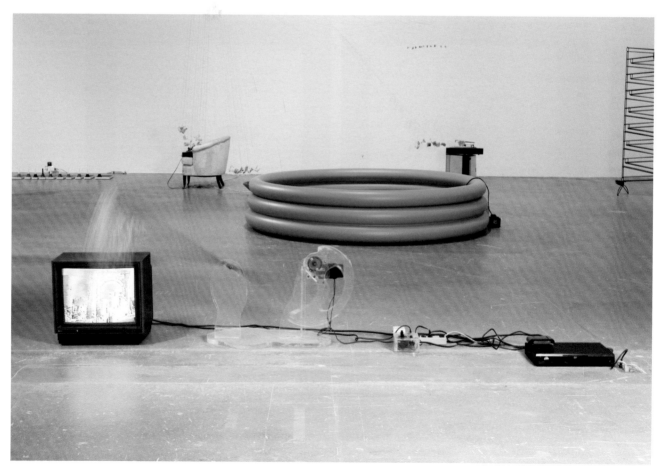

Ensemble, September 7–December 16, 2007. Installation view at the Institute of Contemporary Art, University of Pennsylvania.

volunteer Penn student, whom Knowles armored in crinkling sheets of mulberry paper and paraded ceremoniously (and blindly) about.

Collectively the Accompanists pitched into relief the musical meaning of ensemble: A concert piece involving a number of voices or instruments. The show was also a score, arranged by Marclay only to be played, sampled, and given variation by the viewers who interacted with it. Sampling and scoring being the primary modes of Marclay's practice, *Ensemble* was as representative as it was generative. Its staging calls to mind *Graffiti Composition* (1996–2002) in which sheets of musical composition paper were pasted around the city to be marked up by people and documented through photographs, which were published as an edition to be used as a score.

As much a populist as he is a conceptual artist, Marclay often plays off and with public accessibility and participation. Performed annually, *The Sounds of Christmas* (1999) allows deejays to spin, mash, and mix tunes from Marclay's collection of more than one thousand holiday records. Likewise, so many images, ideas, and anecdotes continue to spin out of *Ensemble* and attach themselves to bigger thinking and to memory. As a viewer, each visit was episodic, depending on who and what sounds were playing in the gallery with you. Small children leaping to pull the clappers of Jim Hodges's blown–glass bells come to mind. As does the day that a talented viewer picked up the mallets and hammered beautiful music from Doug Aitken's *K-N-O-C-K-O-U-T*. And from my peripheral curatorial involvement, I know the show created much lore within the institution and for the individuals involved. There was that scavenger hunt for the vintage amp required by one of the performers that plunged the ICA curatorial department into an uproar.[3] And there is the idea of the Accompanists as a curatorial model of programming that activates an exhibition from within: Each performance was integral—as opposed to ancillary—to the artist-curator's total composition of objects within the gallery. Perhaps my favorite outcome is the various recordings, including one you can find on Ubuweb online, of a student reciting John Cage's *Notes on Silence* inside the exhibition.[4] You can actually hear the walls of the gallery, baffling and bouncing with all of the intriguing and dissonant volumes this exhibition contains. What is especially audible is the reality of the situation: ICA's galleries were not built for showing sound. The acoustics are terrible! But boy, did *Ensemble* sound good.

Ingrid Schaffner is the Senior Curator at the Institute of Contemporary Art, University of Pennsylvania, where her recent projects include *Queer Voice*, a group show looking at (and listening to) the sound of voice as a material in contemporary art.

ENDNOTES

1 Christian Marclay, *Ensemble*, exh. cat (Philadelphia: Institute of Contemporary Art, University of Pennsylvania, 2008), n.p. The publication documents the installation and includes a CD recording (featuring the sounds of individual works, plus excerpts from the eight performances that accompanied the exhibition and a compilation based on them by Aaron Iglar).
2 In accepting the invitation, Marclay inaugurated the Sachs Guest Curator Program, a new series of exhibitions aimed at bringing outside perspectives to ICA's program.
3 Thanks to ICA Whitney-Lauder Curatorial Fellow Stamatina Gregory for administrating to all the many logistics of producing the Accompanists and sharing her recollections with me.
4 This recording of Kaegan Sparks was one of a number of engagements with *Ensemble* by Penn students in poet Kenneth Goldsmith's "Writing Through Contemporary Culture." A collaboration between ICA and Penn's Center for Contemporary Writing, the class produced *Cover Without a Record*, a journal of texts based on strategies lifted from Marclay's art. http://ubu.artmob.ca/sound/Sparks-Kaegan_Cage-John_Lecture-on-Nothing_2007.mp3

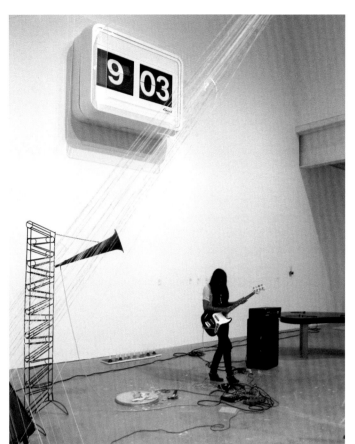

Mika Tajima performing on October 17, 2007, during *Ensemble* at the Institute of Contemporary Art, University of Pennsylvania.

15

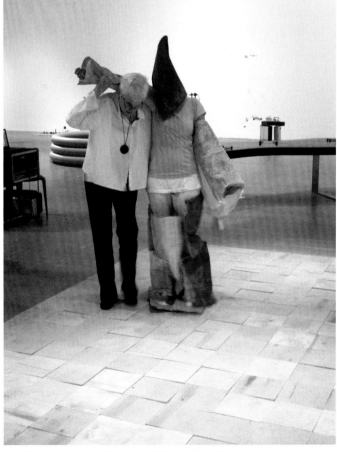

Alison Knowles performing on November 14, 2007, during *Ensemble* at the Institute of Contemporary Art, University of Pennsylvania.

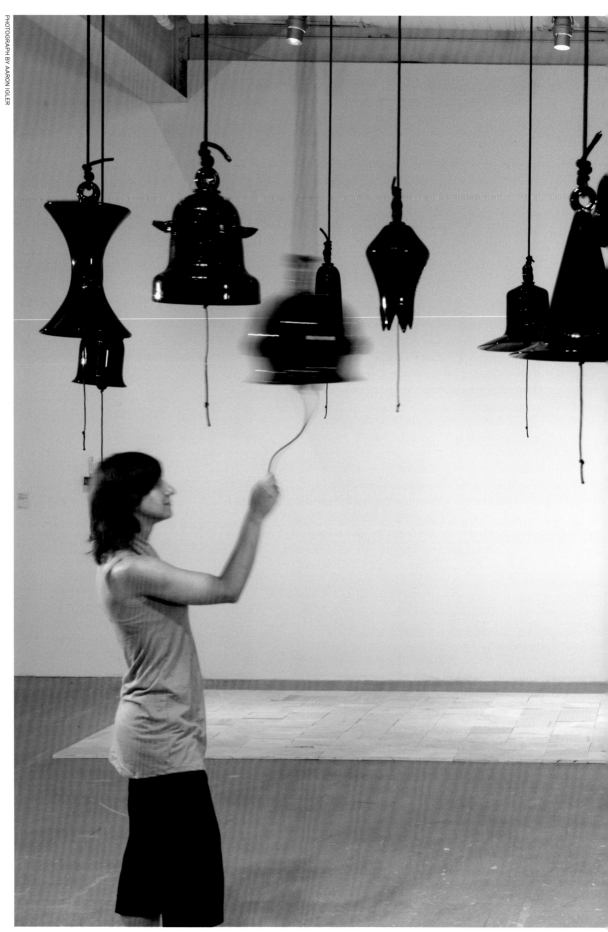

PHOTOGRAPH BY AARON IGLER

16

Installation view of *Ensemble*, September 7–December 16, 2007, at the Institute of Contemporary Art, University of Pennsylvania.

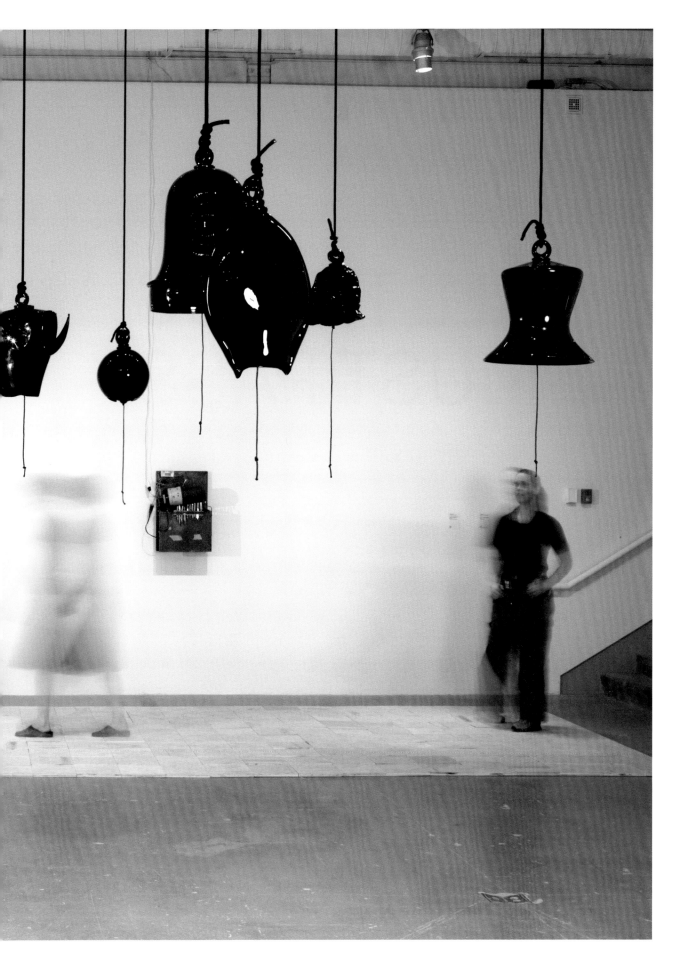

ALL THINGS MUST PASS

Jean-Pierre Criqui

EPHEMERA

A MUSICAL SCORE
BY CHRISTIAN MARCLAY

Ephemera (detail), 2009. Twenty-eight folios in slipcase, edition of 100. Published by mfc-michèle didier, Brussels.

Irène Schweizer performing *Ephemera* at Gare du Nord, Basel, June 12, 2009.

Without life, music would be a mistake. Christian Marclay dedicates his artistic activity to flushing out the traces of the latter in the former, particularly in music's silent forms. On first inspection, *Ephemera* (2009) continues with this deliberately paradoxical undertaking. It consists of twenty-eight autonomous folios, each one reproducing a composition (in the visual sense of the term) made from a great variety of printed materials—pieces of paper, cardboard, fabric, and so on—that all allude to the world of music. I open one of these double pages at random and discover the flattened wrapping for some brand of chocolate with a creamy center subtly called "la do ré" (the notes A C D)—which in French sounds like "l'adoré" (the adored). The image of the thing in question, which in itself is not especially attractive, stands out against a red background strewn with gold musical notes. That same folio features the inner sleeve of a vinyl record, its circular hole bristling with an assortment of bass and treble clefs. Then a second candy wrapper, this time called "Sonho de Valsa," its shiny paper adorned with dancing couples and undulating staves on which notes alternate with violins and their bows; the back cover of a Claire Fontaine-brand notebook (the name echoes an old French song), decorated with two sixteenth notes floating on a simplified image of a river; the top part of a page torn from a spiral notebook, showing the image of a young

violinist surrounded by a stave empty of notes except for an A with allegretto and mf markings.

Something ephemeral, as we know, lasts only a day. This strict etymological meaning, and the word, can be applied, for example, to a certain kind of fever, or to a kind of insect that resembles a small dragonfly and which, having spent a year as a waterborne larva, lives for only twenty-four hours once it has reached adulthood. A similar destiny awaits the heroes in the old David Bowie song, who can enjoy their status "just for one day." Before the advent of recording, indeed, music was, like dance or sand painting, very much an ephemeral art form; even if it could be transcribed in notes, each performance was always irremediably unique, impossible to repeat (and therefore hear again) in identical form. It was an evanescent singularity that happened only once and that was often enriched by improvisation.

Although quintessentially an artist of the age of reproduction and its ubiquitous dissemination, in whose work all those "re" words (*record, replay, re-use*) come so forcefully to the fore, nevertheless Marclay has always insinuated into his pieces, like a kind of antidote to its basic condition, various elements that are completely unamenable to repetition (indeed, improvisation itself is one of the most salient aspects of his

Ephemera (detail), 2009.

practice). One example among a great many, but an extremely significant example for its representation of fleetingness, is composed of pieces of torn photographs that form the irremediably fragmentary ensemble titled "Fourth of July" (2005). As the traces of a literally ephemeral event, they denote Marclay's subjacent attachment to an irreducible form of uniqueness.

The title of the work *Ephemera* designates its raw material: All those cheap, mass-produced, and extremely perishable things, often with no real function, and that nobody usually keeps or bothers about. But however great his capacity for waste, *Homo modernus* can also be quite a preserver of things, as well: Hence all the many societies, research centers and collections all over the world that are dedicated to ephemera, as well as some very serious publications on the subject.[1] Himself an amasser and collector of things, with *Ephemera* Marclay is contributing to the writing of this minor history that turns away from monuments (whether hallowed or still to be discovered) and brings its attention to bear on the slighter or even pathetic documents of human activity. This is a huge field, hardly limited by a para-musical theme: Even toilet paper—and you don't get much more ephemeral than that—gets roped into this investigation, with one of Marclay's folios reproducing the wrapping of

Untitled (from the series "Fourth of July"), 2005. Chromogenic print, 28 ½ x 34 ½ in. (72.1 x 87.6 cm). Framed: 35 ¼ x 41 ¼ in. (89.2 x 104.8 cm).

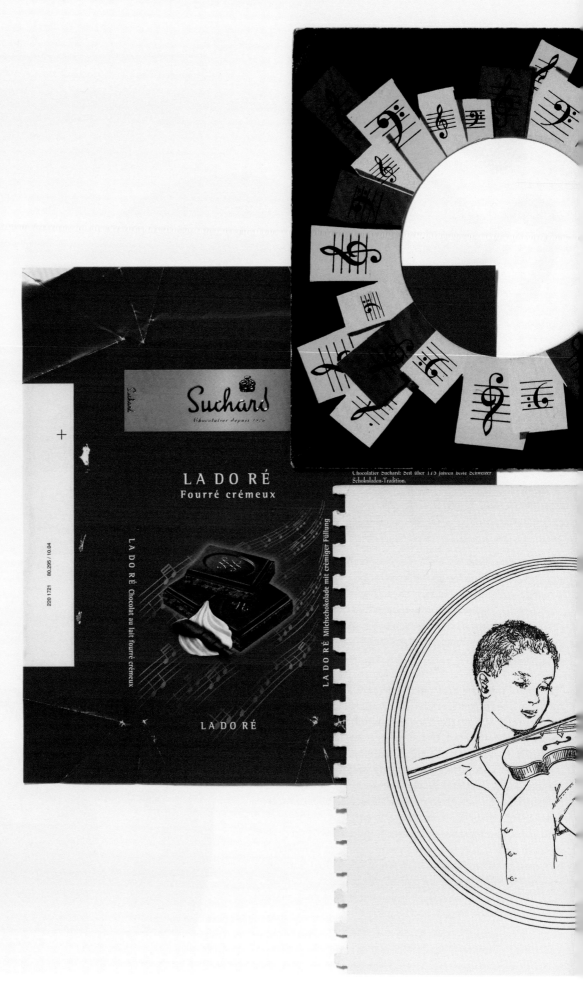

Ephemera (detail), 2009.

23

If You Can't Lick (from the series "Body Mix"), 1992. Three record covers and cotton thread, 22 x 16 ½ in. (55.9 x 41.6 cm).

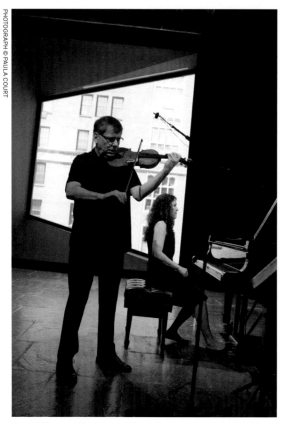

PHOTOGRAPH © PAULA COURT

Mark Feldman and Sylvie Courvoisier performing *Ephemera*, July 3, 2010, at the Whitney Museum of American Art, New York.

a certain Japanese brand ("Best quality toilet paper, tears off evenly & ends waste"), the name of which is inscribed on a stave surrounded by a scattering of notes.[2] Of course, Marclay assembles his artist's discoveries with no concern for taxonomy or history, and delights in applying his usual visual wit to inventing false connections, to suggesting a continuity between disparate elements, as he has already done, for example, with the record covers of his "Body Mix" series. But when we see these montages governed by the spirit of play, the question that comes to mind is the same as for the most reasonable enterprises: For what, in the end, is not ephemeral? And on the basis of what principles can one decide what must or must not be preserved? In a short text published in 1916, "On Transience" [*Vergänglichkeit*], Freud considered the melancholy that sometimes comes over us at the thought that all things, not least the works of art we most admire, will, one day or another, be no more. Comparing such a feeling to mourning, Freud concluded that it was unfounded and argued that the transience of beauty should instead be seen as something that heightens its value.[3] In his own way, Marclay also celebrates the fleeting and exhorts us, in keeping with the carpe diem of the ancients—to seize the day.

I said when I started that *Ephemera* concerned silent representations of music. But that is only half true, for this work, which is subtitled "A Musical Score," was also conceived to serve as a reservoir from which musicians are free to draw motifs on which to improvise, in whatever order they please. The two renditions, both on piano, that I had the good fortune to hear—one, at the premiere of the piece, by Irène Schweizer, on June 12, 2009, in the concert hall of the Badischer Bahnhof in Basel, and the other, by Steve Beresford, on October 24 of the same year, at the Auditorium du Louvre—brilliantly illustrated the infinite aesthetic potential of channeling the visual back into the aural.

Jean-Pierre Criqui is in charge of the lectures program at the Centre Pompidou (Paris) and is the editor of *Les Cahiers du Musée national d'art moderne*.

ENDNOTES

1 One of the most impressive is Maurice Rickards, *The Encyclopedia of Ephemera. A Guide to the Fragmentary Documents of Everyday Life for the Collector, Curator, and Historian*, edited and completed by Michael Twyman, London: The British Library, 2000.
2 *The Encyclopedia of Ephemera* has a sizeable entry on this subject ("Lavatory Paper"), which traces its development since it was first made commercially available in the 1840s (with a very British sense of understatement, the author notes that "prior to that, it must be assumed, mankind was left to its own devices," and refers to chapter XIII of *Gargantua* by Rabelais) as well as to contemporary models with crests and crosswords on (*op. cit.*, p. 190-191).
3 Sigmund Freud, "On Transience" (translated from the German by James Strachey), in *Writings on Art and Literature*, London: Pelican Freud, 1988, p. 283-290.

24

Top/Bottom: *Ephemera* (details), 2009.

LES SORTILÈGES: IM BANN DES ZAUBERS

Christian Marclay appropriated a thousand props from the warehouses of the National Theater and the Marstall Theater in Munich to create an evocative choreography of these objects through gestures, light, and music. Mundane objects such as a disco ball, a vacuum cleaner, a coffin, furniture, cutlery, and blankets were brought to life through music and action. The work was inspired in part by Maurice Ravel's *L'enfant et les sortilèges* (1925) and Walt Disney's anthropomorphic animation. Though handled by six performers, the objects were the real actors, and were manipulated like puppets, or props in a magic show; their staging gave the objects a distinct psychological charge. *Les Sortilèges* could have been the soundtrack to Surrealist poet Comte de Lautréamont's famous phrase, "the chance meeting on a dissecting-table of a sewing machine and an umbrella."

Directed by Christian Marclay. Assistant to the director: Birgit Wiens. With Phillip Adams, Ruth Geiersberger, Armin Nagel, Brygida Ochaim, Lynn Parkerson, Klaus B. Wolf. Music by Kalle Laar, Peer Quednau, Frank Schulte, G. Ess Zeitblom. A co-production of the Bayerisches Staatsschauspiel/Marstall, Munich, and the Kitchen, New York. Premiere at the Marstall on April 26, 1996.

Les Sortilèges: Im Bann des Zaubers, Marstall Theater, Munich, April 26–30, 1996.

Les Sortilèges: Im Bann des Zaubers, Marstall Theater, Munich, April 26–30, 1996.

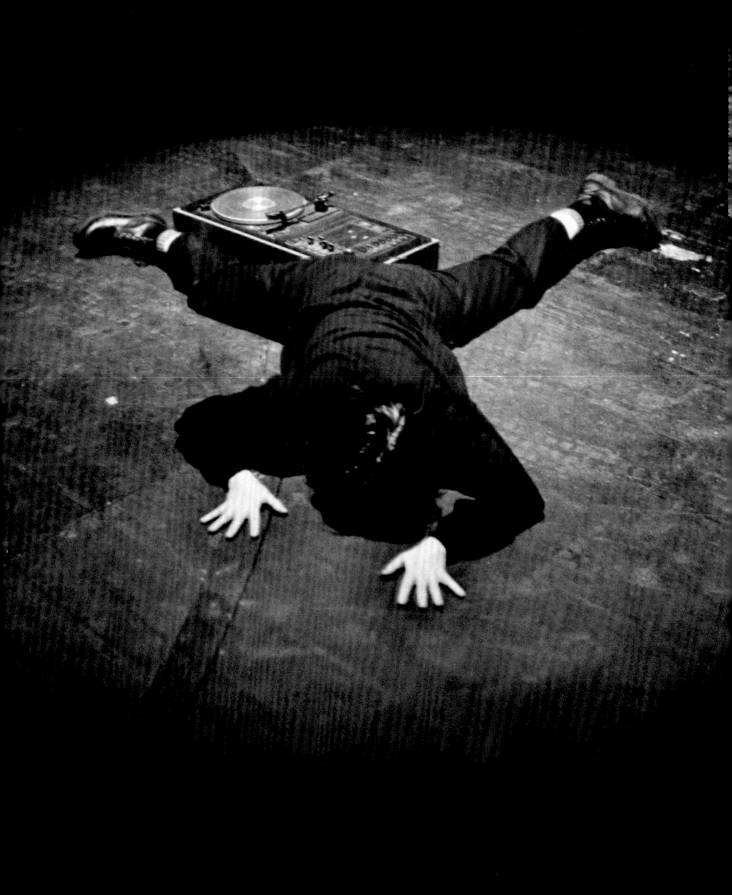

Les Sortilèges: Im Bann des Zaubers, Marstall Theater, Munich, April 26–30, 1996.

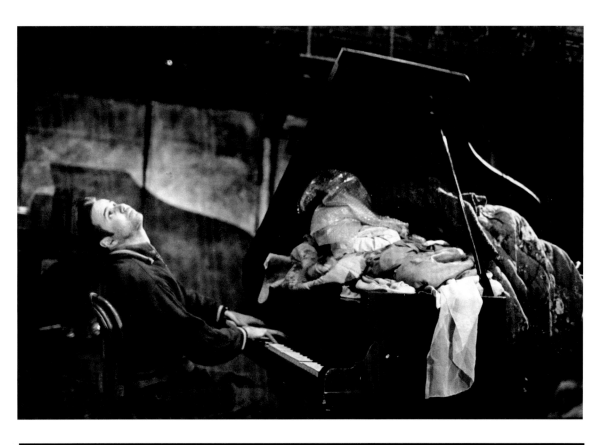

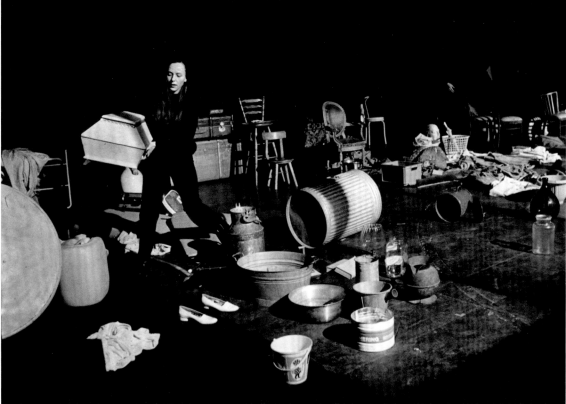

Top/Bottom: *Les Sortilèges: Im Bann des Zaubers*, Marstall Theater, Munich, April 26–30, 1996.

32

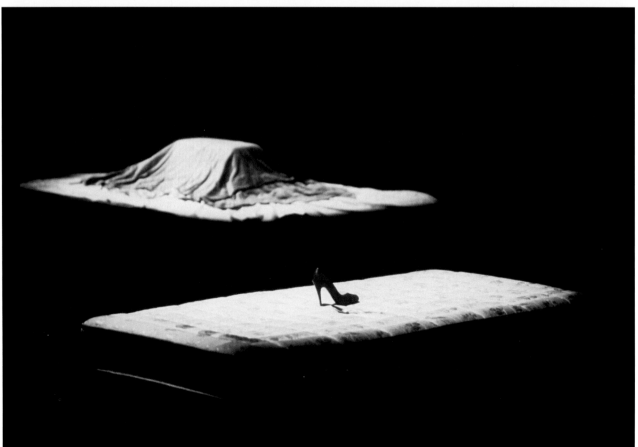

Top/Bottom: *Les Sortilèges: Im Bann des Zaubers*, Marstall Theater, Munich, April 26–30, 1996.

33

Above: *Les Sortilèges: Im Bann des Zaubers*, Marstall Theater, Munich, April 26–30, 1996.

SIXTY-FOUR BELLS AND A BOW

Small hand bells—such as dinner bells, decorative bells, and souvenir bells; made from glass, porcelain, or metal—are to be used as sound sources for a performance. The musician(s) can ring the bells, amplify them, or sample and process them electronically. The metal ones can also be vibrated using the bow. The only stipulation is that all sounds must originate from this collection of bells.

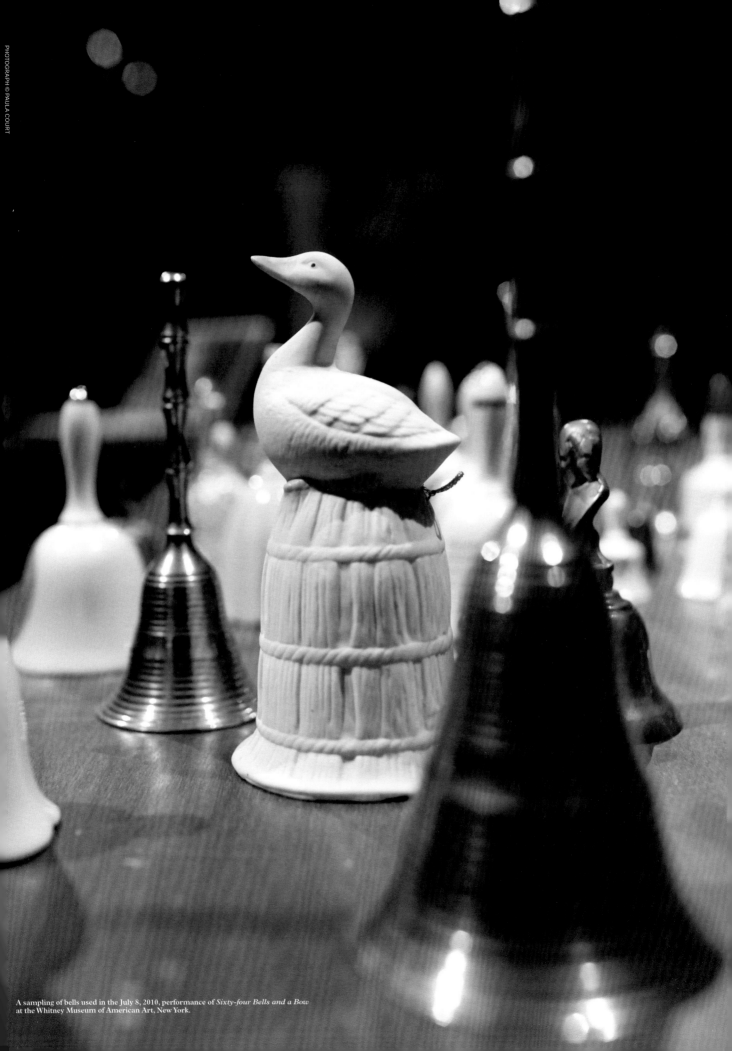

A sampling of bells used in the July 8, 2010, performance of *Sixty-four Bells and a Bow* at the Whitney Museum of American Art, New York.

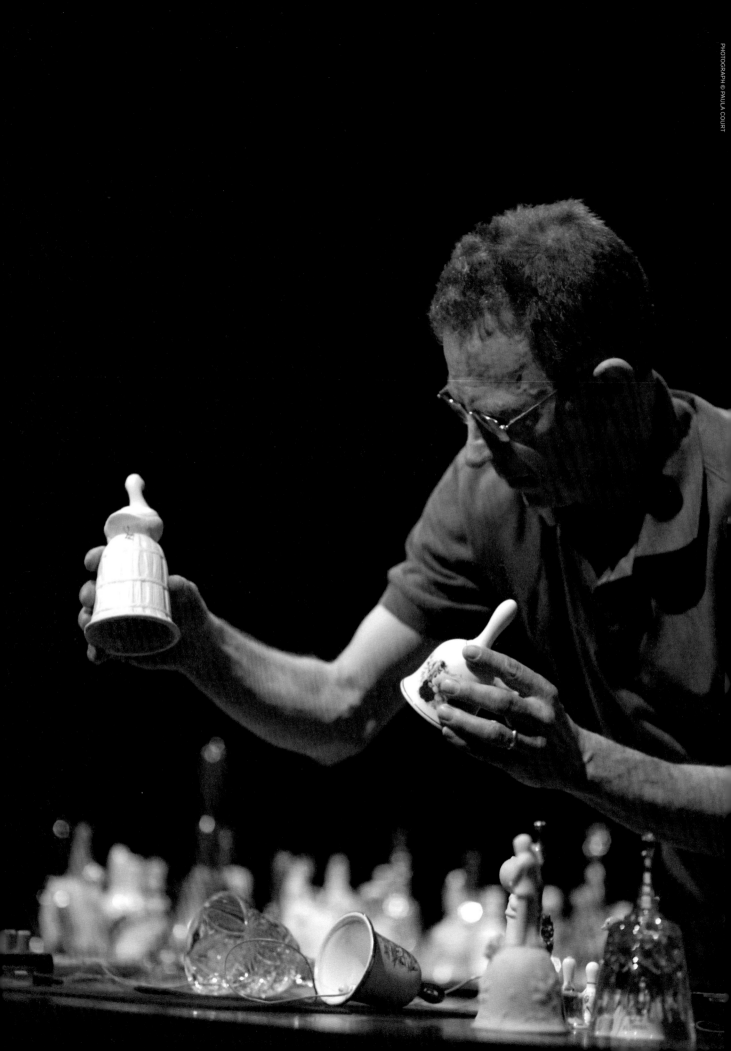

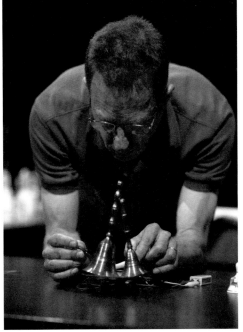
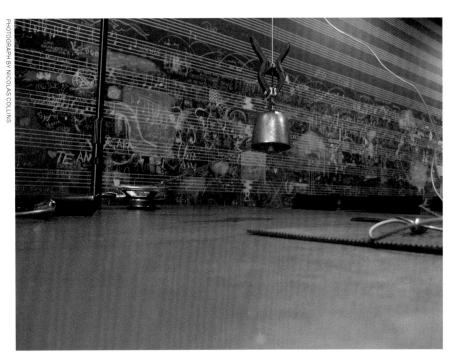
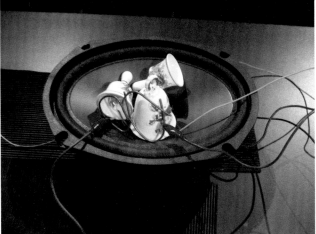
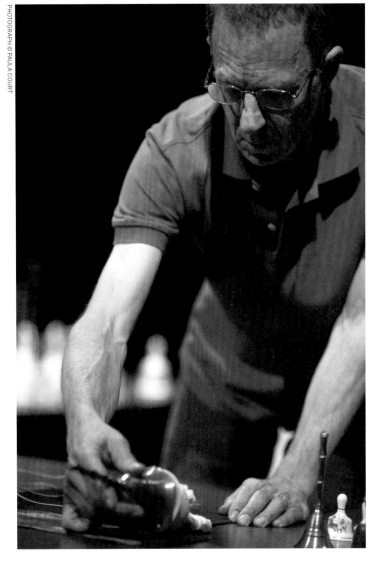

37

This spread: Nicolas Collins performing *Sixty-four Bells and a Bow*, July 8, 2010, at the Whitney Museum of American Art, New York.

you to the ouch with your naked oot ready to keep t

Sixty-four Bells and a Bow, 2010. Sixty-four glass, porcelain, and metal hand bells, and a violin bow, dimensions variable.
Installation view at *Christian Marclay: Festival* at the Whitney Museum of American Art. Background: *Mixed Reviews*, 1999–2010.

at. Thirty minutes into the album suddenly the sax, wit

COVERS

Thirty empty record sleeves are arranged in a sequence and interpreted by a soloist as a series of short sound events. Or they may be interpreted by a group of musicians, each of whom selects different sequences and responds to them in an unsynchronized way, so that the sounds overlap. Any graphic notation should be performed as literally as possible. Inspiration should be drawn from the graphic notation rather than the original content of the missing record, unless its music is notated on the cover. The memory of the original content may color the interpretation, not dictate it.

Covers (details), 2007–10. Thirty 12-inch found record covers [each] 12 ¼ x 12 ¼ in. (31 x 31 cm).

ties on the stereo effect, especially when the trumpet solo bounces from one speaker to the next. Rhythm guitar, bass and percussion throw out Jazz and funk riffs against an unstructured time signature while clarinet, saxophone and accordion bring forth angrily rising, winding melodies. Most of the songs are gigantic sound-sucks, twisted and so good that even if one already knows the flavor one isn't in a rush to get to the next hit. Contrary to what one hears in rock today these songs throw o

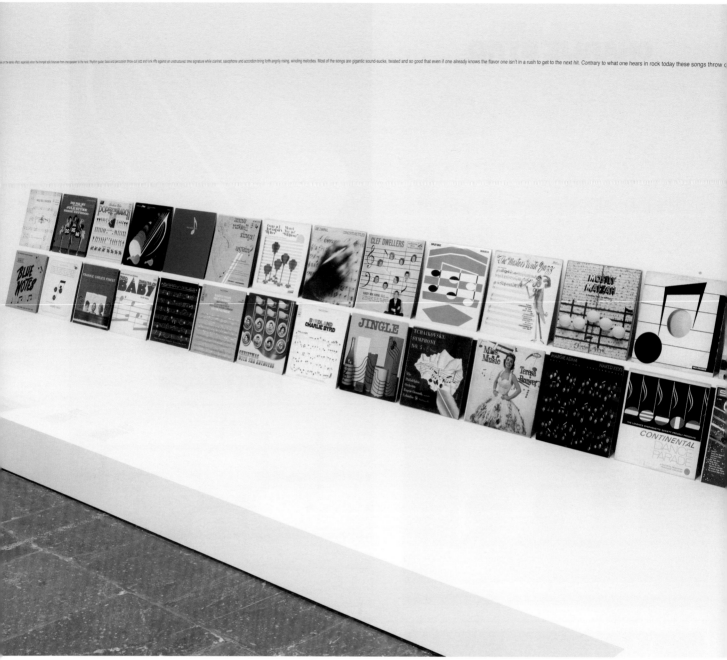

Covers, 2007–10. Installation view at *Christian Marclay: Festival* at the Whitney Museum of American Art. Background: *Mixed Reviews*, 1999–2010.

PHOTOGRAPHS BY BILL ORCUTT. COLLECTION OF THE ARTIST; COURTESY PAULA COOPER GALLERY, NEW YORK

PHOTOGRAPHS BY BILL ORCUTT. COLLECTION OF THE ARTIST; COURTESY PAULA COOPER GALLERY, NEW YORK

azy. My favorite is an intensely twisted guitar tune tha

43

Covers (details), 2007–10. Thirty 12-inch found record covers [each] 12 ¼ x 12 ¼ in. (31 x 31 cm).

BOX SET

This selection of found boxes adorned with decorative musical notations is to be played as literally as possible by a solo musician. The boxes are placed one inside the other, like Russian nesting dolls. There are several possible sequences of boxes, and the performer may organize the boxes freely, although the order in which the boxes are played is determined by their size. Opening and closing the boxes is part of the performance.

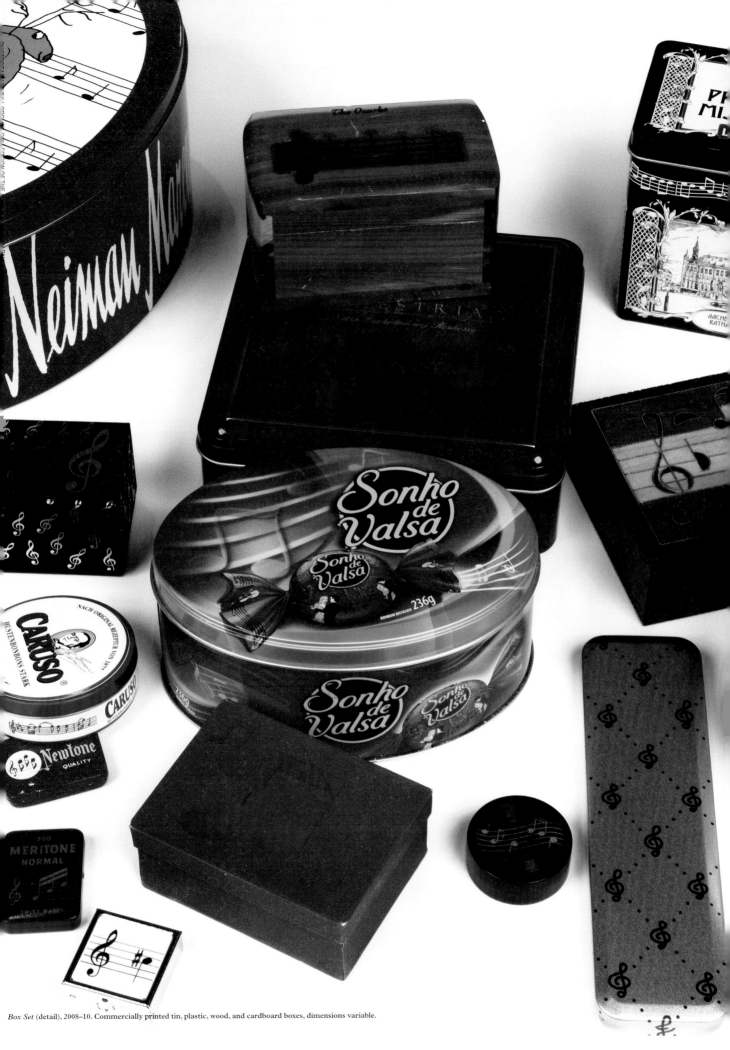

Box Set (detail), 2008–10. Commercially printed tin, plastic, wood, and cardboard boxes, dimensions variable.

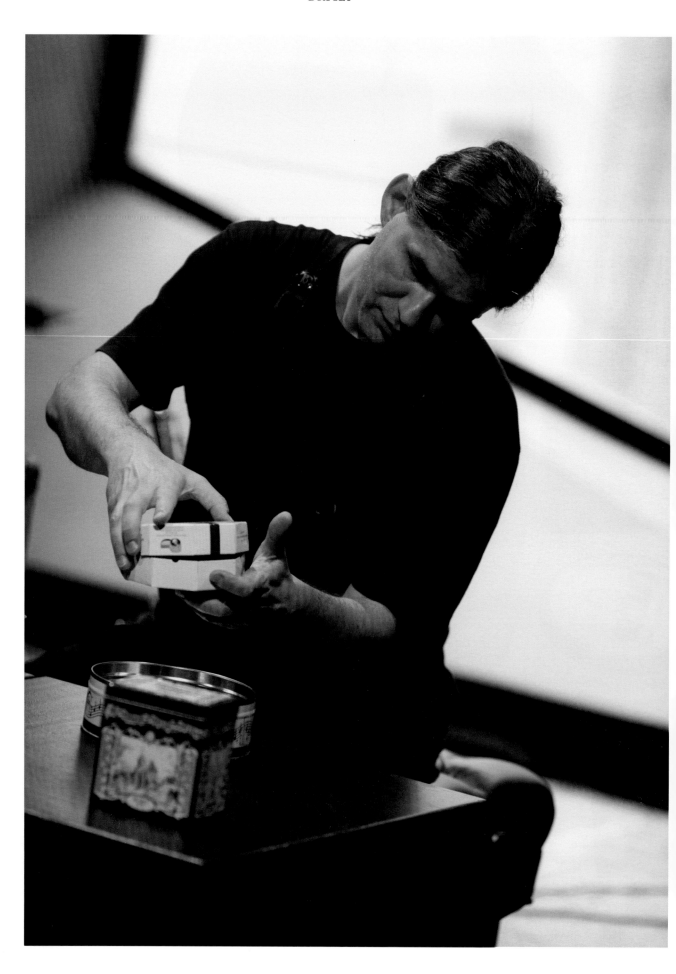

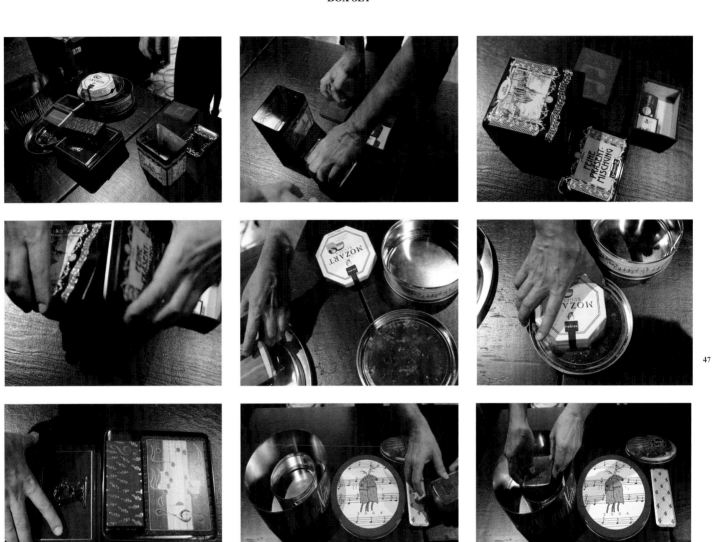

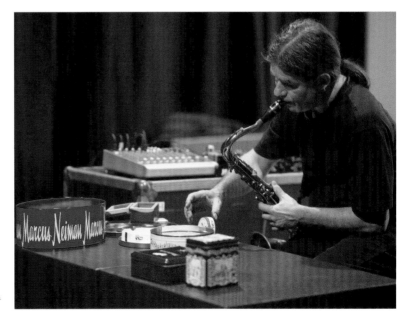

This spread: Ulrich Krieger performing *Box Set*, July 1, 2010, at the Whitney Museum of American Art, New York.

MIXED REVIEWS

To make this work, Christian Marclay used the descriptive, and often colorful, language reviewers have used to describe and critique concerts, performances, and recordings. The result is a long, continuous text that is applied to the walls of a gallery. Since its first iteration in 1999, each new presentation of the text is translated from the language of the place where it was previously exhibited into the language of the country where it is being shown. In this process of serial translation, some words and meanings inevitably change and mutate. The text in this exhibition has been translated from the Swedish text used for its 2002 installation at the Konstmuseum in Ystad. This piece was not originally meant to be performed by musicians—viewers activate the work by reading the walls of the gallery—but in 2002 Marclay asked Mats Gustafsson to interpret it with his saxophone, walking through the space while the audience followed him.

The only fixed version of this evolving text is a thirty-minute silent video of Jonathan Kovacs, a deaf actor, interpreting the sound description in American Sign Language (ASL).

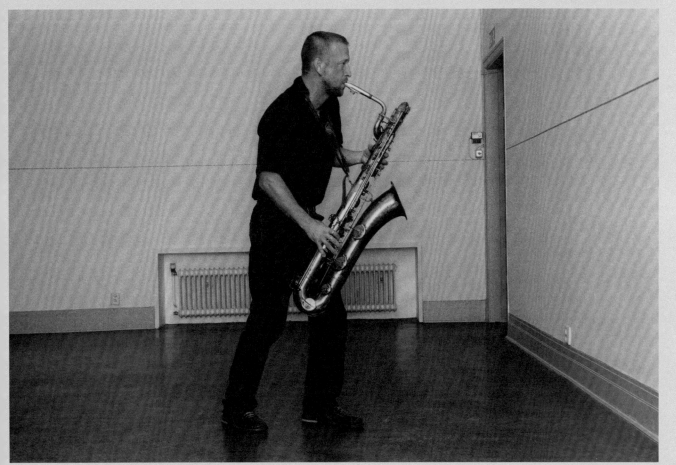

Top: Installation views of *Mixed Reviews* in *Christian Marclay: Three Compostions*, October 5–December 15, 2002, at Contemporary Arts Center, New Orleans.
Bottom: Mats Gustafsson performing *Mixed Reviews* at the Konstmuseum, Ystad, 2002.

ALL IMAGES THIS SPREAD: COLLECTION OF THE ARITST; COURT=SY PAULA COOPER GALLERY, NEW YORK

50

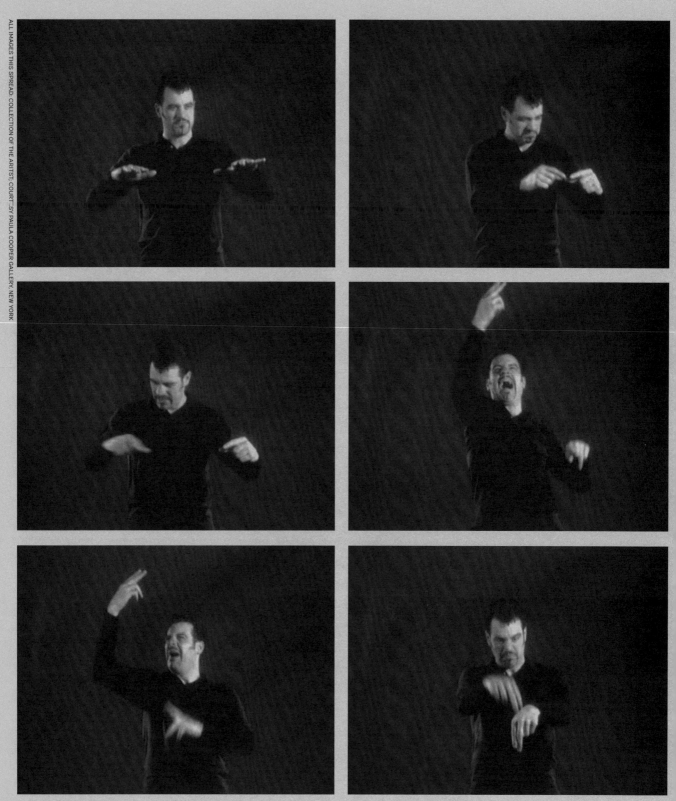

Stills from *Mixed Reviews (American Sign Language)*, 1999–2010. Single-channel color video, silent, 30 minutes. Pictured: Jonathan Kovacs

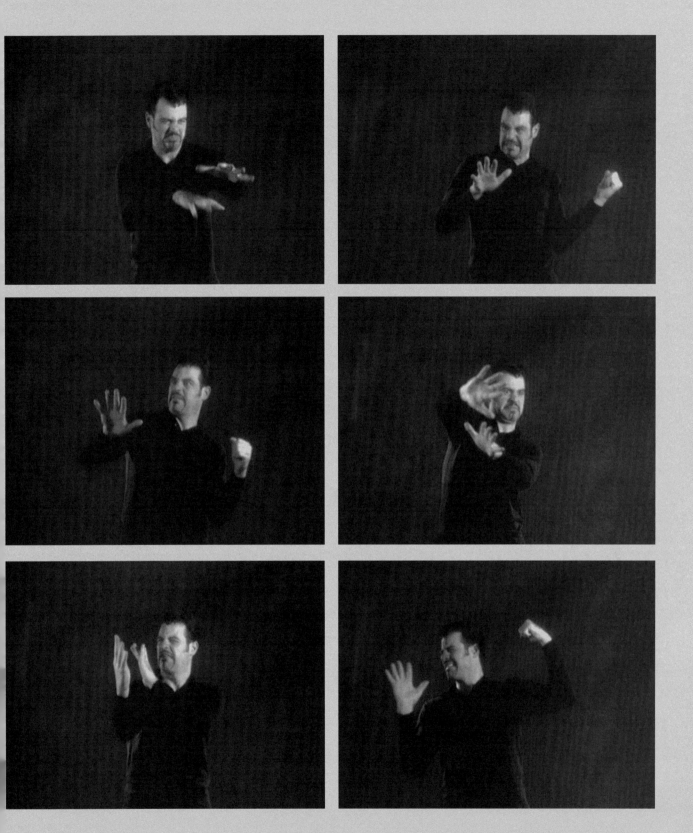

ELLIOTT SHARP

In 1981 I came across The Bachelors, even in a fanzine. I was intrigued by the band's name, with its Duchamp reference, and their Cagean use of records. A short while later I was invited to a dinner at the apartment of a friend. Her housemate was Christian Marclay, who turned out to be one-half of The Bachelors, even. Christian brought me into his workroom where records assembled from pieces of different discs hung on the wall. My eye then took in the piles of LPs: exotica, easy-listening, avant-garde. I was then producing the first *State of the Union* compilation of one-minute pieces and immediately invited Christian to contribute.[1] After that first serendipitous meeting, we continued to cross paths at the various obscure dumps where improvised

defretted Stratocaster, a sound source more than a guitar, which I attacked with extended techniques and processed with distortion.[2]

Christian's *Wind Up Guitar* (1995) took his transmediality to a new level: A lacquered acoustic guitar installed with twelve wind-up music boxes that play classical and pop themes. This was first performed at the Miami Center for the Fine Arts in January 1996. My strategy was to amplify the body of the instrument and process it through electronics: Looping delays, filters, distortion. The music boxes could be layered in any combination, and additional sounds were created using the strings. With multiple music boxes running and distorted, the melodies were often rendered unrecognizable.

The creative process I share with Christian might best be characterized through a description of one of our earliest gigs, this one in Bern, Switzerland, while Christian, Nicolas Collins, and I were on tour in Europe in 1986. We carried our equipment over precarious bridges and through subterranean tunnels to reach the third sub basement of an abandoned office building where an illicit after-hours club had been established. Our set somehow morphed from pure performance to warped functionality with Christian spinning (and destroying) records to the confused but delighted audience.

http://en.wikipedia.org/wiki/Elliott_Sharp

52

ENDNOTES

1 *State of the Union*: (1982); reissued on CD with additional tracks from 1991 and 1996 as *Atavistic*. Christian Marclay's contribution is "Composition #23."
2 An excerpt of this concert appears on the LP *(t)here* (1984).
3 These musicians include Rachel Golub on violin and tabla; Luke Dubois on electronics; Wu Na on gu-jin; Wang Li-Chuan and the Beijing Opera on percussion; Hernan Hecht on percussion; Juan Jose Rivas on electronics; Helene Breschand on harp and electronics; Luca Bonvini on trombone, ney, and gu-jin.

PHOTOGRAPH © PAULA COURT

Elliott Sharp performing *Screen Play*, July 3, 2010, at the Whitney Museum of American Art, New York.

Elliott Sharp performing with *Wind Up Guitar*, June 30, 2010, at the Whitney Museum of American Art, New York.

music was presented, and played our first duo in 1982 at the notorious Pyramid Club in the East Village. That set established the basis of much of our musical collaboration. Gestures shift between timbral counterpoint, imitation and transformation, pure noise, and oblique puns, all performed without prior discussion or prepared structure.

Of our many gigs, one of the most notable was in August 1983 at a venue/construction site on Avenue A, nicknamed the Ski Lodge. Christian was on his "turntable guitar," a record player held like a guitar and used to manipulate music through effects pedals and an amp. It was a clear and powerful manifestation of Christian's ability to transpose one media onto another, ultimately recontextualizing both. It was also a perfect match for my

In 2005, Christian asked me to interpret a new piece, *Screen Play*, a work that functions both as musical score and single-channel video. Christian's cinematic cutting and cross-genre punning work together to create a non-linear narrative, enigmatic, evocative, and filled with jarring juxtapositions, such as a time-lapse flower blooming into fireworks. I created a prerecorded electronic version of the score using synthesizers and samples as source materials. For the premiere at Performa 2005, I used this track as a jumping-off point for a live improvisation that would not literally illustrate the events on the screen but add another layer of interpretation. Later performances included musicians who followed the video as well as played along to my electronic track.[3]

53

Elliott Sharp performing *Screen Play*, July 3, 2010, at the Whitney Museum of American Art, New York.

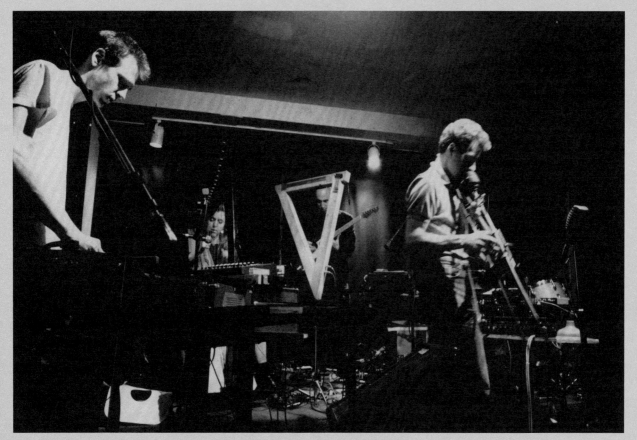

From left to right: Christian Marclay, Zeena Parkins, Elliott Sharp, and Nicolas Collins performing at Knitting Factory, New York, 1989.

STEVE BERESFORD

I played Christian Marclay's *Ephemera* as a piano solo at the Louvre in 2009. From the twenty-eight folios that make up the piece, I chose about a dozen. I planned to play a neat, sectional piece with music inspired by each of the twelve folios in turn. Each section would ritually end with me finishing that "movement," folding the folio and putting it neatly to one side.

But during the event, the folios were thrown roughly all over the floor because I couldn't wait to get to the next one. Playing a Marclay piece is like playing free improvisation with a great musician—you get a sense of overwhelming urgency and you don't want to miss a trick. (Take your eyes off the ball with Han Bennink and he'll trap you in a second.)

The tech guys had supplied a clock to tell me when half an hour was up. (When I'm performing, I can lose all track of time. Once, in a duo with Roger Turner, we played five minutes and then I packed up, thinking that we had played around half an hour. People were quite vexed.) It was ticking away happily when we set things up, but when I sat down to play, it had stopped. This was therefore a section in which my wristwatch was removed and placed on the piano while some sort of music

was being produced by parts of my body not involved in watch removal.

Throughout the performance the actual reading of the piece somehow got more convoluted. The notation (or approximation of notation) is sometimes vertical, quite small, and slightly wonky. I ended up playing without my spectacles. I'm shortsighted, and when you wear spectacles all the time, taking them off makes you feel vulnerable, but mildly excited as well.

Graphic scores and pictorial instructions usually have one effect on me: they make me lose the will to live. Somehow they manage to be simultaneously complicated and boring. Christian's stuff is a huge exception because he's one of the few visual artists who supplies material that musicians love working with.

I have played *Shuffle*, *Screen Play*, *Graffiti Composition*, and the aforementioned *Ephemera*. I always choose the best improvisers I know to play the ensemble pieces. Inevitably we have a brilliant time despite the fact that, or more likely because, our playing is very different from how we usually play. I remember how the drummer and bandleader John Stevens would sneak around during a performance, whispering

things in players' ears and creating tensions from the smallest sound. Or the edge that a player like Rico Rodriguez, the great Jamaican trombonist, gives to any band he sits in with.

Sometimes the difference between improvising and playing one of Christian's pieces is obvious: Readable bits of notation in *Ephemera* which turn out to be old American folk songs get played quite literally; over-repetitive phrases that look good to a graphic designer sound obtuse if actually played. In the end, though, is there a way to characterize the difference between a totally free improvisation and a "realization" (if they still use this word) of one of Christian's pieces? It's hard to say. When we're playing but also looking at pictures or printed words or mutated music notation, perhaps we engage bits of our brains usually not involved in playing music. As musicians who read music, we get information from Christian's pieces that he, who does not read music, cannot. Christian's scores get us playing things we would never have thought of.

Steve Beresford plays the piano and sometimes other things, generally in the context of free improvisation.

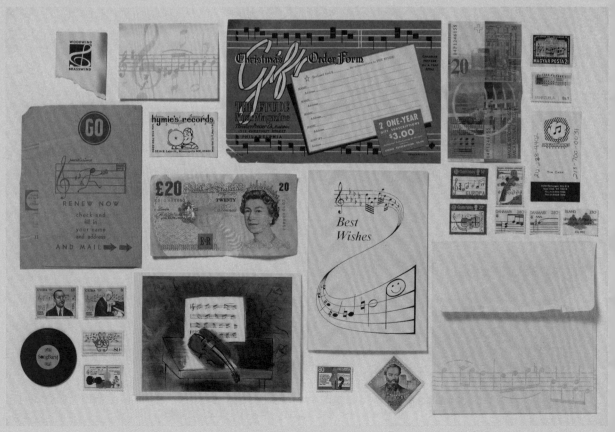

Ephemera (detail), 2009. Twenty-eight folios in slipcase, edition of 100. Published by mfc-michèle didier, Brussels.

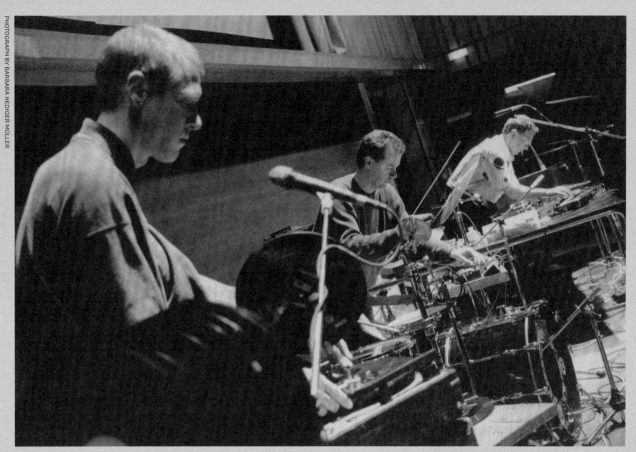

Christian Marclay, Steve Beresford, and Günter Müller performing during *Doubletake: Collective Memory and Current Art*, Kunsthalle Wien, Vienna, July 7, 1993.

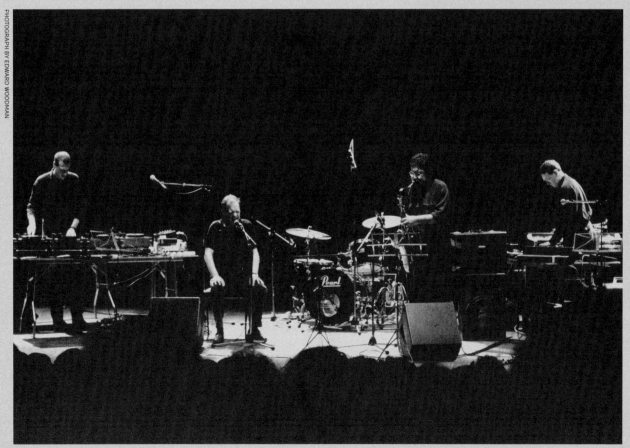

Christian Marclay, Phil Minton, Evan Parker, Steve Beresford, and Han Bennink. *Mary Had a Little Lamb*, February, 28, 1992, South Bank Centre, London.

KENNETH GOLDSMITH: DO SOMETHING

"It's simple, you just take something and do something to it, and then do something else to it. Keep doing this, and pretty soon you've got something." Jasper Johns's famous dictum resonates not just with artists, but also musicians, particularly those whose specialty is improvisation. They take a riff and do something with it, then something else, and so on. So it was on July 10, when Alan Licht improvised for forty minutes with Christian Marclay's *Wind Up Guitar*, an acoustic guitar with a dozen music boxes mounted inside the body, activated by keys. This performance, one of several that Licht did with *Wind Up Guitar* during *Christian Marclay: Festival*, reveals the freedom that comes with constraints—that is, Marclay provides the scores, or in this case, an altered instrument, and musicians respond by simply "doing something," resulting in an interpretation that is completely unexpected and new.

The addition of music boxes to a guitar presents many musical possibilities for a performer. Although he could have strummed it in the traditional fashion, Licht chose to lay the guitar on its back, dobro-style, atop a wooden box, which doubled as an additional resonator and percussion instrument.

Licht also chose to counter the tunes played by the music boxes, rather than simply accompany them. As "The Blue Danube Waltz" tinkled quietly, Licht began playing against the melody, plucking the guitar strings in a seemingly random, intuitive way. From time to time he used a tuning fork and a pitch control–box to add sheets of electronic feedback. He rapped his fingers on the face of the guitar and resonator box percussively. The resulting music was quiet and meditative. All the while the mechanical melodies of "It's a Small World" and "Stardust" floated across the space of the museum, mingling with footsteps of museum visitors, quiet talking, the cries of children, and the distant murmur from Marclay's music escaping an adjacent gallery. Licht's improvisation, the ambient noises from the museum, and the music boxes were discrete yet coexisted within the same space, creating a sort of Marclayan mega-mix.

To end his performance, Licht wound up all the music boxes at once. He then moved back from the *Wind Up Guitar*, sat down on a black box, crossed his legs, and listened with the rest of us to the decelerating plinks until there was nothing left but the sounds of the museum. With this simple gesture

Licht reversed the usual roles of performer and audience member. As the mechanical music diminished, it became clear that *Wind Up Guitar*, or at least Licht's interpretation of it, demanded our attention not only to the instrument's odd harmonies, but those of our surroundings.

Kenneth Goldsmith is a poet and founder of UbuWeb (ubu.com).

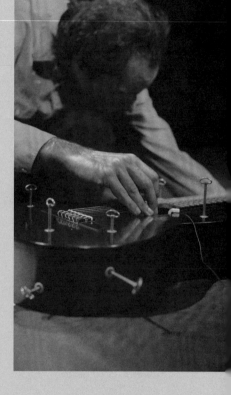

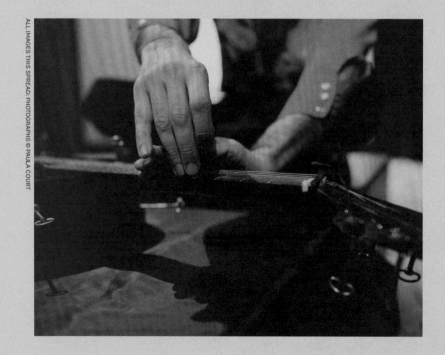

This spread: Alan Licht performing with *Wind Up Guitar*, July 2010, at the Whitney Museum of American Art, New York.

56

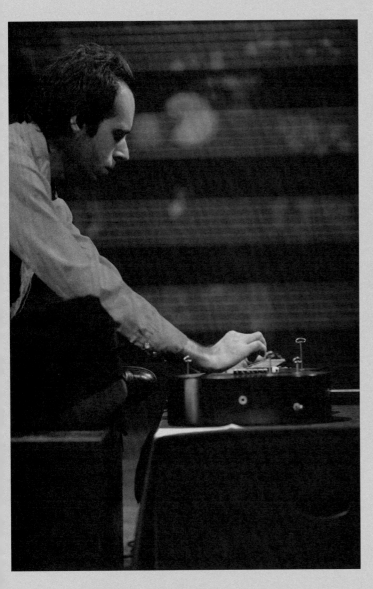

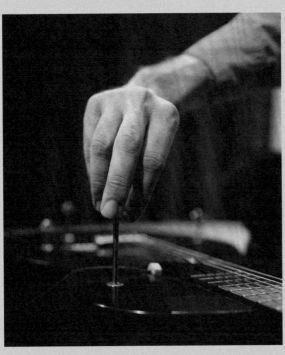

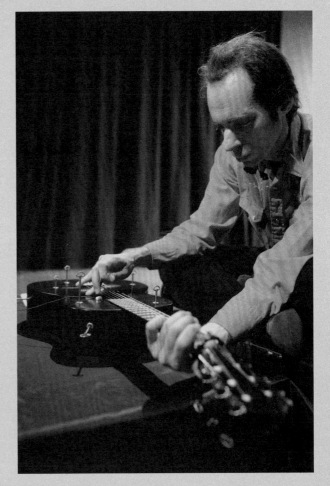

DAMON KRUKOWSKI: NEARER TO THEE

In musical terms, Christian Marclay's work with vinyl might be described as extended technique—in a piece such as *Record Players* (1984) all manner of making sounds with LP records are explored, except placing them on 33 rpm turntables. This is analogous to the avant-garde musician's practice of developing a new palette of sounds for her instrument, in place of or in addition to those established by tradition and training.

But as Marclay commented in his interview with Russell Ferguson, included in the first issue of this three-part catalogue, "performing with records and turntables is less interesting to me today because vinyl records don't have the same cultural relevance they had in the 1980s." In *Festival*, Marclay's *Recycled Records* (1980–86) "work records," c. 1980s, and the deservedly famous *Record Without a Cover* (1985) look all too right in a vitrine. Over the span of Marclay's career, LPs have quickly become historical artifacts, whose original twentieth-century function may well soon require explanation, rendering Marclay's witty extension of their use as obscure as an Elizabethan poet's play on now-forgotten words.

Is this festival, then, a New Orleans–style funeral for the LP? In one small, all-white room, vinyl lies in state. Meanwhile, in a large hall draped with black curtains, a parade of improvisers makes a living music. *Chalkboard* (2010) where visitors are encouraged to leave their mark on a developing score, might even serve this extended metaphor as a kind of funereal guest book, although again, not without an exuberant twist: The active marking of that wall is the opposite of the passive, zombie-like shuffle of the typical audio-guided museum-goer. Even as we pay our respects to the death of recorded music-as-object, we celebrate the creation of a new, potential music, expressed as score.

If the performances taking place throughout the exhibition seem necessary to realize that music, it is useful to keep in mind Marclay's instruction from *Shuffle* (2007): "Sounds may be generated or simply imagined." This openness to the varieties of potential performance—private or public, voiced or silent—is a continuation of Marclay's interest in extended technique, here applied to the art object itself. The scores of *Festival* look like gallery works—video, photography, lithography, assemblage—but they don't act like them, or rather Marclay has instructed us not to treat them that way.

When guitarist Lee Ranaldo plucks Marclay's *Wind Up Guitar* (1994) from its plinth in the gallery and starts to play it, he enacts a very different relationship to the object than we expect in a museum. Ranaldo is, like all the performers Marclay has invited to participate in this festival, himself a player of extended techniques, and begins his July 15 performance by exploring the instrument—knocking on it, scratching at it, tuning and detuning, stroking and attacking, slowly developing a vocabulary of sounds and effects with which he constructs a foundation for his improvisation. It is only once that ground is firm, that Ranaldo reaches for the dozen music-box keys stuck in this guitar, like nails in a fetish.

These wind-up toys are a set of musical readymades, like so many of Marclay's chosen devices, from his early "Altered LPs" to the live bands he gathered together for *Berlin Mix* (1993). However, in Ranaldo's improvisation these found melodies are rendered largely unrecognizable. Emerging only quietly under the ground he has laid of looped and delayed guitar sounds, the first music box enters more as texture than melody. Ranaldo winds more of the boxes, increasing their volume through multiplication to the point where they rival the guitar loops he has built, and then

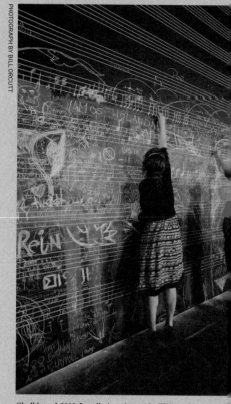

Chalkboard, 2010. Installation view at the Whitney Museum of American Art, New York.

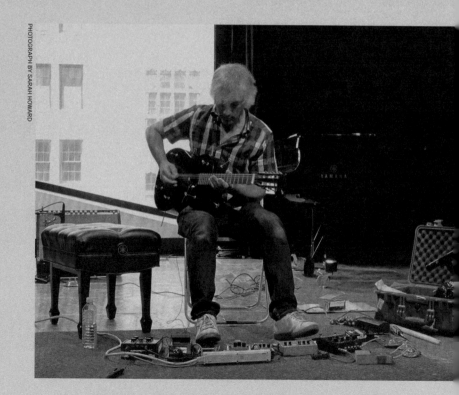

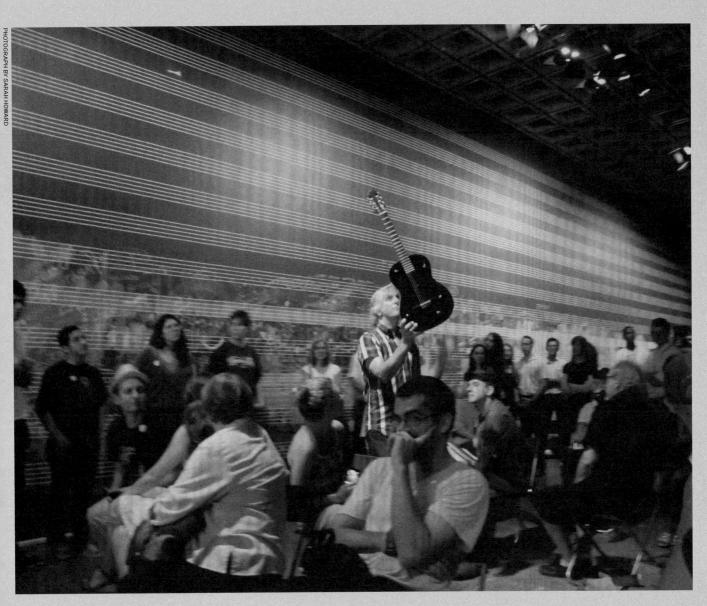

PHOTOGRAPH BY SARAH HOWARD

59

cuts that ground away, leaving the boxes to play on their own. But there are now so many playing at once, we still cannot distinguish their individual melodies. As Ranaldo's improvisation continues, this interplay between the amplified, manipulated sounds of the guitar and its acoustic, readymade qualities intensifies until, in a breathtakingly unexpected coda, Ranaldo rips the pickups and mics he has been using from the instrument, winds all its boxes tight, and parades through the room, letting the object play of its own accord until it stops. And with that, the silent *Wind Up Guitar* returns to its gallery plinth.

Ranaldo's performance highlights a characteristic of the more recent Marclay work gathered in *Festival*, one that connects to his earlier work as a performer himself: Just as Marclay the turntablist applied extended technique to the LP, here we might say that Marclay is using improvising musicians to extend the techniques of his visual art. Each performance introduces a new use for these objects, taking them off the wall and into our midst.

Damon Krukowski is a musician and writer based in Cambridge, Massachusetts.

Left and above: Lee Ranaldo performing with *Wind Up Guitar*, July 15, 2010, at the Whitney Museum of American Art, New York.

1

All images on this spread and the following are of performances during *Christian Marclay: Festival* at the Whitney Museum of American Art, New York.

1 Joan La Barbara performing *Manga Scroll*, July 16, 2010.
2 Maria Chavez and Marina Rosenfeld rehearsing *Screen Play*, July 9, 2010.
3 Joan La Barbara performing *Manga Scroll*, July 16, 2010. (Holding scroll: Odeya Nini and Zach Crumrine).
4 Ronald Bronstein and Leah Singer in front of *Zoom Zoom*, July 17, 2010.
5 Audience watching *Screen Play*, July 17, 2010.
6 Audience during the performance of *Zoom Zoom*, July 17, 2010.
7 Joan La Barbara performing *Manga Scroll*, July 16, 2010.

2

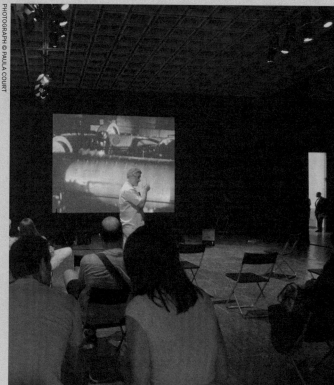

4

5

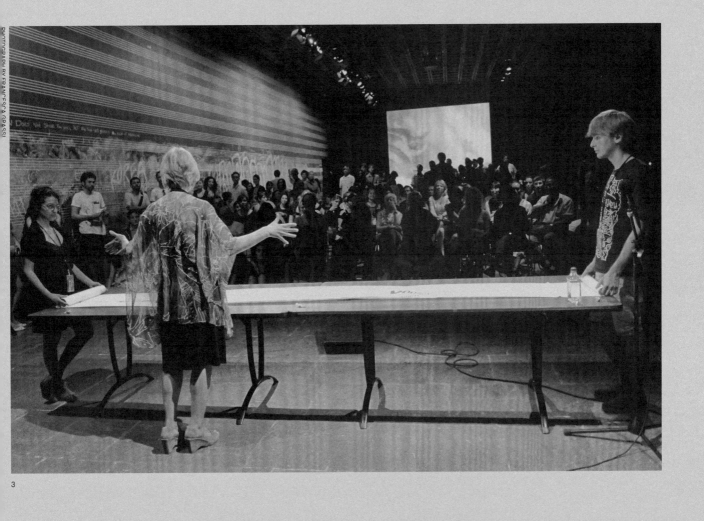

3

61

6

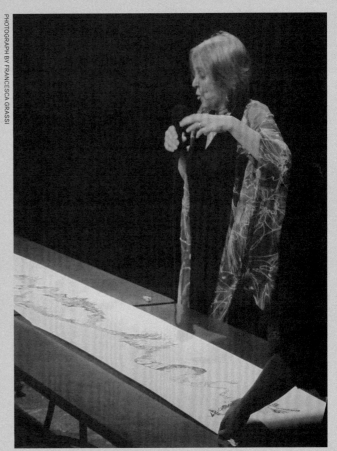

7

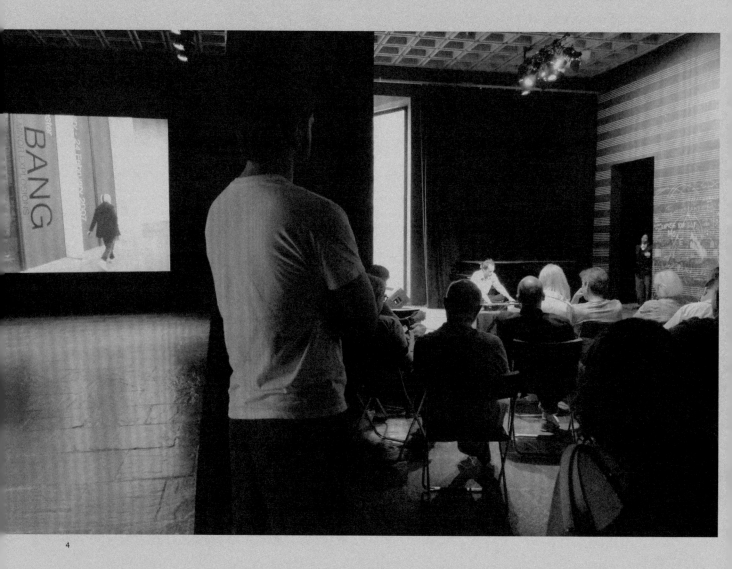

1 Maria Chavez and Marina Rosenfeld performing
 Screen Play, July 9, 2010.
2 Lee Ranaldo performing with *Wind Up Guitar*,
 July 15, 2010.
3 Rob Schwimmer performing *Chalkboard*, July 11, 2010.
4 Alan Licht performing with *Wind Up Guitar*, July 10,
 2010. Background: *Zoom Zoom*, 2007–09.
5 John Butcher and Ned Rothenberg performing
 Ephemera, July 18, 2010.
6 Audience during the performance of *Zoom Zoom*,
 July 17, 2010.
7 Min Xiao-Fen performing *Shuffle*, July 10, 2010.

Following Page:

8 *Chalkboard*, 2010. Installation view at the
 Whitney Museum of American Art, New York.
9 Audience viewing *Screen Play*, July 17, 2010.

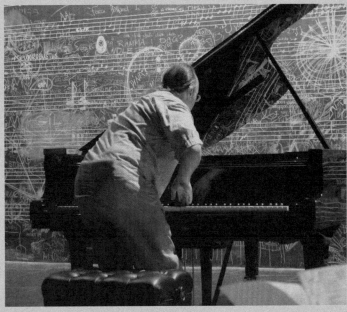

3

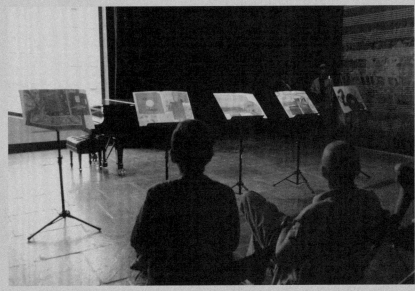

63

5

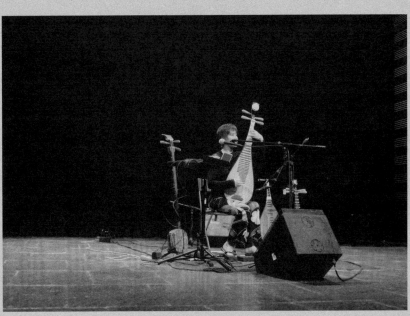

6 7

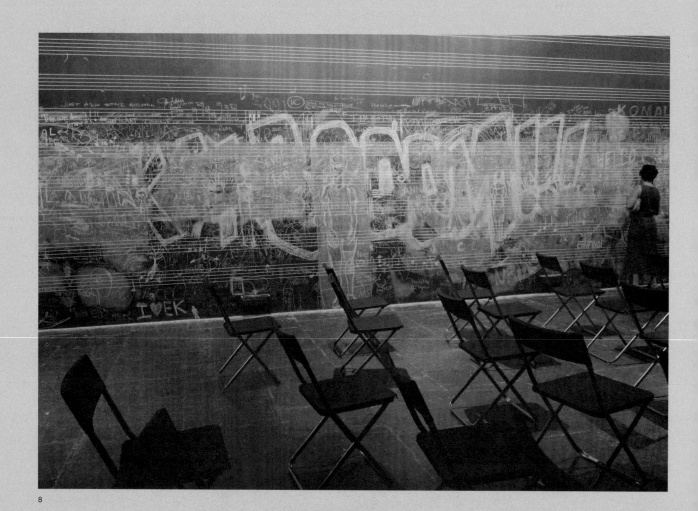

8

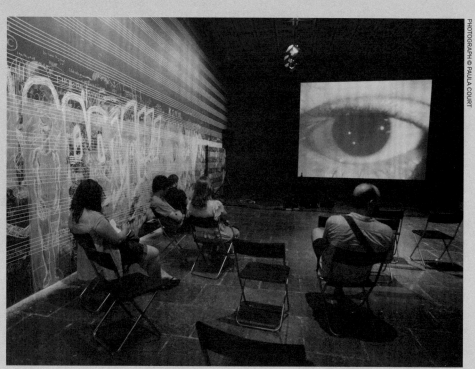

9

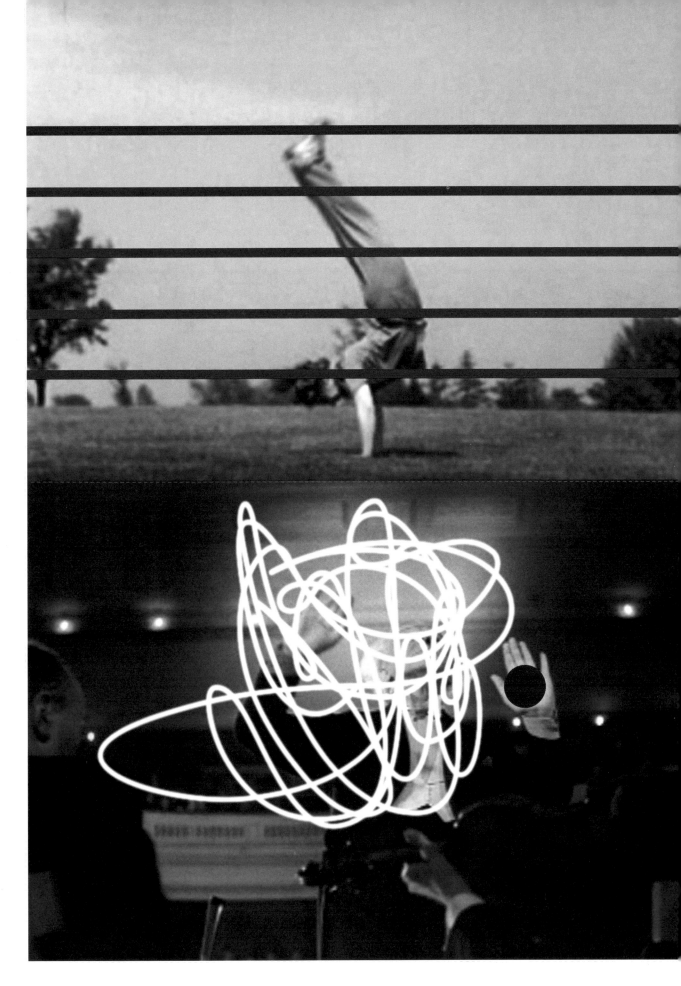

Christian Marclay, *Screen Play*, 2005. Single-channel video projection, black-and-white with color, silent; 29 min. Courtesy the artist. © Christian Marclay

Christian Marclay, *Screen Play*, 2005. Single-channel video projection, black-and-white with color, silent; 29 min. Courtesy the artist. © Christian Marclay

SELECTED PERFORMANCE CHRONOLOGY, 1979–2010

Unless otherwise noted, Christian Marclay performed solo. Marclay was a member of two musical groups: The Bachelors, even with Kurt Henry (1979–80) and Mon Ton Son with Rob Harrison and Janette Riedel (1982–83). He has also performed with David Moss's Dense Band in the 1980s and more recently with Text of Light (William Hooker, Ulrich Krieger, Alan Licht, and Lee Ranaldo). In 1996, Marclay founded djTRIO—a rotating roster of performers showcasing some of the best avant-garde turntablists.

Compiled by David Kiehl

Han Bennink during *Mary Had a Little Lamb* on February, 28, 1992, South Bank Centre, London.

SELECTED PERFORMANCE CHRONOLOGY, 1979–2010

1979

30 November	The Bachelors, even. Red Alert. Boston Film and Video Foundation, Boston.
8 December	The Bachelors, even. The Space, Boston.

1980

12 April	The Bachelors, even. Eventworks '80. Bradford Hotel, Boston.
22 June	The Bachelors, even. Mabuhay Gardens, San Francisco.
28 June	The Bachelors, even. Club Foot, San Francisco.
4 July	The Bachelors, even. Club Generic, San Francisco.
10 July	The Bachelors, even. Savoy Tivoli, San Francisco.
11 July	The Bachelors, even. With Bruce Conner. Club Foot, San Francisco.
7 August	The Bachelors, even. The Underground, Boston.

1981

13 January	The Bachelors, even. Inroads, New York.
25 October	Sunday Night at the Furnace. Franklin Furnace, New York.
18–19 December	Mon Ton Son and Kinematic Dance Company. The Bowery Project, New York.

1982

16 January	*Disc Composition*. The Kitchen, New York.
30 January	CM with dancer Christine Brodbeck. Ausstellung Raum Kaserne, Basel.
2 February	CM with dancer Christine Brodbeck. Raum für Aktuelle Schweizer Kunst, Rägeboge-Zentrum, Lucerne.
7 February	Palud No 1, Lausanne.
10 February	CM with dancer Christine Brodbeck. Presented by Apartment, Le Palladium, Geneva.
23 April	Mon Ton Son. The Pyramid Club, New York.
11 July	Mon Ton Son. Tompkins Square Park, New York.
12 July	Mon Ton Son. Tramps, New York.
18 July	Mon Ton Son. CBGB's, New York.
7 August	Mon Ton Son. Inroads, New York.
20 September	Mon Ton Son. Tramps, New York.
22 September	*Guitar Crash*. CM with dancer Yoshiko Chuma. Armageddon, New York.
23 September	*Guitar Crash*. CM with dancer Yoshiko Chuma. Museum of the Night, Danceteria, New York.
5 November	John Zorn, *Track & Field*. The Public Theater, New York.

17 November	Mon Ton Son. Pyramid Club, New York.
24–25 November	His Master's Voice: The Art of Record Players. The Kitchen, New York.
28 December	Mon Ton Son. The Kitchen, New York.

1983

5 January	Mon Ton Son. Music for Dozens. Folk City, New York.
19 January	CM with George Lewis. The Saint, New York.
8 February	Mon Ton Son. Mudd Club, New York.
9 February	John Zorn, *Locus Solus*. CM with Peter Blegvad and John Zorn. Folk City, New York.
10 February	Mon Ton Son.
15–16 February	Guitar Crash. CM with dancer Yoshiko Chuma. The Bowery Project, New York.
24 February	John Zorn, *Rugby*. CM with John Zorn, Ikue Mori, Arto Lindsay, and Tom Cora. Danceteria, New York.
2 March	Mon Ton Son. Bound for Glory II. Danceteria, New York.
8–9 March	Mon Ton Son. With Kinematic Dance Company (Tamar Kotoske and Mary Richter). The Bowery Project, New York.
11–12 March	John Zorn, *Track & Field*. Dance Gallery, New York.
22 March	John Zorn, *Rugby*. CM with John Zorn, George Cartwright, Robin Holcomb, Wayne Horvitz, and Lou Silosaq. International Festival of Microtonal Music. St. Stephen's Church, New York.
25 March	John Zorn, *Rugby*. CM with John Zorn, George Cartwright, Wayne Horvitz, Miller, and Elliott Sharp. George Gomelsky's loft, New York.
2 April	CM with Elliott Sharp. The Ski Lodge, New York.
14–17 April	Five Car Pile Up. Yoshiko Chuma and the School of Hard Knocks. Live music by CM. Danspace Project at St. Mark's Church, New York.
30 April	CM with Elliott Sharp. The Pyramid Club, New York.
3 May	CM with Derek Bailey and Lesli Dalaba. The Ski Lodge, New York.
6 May	CM and Charles K. Noyes. Studio P.A.S.S. (a program of Harvestworks, Inc.), New York.
13 May	John Zorn, *Rugby*. CM with Polly Bradfield, Tom Cora, Carol Emanuel, Wayne Horvitz, and Bob Osterlag. Studio P.A.S.S. (a program of Harvestworks, Inc.), New York.
20 May	CM with David Moss. Solos and Duos. Studio P.A.S.S. (a program of Harvestworks, Inc.), New York.
5 June	P.S. 1, Institute for Art and Urban Resources, Long Island City, New York.
24 June	CM with Michael Lytle, George Cartwright, and David Moss. Experimental Intermedia Foundation, New York.

22 July	CM with Elliott Sharp. The Saint, New York.
24 August	CM with Ikue Mori. Folk City, New York.
10 September	CM with Arto Lindsay and David Moss. The Saint, New York.
22 September	CM with Tom Cora. The Pyramid Club, New York.
23 September	CM with Carol Emanuel and John Zorn. The Saint, New York.
8 October	New Music America Festival. Intermedia Performances. W.P.A. Theater Space, Washington, D.C.
26 November	CM with David Moss. Totentanz. Culture Club for Art & Music, Basel.
15 December	John Zorn, *Locus Solus*. CM with Peter Blegvad and John Zorn; and CM solo. Houdini Jazz Festival, presented by Recommended Records. Im Kino Theater, Walche, Zürich.

1984

23–24 March	*Dead Stories*. CM with Roberta Baum, Arto Lindsay, David Moss, and Susie Timmons. Mort aka the Plug Club, New York.
7 April	John Zorn, *Darts*. Taller Latino Americano, New York.
14 April	Wish She Was Alive. Hallwalls, Buffalo.
26–28 April	*Dead Stories* (concert version). CM with Roberta Baum, Arto Lindsay, David Moss, and Susie Timmons. Festival of Voices. Studio P.A.S.S. (a program of Harvestworks, Inc.), New York.
27 April	John Zorn, *Sebastopol*. Roulette, New York.
9 June	New York Noise Projekt. CM with Fred Frith, Tom Guralnik, Arto Lindsay, Anne Ruppert, and John Zorn. Moers Festival. Moers, Germany.
9–10 June	The Moss Men. CM with David Moss, Fred Frith, and Arto Lindsay. Moers Festival. Moers, Germany.
5 July	John Zorn, *Rugby*. New Music America Festival. Hartford, Connecticut.
31 August	*New York Objects and Noise*. CM with David Moss, Arto Lindsay, and John Zorn. Willisau Festival. Willisau, Switzerland.
8 September	CM with David Moss. 8BC, New York.
14 September	Maxwells, Hoboken, New Jersey.
13 October	John Zorn, *Cobra*. Roulette, New York.
20 October	*New York Objects and Noise*. CM with David Moss, Arto Lindsay, and John Zorn. Walker Art Center, Minneapolis.
27 October	Roulette, New York.
15–18 November	*Five Car Pile Up*. Yoshiko Chuma and the School of Hard Knocks. Live music by CM. Dance Umbrella Festival. Riverside Studios, London.

24 November	CM with David Moss. Centre d'art contemporain, Geneva.
30 November	Henry Hills, *Money*. Roulette, New York.

1985

9 January	Artists Make Noise. Spit, Boston.
1 February	Butch Morris, *Current Trends in Racism in Modern America* (Conduction® #1). CM with Frank Lowe, John Zorn, Thurman Barker, Curtis Clark, Brandon Ross, Zeena Parkins, Eli Fountain, Tom Cora, and Yasunao Tone. The Kitchen, New York.
22–24 February	John Zorn, *Cobra*. Tensile Strength. The Boston Shakespeare Company Theater, Boston.
9–10 March	*Ghosts*. The Kitchen, New York.
1 May	CM with John Armleder. Fri-Art: Made in Switzerland. La Mama Experimental Theatre Club, New York.
10 May	*Dead Stories*. CM with Sussan Deyhim, David Garland, Shelley Hirsch, Arto Lindsay, David Moss, and Susie Timmons. 8BC, New York.
25 May	John Zorn, *Cobra*. CM with John Zorn, Carol Emanuel, Zeena Parkins, Arto Lindsay, Elliott Sharp, Bill Frisell, Wayne Horvitz, Anthony Coleman, Bob James, Jim Staley, Guy Klucevsek, and Bobby Previte. Moers Festival. Moers, Germany.
26 May	David Moss Dense Band. CM with David Moss, Tenko, John Rose, Wayne Horvitz, Fred Frith, and Jim Menessis. Moers Festival. Moers, Germany.
27 May	*Tower of Babel*. CM with Sussan Deyhim, Shelley Hirsch, Arto Lindsay, David Garland, and David Moss. Moers Festival. Moers, Germany.
28 May	*Tower of Babel*. CM with Sussan Deyhim, Shelley Hirsch, Arto Lindsay, David Garland, and David Moss. Rote Fabrik, Zürich.
11 September	CM with Anthony Coleman, Shelley Hirsch, and John Zorn. 8BC, New York.
21 October	John Zorn, *Cobra*. Rensselaer Polytechnic Institute, Troy, New York.
5 November	New Music America Festival. Los Angeles.
8–10 November	Stephanie and Irving Stone Festival of Improvisers. Roulette, New York.
15–17 December	Tour of the Netherlands. Dec. 15: Het Apollohuis, Eindhoven. Dec. 16: Diogenes, Goem Galerie, Nijmegen. Dec. 17: Grand Theatre, Groningen.
20 December	Jazz Now Bern. Schweizerbund, Bern, Switzerland.

1986

21–23 March	*Dead Stories*. CM with René Cendre, David Garland, Shelley Hirsch, David Moss, Sheila Schonbrun, and Susie Timmons. The Performing Garage, New York.
5 April	*Dead Stories*. CM with René Cendre, David Garland, Shelley Hirsch, David Moss, Sheila Schonbrun, and Susie Timmons. Walker Art Center, Minneapolis.

67

11 April Pyramid Arts Center, Rochester, New York.

7 May CM with Sokhi Wagner.
Experimental Intermedia, New York.

3 June Ooyevaer Muziek Festival.
Gemeentemuseum, the Hague.

10 June Centre d'art contemporain, Geneva.

28 June Festival de Belluard. Fribourg, Switzerland.

7 July Steve Blush & Duchamp's Garage present: Christian Marclay, the Master of Syntax Scratch. The Cat Club, New York.

2–3 October CM with David Moss. International Festival Musique Actuelle. Victoriaville, Quebec.

31 October–1 November John Zorn, *Once Upon a Time in the East Village: The Music of Ennio Morricone*. Next Wave Festival. Brooklyn Academy of Music, New York.

5–24 November CM with David Moss, Tour in Japan:
Nov. 5: Crocodile, Tokyo. Nov. 7: Studio Denega, Hirosaki. Nov. 8: The Loft, Hakodate. Nov. 9: Festival of Now Music. Otani-Kaikan, Sapporo. Nov. 10: Monbetsu. Nov. 12: Studio 200, Tokyo. Nov. 15: Fukuoka. Nov. 16: Hiroshima. Nov. 18: Tokushima. Nov. 20: Yokohama. Nov. 21: Tokyo. Nov. 22: Shizuoka. Nov. 23: City 8, Hamamatsu. Nov. 24: Actual Music Festival. Nikkatsu Studio, Tokyo.

10 December John Zorn, *Godard, Spillane*. CM with John Zorn, Anthony Coleman, Wayne Horvitz, David Weinstein, Carol Emanuel, Bill Frisell, Bob James, Jim Staley, David Hofstra, Bobby Previte, and Wu Shao-Ying. Whitney Museum of American Art at Philip Morris, New York.

1987
12 February CM with Fred Frith. The Kitchen, New York.

25 February *Captured Music*. Wintermusik '87. Karlsruhe, Germany

27 February CM with Elliott Sharp and Nicolas Collins. Kulturkarussell Rössli, Zürich.

28 February CM with Elliott Sharp and Nicolas Collins. Jazz Now Bern. Bern, Switzerland.

14 March *Through the Looking Glass*. Performed by Frank London, Steve Bernstein, Jim Staley, and Vincent Chancey. Roulette, New York.

28 March CM with Wayne Horvitz and Butch Morris. Tin Pan Alley, New York.

6 April Salon Jaune. Bordeaux, France.

9 April Centre Culturel Suisse, Paris.

24 April CM with David Linton and Wayne Horvitz. Darinka, New York.

11–30 May David Moss's Dense Band Tour. CM with David Moss, Wayne Horvitz, Jon Rose, and Jean Chaine. May 11: Nijmegen, The Netherlands. May 13: Lindau, Germany. May 14: Ulm. May 15: Kulturwerkstatt

Kaserne, Basel. May 16: Bern. May 17: Linz. May 19: Budapest. May 20: Vienna. May 22: Musique Action Internationale 87. Vandoeuvre-lès-Nancy, France. May 26: Festival Ljubljana. Ljubljana, Slovenia. May 28: Hamburg. May 29: Rotterdam. May 30: Amsterdam.

22 May Nuit des Solos. Musique Action Internationale 87. Vandoeuvre-lès-Nancy, France.

23 May John Zorn, *Ruen Lingyu*. CM with John Zorn, Wayne Horvitz, Anthony Coleman, David Weinstein, Bobby Previte, Ikue Mori, Carol Emanuel, Gil Jaffii, Mari Shirotori, Diem N'Guyen, and Luo Welzi. Musique Action Internationale 87. Vandoeuvre-lès-Nancy, France.

6 June An Evening with Christian Marclay. Links Hall, Chicago.

24 June CM with Davey Williams, Knitting Factory, New York.

15 July CM with Nicolas Collins, Zeena Parkins, and John Zorn. Knitting Factory, New York.

18 July CM with David Moss. Summerfare: New Sounds on the Mall. Neuberger Museum, Purchase, New York.

27 September Hidden Fortress: New Music from Japan. Improvisations: East Meets West. Curated by John Zorn. The Kitchen, New York.

16–24 October CM with Louis Sclavis. October Meeting 87. Bimhuis, Amsterdam.

20 October Butch Morris, *The Fall Conduction* (Conduction® #7). CM with Herb Robertson, Leo Smith, Konrad Bauer, George Lewis, Evan Parker, A B Baars, Fred von Hove, Maartje ten Hoorn, Maurice Horsthuis, Tristan Honsinger, Jean-Jacques Avenel, Hans Hasebos, and Han Bennink. Bimhuis, Amsterdam.

21 October Butch Morris, *The Fall Conduction* (Conduction® #8). CM with Herb Robertson, Leo Smith, Konrad Bauer, George Lewis, Evan Parker, A B Baars, Fred von Hove, Maartje ten Hoorn, Maurice Horsthuis, Tristan Honsinger, Jean-Jacques Avenel, Hans Hasebos, and Han Bennink. Club Theolonious, Rotterdam.

7 & 9 December Rencontres Trans Musicales. Rennes, France.

1988
30 April The Performing Garage, New York.

2 May CM with Fred Frith. Knitting Factory, New York.

8 May Bang on a Can Festival. New York.

14 August Record Manipulations. Freunde Güter Musik, Institut Unzeit, Berlin.

16 August Württenbergischer Kunstverein, Stuttgart.

1989
20–21 January CM and Perry Hoberman. The Kitchen, New York.

30 April *Christian Marclay: Improvised Duos*. CM with Samm Bennett, Nicolas Collins, Zeena Parkins, and Elliott Sharp. Knitting Factory, New York.

6 May	The Center for Contemporary Arts, Santa Fe.
29 June	*Chemin de Croix*. CM with Butch Morris and Günter Müller. Église des Jésuites, Sion, Switzerland.
1 July	Butch Morris, *Conduction® #16*. CM with Andreas Bossard, Wayne Horvitz, Shelley Hirsch, Bobby Previte, Martin Schutz, and Stephan Wittwer. Rendez-Vous Zürich. Rote Fabrik, Zürich.
12 July	CM with Nicolas Collins and Anthony Coleman. Knitting Factory, New York.
19–22 October	*No Salesman Will Call*. CM with Perry Hoberman. The Kitchen, New York.
30 October	*No Salesman Will Call*. CM with Perry Hoberman. Steirisches Herbstfestival. Graz, Austria.
18–23 November	John Zorn, *Kafka Prozess*. Tokyo Yuraku-cho Asahi Hall, Tokyo.
19 November	CM with Haruna Miyake and Tenko. Romanisches Café, Tokyo.

1990

18 March	CM with Bob Ostertag and Tom Cora. Knitting Factory, New York.
3 April	Collaboration with S.E.M. Ensemble. Paula Cooper Gallery, New York.
17 May	*No Salesman Will Call*. CM with Perry Hoberman. Groupe de Musique Experimentale de Marseille, Théâtre de La Criée, Marseilles.
22 May	*No Salesman Will Call*. CM with Perry Hoberman. Musique Action 90. Vandoeuvre-lès-Nancy, France.
29 May	Recycled Records. Knitting Factory, New York.
4 November	CM with Martin Tétreault. Broken Music. Musée d'art contemporain, Montreal.
9 November	CM with Anthony Braxton and Ron Kuivila. Experimental Music. Wesleyan University, Middletown, Connecticut.

1991

26 January	Collaboration with the Kronos Quartet. Hancher Auditorium, Iowa Center for the Arts, University of Iowa.
24–25 May	*One Hundred Turntables*. CM with Nicolas Collins, Jazzy Joyce, Perry Hoberman, and Otomo Yoshihide. Panasonic National Hall, Tokyo.
31 May–1 June	CM with Andres Bosshard, Günter Müller, and others. Telefonia. Hall of Science, Queens, New York.
13 June	*The Sound of Money*. CM with Alder Buebe. Extra Muros: Art Suisse Contemporain. Musée Cantonal des Beaux-Arts, Lausanne.
24 October	*Smash Hits*. Burp: Soup and Tart Revisited. The Kitchen, New York.

1992

28 February	*Mary Had a Little Lamb*. CM with Phil Minton, Evan Parker, Steve Beresford, and Han Bennink. *Doubletake: Collective Memory and Current Art*. Purcell Room, South Bank Centre, London.
7 March	CM with Nicolas Collins. Fri-Art/Kunsthalle Fribourg, Switzerland.
10 March	*The Sound of Money*. CM with Alder Buebe. Performance in conjunction with the exhibition *Visionaire Schweiz*. Centro de Arte Reina Sofia, Madrid.
12 March	CM with Günter Müller. Teatro Pradillo, Madrid.
14 June	Butch Morris, *Gloves and Mitts* (Conduction® #22). CM with Martin Schutz, Le Quan Ninh, J. A. Deane, and Günter Müller. Documenta 9, Kassel, Germany.
22 June	*Cardinal Points*. CM with J.A. Deane, Butch Morris, and Günter Müller. Raiffeinsenhalle, Frankfurt-am-Main.
25 June	*The Sound of Money*. CM with Alder Buebe. Performance in conjunction with the exhibition *Visionaire Schweiz*. Städische Kunsthalle, Düsseldorf.
26 June	CM with Günter Müller. Performance in conjunction with the exhibition *Visionaire Schweiz*. Mimi Festival, Düsseldorf.
21 July	Third Person. CM with Tom Cora, and Samm Bennett. Knitting Factory, New York.
17 October	CM with Günter Müller. Festival Nouvelles Scènes 92. Dijon, France.

1993

18 June	CM with Günter Müller. Art Basel 24. Basel.
7 July	CM with Steve Beresford and Günter Müller. Performance in conjunction with the exhibition *Doubletake: Collective Memory and Current Art*. Kunsthalle Wien.
24 July	*Berlin Mix*. Strassenbahndepot, Berlin.
25 September	The Stockholm Electronic Music Festival XV. Lido, Stockholm.
11–12 November	Butch Morris, *Conduction® #39*. CM with Elliott Sharp, Chris Cunningham, George Kitzis, Dana Friedli, Jason H. Wang, Myra Melford, Damon Ra Choice, Reggie Nicholson, Michelle Kinney, Deidre L. Murray, Elizabeth Panzer, William Parker, Mark Helias, and Fred Hopkins. Thread Waxing Space, New York.

1994

20 August	Butch Morris, *Conduction® #44*. CM with Terry Atkins, Kitty Brazelton, Marty Ehrlich, Daniel Carter, Rolando N. Bricono, Margaret Lancaster, Elsie Wood, William Connell, Sabir Mateen, Bruce Gremo, Kahil Henry, Jeweel Morndoc, Sarah Andrews, Laurie Hockman, and Arthur Blythe. Ornithology (A Dedication to Charlie Parker). Tompkins Square Park, New York.
26 October	Allen Ginsberg: Holy Soul Jelly Roll. CM with Allen Ginsberg, Hal Willner, Lee Ranaldo, Arto Lindsay, Philip Glass, and others. The Poetry Project at St. Mark's Church, New York.

69

4–5 November	Before and After Ambient. The Kitchen, New York.
10 December	CM with Günter Müller. The Swiss Institute, New York.

1995

10 February	The Cooler, New York.
13 April	Samm Bennett-Christian Marclay Duo. Knitting Factory, New York.
20 June	*La guerre des platines*. CM with Erik M and Otomo Yoshihide. La Friche, Marseilles, France.
12 November	CM with Chris Cutler and Peter Hollinger. Music Unlimited Festival. Alter Schlachthof, Wels, Austria.

1996

12 March	Salon. The Clocktower, P.S. 1 Contemporary Art Center, New York.
26-30 April	*Les Sortilèges: Im Bann des Zaubers*. Marstall Theater, Munich.
28 June	*Swiss Mix*. Festival du Belluard. Fribourg, Switzerland.
9 September	The Cooler, New York.
29 September	CM with Chris Cutler. Jazz Kartell. Sauschdall, Ulm, Germany.
7 November	djTRIO (CM with DJ Olive and Toshio Kajiwara). Roulette, New York.

1997

26–27 April	CM with Shelley Hirsch. Marstall Theater, Munich.
5 June	CM with Steve Shelley. Music in the Anchorage. Brooklyn, New York.
24 August	*Tourbillon*. CM with Carlos Baumann, Günter Müller, Stefan Schégel, and Martin Ross. Kunsthaus, Aarau, Switzerland.
30 August	*Hissing Records*. Pfeifen im Walde Internationale Musikfestwochen. Lucerne.
26 October	*Christian Marclay Project*. FabrikJazz. CM with David Moss, Günter Müller, Corin Curschelles, and others. Kunsthaus, Zürich.
7 November	*Wirbel*. CM with Ben Neill, Günter Müller, Carlos Baumann, Stefan Schlégel, Hans Kennel, and Marcel Huonder. Presented by Kunsthalle Wien. Semperdepot, Vienna.
9 November	DJs Go Pop. CM with Yasunao Tone and Jim O'Rourke. Anthology Film Archives, New York.
20 November	djTRIO (CM with DJ Olive and Toshio Kajiwara). Performance on 42nd. Whitney Museum of American Art at Phillip Morris, New York.
3 December	CM with Elliott Sharp. Knitting Factory, New York.

1998

29 January	Merce Cunningham Dance Company. Music by CM, Yasunao Tone, and Christian Wolff. Flynn Theater for the Performing Arts, Burlington, Vermont.
7 April	djTRIO and Christian Wolff. Knitting Factory, New York.
8 May	djTRIO (CM with Toshio Kajiwara and Otomo Yoshihide). Sergey Kuryokhin International Festival. The Cooler, New York.
15 May	djTRIO (CM with DJ Olive and DJ Speedranch). Fri-Art: Technoculture. Fri-Art Kunsthalle, Fribourg, Switzerland.
23 May	CM with Otomo Yoshihide. Festival International des Musiques Nouvelles. Tom Cora Memorial Concert. Vandoeuvre-lès-Nancy, France.
25 May	Do Chinese Postmen Ring Twice Too? CM and Hans-Peter Litscher, presenting music of Sarah Mandelblut. Semperdepot/Kunsthalle, Vienna.
29 August	CM with Shelley Hirsch. Akademie der Künste, Berlin.
7 August	Merce Cunningham Dance Company: Great Dance in the Bandshell. Music by CM, Takehisa Kosugi, and Jim O'Rourke. Lincoln Center, New York.
12 September	Merce Cunningham Dance Company: Event for the Garden. Music by CM, Takehisa Kosugi, and Jim O'Rourke. Walker Art Center Sculpture Garden, Minneapolis.
11 November	*Cinema: Three Deejays and Fifteen Flutes*. CM with Erik M. and DJ Olive, among others. Kölner Philharmonie, Cologne.
14 November	Christian Marclay and friends. CM with Arto Lindsay, Shelley Hirsch, and DJ Olive. Tonic, New York.
19 December	CM with Ikuo Mori and Zeena Parkins. Knitting Factory, New York.

1999

3–12 February	CM with Erik M. Tour of France. Feb. 3: Les instants chavirés, Montreuil. Feb. 4: Musée d'art moderne et contemporain, Strasbourg. Feb. 5: Centre Culturel André-Malraux, Vandoeuvre-lès-Nancy. Feb. 6: 102 Rue d'Alembert, Grenoble. Feb. 12: Musée d'art contemporain, Lyon.
26 March	*Duo for Turntables, Piano and Guitar*. CM with Christian Wolff. Columbia University Faculty House, New York.
24 April	CM with William Hooker and Lee Ranaldo. Knitting Factory, New York.
24 May	CM with Thurston Moore and Lee Ranaldo. International Festival Musique Actuelle. Victoriaville, Québec.
26 May	CM with DJ Soulslinger, Elliott Sharp, and Eric M. Tonic, New York.

1 June	Knitting Factory, New York.
26 June	Festival Agora. IRCAM/Institut de Recherche et Coordination Acoustique/Musique, Centre Georges Pompidou, Paris.
27 July	CM with Jim O'Rourke. Tonic, New York.
10–18 September	Tour of Japan. Sept. 10: Bessie Hall, Sapporo. Sept. 11: BOP, Hakodate. Sept. 12: City Art Hall, Kushiro. Sept. 14: Club Metro, Kyoto. Sept. 16: CM with Otomo Yoshihide, and Keiji Haino. Tokyo Opera City Art Gallery, Tokyo. Sept. 18: Star Pines Café, Tokyo.
25–26 October	Merce Cunningham Dance Company, Music by CM and Takehisa Kosugi. Luzerner Theater, Lucerne.
26–30 October	Do Chinese Postmen Ring Twice Too? CM and Hans-Peter Litscher, presenting music of Sarah Mandelblut. The Kitchen, New York.
14 November	CM with Arto Lindsay, DJ Olive, and Shelley Hirsch. Tonic, New York.
16 December– 13 January	*The Sounds of Christmas* (9 December 1999–16 January 2000). ArtPace, San Antonio.
	DJs: Mike Pendon aka DJ Jester the Filipino Fist, Daddy Rabbit, Sister Stroke, Crevice, Justin Boyd, DJ Lysurgic, and others.

2000

11 February	djTRIO (CM with Erik M. and DJ Olive). Les Spectacles Vivants. Centre Georges Pompidou, Paris.
26 March	Music [with]out Memory. CM with Min Xiao-Fen and Otomo Yoshihide. Festival Archipel. Geneva.
31 May	CM with Chris Mann. Tonic, New York.
16 June	CM with Arto Lindsay. Tonic, New York.
15 July	Lincoln Center Festival. Electronic Evolution 4: The Turntable as an Ensemble Instrument. Lincoln Center, New York.
17 September	djTRIO (CM with Erik M. and DJ Olive). Electroluxe Festival. Tonic, New York.
6 December	CM with CCMC (Michael Snow, John Oswald, and Paul Dutton). The Rivoli, Toronto.
14–30 December	*The Sounds of Christmas* (14–30 December). The New Museum of Contemporary Art / Media Z Lounge, New York.
	DJs: Dec. 14: Toshio Kajiwara, Darryl Hell, and CM. Dec. 16: DJ Singe, Justin Boyd, and Hahn Rowe aka Somatic. Dec. 23: DJ Olive aka the Audio Janitor, Marina Rosenfeld, and Chris Sattinger aka Timeblind. Dec. 30: 5th Platoon, DJ Kutting Kandi, Sugarcuts, Rodriquez, DJ Roli Rho, DJ Daddy Dog, Wali Zafir, and Neil Armstrong.

2001

7 March	CM with Ikue Mori and Elliott Sharp. Tonic, New York.

20 March	CM with Lee Ranaldo. Art>Music. Sydney Opera House, Sydney.
23–24 March	CM with Lee Ranaldo. Star Pines Café, Tokyo.
25 March	CM with Lee Ranaldo. Club Metro, Tokyo.
21 April	Butch Morris, *Conduction® #118*. CM with J.A. Deane, Graham Haynes, Andrew Bemkey, Billy Bang, Jana Andeuska, Okkyung Lee, Simon H. Fell, Rhodri Davies, Elliott Sharp, and Morgan Craft. Tonic, New York.
4 May	CM with Toshio Kajiwara and Bus Ratch. Museum of Contemporary Art, Chicago.
29 May	CM with Text of Light (William Hooker, Ulrich Krieger, Alan Licht, and Lee Ranaldo). Tonic, New York.
20 June	*Rainforest*. Music by CM and Takehisa Kosugi for Merce Cunningham Dance Company. Oporto, Portugal.
22 June	djTRIO (CM with Erik M. and Toshio Kajiwara). Bienal de Maia: Urban Lab. Oporto, Portugal.
17 August	djTRIO (CM with DJ Olive and Toshio Kajiwara). Naumburg Band Shell, Central Park, New York.
23 August	CM with Text of Light (William Hooker, Ulrich Krieger, Alan Licht, and Lee Ranaldo). Knitting Factory, New York.
11 October	CM with CCMC (Michael Snow, John Oswald, and Paul Dutton). Tonic, New York.
20 & 27 December	*The Sounds of Christmas* (6–27 December), Yerba Buena Center for the Arts, San Francisco.
	DJs: Dec. 20: DJ Horse Horse Tiger Tiger and Sutekh. Dec. 27: DJ Cliff Hengst, DJ Realm, and DJ Streak.

2002

11–12 March	*Graffiti Composition*. Performed by Butch Morris, Shelley Hirsch, Anthony Coleman, and Zeitkratzer. Maerzmusik—Festival für Aktuelle Musik. Neue Nationalgalerie, Berlin.
13 June	Sónar Festival. Museu d'Art Contemporani de Barcelona.
5 July	djTRIO (CM with Toshio Kajiwara and DJ Olive). The Andy Warhol Museum, Pittsburgh.
3 August	Merce Cunningham Dance Company. Music by CM and Takehisa Kosugi. Kalamata Dance Festival. Kalamata, Greece.
21 September	djTRIO (CM with Toshio Kajiwara and DJ Olive). Hirshhorn Museum and Sculpture Garden, Washington, D.C.
11–12 October	*Look at the Music/See Sound*. Kulturbron 2002. Konstmuseum, Ystad, Sweden.
7–9 November	*Mixed Reviews*. Performed by the Asko Ensemble. *Graffiti Composition*. Performed by E-RAX. November Music 2002. Musiekcentrum, 's-Hertogenbosch, the Netherlands; Essen, Germany; and Gand, Belgium.

71

19 November Black Bonds. The Swiss Institute, New York.

3–27 December *The Sounds of Christmas* (3–31 December 2002). Museum of Contemporary Art, North Miami.

DJs: Dec. 3: Phoenecia aka Soul Oddity. Dec. 6: DJ Psh Button Objects. Dec. 7: Edward Bobb aka DJ Needle. Dec. 8: DJ Otto von Shirach. Dec. 13: DJ Snowhite. Dec. 27: DJ Le Spam.

21 December djTRIO (CM with Toshio Kajiwara and DJ Olive). Detroit Institute of Arts, Detroit.

2003

21–29 March *After Yodel*. Swiss Peaks Festival. Tonic, New York.

17, 18 & 21 May *The Bell and the Glass*. Music by CM, performed by Relâche Ensemble. Philadelphia Museum of Art, Philadelphia.

5 June CM with Lee Ranaldo. UCLA Hammer Museum, Los Angeles.

4 July CM with Steve Beresford. The Spitz, London.

24 July *Graffiti Composition*. Performed by Stephen Prina. UCLA Hammer Museum, Los Angeles.

31 July djTRIO (CM with Tom Recchion and Toshio Kajiwara). UCLA Hammer Museum, Los Angeles.

21 August djTRIO (CM with Toshio Kajiwara and Marina Rosenfeld). Subtonic phOnOmena. Tonic, New York.

3 September *Tabula Rasa*. CM with Flo Kaufmann. La Bâtie Festival. Geneva.

19 November djTRIO (CM with Toshio Kajiwara and Marina Rosenfeld). Robert B. Fisher Center for the Performing Arts, Bard College, Annandale-on-Hudson, New York.

6–18 December *The Sounds of Christmas* (6–22 December 2003). Centre for Contemporary Arts, Glasgow.

DJs: Dec. 6: Guy Veal and Torsten Lauschmann. Dec. 14: Yam Voguetti. Dec. 16: Kosten Koper and Luke Fowler. Dec. 18: Mingo-go.

2004

3 February djTRIO (CM with Marina Rosenfeld and Toshio Kajiwara). Virginia Festival Film Society, Jefferson Theater, Charlottesville, Virginia.

14 August *Tabula Rasa*. CM with Flo Kaufmann. Taktlos Festival. Dojo Theater, Reithalle, Bern, Switzerland.

23 August djTRIO (CM with DJ Olive and Toshio Kajiwara). Summer Music & Movies: *Six the Hard Way*. Loring Park, Minneapolis.

10–18 December *The Sounds of Christmas* (10–18 December 2004). Tate Modern (Thameside Pavilion), London.

DJs: Dec. 10: CM and Matt Wand. Dec. 11: Strictly Kev (aka DJ Food) and Paul Hood (aka Resonance FM). Dec. 17: Matt Black aka Coldcut, Ergo Phizmiz, and Bohman Brothers. Dec. 18: Janek Schaefer, People Like Us, and Simon Russell.

2005

22 March *Tabula Rasa*. CM with Flo Kaufmann. St. Luke's Church, London.

13 May *Tabula Rasa*. CM with Flo Kaufmann. Variations on a Silence: Project for a Recycling Plant. Rentem Company, Tokyo.

6–7 October CM with Text of Light (William Hooker, Ulrich Krieger, Alan Licht, and Lee Ranaldo). The Kitchen, New York.

11 November *Screen Play*. Performed by Elliott Sharp, Okkyung Lee, Toshio Kajiwara, Min Xiao-Fen, Zeena Parkins, Christine Bard, and Jim Pugliese. Performa 05. Eyebeam, New York.

9–22 December *The Sounds of Christmas* (9–22 December 2005). Milwaukee Art Museum, Milwaukee.

DJs: Dec. 9: CM, Jim Schoenecker, and Chris Rosenau. Dec. 15: DJ Mad Matter and Paul Host. Dec. 22: DJ Whitebread and Doormouse.

2006

18 February *Screen Play*. Performed by Steve Beresford, Paul Lovens, and John Butcher. Kill Your Timid Nation. Dundee Contemporary Arts Centre, Dundee, Scotland.

17 May *Screen Play*. Performed by Elliott Sharp Trio and Okkyung Lee, Tim Barnes, and Toshio Kajiwara. PlayVision. World Financial Center, New York.

2 June *Shuffle*. Performed by Anthony Coleman, Okkyung Lee, Peter Evans, Zeena Parkins, Elliott Sharp, Jim Staley, and John Zorn. Roulette, New York.

13 September *Graffiti Composition*. Performed by Melvin Gibbs, Mary Halvorson, Lee Ranaldo, Vernon Reid, and Elliott Sharp. Museum of Modern Art, New York.

1 December *Turntable Toss, Composition* (1960) by La Monte Young, and *Drip Music* (1959) by George Brecht. CM and John Armleder. Performance in conjunction with the exhibition *John Armleder: About Nothing, Works on Paper 1962–2007*. Institute of Contemporary Art, Philadelphia.

2007

14 April *Graffiti Composition*. Performed by Hélène Breschand. Galerie Yvon Lambert, Paris.

5 May *Screen Play*. Performed by Elliott Sharp, Erik M., Hélène Breschand, John Butcher, Luca Bonvini, Paul Lovens, Steve Beresford, Dailla Khatir, and Eric-Maria Couturier. Cité de la Musique, Paris.

10 May djTRIO (CM with Jonas Oleson and Erik M.). Spor Festival. Åarhus, Denmark.

13 May *Screen Play*. Performed by Zeena Parkins, Ikue Mori, Erik M., Dalila Khatir & Eric-Maria Couturier, and Jakob Riis & Jacob Anderskov. Spor Festival. Åarhus, Denmark.

19 May — *Shuffle*. Performed by Martin Schütz and Hans Koch. Kunsthalle, Bern, Switzerland.

22 November — *Screen Play*. Performed by Vicki Bennett, Ergo Phizmiz, Steve Beresford, John Butcher, Roger Turner, Blevin Blectum, and J. G. Thirwell. The Wire 25 Anniversary. Bush House, London.

13 & 19 December — *The Sounds of Christmas* (11–23 December 2007). MAMCO/Musée d'art moderne et contemporain, Geneva.

DJs: Dec. 13: de marieavril, and Christian Pahud. Dec. 19: CM, Francis Baudevin, and DJ Phatstaff.

2008

28 January — *Tabula Rasa*. CM with Flo Kaufmann. Club Transmediale, Berlin.

17 May — *Shuffle*. Performed by Hélène Breschand, Arnaud Debreu, Benoît Delaune, Guillaume Dubreu, Jean-Christophe Masson, Johann Mazé. Jean-François Pauvros and Zap Pascal. *Graffiti Composition*. Performed by Hélène Breschand and Jean-François Pauvros. No Clubbin'. Pére Ubu, Rennes.

20 September — *Zoom Zoom*. CM with Shelley Hirsch. *Graffiti Composition*. Performed by Jacques Demierre. *Shuffle*. Performed by Vincent Barras, Jacques Demierre, D'incise, Laurent Estoppey, Nicolas Field, John Menoud, and Dragos Tara. Théâtre de Grütli, Geneva.

22 October — *Screen Play*. Performed by Elliott Sharp, Wu Na, Wang Li Chuan, Ben Houge, Yan Jun, Bruce Gremo, and Top Floor Circus. Shanghai E-arts Festival. Xujiahui Park, Shanghai.

14 & 20 December — *The Sounds of Christmas* (14–31 December 2008). DHC/ART Foundation for Contemporary Art, Montreal.

DJs: Dec. 14: Christof Migone, Mitchell Akiyama, and CM. Dec. 20: Nancy Tobin, Martin Tétreault, Raf Katigbak, and Olivier Alary.

2009

10 March — CM with Otomo Yoshihide and Sachiko M. Café Oto, London.

1 May — CM with Okkyung Lee, Steve Beresford, and John Butcher. Café Oto, London.

12 June — *Ephemera*. Performed by Irène Schweizer. Gare du Nord, Basel.

19 June — CM with Shelley Hirsch. Café Oto, London.

24 October — *Ephemera*. Performed by Steve Beresford. Musée de Louvre, Paris.

24 October — *Zoom Zoom*. CM and Shelley Hirsch. Musée du Louvre, Paris.

12 November — *Berlin: Symphony of a Great City* for Walter Ruttmann's 1928 film. Text of Light (CM, Ulrich Krieger, Alan Licht, and Lee Ranaldo). Performa 09. High Line, New York.

21 November — CM with Shelley Hirsch. A Fantastic World Super-imposed on Reality: A Select History of Experimental Music. Performa 09. Gramercy Theater, New York.

12–20 December — *The Sounds of Christmas* (12–20 December 2009). MOCAD/Museum of Contemporary Art, Detroit.

DJs: Dec. 12: CM. Dec. 17: Jon Moshier, and Ed Special. Dec. 18: Ian Clark/Perspects. Dec. 19: Jeff Karolski.

2010

6 March — CM with Steve Beresford and John Butcher. Steve Beresford's Birthday. Café Oto, London.

25 March — *4'33 After J.C.* Performed by Louise Stern and Oliver Pouliot. IRCAM/Institut de Recherche et Coordination Acoustique/Musique, Centre Georges Pompidou, Paris.

7 May — CM with Okkyung Lee, John Butcher, and Steve Beresford. Café Oto, London.

73

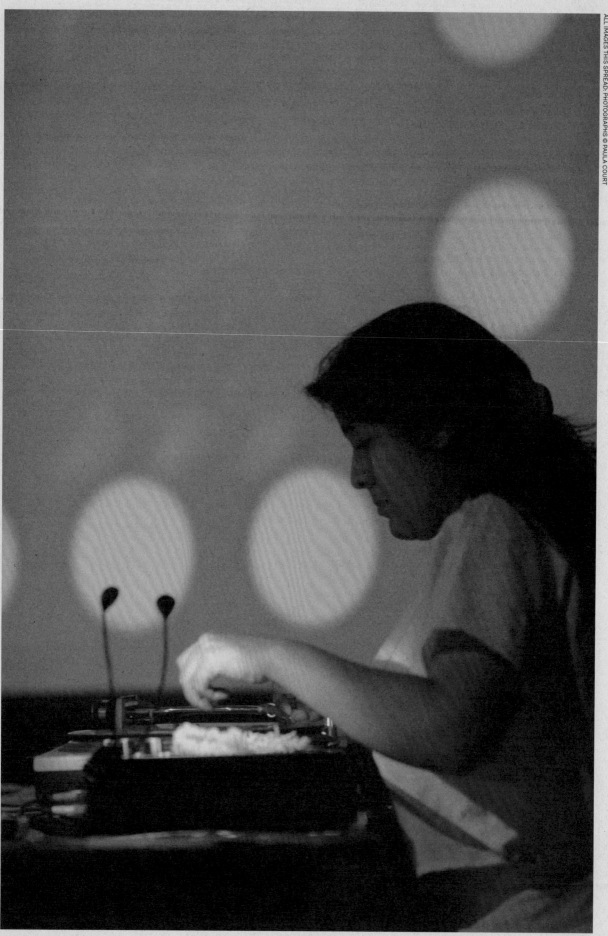

Maria Chavez performing *Screen Play*, July 1, 2010, at the Whitney Museum of American Art, New York.

Tristan Shepherd performing *Screen Play*, July 1, 2010, at the Whitney Museum of American Art, New York.

PERFORMANCE SCHEDULE

WEDNESDAY, AUGUST 4

4:00pm – Shuffle
Anthony Coleman

THURSDAY, AUGUST 5

1:00pm – Ephemera
Anthony Coleman

4:00pm – Ephemera
Marilyn Crispell

FRIDAY, AUGUST 6

2:00pm – Shuffle
Marilyn Crispell

7:00pm – Pret-à-Porter
Anthony Coleman, Mary Halvorson

SATURDAY, AUGUST 7

1:00pm – Ephemera
Marilyn Crispell

4:00pm – Graffiti Composition
Anthony Coleman, Mary Halvorson

SUNDAY, AUGUST 8

1:00pm – Graffiti Composition
Anthony Coleman

4:00pm – Wind Up Guitar
Mary Halvorson

WEDNESDAY, AUGUST 11

1:00pm – Covers
Anthony Coleman

3:00pm – Screen Play
Elliott Sharp and ensemble

THURSDAY, AUGUST 12

1:00pm – Box Set
Anthony Coleman

4:00pm – Screen Play
Anthony Coleman, o.blaat, Zeena Parkins

FRIDAY, AUGUST 13

2:00pm – Sixty-four Bells and a Bow
Raz Mesinai

7:00pm – Graffiti Composition
Elliott Sharp, Dither Guitar Quartet

SATURDAY, AUGUST 14

1:00pm – Covers
Zeena Parkins

4:30pm – Screen Play
Zeena Parkins, special guests

SUNDAY, AUGUST 15

1:00pm – Shuffle
Rob Schwimmer

2:30pm – Graffiti Composition
Zeena Parkins, Elliott Sharp

4:30pm – Covers
Zeena Parkins

WEDNESDAY, AUGUST 18

1:00pm – Box Set
Peter Evans, Zeena Parkins

4:30pm – The Bell and the Glass
Peter Evans, Zeena Parkins

THURSDAY, AUGUST 19

1:00pm – Covers
Peter Evans, Kato Hideki, Zeena Parkins,
special guest

4:30pm – Screen Play
Peter Evans, Kato Hideki, Zeena Parkins,
special guest

FRIDAY, AUGUST 20

2:00pm – Sixty-four Bells and a Bow
Kato Hideki, Zeena Parkins

7:00pm – Manga Scroll
David Moss

SATURDAY, AUGUST 21

1:00pm – Sixty-four Bells and a Bow
Kato Hideki, Zeena Parkins

4:00pm – Manga Scroll
Joan La Barbara

SUNDAY, AUGUST 22

12:30pm – Ephemera
Kato Hideki

4:30pm – The Bell and the Glass
Zeena Parkins, special guests

WEDNESDAY, AUGUST 25

4:00pm – Graffiti Composition
Robin Holcomb, Wayne Horvitz

THURSDAY, AUGUST 26

1:00pm – Wind Up Guitar
Bill Frisell

2:30pm – Sixty-four Bells and a Bow
Cyro Baptista

4:00pm – Shuffle
Robin Holcomb, Wayne Horvitz

FRIDAY, AUGUST 27

4:00pm – Screen Play
Marina Rosenfeld, Leila Bourdreuil, Bonnie
Jones, Tommy Martinez, Sergei Tcherepnin

7:00pm – Sixty-four Bells and a Bow
Raz Mesinai, Marina Rosenfeld

SATURDAY, AUGUST 28

12:30pm – Sixty-four Bells and a Bow
Cyro Baptista

4:00pm – Screen Play
Kato Hideki, Robin Holcomb, Wayne Horvitz

SUNDAY, AUGUST 29

12:30pm – Ephemera
Robin Holcomb, Wayne Horvitz

4:00pm – Screen Play
Kato Hideki, Marina Rosenfeld, special guest
Sergei Tcherepnin

WEDNESDAY, SEPTEMBER 1

1:00pm – Covers
Guy Klucevsek

4:00pm – Box Set
Okkyung Lee

THURSDAY, SEPTEMBER 2

1:00pm – Ephemera
Guy Klucevsek

4:00pm – Ephemera
Peter Evans, Okkyung Lee

FRIDAY, SEPTEMBER 3

4:00pm – The Bell and the Glass
Peter Evans, Guy Klucevsek, Okkyung Lee

7:00pm – Manga Scroll
Kate Valk

SATURDAY, SEPTEMBER 4

2:30pm – Screen Play
Peter Evans, Guy Klucevsek, Okkyung Lee,
o.blaat

4:00pm – Sixty-four Bells and a Bow
Yasunao Tone

SUNDAY, SEPTEMBER 5

1:00pm – Ephemera
Peter Evans, Okkyung Lee

4:00pm – Covers
Guy Klucevsek

WEDNESDAY, SEPTEMBER 8

1:00pm – Ephemera
Butch Morris and string octet

THURSDAY, SEPTEMBER 9

1:00pm – Mixed Reviews
Butch Morris and Chorus of Poets

FRIDAY, SEPTEMBER 10

2:00pm – Graffiti Composition
Butch Morris and string octet

7:00pm – Through the Looking Glass
Steven Bernstein, Vincent Chancey, Frank
London, David Taylor

SATURDAY, SEPTEMBER 11

1:00pm – Mixed Reviews
Butch Morris, Chorus of Poets

SUNDAY, SEPTEMBER 12

1:00pm – Graffiti Composition
Butch Morris and string octet

WEDNESDAY, SEPTEMBER 15

1:00pm – Covers
Guy Klucevsek

4:00pm – Wind Up Guitar
Elliott Sharp

THURSDAY, SEPTEMBER 16

2:00pm – The Bell and the Glass
Guy Klucevsek, Ned Rothenberg

4:00pm – Wind Up Guitar
Elliott Sharp

FRIDAY, SEPTEMBER 17

3:00pm – Screen Play
Guy Klucevsek, o.blaat, Ned Rothenberg

7:00pm – Wind Up Guitar
Thurston Moore

SATURDAY, SEPTEMBER 18

2:30pm – Manga Scroll
Shelley Hirsch

4:00pm – The Bell and the Glass
Guy Klucevsek, Ned Rothenberg

SUNDAY, SEPTEMBER 19

12:30pm – Screen Play
Guy Klucevsek, o.blaat, Ned Rothenberg

4:00pm – Screen Play
Elliott Sharp and ensemble

WEDNESDAY, SEPTEMBER 22

1:00pm – Ephemera
Guy Klucevsek

4:30pm – Zoom Zoom
Shelley Hirsch with Christian Marclay

THURSDAY, SEPTEMBER 23

1:00pm – Covers
Guy Klucevsek

FRIDAY, SEPTEMBER 24

2:00pm – Wind Up Guitar
Elliott Sharp

7:00pm – Through the Looking Glass
TILT Brass (Chris McIntyre with Russ Johnson,
Nathan Koci, Nate Wooley)

SATURDAY, SEPTEMBER 25

1:00pm – Graffiti Composition
Elliott Sharp and string ensemble

2:30pm – Ephemera
Guy Klucevsek

4:00pm – Through the Looking Glass
TILT Brass (Christ McIntyre with Russ Johnson,
Nathan Koci, Nate Wooley)

SUNDAY, SEPTEMBER 26

2:30pm – Shuffle
Michael Snow

4:00pm – Manga Scroll
Joan La Barbara

PERFORMER BIOS

Cyro Baptista
Cyro Baptista is a Brazilian percussionist and composer whose experience and gift for innovation have made him one of the most respected percussionists in the world. In addition to leading five different live and recording projects, he has worked with several jazz, pop, classical, and avant-garde artists including Herbie Hancock, Yo-Yo Ma, Wynton Marsalis, Paul Simon, Laurie Anderson, John Zorn, Trey Anastasio (of the band Phish), and Sting.

Steven Bernstein
Steven Bernstein plays trumpet and slide trumpet, is a bandleader, composer, and arranger, and lives outside of musical convention. His groups, Sexmob and the Millennial Territory Orchestra, tour festivals and concerts worldwide, and he leads the Diaspora Series, which has released four records on John Zorn's Tzadik label. In 1992 Bernstein started working with producer Hal Willner on collaborations with Lou Reed, Robert Altman, and U2. He is also a proud member of the Levon Helm Band.

Vincent Chancey
Native Chicagoan Vincent Chancey moved to New York after receiving a bachelor of music degree from the Southern Illinois University School of Music. Chancey has performed with the Brooklyn Philharmonic, the Pan American Symphony, the One World Symphony, the Zephyr Woodwind Quintet, and the Netherlands Opera. He has released three CDs: *LEGenDES Imaginaires*, *Next Mode* (a Julius Watkins tribute), and *Welcome Mr. Chancey*.

Anthony Coleman
Anthony Coleman is a composer, improvising keyboardist, and teacher from New York City. His ensembles have included the trio Sephardic Tinge and the Selfhaters Orchestra. CDs include the cycle *by Night* (1987–92), a series of works inspired by Coleman's experiences in (the ex-) Yugoslavia; and *Shmutsige Magnaten*, a live solo performance from the Krakow Jewish Culture Festival (Summer 2005) that features interpretations of the songs of Mordechai Gebirtig. Coleman has toured and recorded with John Zorn, Elliott Sharp, Marc Ribot, Shelley Hirsch, Roy Nathanson, and many others.

Marilyn Crispell
Marilyn Crispell has been a composer and performer of contemporary improvised music since 1978. For ten years she was a member of the Anthony Braxton Quartet and the Reggie Workman Ensemble, and has performed and recorded extensively as a soloist and with players on the American and international jazz scenes. She has been the recipient of three New York Foundation for the Arts Fellowship grants, a Guggenheim Fellowship, and a Mary Flagler Cary Charitable Trust composition commission.

Peter Evans
Peter Evans has been a member of the New York musical community since 2003, when he moved to the city after graduating Oberlin Conservatory with a degree in classical trumpet. Evans works solo and with chamber orchestras, and also does performance art, improvisation, electro-acoustic music, and composition.

Bill Frisell
With a career spanning more than thirty years, Bill Frisell is now firmly established as a visionary presence in American music. The guitarist, composer, and bandleader has collaborated with artists, filmmakers, and musicians. The *New York Times* described Frisell's music this way: "It's hard to find a more fruitful meditation on American music than in the compositions of guitarist Bill Frisell. Mixing rock and country with jazz and blues, he's found what connects them: improvisation and a sense of play. Unlike other pastichists, who tend to duck passion, Mr. Frisell plays up the pleasure in the music and also takes on another often-avoided subject, tenderness."

Kato Hideki
Kato Hideki is an independent composer, bassist, and multi-instrumentalist. His projects include Death Ambient with Fred Frith and Ikue Mori, Green Zone with Otomo Yoshihide and Uemura Masahiro, and OMNI with Nakamura Toshimaru and Akiyama Tetsuzi. Kato has collaborated with Nicolas Collins, James Fei, and Ursula Scherrer. He is a member of the analog synthesizer collective, Analogos.

Robin Holcomb
Pianist, composer, singer, and songwriter Robin Holcomb performs internationally as a solo artist and leader of various ensembles. She composes extensively for chamber ensembles, big bands, dance, theater, and film. Her music has been released on the Nonesuch, Tzadik, and Songlines labels, and has been called "staggeringly beautiful" by the *New York Times*.

Wayne Horvitz
Pianist and composer Wayne Horvitz has been commissioned by the Icicle Creek Trio, Meet the Composer, Kronos, Seattle Chamber Players, Mary Flagler, PGAFF, BAM, and others. He has produced CDs for Eddie Palmieri, Fontella Bass, Robin Holcomb, and Bill Frisell, among others. He appears on more than three hundred CDs, thirty as a leader. He is the recipient of the 2008 NEA American Masterpieces Award.

Guy Klucevsek
Guy Klucevsek is a versatile composer and accordionist who has worked with Laurie Anderson, Bang on a Can, Anthony Braxton, Dave Douglas, Bill Frisell, Kronos Quartet, Natalie Merchant, Present Music, Relache, John Williams, and John Zorn. He is the founder of Accordion Tribe, which was the subject of the 2002 documentary film, *Accordion Tribe: Music Travels*. He was also a guest on *Mr. Rogers' Neighborhood*.

Okkyung Lee
Korean cellist Okkyung Lee has been developing her own voice in contemporary cello performance, improvisation, and composition by mixing her multifaceted artistic influences. She has worked with numerous artists including Laurie Anderson, John Butcher, Vijay Iyer, Andrew Lampert, Christian Marclay, Thurston Moore, Evan Parker, and John Zorn, and received a NYSCA composer commission in 2007 and an FCA grant in 2010.

Frank London
Trumpeter and composer Frank London is a member of the Klezmatics, Hasidic New Wave, and Klezmer Brass Allstars, which he leads; has performed with John Zorn, LL Cool J, Itzhak Perlman, Mel Tormé, Lester Bowie's Brass Fantasy, LaMonte Young, They Might Be Giants, David Byrne, Jane Siberry, Ben Folds 5,

Mark Ribot, Iggy Pop, Michael Tilson Thomas, Gal Costa, and others, and is featured on more than three hundred CDs. London is a Grammy Award winner, and his CD, *Carnival Conspiracy*, was *Rolling Stone's* #1 Non-English Recording of 2006.

Butch Morris
Lawrence D. "Butch" Morris is recognized internationally as the principal theorist and practitioner in the evolution of Conduction®; he is a leading innovator whose work redefines the roles of composer, conductor, arranger, and performer. Since 1974, his career has been distinguished by unique and outstanding international contributions.

Christopher McIntyre
Christopher McIntyre leads a multifaceted career as performer, composer, and curator-producer. He interprets and improvises on trombone and synthesizer and composes new work for TILT Brass and Ne(x)tworks. He has recorded for Tzadik, New World, and Mode. Curatorial work includes projects at the Kitchen, Issue Project Room, and the Stone. He has served as artistic director of the MATA Festival since 2007.

Raz Mesinai
Composer, producer, and sound alchemist Raz Mesinai makes music at the intersection of dub and modern composition. His recordings as Badawi have placed him at the forefront of the experimental electronic dance music scene for more than a decade. Mesinai's piece *Crossfader*, for string quartet, was commissioned and performed by the Kronos Quartet in 2008. His piece for solo cello and electronics, *The Echo of Decay*, was commissioned by cellist Maya Beiser and also premiered at Zankel Hall in 2008. In July of this year, Mesinai remixed his opera *Myth of Nations* for BBC Radio 1.

Thurston Moore
Thurston Moore cofounded the New York–based rock group Sonic Youth in 1980. He records and performs as a solo artist as well and has worked collaboratively with Merce Cunningham, Cecil Taylor, Lydia Lunch, and Glenn Branca. He has composed music for films by Olivier Assayas, Gus Van Sant, and Allison Anders. He publishes art books and literature through Ecstatic Peace Library and releases music through Ecstatic Peace Records + Tapes.

David Moss
David Moss is considered one of the most innovative singers and performers in contemporary music. He began performing with Christian Marclay in 1983. In 1991, he received a Guggenheim Fellowship and, in 1992, a DAAD Fellowship in Berlin. Moss is the artistic director of the Institute for Living Voice, and he performs with the groove trio Denseland. He lives in Berlin.

Rob Schwimmer
Rob Schwimmer is a composer-pianist, thereminist, and a founder of the legendary Polygraph Lounge with Mark Stewart. He wrote the score for the 2008 Academy Award–winning documentary short, *Freeheld*. Schwimmer has been the featured theremin soloist with the Orchestra of St. Luke's. His most recent CD, *Beyond The Sky*, has been reviewed as "extraordinary... harmonically ravishing... dazzling" in *Gramophone* and "...the finest solo piano CD of the year" in *All About Jazz—New York*.

Michael Snow
Michael Snow was born in Toronto not so long ago and lives there now. A multi-instrumentalist, he performs solo as well as with various ensembles—most often with the CCMC of Toronto—in Canada, the United States, Europe, and Japan. He has been a painter and sculptor, although since 1962 much of his gallery work has been photo-based or holographic. Snow was commissioned to do an exterior art work titled *Lightline* on the Trump Tower at Bay and Adelaide, which will open this year.

David Taylor
Receiving B.S. and M.S. degrees from the Juilliard School of Music, David Taylor started his playing career as a member of Leopold Stowkowski's American Symphony Orchestra, and by appearing with the New York Philharmonic under Pierre Boulez. Simultaneously, he was a member of the Thad Jones Mel Lewis jazz band and recorded with groups ranging from Duke Ellington to the Rolling Stones. He also recorded numerous solo CDs on the following labels: Koch, New World, ENJA, DMP, Tzadik, CIMP, and PAU.

JG Thirlwell
JG Thirlwell is a Brooklyn-based composer-producer-performer who also works under many pseudonyms, including Foetus, Steroid Maximus, Manorexia, Baby Zizanie, Clint Ruin, and Wiseblood. Thirlwell has completed commissions for Kronos Quartet, Bang on a Can, and LEMUR and is also a member of the "freq_out" sound-art collective, which creates on-site sound and light installations. Thirlwell performs live with a chamber version of his Manorexia project, and also scores "The Venture Brothers," a cartoon on Adult Swim/Cartoon Network.

Yasunao Tone
Yasunao Tone, a founder of Group Ongaku and an original member of Fluxus, was born in Tokyo in 1935 and moved to New York in 1972. Public performances include *Kitchen*, *Roulette*, and pieces at the Guggenheim Museum Soho, Museum of Contemporary Art of Barcelona, Tokyo Opera City Gallery, and a commission by the American Dance Festival for Merce Cunningham. His work has been featured in group shows at the Venice Biennale, the Guggenheim Museum, the Whitney Museum, and the Yokohama Triennale.

Kate Valk
Kate Valk began working with the Wooster Group in 1979 and since then has co-composed and performed in all of the group's theater productions. She has also worked on and been featured in the group's radio, film, and video projects, most recently the 360-degree video installation *THERE IS STILL TIME... BROTHER*. Valk founded and directs the group's Summer Institute, an intensive performance program for public high-school students.

John Zorn
Drawing on his experience in a variety of genres; including jazz, rock, hardcore punk, classical, klezmer, film, cartoon, popular, and improvised, John Zorn has created an influential body of work that defies strict categorization. A native of New York City, he has been a central figure in the downtown scene since 1975, incorporating a wide range of musicians in various compositional formats. Zorn is the executive producer of Tzadik, a record label dedicated to experimental and avant-garde music, and the founder and artistic director of the Stone, a performance space in Manhattan's East Village.

79

VIDEO DOCUMENTATION IN THE EXHIBITION
Documentation of Performances

Fast Music, 1982 (15 seconds)

Performer and director: Christian Marclay

Included in *Commercial Eruption*, a film by Yoshiko Chuma; camera: Jacob Burckhardt 16 mm film transferred to video

Record Players, 1984 (4 minutes)

Director: Christian Marclay; performers: Catherine Bachman, Nicolas Ceresole, Thierry Cheverney, Yoshiko Chuma, Helmut Federle, Tetsuo Fukaya, Robert Harrison, Pat Hearn, Dan Hill, Charles Long, Sylvie Matthey, Dominique Noel, Thom O'Brien, Martha Swetzoff, Sokhi Wagner, Erich Winkler, Peter Zajonc, Zev; director of photography: Jack Walworth; crew: Shelly Silver, Witt Johnston

This project was made possible in part by a Finishing Fund Grant from the New York State Council on the Arts and the Media Bureau/the Kitchen

Ghost (I don't live today), 1985 (4 minutes)

Performer: Christian Marclay; camera: Tom Bowes

The Kitchen, New York, March 10, 1985

Dead Stories, 1986 (excerpt: 3 minutes)

Director: Christian Marclay; performers: René Gendre, David Garland, Shelley Hirsch, David Moss, Sheila Schonbrun, Susie Timmons (excerpt edited by John Lowe)

The Performing Garage, New York, March 22, 1986

Courtesy the Performing Garage, New York

One Hundred Turntable Orchestra, 1991 (excerpt: 3 minutes)

Director: Christian Marclay; performers: Nicolas Collins, Jazzy Joyce, Christian Marclay, Otomo Yoshihide; projections and lights: Perry Hoberman; camera: Numayama Yoshiaki (excerpt edited by Paul Smith)

Panasonic National Hall, Tokyo

Funded by Matsushita/Panasonic Corporation

Smash Hits, 1991 (5 minutes)

Performer: Christian Marclay; camera: Arleen Schloss (excerpt edited by S. Giuliano)

The Kitchen, New York, October 24, 1991

Courtesy the Kitchen, New York

Berlin Mix, 1993 (excerpt: 5:30 minutes)

Director: Christian Marclay; camera: Anita Mechthild; produced by Freunde Guter Musik Berlin and the DAAD/Deutscher Akademischer Austausch Dienst (excerpt edited by Paul Smith)

Les Sortilèges: Im Bann des Zaubers, 1996 (excerpt: 3 minutes)

Director: Christian Marclay; performers: Phillip Adams, Ruth Geiersberger, Armin Nagel, Brygida Ochaim, Lynn Parkerson, Klaus B. Wolf; music by Kalle Laar, Peer Quednau, Frank Schulte, G. Ess Zeitblom; assistant to the director: Birgit Wiens; video documentation: Reiner-Josef Klein (excerpt edited by John Lowe)

Bayerisches Staatsschauspiel/Marstall, Munich, April 26–30, 1996

Co-production Bayerisches Staatsschauspiel/ Marstall and the Kitchen, New York, with additional support from Siemens Kulturprogramma and Penta-Hotel, Munich

Mixed Reviews, 1999–2002 (excerpt: 3:20 minutes)

Performer: Mats Gustafsson; video documentation: Ulf Gertz; co-production: Ystad Konstmuseum & Kulturbro (excerpt edited by John Lowe)

Ystad Konstmuseum, Ystad, Sweden, 2002

Christian Marclay: Festival

ISSUE 3

Whitney Museum of American Art, New York

FROM THE CURATORS

PHOTOGRAPH © PAULA COURT

As we write this, *Christian Marclay: Festival* is drawing to a close. Looking back on our experience—both as curators and as viewers—we have been able to pinpoint a few distinguishing aspects of the exhibition, which helped to make it so successful. First, *Festival* was the longest-running improvised-and-experimental music event ever— a three-month marathon of almost nonstop concerts by dozens of musicians who performed hundreds of times. Second, performers and audience members spent an unprecedented amount of time together, sharing thoughts, ideas, and impressions, both before and after performances. Any fan of New York's music scene knows how difficult it is to meet musicians, much less converse with them. *Festival* encouraged such interaction, giving viewers an unusual opportunity to mingle with performers.

While the performances were central to the exhibition's success, the installation, too, bucked one's usual expectations of an art exhibition. Far from being static, the configuration of the space was constantly changing. Chairs were continually rear-ranged as audiences attempted to find the best vantage point from which to view a performance. Adjustable curtains were drawn to form predetermined modular stages. Two- and three-dimensional works were displayed in a side gallery that was similarly in flux; a small sign often informed viewers that certain works were removed for use in a performance. In essence, this side gallery became a walk-in music cabinet, hous-ing many of the scores that were performed within the main gallery space. Moving between the two areas—the performance space and the display space—one realized how smoothly Marclay's oeuvre integrates two seemingly distinctive realms of art: the aural and the visual. The performance of the scores was, after all, the focus and raison d'être for *Christian Marclay: Festival*. While previous exhibitions of Marclay's work have usually focused on the objects themselves, this exhibition took a markedly different tack, giving them over to the musicians for whom they were made. Scores were performed every day, and each performance was different. (Some of these per-formances were streamed live on the Whitney's website; viewers were encouraged to record concerts and upload photographs and videos to the Internet.) Such a multi-tude of experiences and approaches to Marclay's work was, in our view, the best way to do justice to the complexity and the clarity of his vision.

— David Kiehl, Curator, and Limor Tomer, Adjunct Curator for Performing Arts

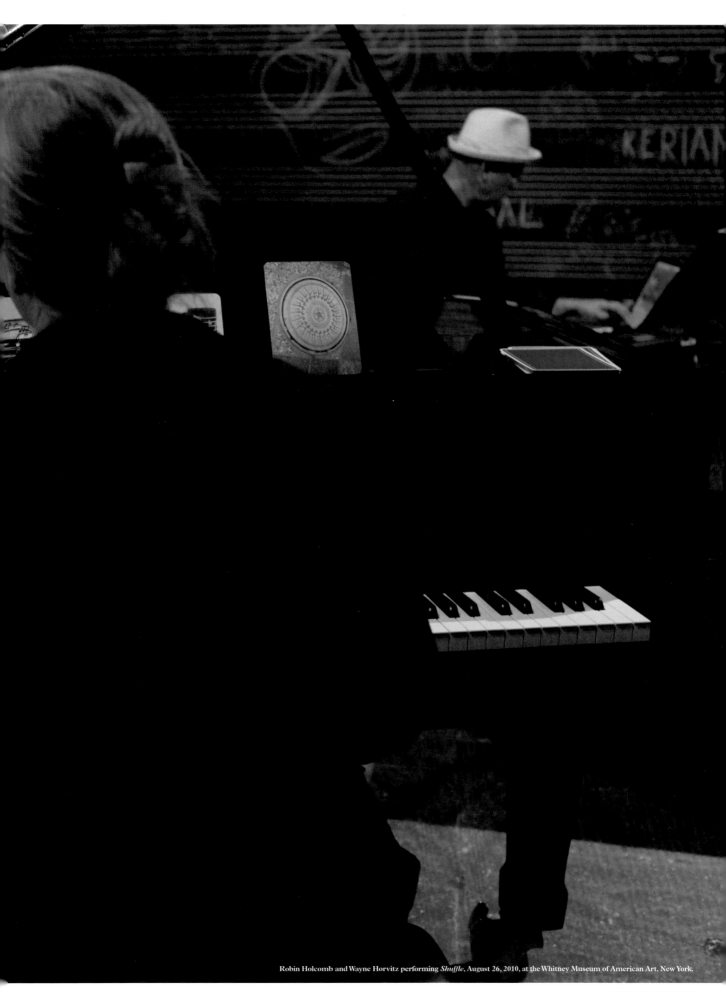

Robin Holcomb and Wayne Horvitz performing *Shuffle*, August 26, 2010, at the Whitney Museum of American Art, New York.

CONTENTS

Festival
Issue 3

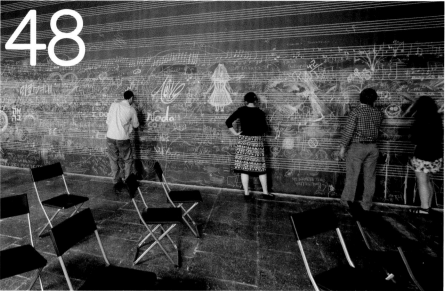

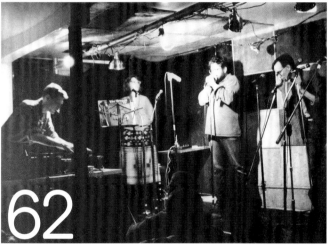

THE BREAKS

Christoph Cox

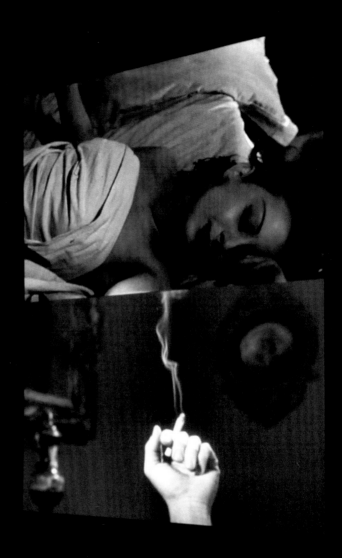

The Bell and the Glass, 2003. Installation view at the Whitney Museum of American Art, New York.

In the early 1920s, the artist-polymath László Moholy-Nagy published a pair of articles proposing novel uses for the phonograph.[1] In its nearly half-century of existence, Moholy-Nagy noted, the phonograph had thus far been used only as an apparatus of reproduction, a machine that played recorded music and speech. Yet it could readily be transformed into an apparatus of production, an instrument for making music, or what Moholy-Nagy more broadly termed "sound effects." The surface of the record, he suggested, could be hand-cut to generate "hitherto unknown sounds and tonal relations." Graphic designs might be laid into wax to create what he called a "groove-manuscript score." Such innovations, Moholy-Nagy thought, would allow the composer to avoid the detour of musical notation and its subsequent interpretation by musicians, and would instead reestablish a direct, amateur experimentation with sound.

It took decades for artists to begin following these suggestions and to realize what Moholy-Nagy had fundamentally grasped: that the advent of the phonograph marked a key turning point in the history of music and sound. Indeed, it was part of a fundamental shift in worldview manifested not only in music and art but also in philosophy, science, and beyond.

From his early experiments with records and turntables through his recent photographic, video, and graphic scores, Christian Marclay has placed himself at this musical and conceptual juncture and has richly explored its sonic and social repercussions. Marclay's work is always clever, direct, and accessible, making creative connections and drawing new possibilities from the detritus of mass culture. Yet it also offers a rigorous historical, conceptual, and material investigation into the history of audio recording and the fate of music and sound after the twilight of the musical work. Before highlighting some of Marclay's key interventions, I want briefly to rehearse this history.

* * *

Sound is a fluid and ephemeral substance that inherently resists efforts to capture it and to forestall its inevitable dissolution and passage. For most of human history, biological and communal memory were the only available mechanisms for the capture—the "recording"—of music.[2] While fundamentally traditional and aimed at the preservation of ancestral culture, folk forms of transmission inevitably involved variant repetition and minor innovations that were amplified and passed on, ensuring that the song had no fixed or singular identity but was always in flux. Likewise, this sonic flux was essentially anonymous, authored not by a creative individual but by the entire community and its lineage.

A second mode of sound recording, musical notation, was introduced to Europe in the late Middle Ages as a supplement to memory, an *aide-mémoire* for accomplished musicians faced with complex polyvocal music. With the rise of capitalism, the written score was enlisted as the means by which to reify and commodify the ephemeral material of music. No longer the fluid production of communal authorship, the musical work became a fixed entity that was the intellectual property of an individual composer. Once merely a supplement to the sonic flux of the song, the musical score came to be, for legal and economic purposes, the musical work itself. The musical work thus paradoxically became an inaudible, mute object; and musical attention was shifted from the ear to the eye. Requiring a new form of literacy, music became the province of a specialist class.

Folk music continued to operate via oral-aural transmission. In the art-music context, however, the musical score served as the dominant means of musical recording and transmission from the sixteenth century until well into the twentieth. It was the invention of the phonograph in 1877 that eventually challenged this hegemony of the visual score and inaugurated a new era. The phonograph record was able to diminish the distance between the visual score and its auditory performance. Where the score provided only a blueprint for skilled musicians to realize a musical work, the phonograph record could deliver actual performances and, to do so, required not a skilled performer but only a machine. Short-circuiting the literate culture of the score, the phonograph record could register performances of all sorts—operas and symphonies, but also folk songs and Tin Pan Alley numbers. Moreover, where the musical score was restricted to the recording of discrete pitches in a limited range, the phonograph could record and play back the entire audible universe.

An exchangeable container of music, the phonograph record intensified the reification of music that began with the score. Yet it also opened up the possibility of undoing this reification and restoring the essential fluidity of sound. As Moholy-Nagy suggested in the early 1920s, the phonograph was capable of becoming more than merely a technology of recording and representation. It could also become an instrument for musical composition and improvisation. In the '20s and '30s, composers such as Stefan Wolpe, Paul Hindemith, Ernst Toch, and John Cage experimented with phonograph recordings in compositions and performances.[3] But the use of recorded sound did not become a prominent compositional tool until 1948, when French radio engineer Pierre Schaeffer broadcast a set of "noise studies" built entirely from recordings—not only of musical instruments but of worldly sources such as pots, pans, and railroad trains. In the years that followed, Schaeffer's Paris studio became a hive of experimental musical activity, attracting a who's who of the European avant-garde.

It's not coincidental that, at precisely this historical moment, the musical score began to fragment and dissolve. The score for Karlheinz Stockhausen's *Klavierstück XI* (1956), for example, consists of a large sheet of paper displaying nineteen musical passages among which the performer is invited to move at random. Similarly, the first section of Pierre Boulez's

Third Sonata for Piano (1958) is a collection of ten pages that can be arranged in any order. More radical still is the score for Earle Brown's *December 1952* (1952), a white page sparsely sprinkled with an array of black bars of various lengths and widths. In his terse instructions, Brown remarks that the score can be read from any direction, performed by any instruments, and played for any length of time.[4]

December 1952 still looks vaguely like a traditional musical score, but one that has been largely erased. (It thus anticipates the *Erased De Kooning Drawing* produced by Brown's friend Robert Rauschenberg the following year.) Yet it also resembles the modernist drawings and paintings of Piet Mondrian and Paul Klee. These correspondences between visual art and the musical score were celebrated by the Polish-born composer Roman Haubenstock-Ramati, who suggested that any abstract picture could be treated as a musical score.[5] It was Haubenstock-Ramati who famously praised the pianist David Tudor for his astonishing ability to realize experimental scores, quipping that Tudor "could play the raisins in a slice of fruitcake."[6] The comment was made in jest; but it proved prescient, as Fluxus artists and other experimental composers began to treat all sorts of objects and events as provocations for sonic production.

Haubenstock-Ramati's own prodigious output of "graphic scores" is clearly indebted to the paintings of Vasily Kandinsky, whose canvases (many of them titled "Composition" or "Improvisation") aspired to the condition of music. Indeed, like many early modernist composers and painters, Kandinsky hoped that his paintings would approximate the neurological condition of synaesthesia, in which different sensory modalities merge to form a common experience. In the age of digital media and intensive neurological research, synaesthesia has once again become a frequent buzzword in the arts and sciences.[7] The graphic score, however, fundamentally resists this synaesthetic condition. Instead of merging the visual and the sonic, the graphic score pries them apart. Where the traditional musical score aims at a one-to-one correspondence between visual symbols and musical tones, the graphic score denies such correspondence. Hence, faithful performances of Brown's *December 1952*, Haubenstock-Ramati's *Batterie* (1969), or Cornelius Cardew's *Treatise* (1963–67), for example, generally bear no audible similarity to one another. With the graphic score, then, the visual and audible content of music diverge, becoming two parallel streams.

<center>* * *</center>

This experience of divergence is, indeed, a general characteristic of our contemporary intellectual condition, of which music is a microcosm.[8] The traditional musical score emerged alongside the classical physical theories of the sixteenth and seventeenth centuries, which construed the universe as a closed system governed by deterministic mechanical laws and set into operation by a transcendent

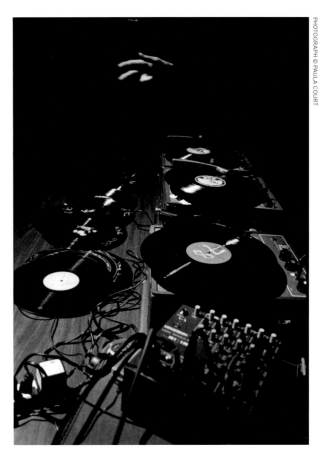

Performance of *djTRIO*, 1998, at the Whitney Museum of American Art at Philip Morris, New York.

Christian Marclay performing at the Metronome, Barcelona, May 1985.

Christian Marclay with Nicolas Collins, Perry Hoberman, Jazzy Joyce, and Otomo Yoshihide performing *One Hundred Turntables*, May 24–25, 1991, at Panasonic National Hall, Tokyo.

creator. From such an external position, the world was present all at once; and the experience of time was only an illusion experienced by immanent entities such as human beings, who were denied a God's-eye view of the whole. The classic musical score mirrors this physical structure. A fixed, bounded totality (the score) is produced by a creator outside of it (the composer) to be executed by musicians who faithfully carry out its predetermined program.

In the mid-nineteenth century, the dominance of deterministic physics was challenged by evolutionary biology, which denied the necessity of a transcendent creator and figured the world as an open system that was irreducibly temporal. Biological species were no longer taken to be fixed types produced in advance; rather, they were seen as the contingent products of countless historical events and processes that could not have been foreseen. In the biological domain, there is no identity. No two individuals are alike; and biological reproduction proceeds not by repetition or replication but by variation, mutation, differentiation, and divergence. For evolutionary biology, then, time is real, and past and future are asymmetrical.

The avant-garde and experimental music of the past half century has resolutely explored these temporal processes of difference and divergence. Indeterminate compositions and graphic scores were just the beginning. John Cage's employment of chance procedures shunned the ordinary musical "time-object" in favor of compositions that "imitated nature in her manner of operation," which meant following "a process essentially purposeless."[9] Iannis Xenakis modeled his musical compositions on stochastic processes such as "the collision of hail or rain with hard surfaces, or the song of cicadas in a summer field."[10] The "event scores" of Fluxus figures such as George Brecht, Yoko Ono, and La Monte Young simply provided provocative verbal prompts for action and could be realized in any number of ways. Ornette Coleman, Derek Bailey, and Musica Elettronica Viva inaugurated practices of free improvisation that dispensed with the score in favor of in-the-moment decision-making and responses to the sounds of fellow musicians.

Cage described as "experimental" "an action the outcome of which is not foreseen"[11]; and, indeed, so much experimental music simply provides a set of initial conditions from which performances then ramify and diverge. This is manifested quite literally in Steve Reich's early tape works *It's Gonna Rain* (1965) and *Come Out* (1966), in which two tape recorders playing the same vocal fragment gradually go out of phase, generating interlocking patterns of extraordinary complexity. So much computer-driven "generative music" celebrates the spontaneous eruption of emergent properties through feedback loops.[12] And DJ culture treats the whole history of recorded music as an archive of fragments to be endlessly sampled, mixed, and remixed. All these modes of music-making, then, affirm a fundamentally complex, open, temporal, and indeterminate world.

* * *

Christian Marclay's work richly references and extends this history. It affirms the historical rupture through which the musical score gave way to audio recording, and celebrates the temporal, conceptual, and sensory divergence that characterizes our contemporary condition. Marclay's first move was to activate the turntable and the record. Beginning in 1979, working independently from hip-hop DJs such as Kool Herc, Grandmaster Flash, and Grand Wizard Theodore who were undertaking similar experiments at the time, Marclay transformed the turntable into a musical instrument and treated the record not as a finished product to be passively consumed but as raw material for creative manipulation.

Like any commodity, a record is what Karl Marx called "dead labor," the congealed residue of human activity.[13] The ordinary commodity disavows or dissimulates this essence; but the phonograph record makes it peculiarly manifest. The sonic remains of past events and bodies no longer living are dug into its grooves, inscribed in a petroleum byproduct that materially consists of fossilized organic matter. The turntable momentarily revives these events and voices, but always retrospectively, as a remembrance of things past. A record collection, then, is a mausoleum that testifies both to the fixity and the fragility of the past. Within this context, Marclay's turntablism performs a temporal inversion. His "recycled records" (LPs cut into pieces and reassembled in new configurations) reorganize the linearity of auditory history; and his multi-turntable collages and improvisations cast the fixed past into an uncertain future.[14]

In 1985, Marclay embalmed a set of his own turntable performances on a commercial LP. This would have been a paradoxical and contradictory move, were it not for the disc's title, *Record Without a Cover*, and an instruction engraved on one of its sides: "Do not store in a protective package." Without such protection, the records would inevitably pick up scratches and attract dust and debris. What began as all-but-identical, mass-produced objects would slowly diverge from one another, becoming unique works of art via the accumulated traces of their singular and contingent trajectories. Marclay thus submitted the prefab world of Andy Warhol's Campbell's Soup cans to Steve Reich's tape-phase procedure, allowing time, chance, and the vicissitudes of commodity circulation to "improvise," adding sonic material to his own and producing results that he could not have foreseen in advance.[15]

A more recent project, *Mixed Reviews* (1999–2010), also celebrates this divergence, in this case via metaphorical leaps across the gaps that separate sound, text, and image. Vivid and bombastic sentences pulled from music reviews—efforts to translate musical experience into language—are strung together to form a horizontal wall text that cuts across the exhibition space. Each installation of the piece translates the text into the local language, increasing the distance between musical referent and linguistic sign. In a video version, *Mixed Reviews (American Sign Language)* (2001), a deaf actor

11

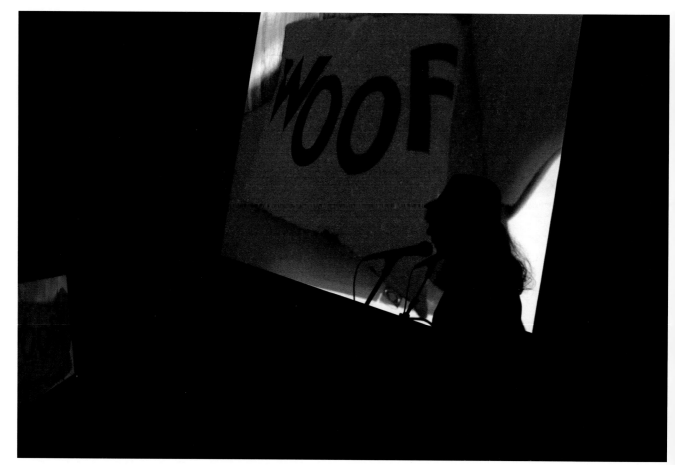

Shelley Hirsch performing *Zoom Zoom*, July 17, 2010, at the Whitney Museum of American Art, New York.

renders the text as a flow of wildly expressive bodily gestures. The circuitous course of translation—from sound to texts in multiple languages to gestural signs on video—operates like the game of "telephone," insuring that the output will diverge substantially from the input. Even so, the text fires the aural imagination, provoking a silent experience that is nonetheless intensely musical. The video is likewise silent; but the actor's hands, arms, and face powerfully capture the physicality of sound, the waves and forces it releases and their social trajectories.

These projects are not evidence of some nostalgia for lost unity, nor are they commentaries on the incapacities or disabilities of various media. Rather, they are testaments to the generative powers of difference and translation. Forestalling the stultifying collapse of the senses and media into identity or unity and the conformist fantasy of perfect correspondence, they celebrate ingenious leaps between sensory modalities and media that produce genuine novelty. Perfect replication, we know from biology, would be a recipe for death and extinction. Life and creativity thrive on mutation, variation, and divergence.

* * *

Such leaps and divergences are actively cultivated by the series of photographic and video scores Marclay has produced over the past fifteen years. *Graffiti Composition* (1996) and *Shuffle* (2007), for example, are decks of photographs to be used as musical scores. Where the earlier piece documents anonymous scribbles on blank score sheets, *Shuffle* collects fragments of conventional musical notation from street signs, clothing, awnings, umbrellas, tattoos, and bric-a-brac of all sorts. They may be intended as mere decoration, signifiers of "music" in general, but Marclay takes these found objects seriously. The collection as a whole combines the Duchampian readymade with Stockhausen's *Klavierstück XI* to create a musical score of endless permutation. As in *Graffiti Composition*, anonymity plays a key role here, though in *Shuffle* it's the anonymity of a vast cadre of designers who go unnamed and uncredited in the visual culture of modern life. Marclay's photographs, then, are form of sampling—not of musical sound, oddly, but of its visual representation. Photography and phonography approach one another and generate sparks across the divide.

Closely linked with these projects are two others, *Zoom Zoom* (2008) and *Manga Scroll* (2010), both of which employ onomatopoeia, that curious effort of language to imitate worldly sounds. Onomatopoeia attempts to circumvent the

semantic content (the signified) that generally stands between the signifier and its referent—an effort by the word not just to *represent* the referent but to *be* it. Yet onomatopoeias turn out to be conventional signs, not natural ones, and, moreover, signs that are culturally specific. (We say "chirp"; the Spaniard says "pio." We say "cock-a-doodle-do"; the Italian says "chicchirichi.") What's more, Marclay's onomatopoeias are textual and visual, not spoken or sonic: *Zoom Zoom* is a photographic compendium of onomatopoeias found on banners, trucks, champagne bottles, candy wrappers, and elsewhere; *Manga Scroll* is a string of onomatopoeias lifted from English versions of Japanese comic books. Composed for a solo vocalist, both pieces ask the performer to undertake a roundabout translation: not to imitate sounds but to use their voices to re-sonify graphisms that vainly attempt to mimic the noises of the world. This proliferation of translations and leaps across various domains becomes dizzying when we consider that *Manga Scroll* pays tribute to composer-vocalist Cathy Berberian's *Stripsody* (1966), which itself alludes to *Blam* (1962), *Whaam!* (1963), and other early paintings by Roy Lichtenstein—making Marclay's piece a deferred and circuitous response to Haubenstock-Ramati's suggestion that any painting might be treated as a graphic score.

Beginning with the early turntable compositions and improvisations, Marclay's work has always followed the logic of sampling and the remix, generating new material from old, insisting that every work is a remix that is itself perpetually open to remixing. Marclay's visual scores intensify this trajectory. In the case of these works, remixing takes place not merely in a single medium—from records to records, films to films—but across media—from photographs and films to musical performances. Furthermore, like any graphic score, they are structurally incomplete. As Umberto Eco put it in an early essay on musical indeterminacy, "they are quite literally 'unfinished': the author seems to hand them on to the performer more or less like components of a construction kit."[16]

Screen Play (2005) provides a rich example. A thirty-minute montage of short clips from black-and-white films (home movies, adventure films, westerns, documentaries, educational films, etc.) periodically overlaid with simple graphic elements (colored lines, dots, staves, and wipes), *Screen Play* begins with the basic instruction: "To be interpreted by a small group of musicians." But how to interpret the score? The intermittent overlay of musical staves and visual metonymies suggests that the video might be read purely formally, the placement and movement of objects on the screen taken as indications of pitch, duration, or rhythm. Yet the abundant visual cues of sonic events (crashing waves, footsteps, fireworks, and the like) seem to direct performers to become foley artists whose aim is to supply the missing audio. More loosely, performers might simply compose or improvise a soundtrack, following the general movement and mood of the visual flow. Any or

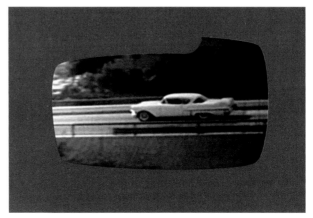

Stills from *Screen Play*, 2005. Single-channel video projection, black and white with color, silent; 29 min.

all of these strategies is possible; and, in order to amplify differences among them, Marclay generally programs three different ensembles to play the score on any given occasion. Each time, the film is given a different soundtrack, which, in turn, produces a different film.[17]

* * *

All these elements and interests come together in Marclay's masterpiece, *The Bell and the Glass* (2003). At once a stand-alone work of art and a visual score, this double-screen video projection presents the unlikely conjunction of two objects: the Liberty Bell and Marcel Duchamp's *Large Glass (The Bride Stripped Bare By Her Bachelors, Even)*. The two screens function like the turntablist's two decks, mechanisms through which fragments of all sorts are drawn into a mix. Discs, spirals, rotating drums, pulsing dots, and phonographs appear on both screens throughout the video, references no doubt to the rotating objects and devices in the lower ("bachelor's") section of the *Large Glass*, but also visual allusions to Marclay's turntablist practice, which he launched in the late 1970s in a band with the Duchampian name: The Bachelors, even.

Arranged vertically, the two screens in *The Bell and the Glass* also operate as the symmetrical staves of the traditional musical score: the lower ("bachelor's") half functioning as the bass clef, and the upper ("bride's") half as the treble. Instances of musical notation (three interviews with Duchamp that Marclay transcribed into staff notation; Duchamp's chance composition *Erratum Musical*; and a collection of songs celebrating the Liberty Bell) appear throughout the video in the manner of *Shuffle*, as found musical material to be read by musicians. Indeed, the entire video is conceived as a graphic score, all its visual elements (images, texts, score fragments, etc.) aimed at provoking musical accompaniment to the video's existing sonic elements (Duchamp's voice; the ringing of souvenir Liberty Bells; overlaid string passages, etc.).

In two interview fragments that recur throughout the video, Duchamp gleefully refers to "the breaks" in the *Large Glass*, the cracks caused in 1926 when the work was damaged during transport. Marclay keys in on this phrase, which becomes an organizing figure of his video, referring not only to the *Glass*, but also to the crack in the Liberty Bell that rendered it at once iconic and mute. More broadly, "the breaks" signifies the connection and disconnection between these two objects, the conjunction and disjunction between the visual and the sonic, and, by extension, between the visual cuts of cinematic montage and the auditory cuts of the turntablist's art, which—from disco, dub, and hip-hop through drum 'n' bass and dubstep—has largely consisted in isolating and extending what DJs call "the breaks" or "breakbeats," those sections of funk and rock songs during which the

melody instruments drop out and the bass and drums come to the fore.

"The break," then, is the cut, line, or bar that both conjoins and disjoins the two terms of an opposition: bride and bachelor, bell and glass, sound and image, phonography and photography, mass culture and high art, staff notation and graphic score. It is also, for Duchamp and Marclay alike, the caesura between past and future, between what the artist puts into the work and its indeterminate destiny. Reflecting on the accidental cracks in the *Glass*, Duchamp remarks, "I like the breaks [. . . .] There's almost an intention there [. . .], a curious intention that I'm not responsible for, a readymade intention, in other words, that I respect and love." For it is his principle, he says elsewhere in the video, "to accept any *malheur* as it comes." This openness to chance, accident, and any eventuality whatsoever defines the work of Duchamp and Cage, a lineage that Marclay makes his own. From his turntablist practice through his graphic scores, Marclay takes the readymade object as raw material for the generation of new work and affirms this fate of his own work as well, acknowledging that nothing remains fixed, that the future will always diverge from the past, and that, well, those are the breaks.

Christoph Cox is Professor of Philosophy at Hampshire College and a faculty member at the Center for Curatorial Studies, Bard College.

ENDNOTES

1 László Moholy-Nagy, "Production–Reproduction" (1922) and "New Form in Music: Potentialities of the Phonograph" (1923), *Moholy-Nagy*, ed. Krisztina Passuth (London: Thames & Hudson, 1985), pp. 289–90, 291–92. Excerpted in *Audio Culture: Readings in Modern Music*, ed. Christoph Cox and Daniel Warner (New York: Continuum, 2004), pp. 331–33.
2 My capsule history of audio recording draws substantially from Chris Cutler's helpful essay "Necessity and Choice in Musical Forms," *File Under Popular: Theoretical and Critical Writings on Music* (New York: Autonomedia, 1993), pp. 20–38.
3 The history of these experiments is helpfully chronicled in Cutler's "Plunderphonia," *Audio Culture*, pp. 138-56.
4 Earle Brown, *Folio (1952–3) and 4 Systems* (1954) (New York: Associated Music Publishers, 1961).
5 Roman Haubenstock-Ramati, "Music and Abstract Art: Remarks on 'Constellations'" (1971), *Konstellationen* (Vienna: Galerie Ariadne, no date).
6 Quoted in John Holzaepfel, liner notes to *David Tudor and Gordon Mumma* (New World Records, 200?)
7 See my "Lost in Translation: Sound in the Discourse of Synaesthesia," *Artforum* (October 2005): 236–4?
8 For different but related accounts of this correspondence between music and science, see Umberto Eco "Poetics of the Open Work" (1959), *The Open Work*, trans. Anna Cancogni (Cambridge, MA: Harvard University Press, 1989), pp. 1–23, and Brian Eno, "Generating and Organizing Variety in the Arts," *Studio International* (Nov./Dec. 1976): 279-83. Both essays are reprinted in *Audio Culture*. My scientific account is also indebted to Ilya Prigogine and Isabelle Stengers' *Order Out of Chaos* (New York: Bantam Books, 1984) and Prigogine's *The End of Certainty* (New York: The Free Press, 1997).
9 See Cage, "Composition as Process: Indeterminacy," in *Silence: Lectures and Writings by John Cage* (Hanover, NH: Wesleyan University Press, University Press of New England, 1961), pp. 35–40, and the introduction to *Themes & Variations* (Barrytown, NY: Station Hill Press, 1982), both reprinted in *Audio Culture*.
10 Iannis Xenakis, *Formalized Music: Thought and Mathematics in Composition* (Bloomington: Indiana University Press, 1971), p. 9.
11 Cage, "History of Experimental Music in the United States," *Silence*, p. 69.
12 For a helpful overview, see David Toop, "The Generation Game: Experimental Music and Digital Culture," *Audio Culture*, pp. 239–47.
13 Karl Marx, *Capital*, Volume 1, trans. Ernest Mandel (New York: Penguin, 1990), 322, 342, and passim.
14 "[R]ecorded sound is dead sound, in the sense that it's not 'live' anymore," Marclay once told an interviewer. "The music is embalmed. I'm trying to bring it back to life through my art." Quoted in *Audio Culture*, p. 327.
15 For an exhibition at Exit Art in 2001, Marclay produced a companion piece to *Record Without a Cover* a wall grid of 200 record covers, all copies of Herb Alpert's *Whipped Cream and Other Delights*. Another variation on Warhol, the display revealed not only production differences among the various copies but also differences due to wear and tear. See Christian Marclay, "The Inner Sleeve," *The Wire* 308 (October 2009): 77.
16 Eco, "Poetics of the Open Work," p. 4.
17 See "Conversation Between Christian Marclay and David Toop," *Arcana III: Musicians on Music*, ed. John Zorn (New York: Hip's Road, 2008), p. 144.

THE BREAKS

Marcel Duchamp lecturing at City Art Museum, St. Louis, 1964.

15

The Breaks, 2003. One of three scores from *The Bell and the Glass*, published in *The Bell and the Glass* (Philadelphia: Philadelphia Museum of Art/ Relâche, 2003).

SCREEN
PLAY

Noam M. Elcott

Marina Rosenfeld performing *Screen Play*, July 1, 2010, at the Whitney Museum of American Art, New York.

18

Still from *Screen Play*, 2005. Single-channel video projection, black and white with color, silent; 29 min.

Elliott Sharp performing *Screen Play*, July 3, 2010, at the Whitney Museum of American Art, New York.

Christian Marclay's *Screen Play* (2005) opens with a close-up of a watch. At the moment the second hand strikes the top of the minute, the video cuts to a boy turning off the light and going to sleep. An animated blue line travels from left to right atop the black-and-white found footage. The camera zooms in on the child's sleeping face, followed by a long dissolve to toy boats rocking in the water, and the rigid blue line becomes wavy. With a quick cut to a rowboat breaking through the waves, the amplitude of the wavy blue line increases. This is followed by rapid cuts between the toy boats and the rowboat in rough seas. We appear to have entered the boy's dream space—a realm perfectly suited to the media of film and video. Within a few minutes, however, it becomes clear that the sequence of images is not driven by a dream's logic but by pure visual analogy. A spinning ballerina becomes a spinning phonograph becomes a spinning fairground centrifuge becomes a spinning tire and so on. Ballerinas and tires have little in common except for their capacity to spin. Indeed, some of the objects in the sequence are unidentifiable. But so long as they spin, their precise designation is of no consequence. Visual analogy, rather than narrative, carries the action forward. A later sequence depicts a snowball on its way to becoming a snowman, a slowly rotating globe, a disco ball, a bowling ball rolling down the lane. At this moment, visual analogy opens onto the second driving logic of the piece, namely, false continuity: A woman reaches down, lifts the bowling ball off the track, and, through a lovely cut, becomes a theater actress lifting a balloon that is released (again through false continuity editing) into the atmosphere, only to become a soccer ball headed by an amateur player, which is then transformed back into a balloon before setting into the ocean as a giant solar ball of fire. What is at stake in these visual analogies and false continuities?

A quick comparison with a historical avant-garde precedent is illuminating. Artist-filmmaker Hans Richter led the short-lived abstract film movement in Germany in the mid-1920s. By the end of the decade, he considered abstract or "absolute" film dead and made *Two Pence Magic*, an advertising short that—similar to *Screen Play*—follows the laws of visual analogy and false continuity: The moon becomes a bald head; a trapped thief's raised arms become the arms of a young diver, who, in a majestic leap, becomes an airplane, and so on. The final moving image is of a masked woman climbing a rope on her way to burglar a house. Scissors invade the frame and nearly cut the rope—at which point the moving image turns into a still photograph. The next shot reveals the hands of a photo editor cutting out the photograph of the now unmasked woman from a magazine. As her identity is revealed, so too the logic of the film: The images are all taken from the pages of the *Kölnische Ilustriete Zeitung*, an illustrated magazine. The "logic" of the analogies and continuities is dictated by the sequence of photographs in an issue of the *Cologne Illustrated Newspaper*.

Richter's advertising film embodies Siegfried Kracauer's nearly contemporaneous insight: "In the illustrated magazine

PHOTOGRAPH © PAULA COURT

19

Marina Rosenfeld performing *Screen Play*, July 1, 2010, at the Whitney Museum of American Art, New York.

PHOTOGRAPH © PAULA COURT

Elliott Sharp performing *Screen Play*, July 3, 2010, at the Whitney Museum of American Art, New York.

the world has become a photographable present, and the photographed present has been entirely eternalized."[1] The bald man, thief, diver, and burglar all occupy an eternal present seemingly freed from the clutches of time and death.

Where Richter's film allows photographs to circulate in the eternal present of modern mass media, Marclay's video insists on the historical embeddedness of all its found film footage. The markers of time are everywhere: The variable quality of the various film sequences; the insistence on black-and-white footage coupled with color animation (squares, circles, and lines not dissimilar to those forms conjured by the absolute film movement); even the canonical shots from Fritz Lang's *Metropolis* (1927) or Buster Keaton's *Cops* (1922) feel more like historical artifacts than timeless Hollywood treasures. What is more, where Richter's advertisement ends with a dénouement, Marclay's piece just ends—there is no secret logic orchestrating the work; there is no product to purchase. Richter's film is motivated by the frenzy of illustrated magazines; Marclay's video dreams the delirium of archival fever.

And yet *Screen Play* refuses to lose itself in the labyrinth of the archive. The visual work is but a video score to be interpreted live by musicians. The historical plunder must be renewed or rejected in the present of performance. Sound, too, is a very powerful tool for false continuity. It is, as Marclay has said, the glue that can give the illusion of flow between unrelated fragments of action. And it is performance—rather than archival footage—that gets the last word. On Saturday, July 17, 2010, Alan Licht, Lee Ranaldo, John Butcher, and Ned Rothenberg played Marclay's *Screen Play* live at the Whitney. It was one of several interpretations of the work in this exhibition alone. The interpretation hovered between two poles: On the one hand, film music to accompany the images and, on the other hand, free music inspired by the images on screen. In the hands of Licht, Ranaldo, Butcher, and Rothenberg, Theodor Adorno's strict division between absolute and program music is voided. Sound and image, music and video move freely between abstraction and representation. At times, the music echoes the video, representing sonically what is depicted visually; at other times, it frees itself from the image, transforming the video into a visual score for independent musical interpretation. It is a world nearly devoid of hierarchy or divisions, actualized only in the act of performance.

Noam M. Elcott is assistant professor of modern art and media history at Columbia University.

ENDNOTE

1 Siegfried Kracauer, "Photography," in *The Mass Ornament*, ed. Thomas Y. Levin (Cambridge, MA: Harvard University Press, 1995), p. 59.

Marina Rosenfeld performing *Screen Play*, July 1, 2010, at the Whitney Museum of American Art, New York.

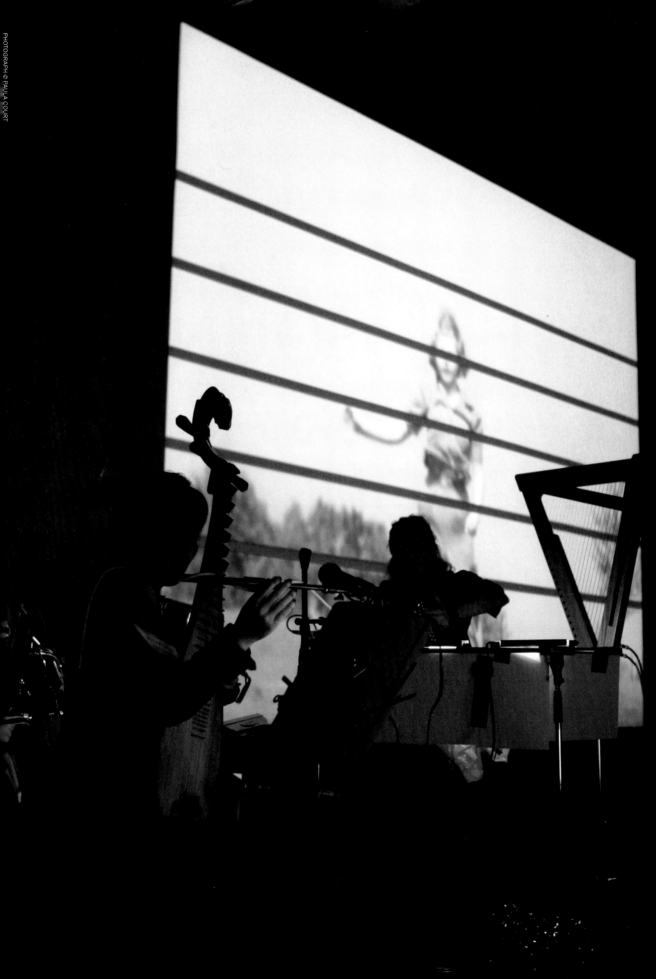

Min Xiao-Fen and Zeena Parkins performing *Screen Play*, November 11, 2005, at Eyebeam, New York. Co-presented by Eyebeam and Performa for *Performa 05*.

WHAT SOUND DOES A CONDUCTOR MAKE?

Alan Licht

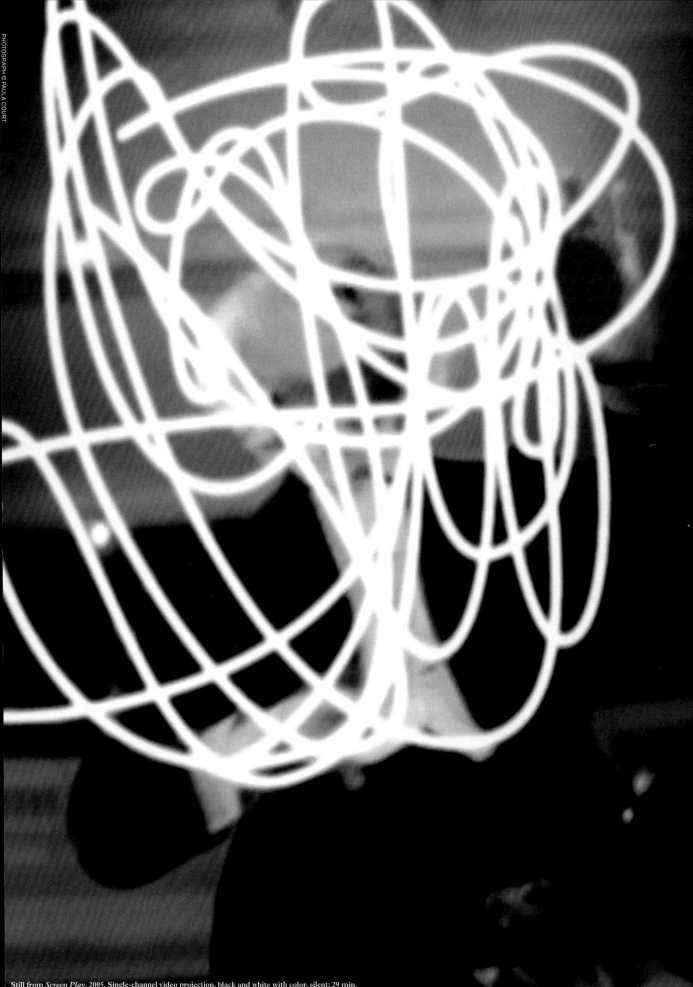

Still from *Screen Play,* 2005. Single-channel video projection, black and white with color, silent; 29 min.

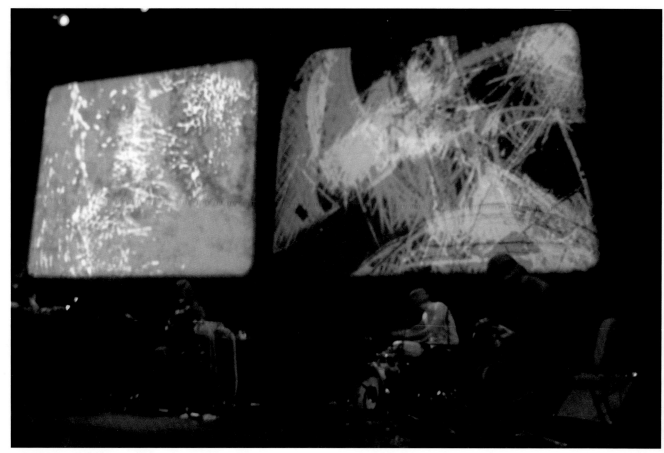

Text of Light performing at the 2005 Rotterdam Film Festival, the Netherlands.

Accidental synchronicities between sound and film are central to the aesthetic of Text of Light, the music-improvisation group formed by Lee Ranaldo and me in 2001, in which Christian Marclay has frequently participated as a turntablist. Conceived as a mixed media, real-time collage, and an exercise in synaesthesia, Text of Light improvises music in conjunction with screenings of abstract experimental films, often those by Stan Brakhage. However, the films are not used as a score or prompt for the musicians (in fact, the performers rarely look at the screen), nor do we consider the music to be a soundtrack to the film. So when Text of Light was invited (as a trio consisting of Ranaldo, Ulrich Krieger, and me) to perform Marclay's video score *Screen Play* (2005) on July 2 and 3, 2010, during the exhibition *Christian Marclay: Festival*, we had to leave our aleatoric approach behind, since *Screen Play* falls into the tradition of graphic scores by providing structural directions, visual stimuli, and, to an extent, pitch specifications (represented by animated staff lines, among other signals) to musicians.

Screen Play consists of clips from old black-and-white stock footage and feature films overlaid with colorful dots and lines meant to be associated with traditional musical notation. Players must respond to movement and shapes, taking into consideration relationships formed onscreen between the lines and dots and the film clips, as well as the tempos of

film montage. The footage presents all manner of activity—things or people spinning, falling, breaking apart, swaying, or traveling (via cars, boats, horses), not to mention actors' physiognomy and the four elements, particularly water and fire. Text of Light is usually unfamiliar with the films we play with, but we viewed *Screen Play* many times prior to the Whitney performances, separately mapping out several sonic areas and extended techniques to delve into for the five different sections (each cued by a close-up of an eye closing and opening).

Unlike the pre-existing films that are shown in their complete form in the context of Text of Light, in *Screen Play*, and the earlier video score *The Bell and the Glass* (2003), the video is a construction from various appropriated sources. Records and films are, for Marclay, found objects to be excerpted and manipulated in any number of ways. Marclay's video scores, then, bear a direct relationship to his music, as exemplified by *Records 1981–1989* [released 1997], a collection of sundry recordings made with snatches of sound from multiple old, scratchy records. There is also a correlation between the film montages and his *Recycled Records* from the early 1980s, which consists of shards of different records glued together to make one 12-inch record. Cracked surfaces are a focal point of *The Bell and the Glass*, whose subjects are Marcel Duchamp's *Large Glass (The Bride Stripped Bare By Her Bachelors, Even)* (1923) and the Liberty Bell, both

PHOTOGRAPH BY CARLOS VAN HIJFTE

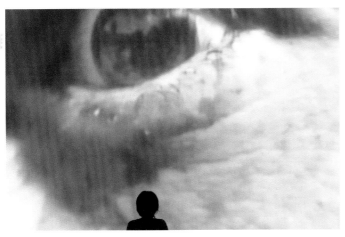

Marina Rosenfeld performing *Screen Play*, July 1, 2010, at the Whitney Museum of American Art, New York.

Still from *Screen Play*, 2005. Single-channel video projection, black and white with color, silent; 29 min.

26

Stills from *The Bell and the Glass*, 2003. Two synchronized video projection loops, color and black and white, with sound; 22 min.

on permanent display in Philadelphia. Among the extracts of interviews with Duchamp on the video's soundtrack are his comments on how much he likes the "breaks" and "the cracks" in the *Large Glass*—surely as much as Marclay likes the scratches in his records. Duchamp has spoken elsewhere of the ever-changing background afforded by the use of glass in his piece[1]; likewise, Marclay's *Record Without a Cover* (1985) alters with every playing because of newly accumulated nicks and scratches.

As a score, *The Bell and the Glass* calls for musicians not only to improvise, but to play fragments of antiquated songs written in honor of the Liberty Bell[2], and to play notated transcriptions of Duchamp's voice. The video can be screened on its own as a freestanding piece, but with the implication that it needs musicians to be completed (as any score would)—a partiality shared by the souvenir jigsaw puzzles of both the Liberty Bell and the *Large Glass* shown in the video. During *Festival* it was intriguing to see visitors sit down and watch both *The Bell and the Glass* and *Screen Play* without any musical accompaniment, perhaps oblivious to the fact that they were missing an audio component. This is ironic given Marclay's own observation that "we tend to think of music as this sightless thing because recordings have distorted our understanding of music,"[3] and the fact that we *do* generally expect moving pictures to have a soundtrack.

The visual representations of sound, and the separation and rejoining of sound and image, have always been themes of Marclay's work. Part of his original intention behind bringing turntables onstage was to show audiences how the music was being made (in his early performance duo—The Bachelors, even—he initially used cassette tapes of records skipping). Once his turntable work was integrated into group improvisations, it always had a strong effect on the musicians he was playing with, by instigating dialogues not only between themselves but with a '40s big band or a church organ that could be summoned at the drop of a needle. When making his video scores, Marclay the film editor now elicits a similar energy as musicians are asked to react to rapid cuts of old film clips shorn of their original soundtracks, though it must be said that in my experience, hearing Marclay cue up an orchestral recording onstage with Text of Light provoked a different musical response than seeing the image of a conductor at the podium in *Screen Play*. Such encounters are indicative of the sensations at work in Marclay's interactions with musicians both as a fellow performer and a visual artist, and their phenomenological divergence underlines the audiovisual disjunctions that are so integral to Marclay's practice.

Alan Licht is a musician, writer, and curator based in New York.

ENDNOTES

1 Uncredited filmed interview incorporated in TV documentary *The Shock of the New Episode 1: The Mechanical Paradise* (1982, directed by David Richardson for the BBC) accessed at http://www.youtub com/watch?v=lmag4vL7hnQ.

2 "Liberty Bell (It's Time to Ring Again)" (1917), "You're a Grand Old Bell" (1909), "Liberty Bell, Ring On" (1918), and John Philip Sousa's "The Liberty Bell March" (1893).

3 Conversation with the author, January 2, 2003. Quoted in Alan Licht, "CBGB as Imaginary Landscape: Th Music of Christian Marclay," in *Christian Marclay* (Los Angeles: UCLA Hammer Museum, 2003), p. 97.

I DIDN'T CARE

Marcel Duchamp interviewed by Richard Hamilton, London 1959.

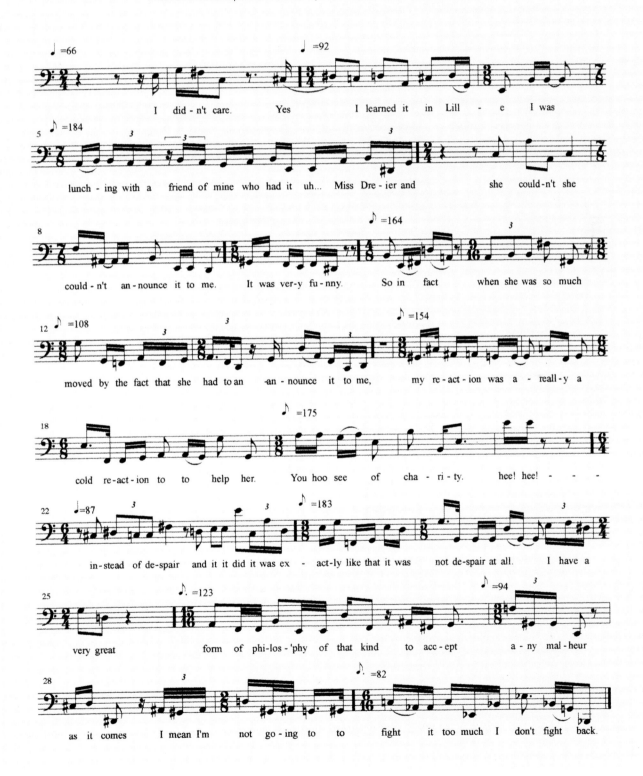

27

I Didn't Care, 2003. One of three scores from *The Bell and the Glass*, published in *The Bell and the Glass* (Philadelphia: Philadelphia Museum of Art/ Relâche, 2003).

THE BELL AND THE GLASS

Marclay's first "video score" was inspired by the Liberty Bell and Marcel Duchamp's *The Bride Stripped Bare By Her Bachelors, Even (The Large Glass)*. These two icons never had anything to do with one another until Marclay found surprising and often humorous affinities between them, aside from both being cracked and situated in Philadelphia.

The Bell and the Glass was originally presented at the Philadelphia Museum of Art as an installation with several components: a looped video projection; three traditional scores based on Duchamp's voice, which was transcribed into notes following the modulation of his speech; an installation of objects culled from the Philadelphia Museum of Art and other local institutions, as well as from the artist's own collection; and occasional performances by the Relâche Ensemble, a contemporary music group based in Philadelphia.

A minimum of two musicians are prompted to respond freely to the two screens, but come together in unison to accompany Duchamp's voice.

Additional sounds by Okkyung Lee (cello) and Miguel Frasconi (glass).

The Bell and the Glass was commissioned in 2003 by Relâche, Inc. under the Future Sounds commission series as Future Sounds 5: Visible Audio, and by the Philadelphia Museum of Art as Museum Studies 7, part of an ongoing series of projects created by contemporary artists.

Bell and the Glass, 2003. Installation view at the Whitney Museum of American Art, New York.

Guy Klucevsek performing *The Bell and the Glass*, September 3, 2010, at the Whitney Museum of American Art, New York.

Guy Klucevsek and Peter Evans (left to right) performing *The Bell and the Glass*, September 3, 2010, at the Whitney Museum of American Art, New York.

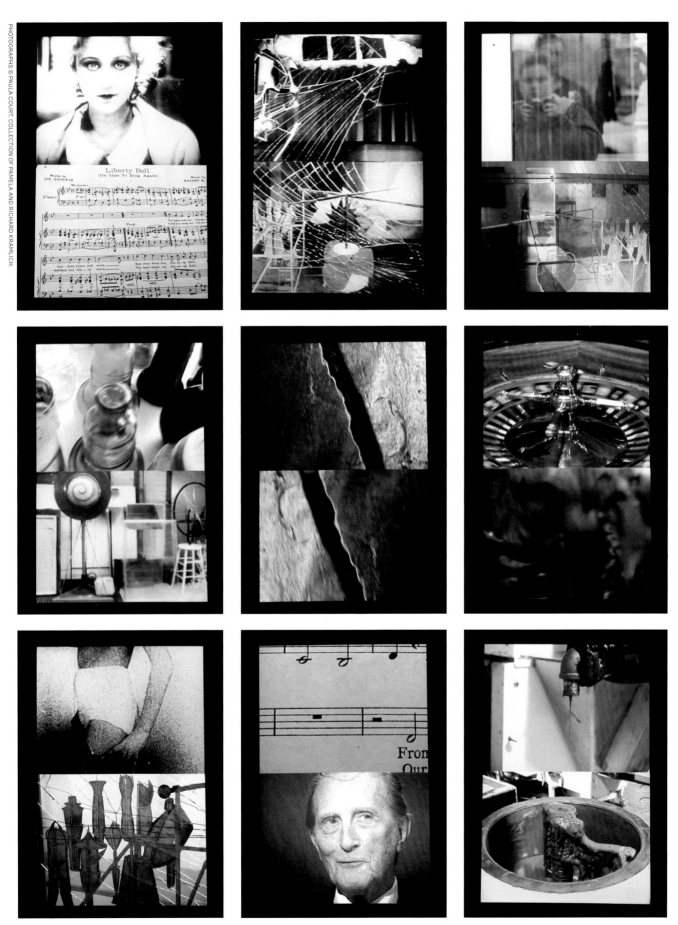

Stills from *The Bell and the Glass*, 2003. Two synchronized video projection loops, color and black and white, with sound; 22 min.

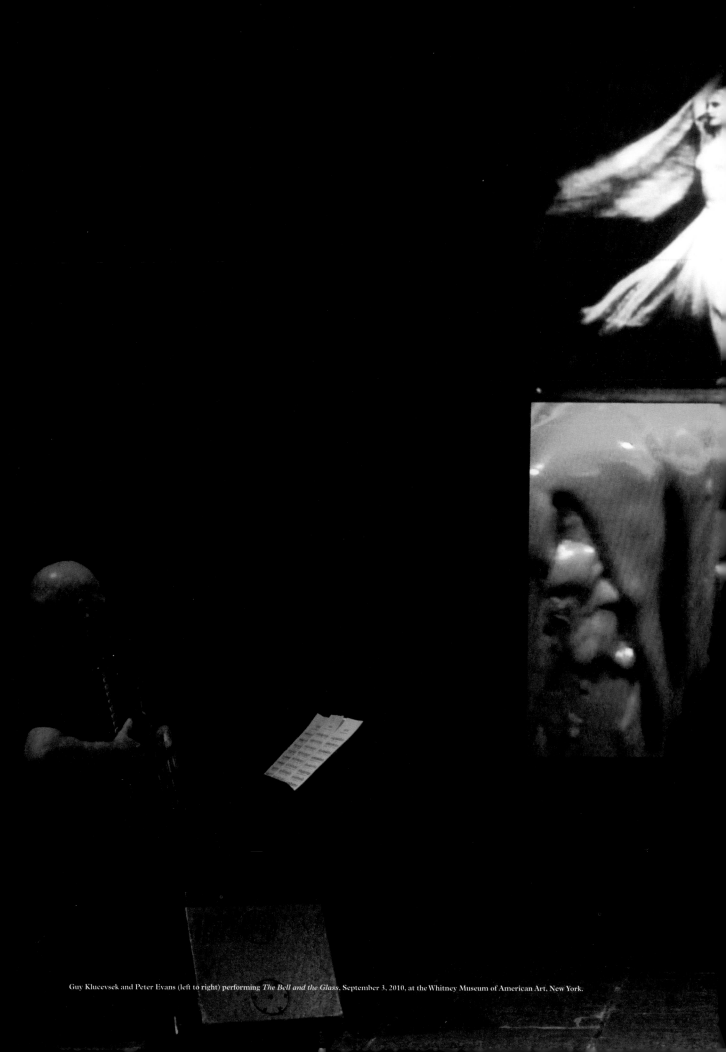

Guy Klucevsek and Peter Evans (left to right) performing *The Bell and the Glass*, September 3, 2010, at the Whitney Museum of American Art, New York.

PHOTOGRAPH © PAULA COURT

ZOOM ZOOM

Zoom Zoom is a slideshow of Marclay's photographs of onomatopoeias that were found primarily on signs, advertising, and product packaging. During a performance with vocal performer Shelley Hirsch, for whom this piece was created in 2008, Marclay selects images to trigger her vocal improvisation and presents her with new images in an ongoing call and response.

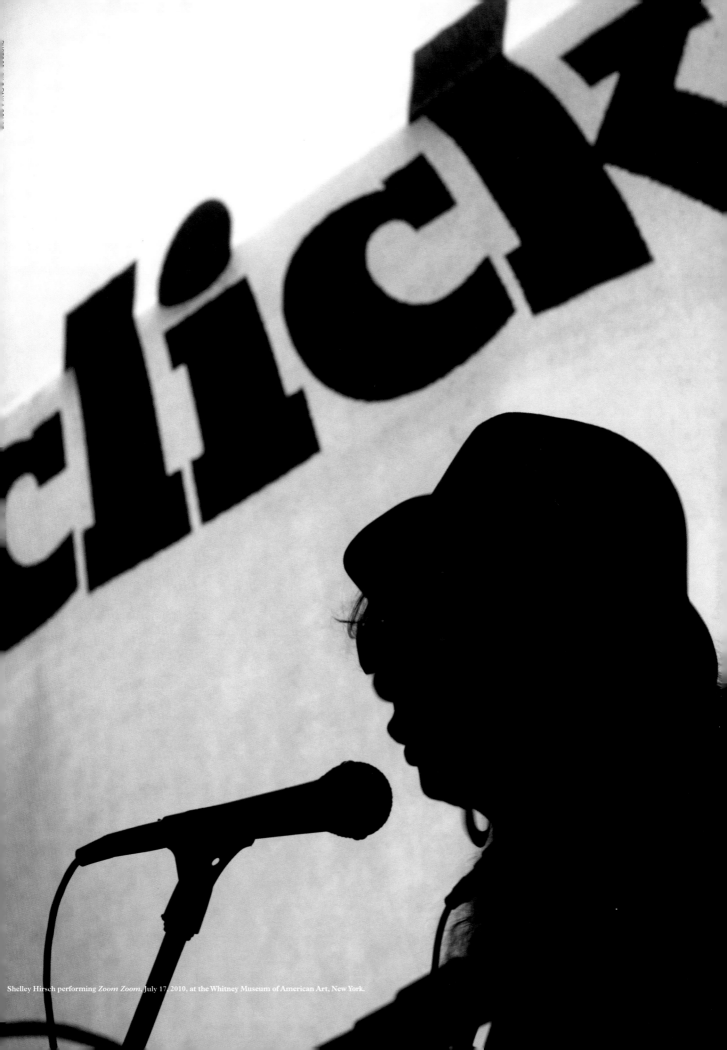

Shelley Hirsch performing *Zoom Zoom*, July 17, 2010, at the Whitney Museum of American Art, New York.

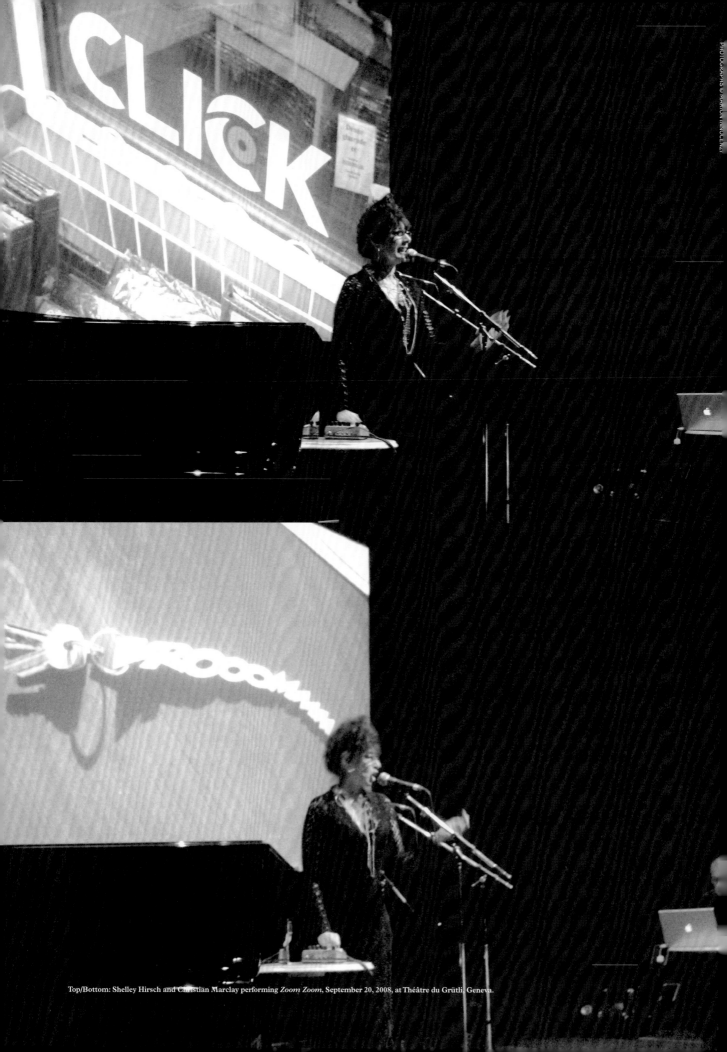

Top/Bottom: Shelley Hirsch and Christian Marclay performing *Zoom Zoom*, September 20, 2008, at Théâtre du Grütli, Geneva.

37

Stills from *Zoom Zoom*, 2007–2009. Slide projection of 150 digital color photographs, silent; duration variable.

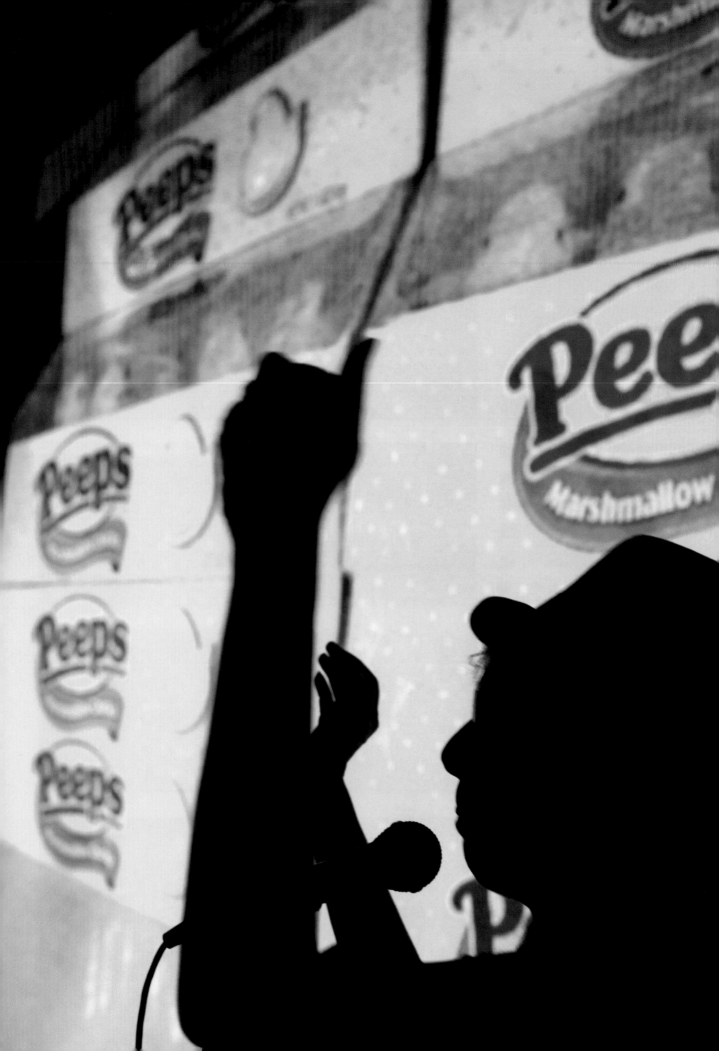

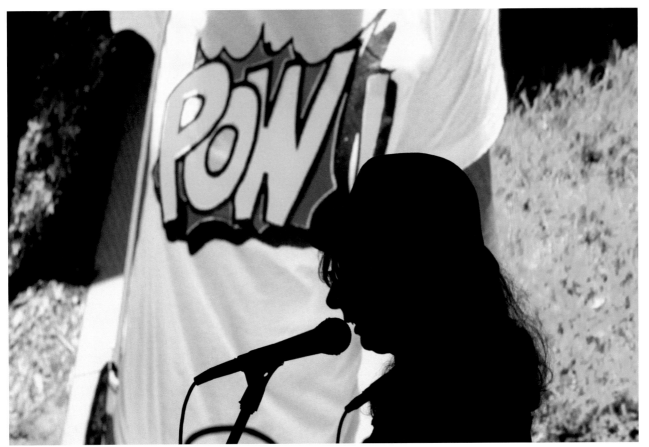

This spread: Shelley Hirsch performing *Zoom Zoom*, July 17, 2010, at the Whitney Museum of American Art, New York.

PRÊT-À-PORTER

Marclay has collected clothing that features musical notation as a decorative motif. These dresses, shirts, socks, scarves, hats, and so on, made from a variety of fabrics, are worn by two models who act as music stands, while musicians read and improvise the music originally meant solely as ornamentation. This 2010 score stipulates that the clothing be layered and changed as often as is required by the performance. The dressing and undressing are part of the performance. A bottle of single-malt whiskey is available to both actors and musicians.

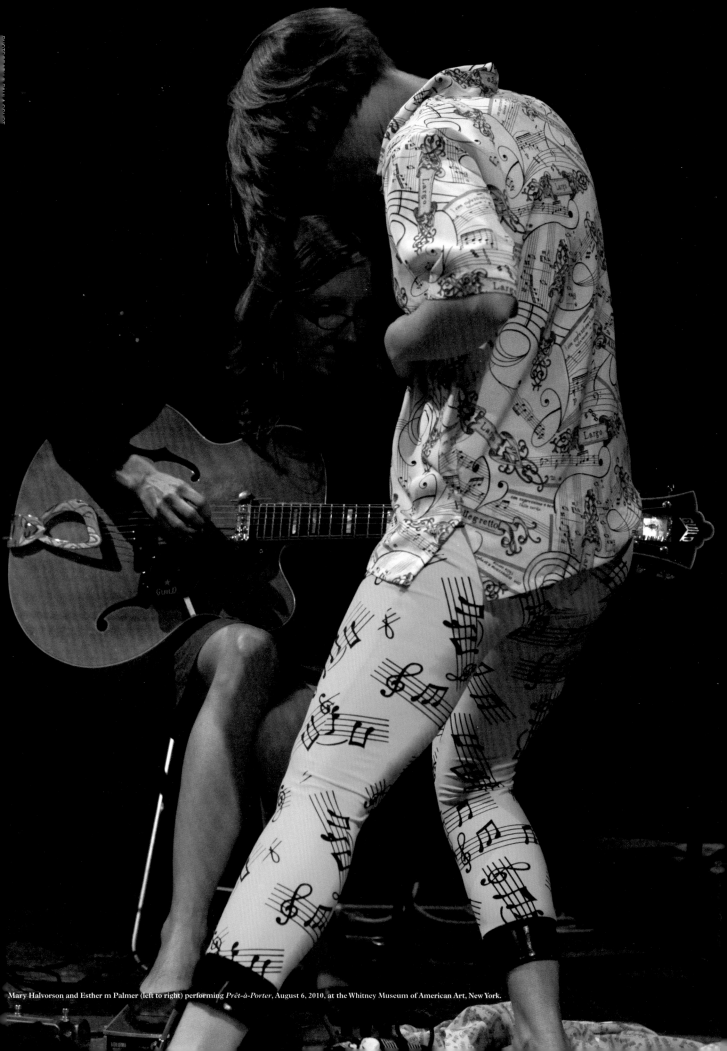

*Mary Halvorson and Esther m Palmer (left to right) performing *Prêt-à-Porter*, August 6, 2010, at the Whitney Museum of American Art, New York.*

42

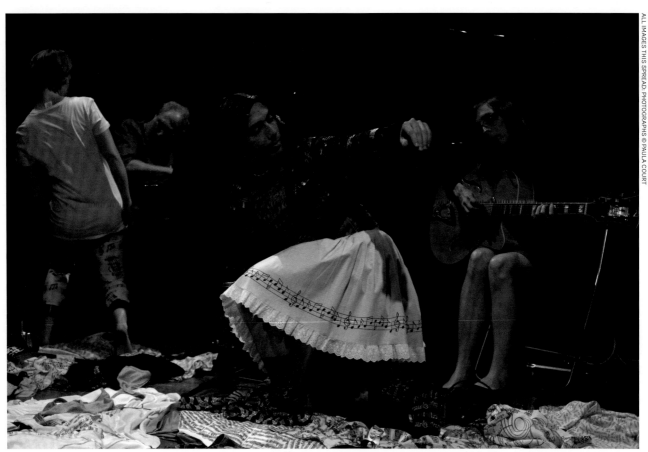

Esther m Palmer, Anthony Coleman, Alberto Denis, and Mary Halvorson (left to right) performing *Prêt-à-Porter*, August 6, 2010, at the Whitney Museum of American Art, New York.

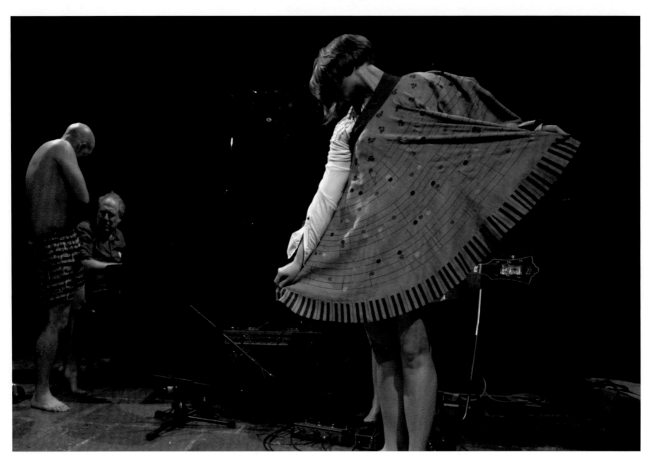

Alberto Denis, Anthony Coleman, Esther m Palmer, and Mary Halvorson (left to right) performing *Prêt-à-Porter*, August 6, 2010, at the Whitney Museum of American Art, New York.

Alberto Denis and Anthony Coleman (left to right) performing *Prêt-à-Porter*, August 6, 2010, at the Whitney Museum of American Art, New York.

43

Esther m Palmer and Anthony Coleman performing *Prêt-à-Porter*, August 6, 2010, at the Whitney Museum of American Art, New York.

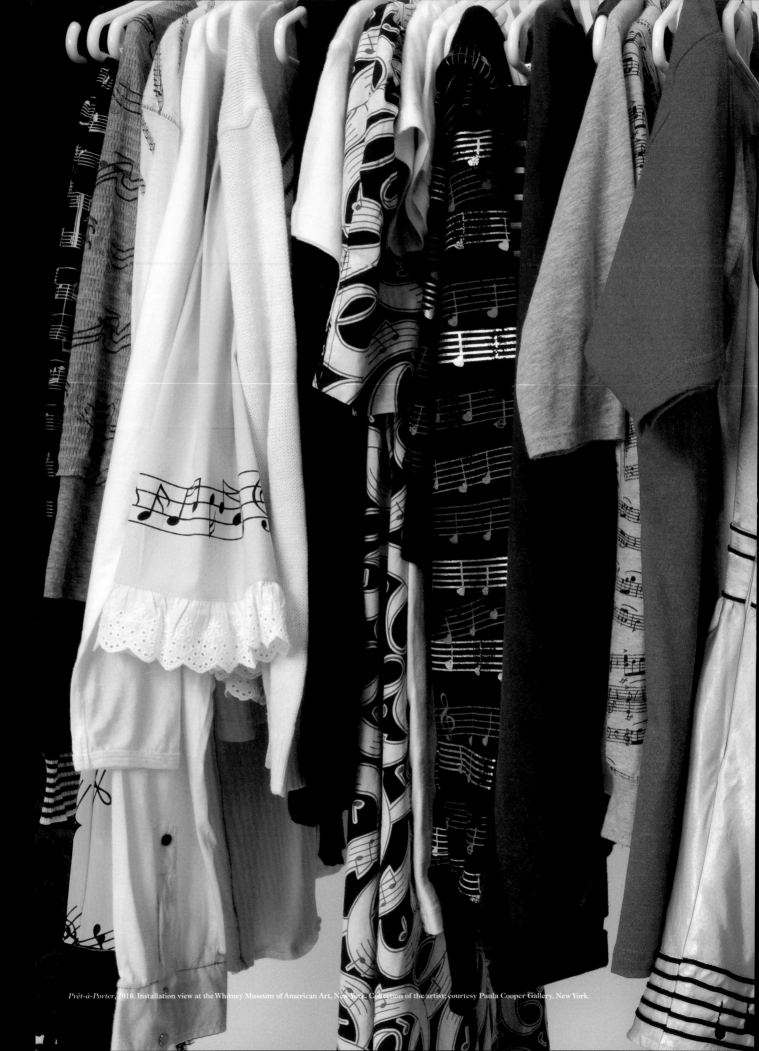

Prêt-à-Porter, 2010. Installation view at the Whitney Museum of American Art, New York. Collection of the artist; courtesy Paula Cooper Gallery, New York.

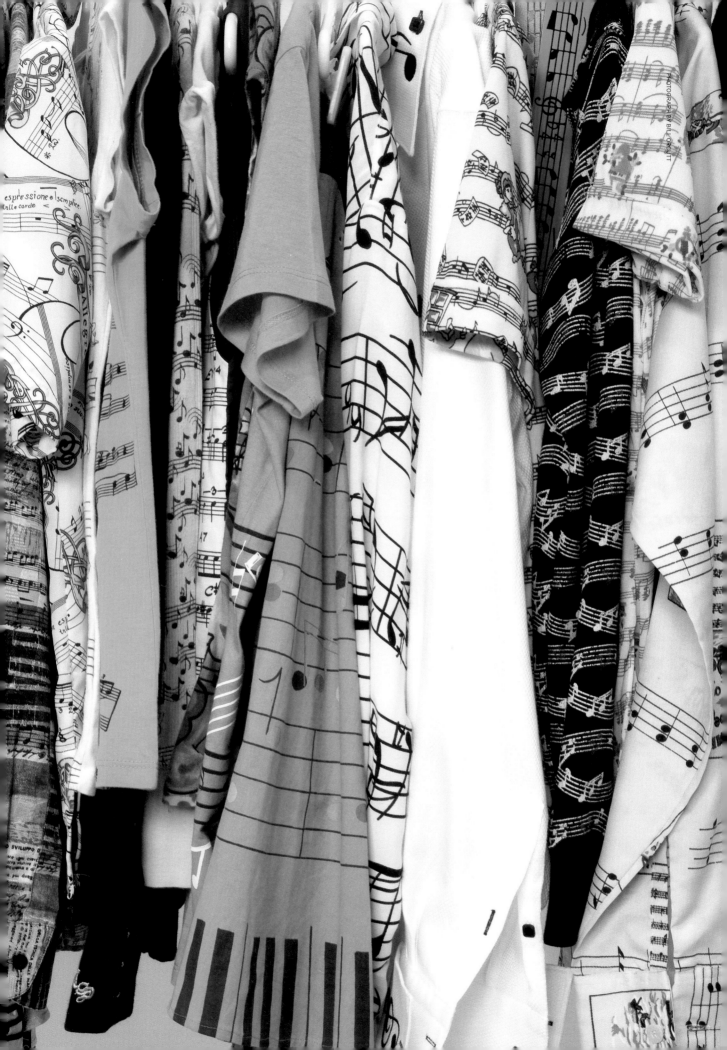

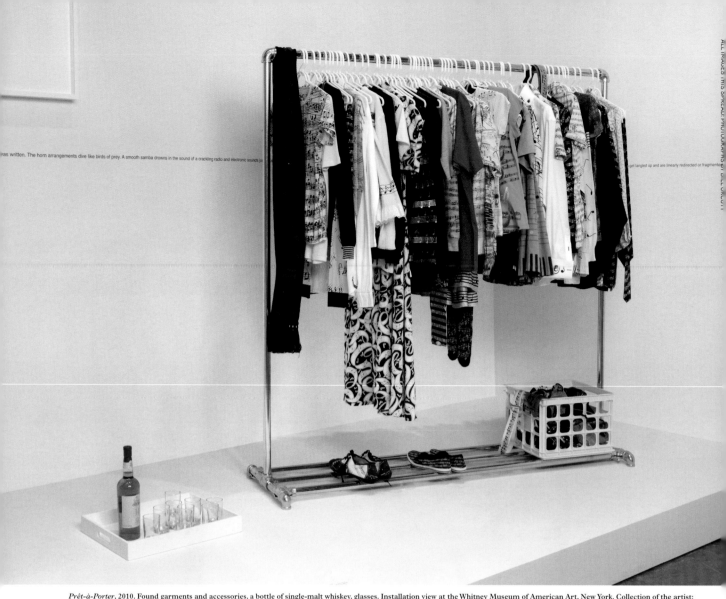

Prêt-à-Porter, 2010. Found garments and accessories, a bottle of single-malt whiskey, glasses. Installation view at the Whitney Museum of American Art, New York. Collection of the artist; courtesy Paula Cooper Gallery, New York.

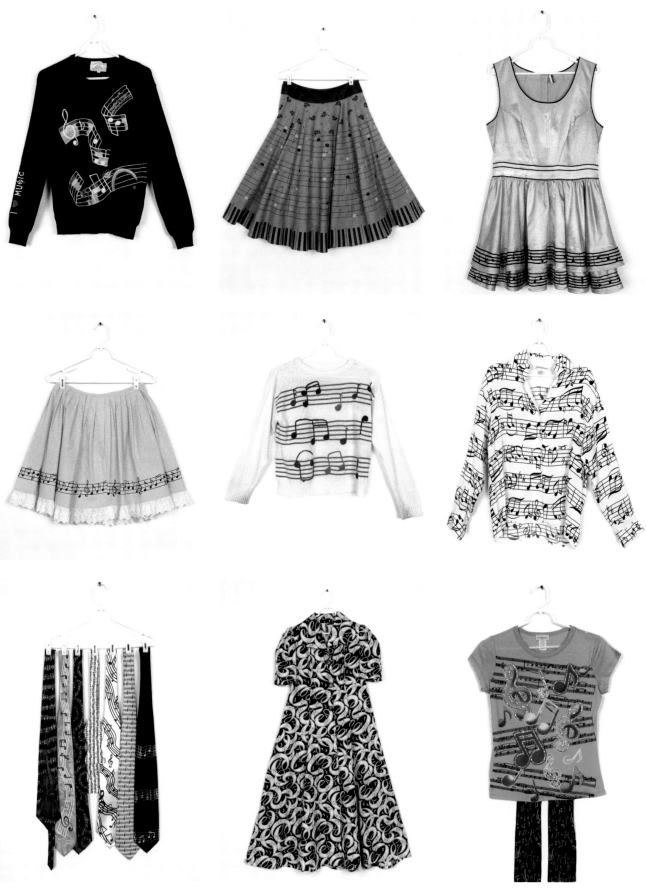

Prêt-à-Porter (details), 2010.

CHALKBOARD

Chalkboard is a new score that was produced by Marclay specifically for *Festival* in 2010. The score consisted of a chalkboard that ran the entire length of an eighty-seven-foot wall in the main gallery on the Whitney's fourth floor. The black wall was printed with white staff lines, and chalk and erasers were provided to visitors to use as they wished, resulting in a cheerfully chaotic mixture of musical notes, slogans, and doodles. The board was washed off once a week, allowing the audience to cover it anew. A number of the musicians interpreted *Chalkboard* during the exhibition—in performances that were sometimes scheduled but often impromptu—including the pianists Rob Schwimmer and Marilyn Crispel, a brass quartet comprising members of TILT, trumpeter Peter Evans, vocalist Helga Davis, and guitarist Mary Halvorson.

I DON'T

A no
Love

What is my name?
Who am I

I HATE THIS

MUSE
SUSPIR

ARTIST ONE DAY

STRA PER ASPERA
E SOGNO VINCES

"do shit." –Dad

Toy Story 2 was okay.

Dough ray me

HIER IST NOCH PLATZ!

EM

LUCAS WUZ HERE

THE PLANET

AMMER SINGING INSTRUMENT

Gustavo

SHARE TIME MANY

MAO

loved

IML URST

10 AM

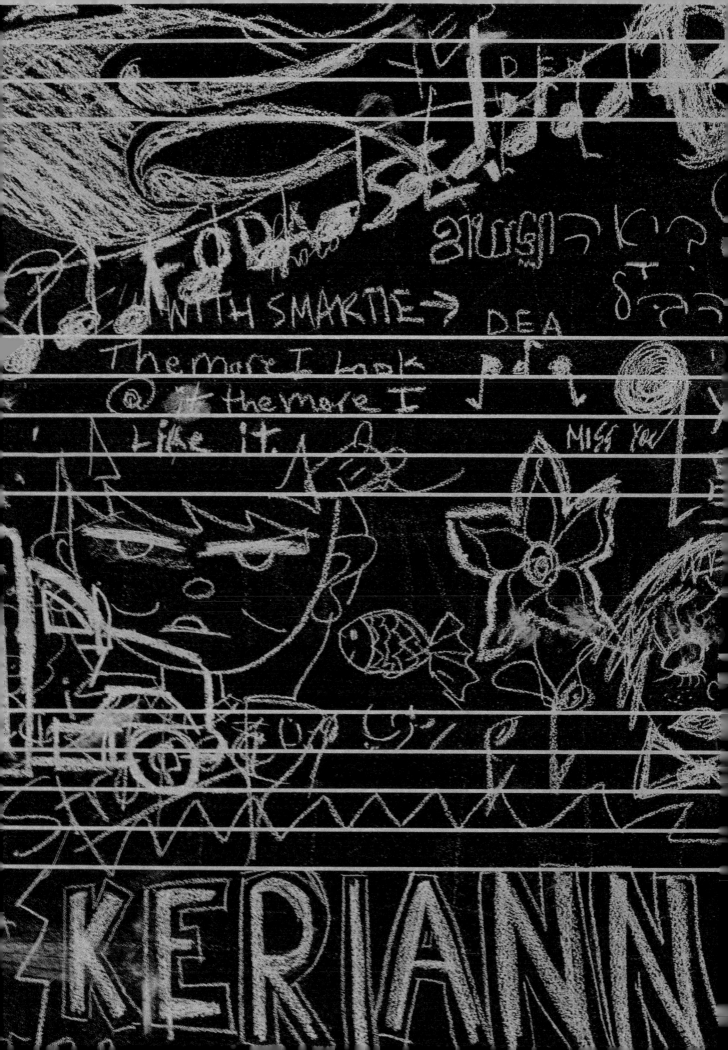

This is high. ↑

TV

music

GLOSOLI ... FOR THE FIRST TIM

...thing is forever but

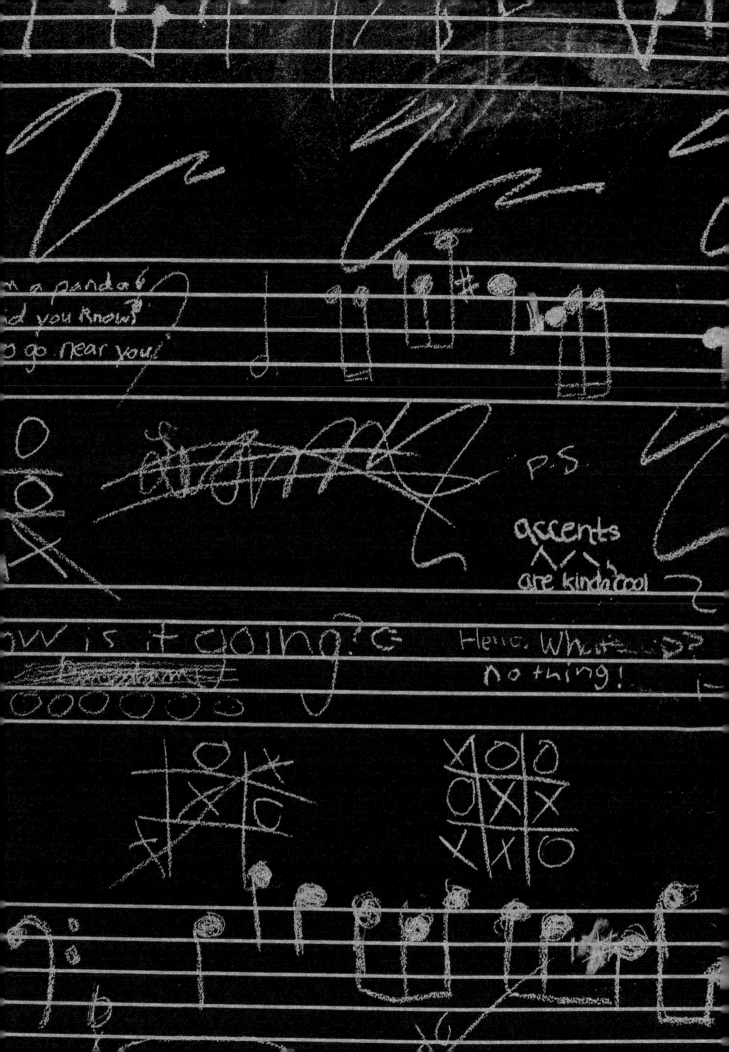

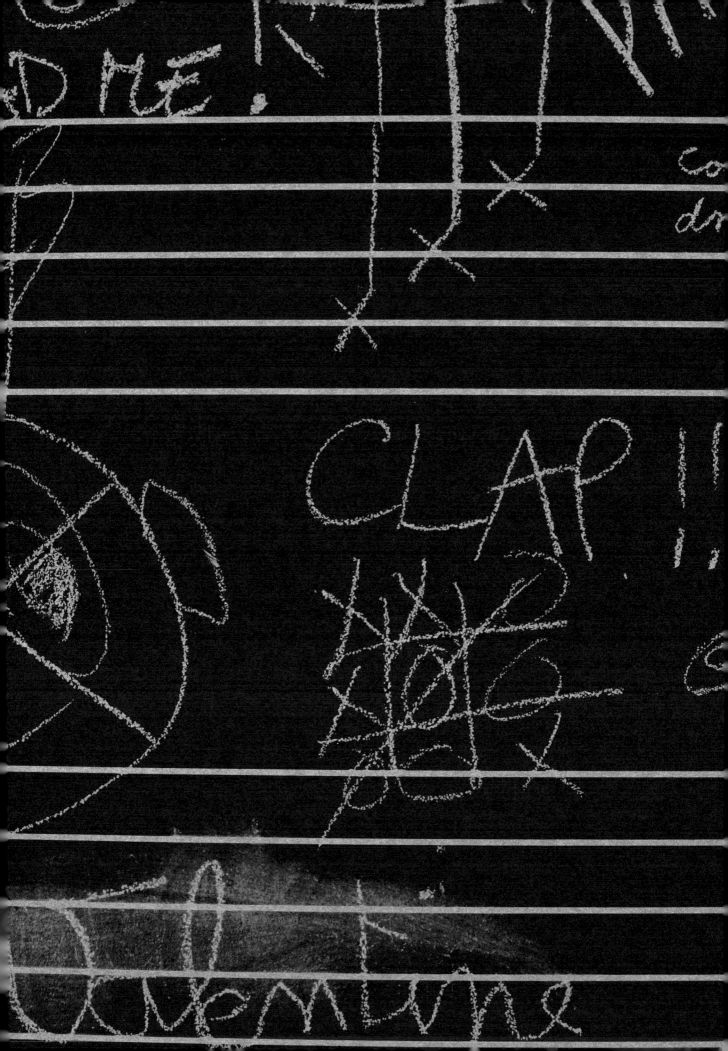

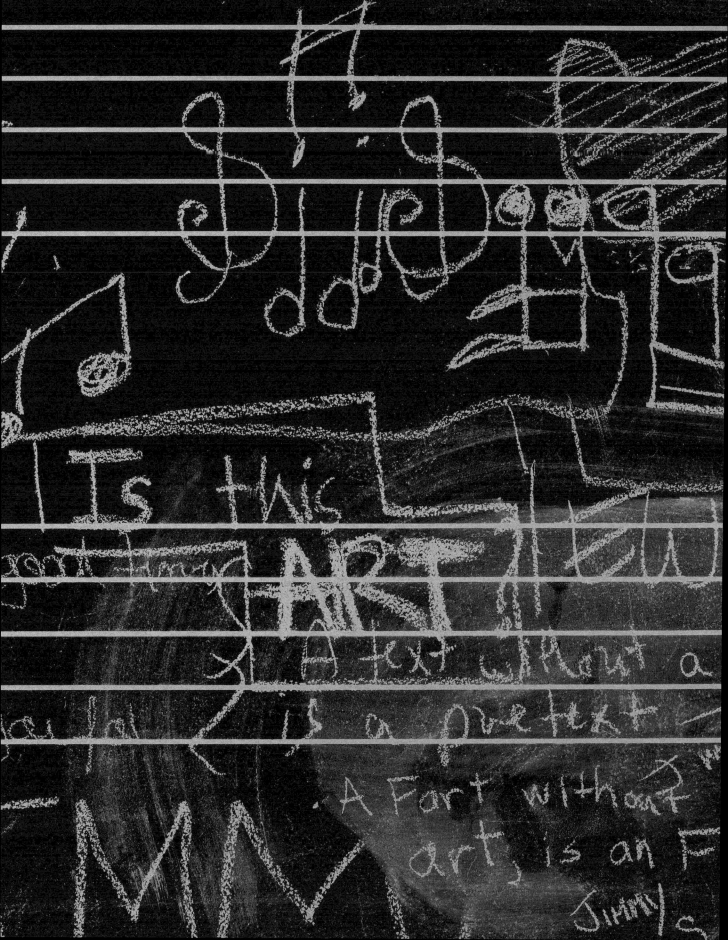

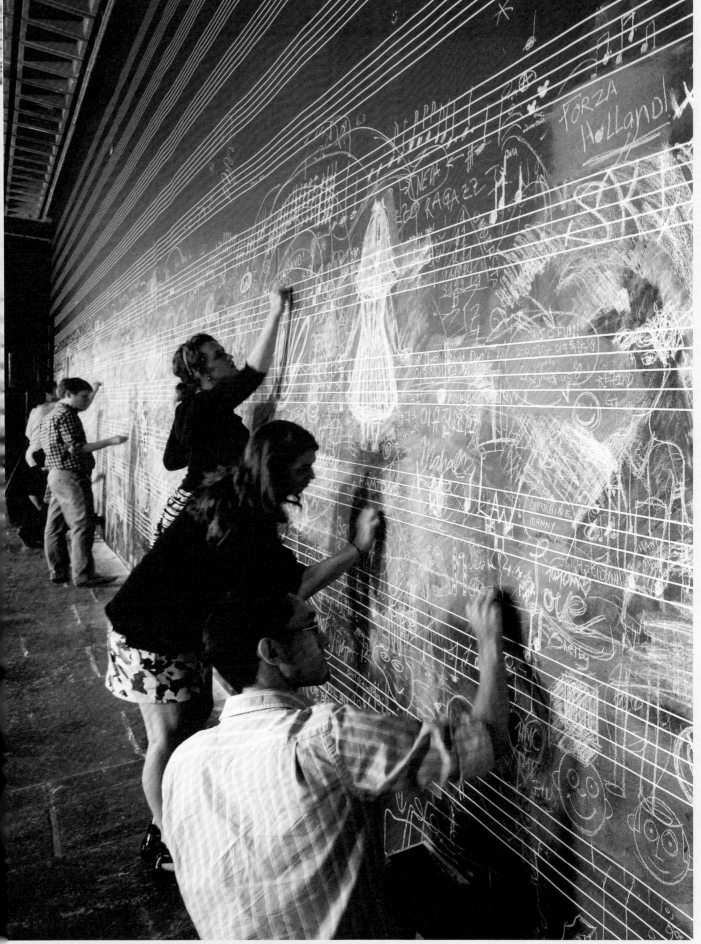

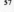

Chalkboard, 2010. Installation view at the Whitney Museum of American Art, New York.

TABULA RASA

While Marclay starts creating sounds only using his turntables, without any records, Florian Kaufmann, who is equipped with a lathe-cutting machine, engraves these manipulations in real time. After the first recording is cut on the lathe Marclay starts remixing it and adding to the next disc being engraved. The performance evolves into a dense layer of recordings generated by Marclay's instant recycling of his own live mix, a cycle that questions the relationship between live and recorded music.

Tabula Rasa was first performed at the Festival de la Bâtie in Geneva, Switzerland, in 2003, and is an ongoing collaboration between Christian Marclay and Florian Kaufmann.

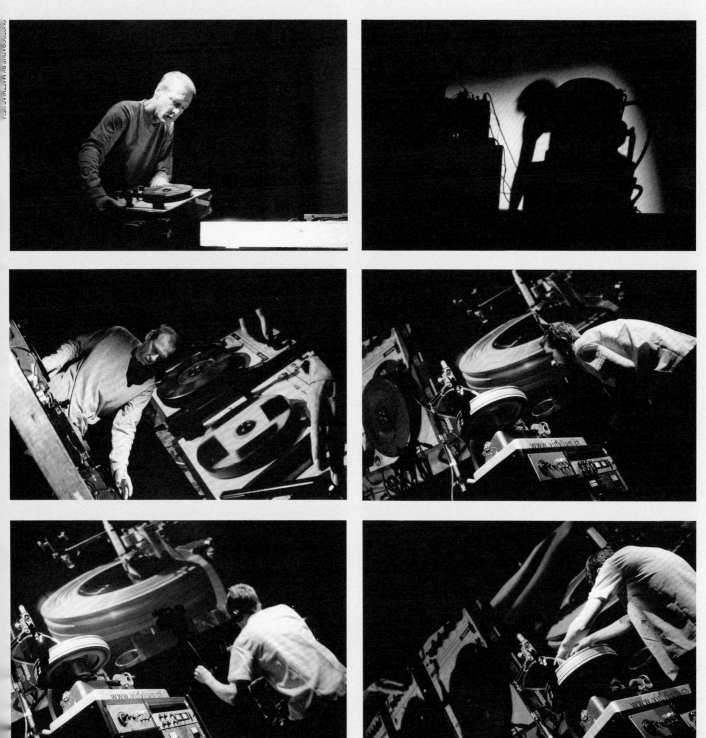

Christian Marclay and Florian Kaufmann performing *Tabula Rasa* at the Reithalle Dojo, Bern, 2004.

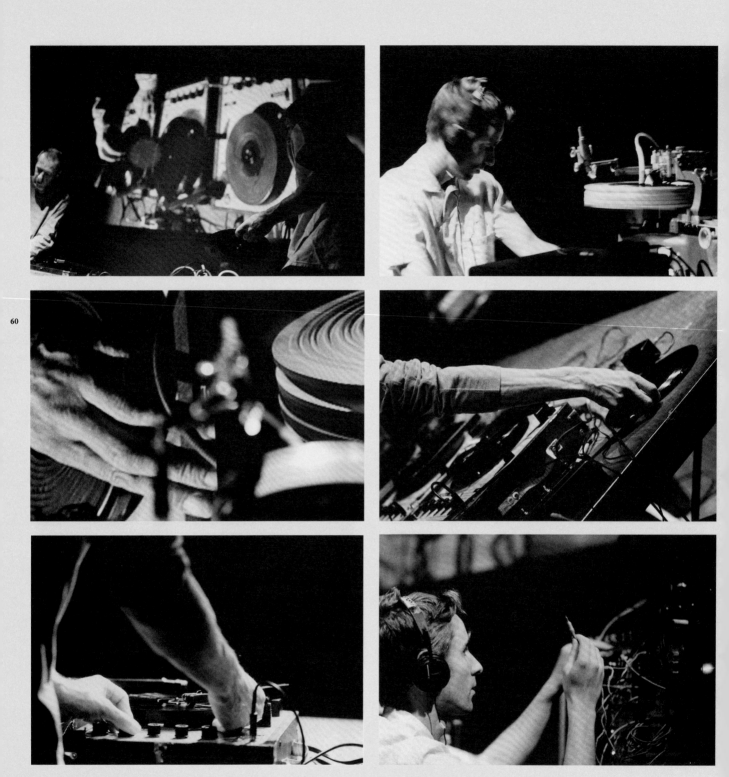

This spread: Christian Marclay and Florian Kaufmann performing *Tabula Rasa* at the Reithalle Dojo, Bern, 2004.

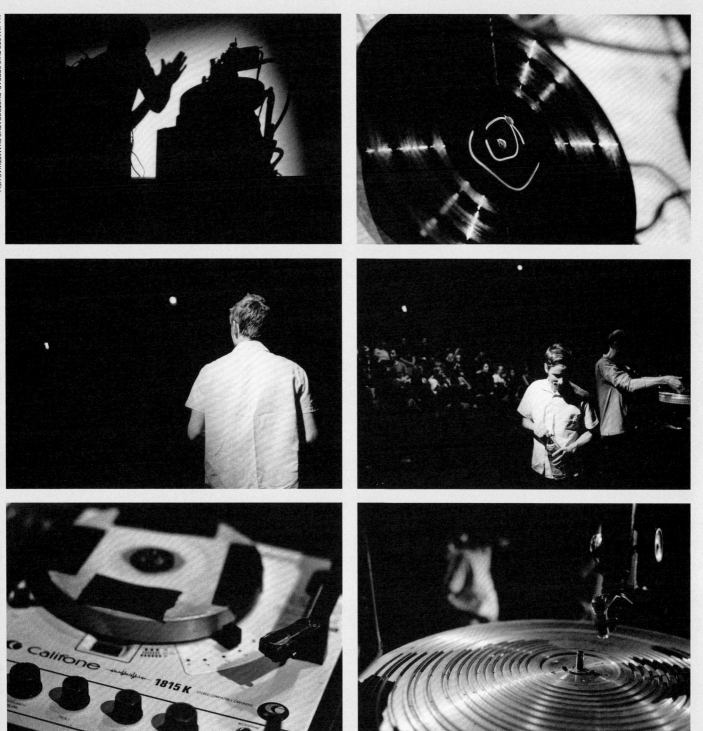

61

DEAD STORIES

Dead Stories was a music-theater piece for four turntables and six voices, in which Marclay explored themes of death and memory by juxtaposing live singers with recordings of voices from his record collection. Marclay mixed fragments of old arias, scratched symphonies, verses, half-forgotten fairytales, lost ballads, disco beats, and snatches of all kinds of narratives in a real-time montage. The various versions of the piece have been performed by vocalists including Roberta Baum, Michel Berthassat aka René Cendre, Susan Deihim, David Garland, Shelley Hirsch, Arto Lindsay, David Moss, Sheila Schonbrun, and Susie Timmons.

First developed in recital versions in 1984 at various venues such as P.A.S.S. (now Harvestworks) and the East Village club 8BC, and through performances with the group Tower of Babel, *Dead Stories* was presented as full-evening performances at the Performing Garage in New York and at the Walker Art Center in Minneapolis in 1986.

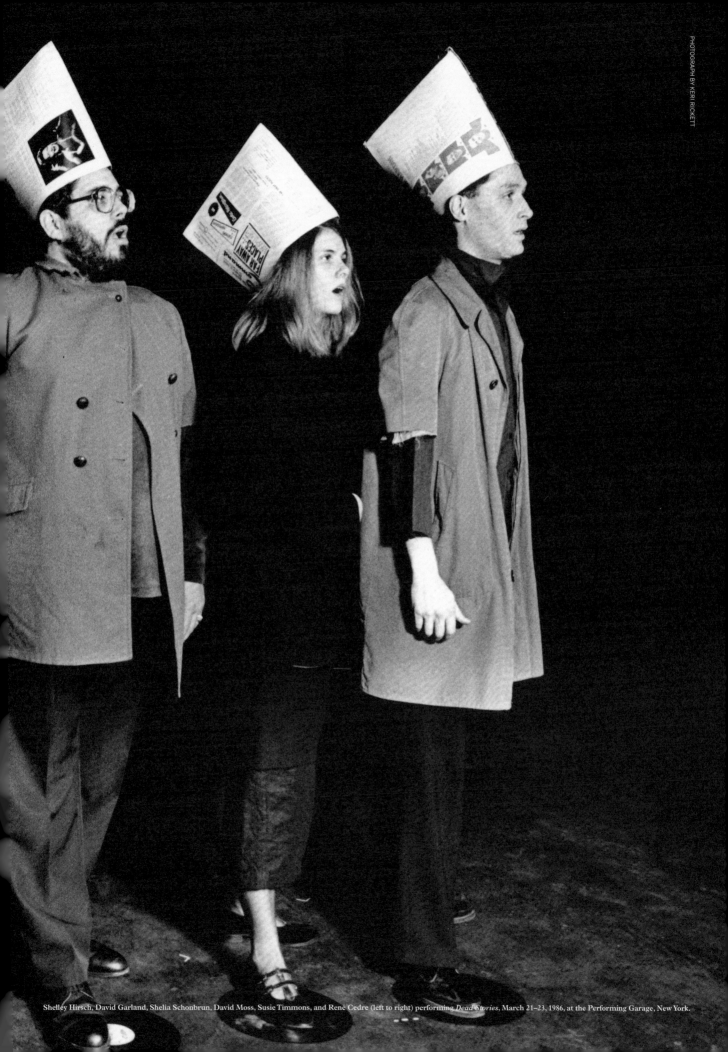

Shelley Hirsch, David Garland, Shelia Schonbrun, David Moss, Susie Timmons, and René Cedre (left to right) performing *Dead Stories*, March 21–23, 1986, at the Performing Garage, New York.

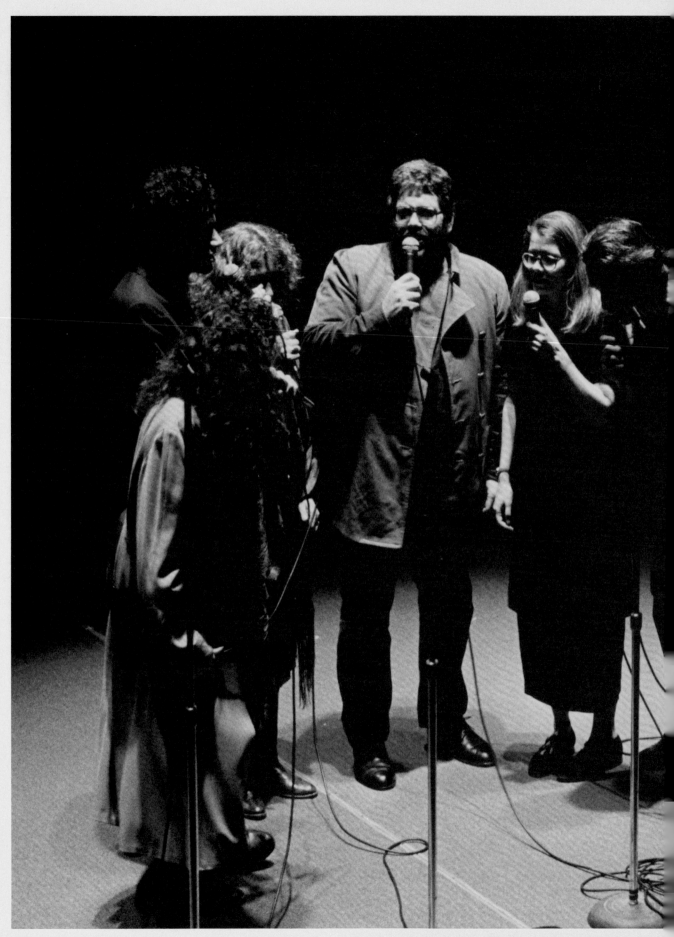

64

Shelley Hirsch, David Garland, Shelia Schonbrun, David Moss, Susie Timmons, René Cedre, and Christian Marclay (left to right) performing *Dead Stories*, April 5, 1986, at the Performing Garage, New York.

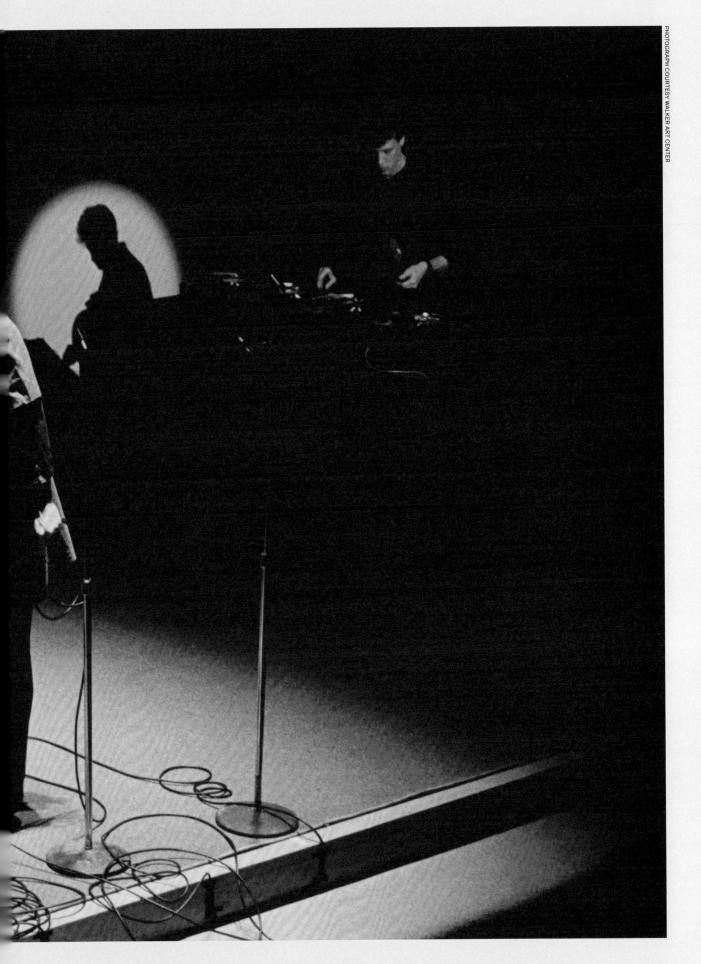

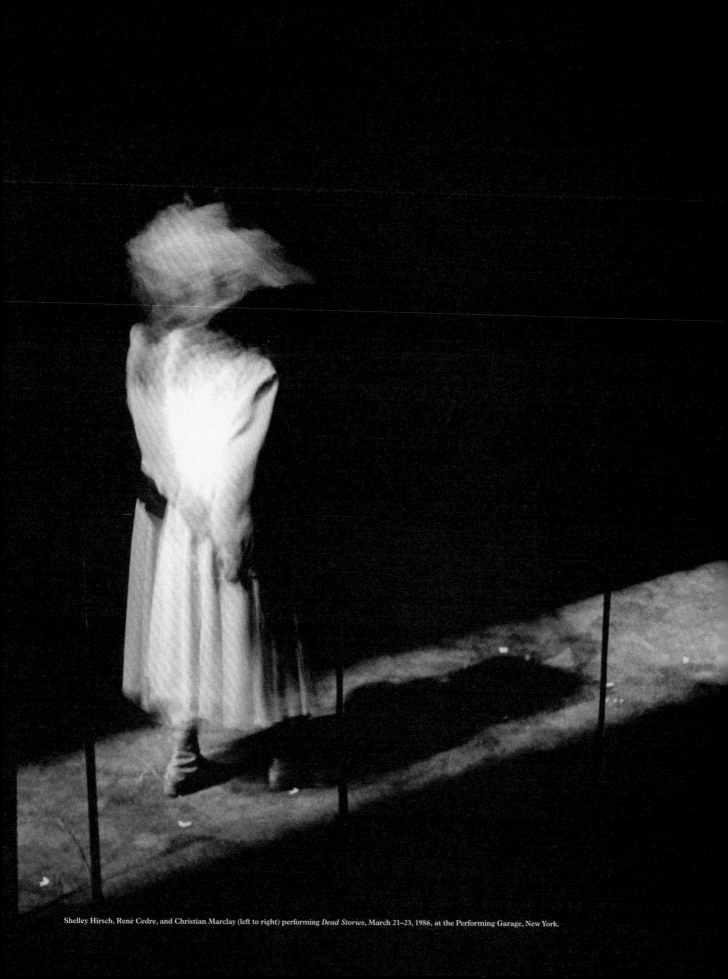

Shelley Hirsch, René Cedre, and Christian Marclay (left to right) performing *Dead Stories*, March 21–23, 1986, at the Performing Garage, New York.

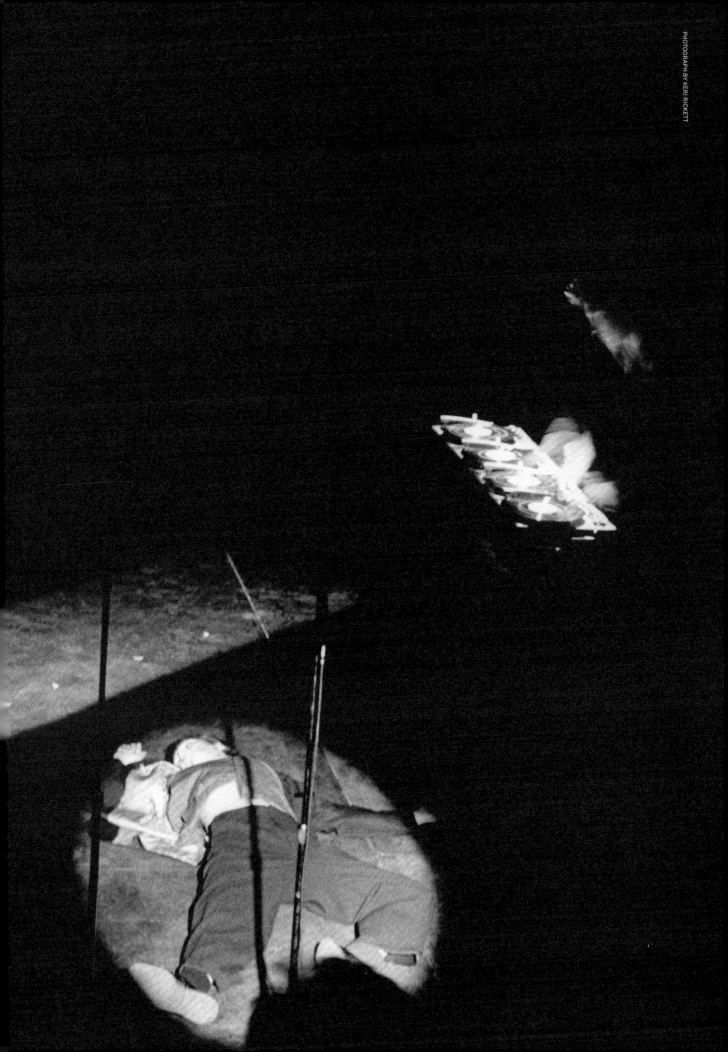

All images on this spread and the following are of performances during *Christian Marclay: Festival* at the Whitney Museum of American Art, New York.

1 Michael Snow performing *Shuffle*, September 26, 2010.
2 Alan Licht, Ulrich Krieger, and Maria Chavez performing *Screen Play*, June 30, 2010.
3 Theo Bleckmann performing *Manga Scroll*, September 26, 2010.
4 o.blaat performing *Sixty-four Bells and a Bow*, July 23, 2010.
5 Anthony Coleman performing *Ephemera*, August 5, 2010.
6 Audience viewing *Manga Scroll*, September 26, 2010.
7 Butch Morris and Chorus of Poets performing *Mixed Reviews*, September 9, 2010.
8 Helga Davis performing *Chalkboard*, September 9, 2010.
9 Raz Mesinai performing *Sixty-four Bells and a Bow*, August 13, 2010.

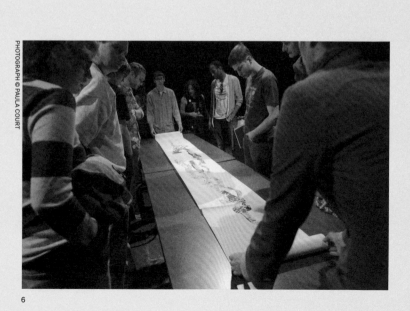

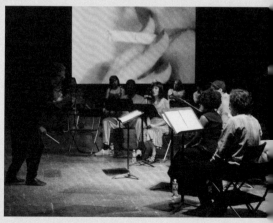

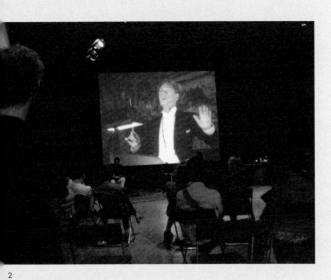

2

PHOTOGRAPH © PAULA COURT

3

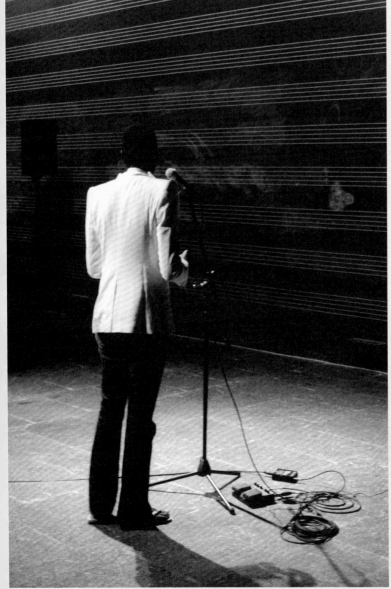

8

9

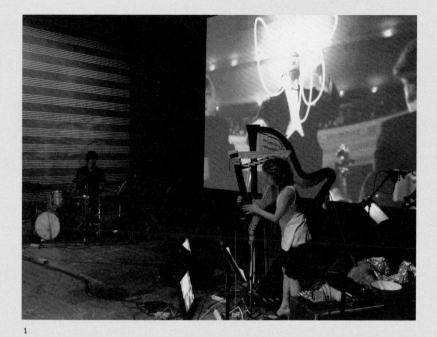

1

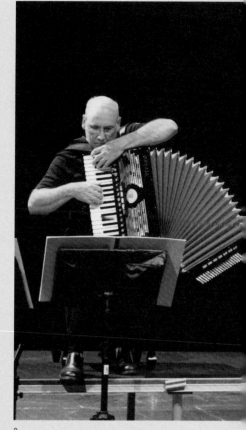

1 Peter Evans, Kato Hideki, Zeena Parkins, and special guests
 Sara Parkins and Ches Smith performing *Screen Play*,
 August 19, 2010.
2 Guy Klucevsek performing *Ephemera*, September 22, 2010.
3 Andrea Parkins, Esther m Palmer, Alexander Waterman, and
 Alberto Denis (left to right) performing *Prêt-à-Porter*,
 September 25, 2010.
4 Wayne Horvitz performing *Shuffle*, August 26, 2010.
5 Rob Schwimmer performing *Chalkboard*, July 11, 2010.
6 Kato Hideki and Zeena Parkins performing *Sixty-four Bells
 and a Bow*, September 10, 2010.
7 Bill Frisell performing with *Wind Up Guitar*, August 26, 2010.

2

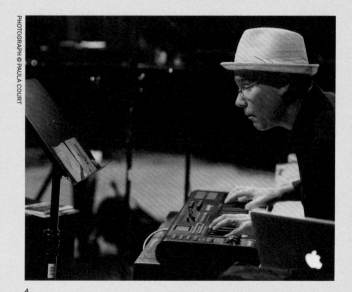

PHOTOGRAPH © PAULA COURT

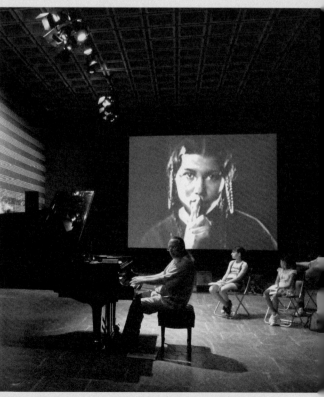

4 5

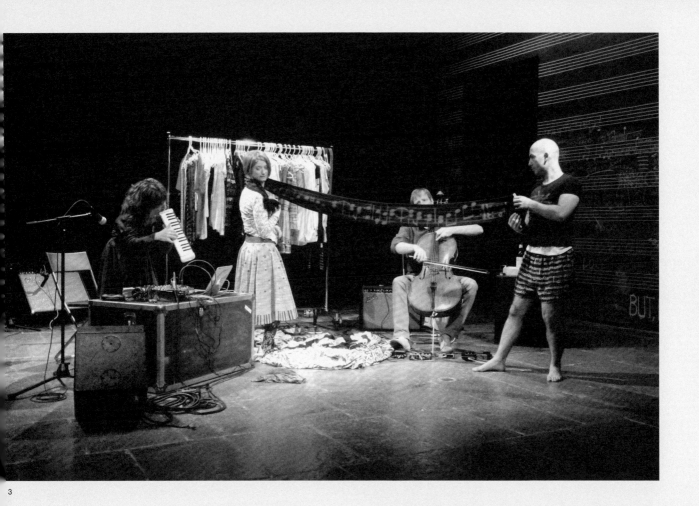

3

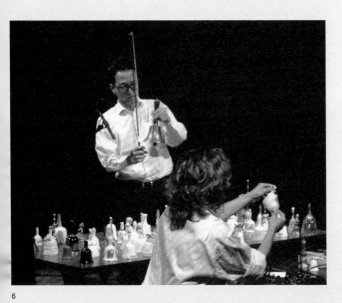

6

7

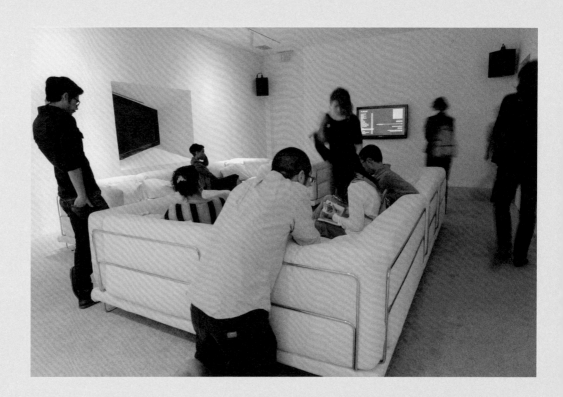

This spread: Installation views of *Christian Marclay: Festival* at the Whitney Museum of American Art, New York, September 11, 2010.

ARTO LINDSAY

During a performance of *Dead Stories* in 1985 at 8BC, a venue in New York's Alphabet City that had a dirt floor, I remember the light on stage as resembling candlelight. And I remember Richard Horowitz, who was not one of the singers, cutting in on his girlfriend Susan Deihim and me in an apparent fit of jealousy as we were dancing on stage, and Shelley Hirsch seeming to comment on everything around her, including this interception, in her singing. For the life of me I don't remember what David Moss, David Garland, or I did, or how the evening sounded. Or how Christian structured it, except that at some point we were supposed to dance with each other. I do remember having a feeling common to a lot of performances in those days: Hey, we can actually do this—it works.

Somewhere I have a contact sheet of shots of the performance of *Tower of Babel* at the 1985 Moers festival, but I wasn't able to locate it for this occasion. Maybe a memory of this contact sheet rather than a memory

of the show itself makes me think that our appearance had an odd sort of glamour. It was an edition of the festival devoted to New York improvisers, and I remember morning workshops and a performance by the Golden Palominos and another of Zorn's Cobra on the same big stage. I remember at times taking matters into my own hands and organizing and concentrating our improvisations, treating Christian as a rhythm section, though I am sure he still started and stopped things.

One way to think about these pieces—singers improvising with various extended techniques over Christian's multiple record-skips and needle noise—is as an answer to the multi-guitar format so popular at that time. This music was much more open and its complexities more apparent if only because it was not so blindingly loud. I think Christian, with his visual-arts background, was attracted to the inquisitive approach common to both improvising and performance art. In the late '70s and early '80s the audiences for both of

these genres were small and rarely overlapped. The artists were more interested in the rock clubs, and the improvisers hardly seemed aware of the history of noise performances by the Futurists or by Fluxus artists or the use of sound by artists in art galleries. By the mid-'80s, Christian was already blithely overriding these distinctions.

I enjoyed these few shows so much that I formed a derivative group called the Christmas Rose Choir after Brazilian songwriter Noel Rosa. We did one excellent show at the Kitchen and one awful show as part of a lunchtime series in the financial district.

Arto Lindsay, formerly of New York, now lives in Rio.

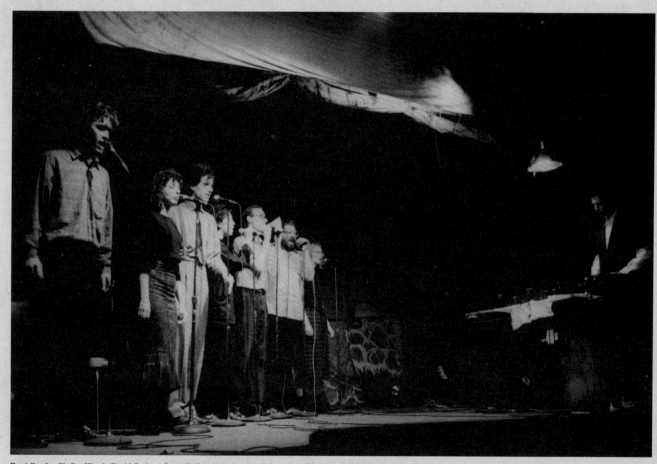

René Cendre, Shelley Hirsch, David Garland, Susan Deihim, Arto Lindsay, David Moss, Susie Timmons, and Christian Marclay (left to right) performing *Dead Stories*, May 10, 1985, at 8BC, New York.

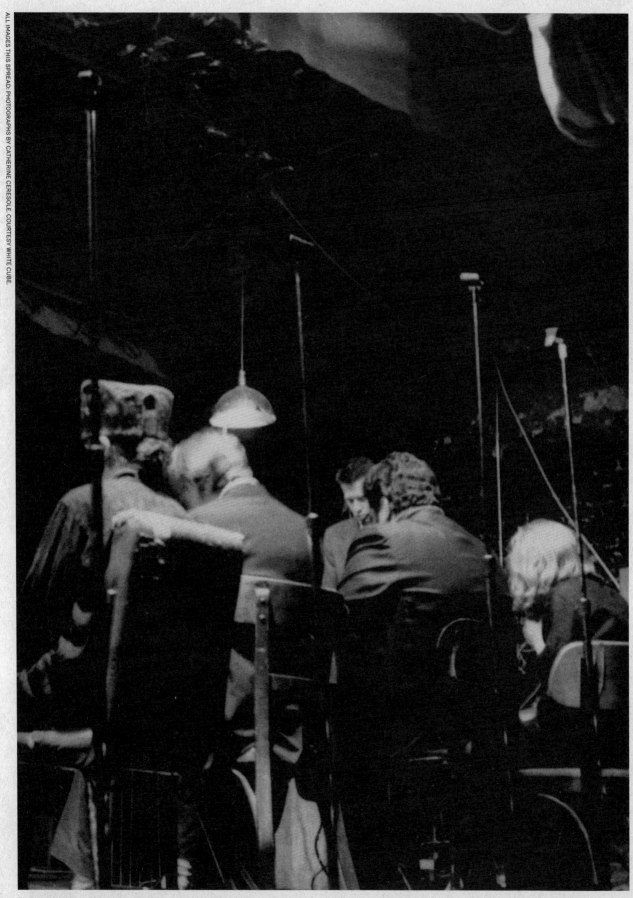

Performance of *Dead Stories*, May 10, 1985, at 8BC, New York.

SHELLEY HIRSCH

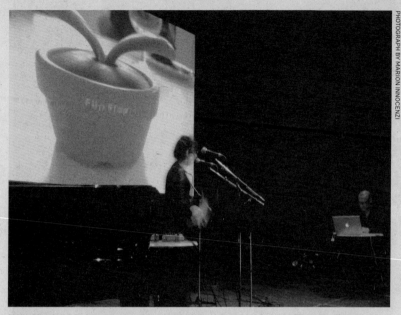

PHOTOGRAPH BY MARION INNOCENZI

When asked to write a piece about working with Christian in the context of his exhibition *Festival*, I decided to use a track of his recorded music[1] as a springboard. I entered into the writing as though I were improvising with him live.

And as a kind of prelude to *Zoom Zoom* (2007–2009), which Christian and I performed in July and September at the Whitney, I loaded it with onomatopoeias.

Shelley Hirsch is a New York–based vocalist, composer, and performance artist.

ENDNOTES

1 "Phonodrum" (1981) from Christian Marclay's *Records: 1981–1989* (Atavistic Records, 1997).

Shelley Hirsch and Christian Marclay performing *Zoom Zoom*, September 20, 2008, at Théâtre du Grütli, Geneva.

PHOTOGRAPH © PAULA COURT

Shelley Hirsch performing *Zoom Zoom*, July 17, 2010, at the Whitney Museum of American Art, New York.

Bursting out of his turning discs
Boinging bongos squiggle ich
chizz whiz blitz krieg
Conga coo

You Marlena D'ed me into your world.

Agitate my thoughts
you do
Onamota what?

ba baa baaaa llistic
some kind of mystic
layering
staggering
stack em up
 Snap it

 Stain the ceiling

Stripoziod noise
comic pix

caskets of hoopla
WoWs and fanfares
slow o o oh
dow WOW ow Wown

ripped curtain show town

 ZOOM! ZOOM!

walkin'

Bits mix
Crackle icious
Nestles quick ish

 SWSSSish

Popped up trip ticks
 Stree grabbed chic flicks

 cluckin

Toes in a shoe store
Breaks on a dance floor
Squish us
Mighty vicious

I hazard a guess
Answer is yes
It's the oo la in the oo la la dat makes the
 brouhahah
hahaha

 Coo coo
Who's in that bird cage with you?

Squawk talk
Fernandos hiding
Tangos throbbing
Pitches scrunching float box punching

in the mood for
Twizzlers?
simply because you're near me!

He's twirlin' em up
Spinnin' em round
Sound bursts to page
Pummeled to grit
Twisted and shouting

 Gonna rub my little
Hub shaper
Brass scrapper
tin snipper
Pow wow OW
what ya call demtings man?

Steel drums
Hula hoopers party poopers
A parade of partisans
Shouting bloopers
Bang sh BANG sh
Boom!!
Squirt to upper left corner
By beating beaks backwards

kuckoolicoo
Curli Que
Frizz balls
 graffiti in toilet stalls

 can ya hear it?
Onomatopeia

She stomps her high heel
through the page as she puts out the trash
Punctures the word SMASH thats lyin' in a
puddle.

(I will not use the word recontextualize)

oops

 EEKS

Bleating lambs in
Her fryin' pans
Sizzling cans
Blistering bands

On a mat a what?

more bongos
Christian heats 'em up

Pops a pop

Prizzle squap
Scrumptialumps

(Hey those aint words)

Ping them pong balls
off the table
Into the room
Scratching
the walls
Contained in frame
He captures
I'm caught

DIZZY

ZZZZZ

Organs Mashed
Grind the brain
To
Recollect
Io ricordo
 is
I remember is
memory is
your souvenir
From twirl it in your hand—to chop it in my
mouth
Throw it back
Back track
Recall
product box
Scrunch fizzle
Shattered shards
Spray SLAM!!!!
Bam!!!! Wham!!!
CrUSHeD
Hush. No bluster
always consequent
tangent tangible
Christian
Dent it, he bent it
Shapes it anywayhewantit
Jabberwocky jocky
Time capsule bling
Fling

Splish Splash
I'm taking a bath
between his
cracklin crannies.

77

PERFORMANCE REPORT

NICOLE LANCTOT: ELECTRICAL CONDUCTOR

On September 12, 2010, a Sunday, composer and conductor Butch Morris led a string sextet through two interpretations of Christian Marclay's *Graffiti Composition* (1996). Waiting for a late-arriving violinist, Morris took a moment to explain to the audience his method of conduction, a practice he first developed in the 1970s to direct improvisers and produce arrangements in real-time, as the music unfolds. Unlike most conductors, who transmit an interpretation of a written work by controlling the tone, tempo, and so on, Morris instead takes a broader compositional idea and presents a framework for the music—while the musicians themselves provide the content, largely through improvisation. For this reason, Morris feels he is *creating* music, whereas a traditional conductor is not. The players here were not entirely cold, however, as rehearsals were required to learn Morris's use of hand signals as directives. A finger to his temple, for instance, indicates "commit what you just played to memory"; a curved C-shape with one hand expresses "repeat"; hands held together,

then spread wide apart, instructs them to develop a musical idea they established.

Morris also explained his affinity with Marclay's work, as they both use "symbolic information and stimulus" to produce outcomes, and embrace musicians and non-musicians alike to interact with their work.

Before each of the two performances that Sunday, Morris shuffled cards featuring the *Graffiti Composition* scores and distributed them among the instrumentalists. The cards, which are part of a portfolio of one hundred and fifty digital prints, are the result of a project Marclay did in 1996, when he posted sheets of blank staff paper around Berlin, and then photographed the scribbles and notation that eventually materialized on the posters. Each musician was given autonomy to determine his or her "parts" (cards), independent of one another and of Morris. When the music commenced, Morris used his own score to modify what he heard from the musicians, primarily determining the length of time they spent on each part. (The cards

were not visible to the audience, although the decision not to highlight the source material is sort of the point, since Marclay's goal is to encourage musicians to extend works far beyond the composition's origins.)

The first was a fluid piece of about thirty minutes, and came across as mostly composed rather than improvisatory, despite the use of both strategies. The timing among the musicians was impeccable; the moves were calibrated, deliberate, and resonated well with other musicians' phrasings. Rarely did one instrument assert itself for more than a moment, and when the musicians played simultaneously, the music never developed into a cacophony of independent voices, although Morris urges the players to incorporate personal styles and techniques. A collective execution of slow, rich notes, almost mournful, soared to moments of bracingly high pitches and panicked-seeming bowing, only to diminish into spare and barely audible pizzicato flutters. The piece's lively last minutes transitioned into a march at a

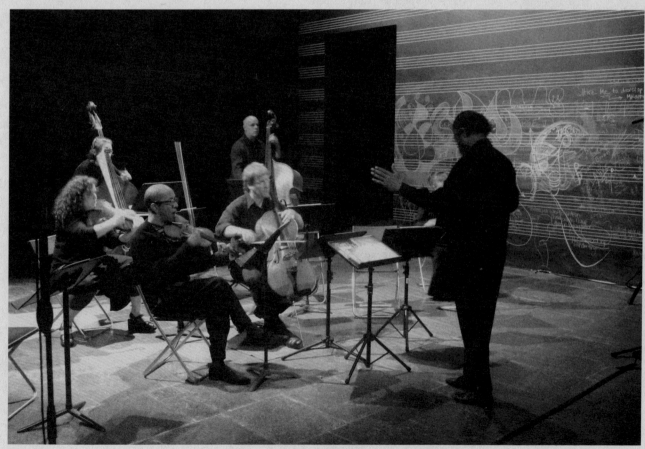

Butch Morris and string sextet performing *Graffiti Composition*, September 12, 2010, at the Whitney Museum of American Art, New York.

moderate clip, and dissolved into a soft crumbling of crackles and electronics-esque decay. This concluding section was the sole moment to resemble *Graffiti Composition*'s recent CD recording—a 2006 performance at the Museum of Modern Art led by guitar impresario Elliott Sharp, with additional guitarists Lee Ranaldo, Melvin Gibbs, Mary Halvorson, and Vernon Reid, whose instrumentation and amplification produced a distortion-steeped, rawer set.

Joining the six other New York–based musicians—including Charlie Burnham (violin), Alex Waterman (cello), Stephanie Griffin (viola), Shawn McGloin (bass), Jane Wang (bass), and Nicole Federici (viola)—for the second piece was violinist Skye Steele, whose bright playing added to the already numerous comical layers of this composition. Using only a few gestures, Morris set the musicians in motion and, this time, stepped aside for several minutes. This hands-off strategy created a markedly different personality. Left to their own devices, the musicians delved into what appeared to be a controlled free-for-all, where each musician's voice diverged and became more distinct from the whole. Playful gestures abounded, with plucks, slaps, knocks, and cartoonish slides. Steele's violin-playing stood out as the most melodic at times, particularly when he kicked into a folksy repetition that recalled the celebratory "Ding Dong, the Witch Is Dead" riff from *The Wizard of Oz*.

Morris's reappearance for the latter half of the piece brought a downshift. Dirgelike bass and cello notes undergirded snappier violins and violas, producing a complicated, moody atmosphere. The music's final move into spare but building rhythms exploded into a sonorous thrumming, reminiscent of Arnold Dreyblatt's textural bowing compositions—after which the piece abruptly ended.

Morris sought conduction's techniques to better foster ensemble spontaneity, and the second piece, which was roughly nine minutes long, sang with this concept. The resulting aural experience felt fresh, and the music was also cohesive in a way that many improvised works do not achieve (a nod to both Morris's finesse and to these very talented musicians' sensitivity and dynamism). And unlike other conducted performances, such as John Zorn's "game pieces," Morris's directives work more like purposeful nods instead of strict rules. The musicians pay close attention to what he asks of them, but they also demonstrated a mirthful freedom within the given parameters.

Marclay's work has, for decades, suggested "that the world isn't a complex sum of completed things, but a score of layered and constantly mutating representations and

View of *Graffiti Composition*, 1996–2002, during performance on September 12, 2010, at the Whitney Museum of American Art, New York.

processes," as Philippe Vergne wrote about the artist in *Parkett* in 2004. First a street installation and then a score, then as a series of concerts and recordings made by others, Marclay's *Graffiti Composition* continues to expand the limits of media—and like Marclay, Morris, too, has expanded notation's limitations, with critical rigor, openness, and irreverence.

Nicole Lanctot is a New York–based writer whose essays and reviews have appeared in *Artforum*, *Bookforum*, *ARTnews*, *The Wire*, and elsewhere.

ENDNOTES

1 Philippe Vergne, "The Bride, Revived by Her Bachelors, on a Dissecting Table, Between a Sewing Machine and an Umbrella" (translated from the French by Anthony Allen), *Parkett*, No. 70, 2004, pp. 46–55.

DISCOGRAPHY

SOLO RECORDINGS

1985 *Record Without a Cover*. Recycled Records, New York (vinyl LP). Re-released, 1999: Locus Solus, Tokyo (picture-disc LP), LP LSV01.

1987 *Untitled (Record Without a Groove)*. Ecart Éditions, Geneva (12-inch vinyl LP, limited edition of fifty).

1988 *Secret*. Self-published, (7-inch mother with padlock, edition of five).

 More Encores. No Man's Land, Würzburg (10-inch LP), nml LP 8816. Re-released, 1997: ReR Megacorp, London (10-inch vinyl LP and CD), ReR LP CMV1 and ReR CD CM1.

1989 *Footsteps*. RecRec Music, Zürich (one-sided vinyl LP), LP RecRec 26.

1990 *Sound Page for Sound by Artists*. Art Metropole, Toronto (7-inch flexi-disc), ISBN 0920956-23-8.

1996 *Untitled*. Robert J. Shiffler Collection and Archive, Greenville, Ohio (7-inch brown-vinyl LP).

1997 *Records: 1981–1989*. Atavistic Records, Chicago, CD alp62cd.

2006 *Guitar Drag* (original soundtrack to the video *Guitar Drag*, 2000). Neon Records, Brösarp, Sweden (12-inch clear-vinyl LP), LP Neon 002.

2007 *Ghost (I Don't Live Today)*. Eight & Zero, in collaboration with the Cabinet des estampes, Geneva (one-sided 12-inch vinyl LP).

COMPILATIONS

1981 *Light Bulb Magazine No. 4: The Emergency*. "Tes Lolos Tremolos." The Bachelors, even (with Kurt Henry). Los Angeles Free Music Society, Los Angeles (double CT).

1982 *State of the Union*. "Disc Composition #23." Zoar Records, New York (vinyl LP), LP ZOAR 10. Re-released, 1992: Arrest Records, United States (CD with additional tracks), CD AR 003; 1993: Muworks Records, New York, CD MUW 1016; 1996: Atavistic Records, Chicago (double CD), CD ALP69CD; 2001: Electronic Music Foundation/EMF, Albany, New York (three-disc set), CD EMF 128-2.

1984 *Unique No. 1—The Cops Are Coming... In Town*. "Who Was Who." Ephemere Enregistrements, France, CT 3.

1985 *Bad Alchemy Magazine + Tape*. "Tower of Babel" and other tracks. Bad Alchemy, Würzburg (CT and magazine), *Bad Alchemy*, no. 3.

 Plow!. "Pandora's Box." Organik/Anorganikprodukt, Zürich (vinyl LP), LP ORG 85-1.

 USA/Germany. "Groove." Tellus, New York, CT 8.

1986 *The Improvisers*. "Untitled." Tellus, New York, CT 15.

 So Und So Und So. "1930." Stitching Shaffy Theater, Amsterdam (CT compilation box set, limited edition), C60.

1987 *Island of Sanity: New Music from New York City*. "1930" and "Wrap Backwards and the Usual Snowflakes/Beda Fomm." No Man's Land, Würzburg (double vinyl LP), nml LP 8707d. Re-released, 1991: No Man's Land, Würzburg, nml CD 8707.

1988 *Audio by Visual Artists*. "16 Great Turn-Ons." CM with John Armleder. Tellus, New York, CT 21.

 La Nuit des Solos. "Improvisation." Vand'Oeuvre/Centre Culturel André Malraux, Vandoeuvre-lès-Nancy (vinyl LP), Vand'Oeuvre LP 8802.

 A Classic Guide to No Man's Land. "Tattersal." CM with Meltable Snaps It. No Man's Land, Würzburg, nml 8813 CD.

1989 *Imaginary Landscapes: New Electronic Music*. "Black Stucco." Elektra/Nonesuch, New York, CD 9 79235-2. Re-released, 1995: Elektra/WEA, New York, (CT) 800008F0VG.

 Captured Music. Remixes by Selektion, Frankfurt-am-Main (vinyl LP), LP SLP019. Re-released, 1993: RRRecords, Lowell, Massachusetts, CD-28.

Live at the Knitting Factory, Volume 2. "Silver Lining." CM with
Samm Bennett. A&M Records, Hollywood (vinyl LP and CD),
LP SP 5276 and CD 5276. Re-released, 1991: Knitting Factory,
New York (vinyl LP and CD), KFWCD 98 and 5; CD set KFWCD
12345; and Enemy, Germany, LP EFA 03512-08 and EMY 112,
CD EFA 03512-26 and EMCD 112-2, and four-CD set EMCD
120 and KFW B1234.

1990 Anti-Disc I. Anti-Utopia, Brooklyn (flexi-disc).

Beets, a Collection of Jazz Songs. "Recollection Bruise." CM
with Tom Cora. Elemental/T.E.C. Tones, United States (10-inch
vinyl LP and CD), LP 90901 and CD 90902.

What else do you do?: A Compilation of Quiet Music. "Les
Boîtes." With Catherine Jauniaux. Shimmy Disc, New York and
Amsterdam (vinyl LP and CD), LP shimmy 034, CD shimmy 034,
CD SDE 9021. Re-released, 1997: Shimmy Disc, New York and
Amsterdam, CT SHM 1997.

1991 Guida Nonesuch alla musica d'avanguardia. "Black Stucco."
Arcana Editions, Italy (CD and book), CD A1.

October Meeting 87'. "Duo." CM with Louis Sclavis. Bimhuis
Records, Amsterdam, Bimhuis CD 001.

1992 A Confederacy of Dances, Volume One: Live Recordings from
the Roulette Series New York. "Untitled." With Ikue Mori.
"Sebastopol." CM with John Zorn. Einstein Records, New York,
CD EIN001.

Pièces pour standards et répondeurs téléphoniques. "Busy."
(Cover art by Christian Marclay.) Nouvelles Scènes, Dijon, NS
CD 1.

1994 Deconstruct. "Blast Mix." Blast First/Disobey, London, BFFP
105CD. Also as limited edition of 500 for The Wire, 1994.

Musicworks 60: Plunderphonia & Vox. "Maria Callas." CD insert
for Musicworks, Fall 1994. Musicworks, Toronto, MW CD 60.

1996 Verona Jazz. "Poverty." CM with John Zorn. Nettle, Verona, NTL
CD 1.

1998 Freie Sicht aufs Mittelmeer: Junge Schweizer Kunst. CD
accompanying the exhibition catalogue for the exhibition,
Freie Sicht aufs Mittelmeer: Junge Schweizer Kunst, 5 June–30
August 1998. Kunsthaus Zürich.

1999 Because Tomorrow Comes. No. 2. "Train Study." BTC/Before
Tomorrow Comes, Cologne, BTC 002CD.

Untitled: Christian Marclay/Yoshihide Otomo. "Don't Stop Now."
Gentle Giant Records, Chicago (split 7-inch vinyl LP, yellow
vinyl, limited edition of 500), LP GG024.

Turntable Solos "Don't Stop Now." AMOEBiC/Valve, Tokyo, CD
AMO-VA-01.

2000 Sonic Boom: The Art of Sound. "Guitar Drag." Double CD
accompanying the catalogue for the exhibition Sonic Boom: The
Art of Sound, 27 April–18 June 2000. Hayward Gallery, London,
ISBN 1-85332-208-3.

The Wire Tapper 6—Special Edition. "Moving Parts" (CM with
Otomo Yoshihide). The Wire, London. Double CD insert for The
Wire, no. 200, October 2000.

2001 Paletten Ljudkonst. "[no title]" (CM with Lee Ranaldo and Alan
Licht). CD insert for Paletten, nos. 4-5, Göteborg, Sweden.

Tellus Tools. "Groove." Harvestworks, New York. Double 12-inch
vinyl LP with cover designed by Christian Marclay, limited
edition of 500, LP TE-LP01.

2002 Adventures, The Wire: 20 Years 1982–2002, Audio Issue. "Juke
Box Capriccio." Mute Records, Ltd., London (three-CD box set),
CD STUMM 220.

November Music 2002: "See the Sound, Hear the Music."
"Improvisation." November Music, 's-Hertogenbosch (CD),
NM 006.

Soundworks: Whitney Biennial 2002. "Guitar Drag." CD
accompanying the catalogue for the Whitney Biennial, 7
March–26 May 2002. Whitney Museum of American Art,
New York.

2003 Factrix: Artifact. "Good Trying, No?" (The Bachelors, even [CM
with Kurt Henry]). Tesco/Storm Records, Birkenau, Germany
(double CD), CD STRM 08.

2004 Haunted Weather—Music, Science, and Memory. "Jukebox
Capriccio." Staubgold, Berlin, CD Staubgold 52 and Headz,
Tokyo, CD Headz 26.

2005 Music for Plants. "Green Breath" (compilation produced by
Peter Coffin). Perfectlfon, Brooklyn (double CD), Perfectlfon
85926/2.

Trax #15. "Washington, 21 September 2002" (CM with DJ Olive
and Toshio Kajimara). Trax Magazine, Spain, CD TCD-015.

2006 From The Kitchen Archives, No. 3—Amplified: New Music Meets
Rock, 1981–1986. "His Master's Voice." Orange Mountain
Music, New York, CD OMM0024 and Number 53 (ISBN
9781888645682).

2007 Visionaire No. 53: Sound. "A Minute of Your Time." Visionaire
Publishing, New York (five 12-inch picture-disc vinyl LPs and
double-CD box set, limited edition), Visionaire, number 53,
ISBN 9781888645682.

2008 Smiling Through My Teeth. "Maria Callas." Sonic Arts Network,
London, SANCD12.

COLLABORATIONS

Afternoon Saints (CM, Lee Ranaldo, David Watson, and Günter Müller)

2009 *The Shirley Jangle*. (K-RAA-K)3, Gent, Belgium (double vinyl LP), LP KED05.

With Barbara Bloom

1999 *The French Diplomat's Office*. Blumarts, Inc., New York (edition of 250), CD.

With Andres Bosshard, Günter Müller, Jin Hi Kim, et al.

1993 *Telefonia: Selected Soundscape No. 2*. For 4 Ears Records, Lupsingen, Switzerland, CD 408.

With CCMC (Michael Snow, John Oswald, and Paul Dutton)

2002 *CCMC + Christian Marclay, 2000–2001*. Art Metropole, Toronto, ART MET CD004 and Non Musica Rex, New York, NMRX 003.0003.

With Jean Chaine

1995 *Sunk in the Sun*. Atonal Records, Berlin, ACD 3020.

With Clonicos

1995 *Esquizodelia*. Triquinoises Producciones, Madrid, TQ 024 CD.

With Nicolas Collins

1989 *100 of the World's Most Beautiful Melodies*. Trace Elements Records, New York, TE-1018 CD.

With Corin Curschellas

1997 *Valdun Voices of Rumantsch, 1997*. Migros-Genossenschafts-Bund/Musikszene Schweize MGB, Zürich, CD MGB 9701 and Traumton Records, Berlin, CD TT 8001.

djTRIO (CM with Jonas Olesen and Erik M.)

2007 *djTRIO Live Spor Festival*. Four Directional Doubt, France (Internet release, www.fourdirectionaldoubt.free.fr; 4xfile, ogg-vorbis), fdd04.

djTRIO (CM with Toshio Kajiwara, DJ Olive, Erik M., and Marina Rosenfeld)

2004 *djTRIO*. Asphodel Records, San Francisco, CD ASP 2023.

With Fred Frith

1988 *The Technology of Tears*. RecRec Music, Zürich (double vinyl LP, double CD, double CT), RecRec LP 20, RecRec 20 and SST Records, Long Beach, California, SST LP 172, SSTCT 172, SST CD 172. Re-released, 2008: Fred Records/ReR Megacorp, London, FRO 11.

With David Garland

1986 *Control Songs*. Review Records, Berlin, rere LP 95. Re-released, 1997: No Man's Land/Review Records, Berlin (CD), rere 95cd.

With Allen Ginsberg

2004 *Wichita Vortex Sutra*. Artemis Records, New York, ATM-CD-51577.

With William Hooker and Lee Ranaldo

2000 *Bouquet: Live at the Knitting Factory*. Knitting Factory Records, New York, CD KFW-264.

With Takashi Kazamaki and Kalle Laar

1990 *Return to Street Level*. Ear-Rational Records, Berlin, ECD 1022.

With Guy Klucevsek

1992 *Manhattan Cascade*. Composers Recording Inc., New York (CD package designed by Christian Marclay), CRI CD 626.

With Okkyung Lee

2005 *Okkyung Lee & Christian Marclay / My Cat Is an Alien–Split CD From the Earth to the Spheres, vol. 7*. Opax Records, Torino, OPX 007LP. Re-released as *From the Earth to the Spheres, vol. 6: A Silent Place*, 2006: Andria, Italy, CD ASP09; and 2008 as an mp3 ASP09.

With Chris Mann

2001 *Chris Mann and the Use*. Lovely Music, Ltd., New York, CD 3091.

With Meltable Snaps It (Michael Lytle, George Cartwright, and David Moss)

1986 *Points Blank*. No Man's Land, Würzburg, nml LP 8604. Re-released, 1993: No Man's Land, Würzburg, nml CD 8604.

With Thurston Moore and Lee Ranaldo

2000 *Fuck Shit Up*. Les Disques Victo, Victoriaville, Quebec, Victo CD071.

With Lawrence "Butch" Morris

1985 *Current Trends in Racism in Modern America*. Sound Aspects Records, Backnang, Germany, SAS LP 4010. Re-released, 1986: Sound Aspects Records, Backnang, Germany, SAS CD 4010; 1990: (digitally remastered by Johannes Wohlleben, Bauer Studio, Ludwigsburg, Germany), Sound Aspects Records, Backnang, Germany, SAS CD 4010.

1995 *Testament: A Conduction Collection (collaboration for Conduction® nos. 22, 39, and 40)*. New World Records, New York (ten-CD box set), CD80478.

With David Moss

1984 *Full House*. Moers Music, Moers, Germany, momu LP 2010. Re-released, 1992: Moers Music, Moers, Germany, momu 2088 CD.

1985 *Dense Band*. Moers Music, Moers, Germany, momu LP 2040. Re-released, 1993: Moers Music, Moers, Germany, momu CD 2076.

1988 *Dense Band—Live in Europe*. Ear-Rational Records, Berlin (vinyl LP and CD), ELP 1004 and ECD 1004.

1998 *Time Stories*. Intakt Records, Zürich, Intakt CD 054.

With Günter Müller

1994 *Christian Marclay & Günter Müller: Live Improvisations*. For 4 Ears Records, Lupsingen, Switzerland, CD 513.

With Yoshihide Otomo

2000 *Moving Parts*. Asphodel Records, San Francisco, CD ASP 2001.

With Zeena Parkins

1987 *Something Out There*. No Man's Land, Würzburg, nml LP 8712.

With poire_z

2002 *poire_z +*. (CM with Günter Müller, Erik M., Andy Guhl, Norbert Möslang.) Erstwhile Records, New York, CD 022.

With Jon Rose

1987 *Jon Rose: Forward of Short Leg*. Dossier Records, Berlin (vinyl LP), ST LP 7529.

1996 *Techno mit Störungen*. Plag Dich Nicht, Wels, Austria, CD 002.

With Michihiro Sato

1989 *Rodan*. Hat Hut Records, Basel, Hat ART CD 6015.

With Elliott Sharp

1983 *(T)here*. Zoar Records, New York (vinyl LP), ZOAR LP 14.

1987 *In the Land of Yahoos*. Dossier Records, Berlin (vinyl LP and CD), ST LP 7536, and SST Records, United States, SST LP 128 and SST CD 128.

2000 *High Noon*. Intakt Records, Zürich, Intakt CD 063.

2001 *Acoustiphobia*. (CM with Ikue Mori.) Sublingual Records, Cambridge, Massachusetts (double CD), CD SL009/010.

2010 *Graffiti Composition*. (CM with Melvin Gibbs, Mary Halvorson, Lee Ranaldo, and Vernon Reid; recorded live at the Museum of Modern Art, New York, September 13, 2006.) Dog W/A Bone, New York, DWAB 006 CD.

With Sonic Youth

1999 *Goodbye 20th Century*. Sonic Youth Records, New York (double vinyl LP and double CD), LP SYR4 and CD SYR4.

With Tenko

1987 *Slope*. RecRec Music, Zürich (vinyl LP), RecRec 16, and Kinniko Bijo Records, Japan, LP KBR 301. Re-released, 2001: Shoh, Japan, SHOH-120.

Text of Light

2004 *052402 Echo 4*. (CM with Alan Licht, Lee Ranaldo, Ulrich Krieger, DJ Olive.) Table of the Elements, New York, LP Dy66.

Music for Stage and Screen. (CM with Alan Licht, Lee Ranaldo, Günter Müller, William Hooker.) Les Disques du Soleil et de l'Acier, Nancy, France, CD DSA 54085.

Text of Light. (CM with Alan Licht, Lee Ranaldo, Ulrich Krieger, William Hooker, DJ Olive.) Table of Elements, New York, Dy 66 LP, and Starlight Furniture Co., San Francisco, STAR 024CD.

2006 *Text of Light: Metal Box*. (CM with Alan Licht, Lee Ranaldo, DJ Olive, William Hooker, Ulrich Krieger, Tim Barnes.) Dirter Promotions, Herne Bay, Kent (three-CD set), DPROM CD58.

Vancouver Ambients 1-4. (CM with Alan Licht, Lee Ranaldo, William Hooker.) Important Records, Newburyport, Massachusetts (7-inch vinyl LP, limited edition), LP imprec 087.

With Yasunao Tone and Christian Wolff

2005 *Event*. Asphodel Records, San Francisco, CD ASP 2032.

With John Zorn

1983 *Locus Solus*. Rift, New York (double LP), LP Rift 007. Re-released, 1991: Evva Records/Wave, Japan, WWCX 2035 CD; 1995: Tzadik Records, New York, TZ CD 7303 and Evva Records, Japan, evva CD 33003.

1986 *Godard Ça Vous Chante?: Tribute to Jean-Luc Godard*. Nato, France (vinyl LP), LP Nato 634. Re-released, 1992: Nato, France. Nato CD 53004.2; 1999, Tzadik Records, New York, TZ CD 7324.

The Big Gundown: John Zorn Plays the Music of Ennio Morricone. Icon, New York (vinyl LP, CD, and CT), Icon LP 5504, Icon 5504 CD, CT Icon 5504c; Nonesuch Digital, New York, LP 979 139-1, CD 979 139-2, CT 979 139-4. Re-released, 2000: Tzadik Records, New York, CD TZ 7328.

1987 *Cobra*. Hat Hut Records, Basel (double LP), Hat ART LP 2034. Re-released, 1991: Hat Hut Records, Basel (double CD), Hat ART CD60401 and 60402, and Nippon Crown, Tokyo, CD CRCJ-2003-4; 2002, hatOLOGY, Basel (double CD), hatOLOGY 2-580.

Spillane. Elektra/Nonesuch, New York (vinyl LP, CD, and CT), LP 979 172-1, CD 9 79172-2, CT 9 79172-4.

1988 *Winter Was Hard*. (With Kronos Quartet.) Elektra/Nonesuch, New York (LP and CD), LP 979 181-1 and CD 979 181-2.

1989 *Cynical Hysterie Hour*. CBS/Sony, New York/Tokyo, CD 24DH 5291. Re-released as *Filmworks VII: Cynical Hysterie Hour*, 1997: Tzadik Records, New York, CD TZ 7315.

Cynical Hysterie Hour—Trip Coaster. CBS/Sony, New York/ Tokyo (3-inch CD), CD 10EH 3327.

1995 *Filmworks III*. Toy's Factory Records and Evva, Japan, CD 33006. Re-released, 1997: Tzadik Records, New York, TZ CD 7309.

1998 *The Bribe*. Tzadik Records, New York, CD TZ 7320.

1999 *Godard/Spillane*. Tzadik Records, New York, CD TZ 7324.

—Compiled by David Kiehl and Julie Kim, September 2010

83

PERFORMER BIOS

Theo Bleckmann
A jazz singer and new-music composer of eclectic tastes and prodigious gifts, Grammy nominee and Echo award recipient Theo Bleckmann makes music that is accessibly sophisticated, unsentimentally emotional, and seriously playful, leading his work to be described as "from another planet" (*New York Times*), "magical, futuristic" (AllAboutJazz.com), "limitless" (*City Paper*, Philadelphia), "transcendent" (*Village Voice*), and "brilliant" (*New York Magazine*). Bleckmann has released a series of albums on Winter & Winter, including the recent *I dwell in possibility* (2010), and has collaborated with musicians and composers including Laurie Anderson, Philip Glass, John Zorn, the Bang on a Can All-stars, and, most prominently, Meredith Monk, with whom Bleckmann worked as a core ensemble member for fifteen years. He has recently been interviewed by Terry Gross on NPR's Fresh Air and appeared with Laurie Anderson on the *Late Show with David Letterman* on July 14, 2010.

Uri Caine
Uri Caine was born in Philadelphia and began studying piano with Bernard Peiffer. He has played in bands led by Philly Joe Jones, Hank Mobley, Johnny Coles, Mickey Roker, Odean Pope, Jymmie Merritt, Bootsie Barnes, and Grover Washington. Since moving to New York City, Caine has recorded twenty CDs as a leader. His most recent CD is *Plastic Temptation* (2009), featuring his jazz trio, Bedrock. His ensemble has performed arrangements of compositions by Mahler, Wagner, Beethoven, Bach, and Schumann. From 2006 to 2009 he was composer-in-residence at the Los Angeles Chamber Orchestra and premiered his *Concerto for Two Pianos and Chamber Orchestra* with Jeffrey Kahane in May 2006. In 2009 he was nominated for a Grammy Award for his 2008 album *The Othello Syndrome*.

Alberto Denis
Alberto Denis is a member of the Arthur Aviles Typical Theater company and has performed in projects for Palissimo Dance Theater, Dixie Fun Dance Theater, Alethea Adsitt and Dancers, Heidi Latsky Dance, Lawrence Goldhuber, Luis Lara Malvacias, Erica Essner Performance Co-op, JoAnna Mendl Shaw's Equus Projects, and Mei Yin Ng's Mei-Be Whatever. His choreography has been produced at Danspace Project's Food For Thought, Dixon Place's Body Blend and Moving Men, and BAAD! (Bronx Academy of Arts and Dance). His sound designs include works for Alexandra Beller, Richard Rivera's Physual, Nathan Trice, Arthur Aviles, and Karl Anderson.

Esther m Palmer
Esther m Palmer is a dancer and independent scholar based in New York. Her interests include the exploration of identity through performance. Palmer is the founding director of Seen Performance, a Queens-based collective specializing in multidisciplinary performances. She holds an MFA in Dance & Technology from Ohio State University.

Andrea Parkins
Andrea Parkins is a composer, sound and installation artist, and electro-acoustic performer known for her uniquely gestural, feedback-driven approach to her electronic accordion and customized sound processing; and immersive audio works featuring amplified objects. Her work has been presented at the Whitney Museum of American Art, the Kitchen, Mexico City's first International Sound Art festival, and NEXT in Bratislava. She has performed both solo and with numerous artists worldwide. Her work has been supported by NYSCA, American Composers Forum, Meet the Composer, and the *Frei und Hanseustadt Hamburg Kulturbehoerde*.

Vernon Reid
Guitarist and composer Vernon Reid started his career on the downtown New York jazz-funk-punk scene with Ronald Shannon Jackson's Decoding Society before leading the pioneering multi-platinum rock band Living Colour. He frequently collaborates with other musicians, choreographers, and filmmakers. In October 2009, Reid premiered his multimedia work *Artificial Afrika*, commissioned by WNYC, at the World Financial Center. Reid has recently joined Jamaaladeen Tacuma and G. Calvin Weston in a free-improvisation trio grounded in funk and rock called Free Form Funky Freqs.

Marcus Rojas
Marcus Rojas has been called a "phenomenal tubist" by *The New Yorker* and is a native of New York City. He has performed with the Metropolitan Opera, New York City Ballet, New York City Opera, American Symphony, American Ballet Theater, Joffrey Ballet, Orpheus Chamber Orchestra, the New York Pops, EOS, Lester Bowie's Brass Fantasy, Charlie Haden's Liberation Music Orchestra, the Art Ensemble of Chicago, and ensembles led by Gil Evans, George Russell, Jim Hall, Lionel Hampton, Dave Douglas, Wayne Shorter, David Byrne, and P.D.Q. Bach. He has also appeared on the *Late Show with David Letterman*, *The Daily Show with Jon Stewart*, and *Saturday Night Live*, among other shows.

Kenny Wollesen
A ubiquitous presence in New York's downtown mucis scene, drummer Kenny Wollesen recently built a music-making mini parade-float for the 2010 International Toy Theater Festival. His other activities include playing bass drum with the marching band Himalayas and Sukkus Mob, playing vibes in John Zorn's Dreamers and on numerous Zorn recordings, playing drums with Sexmob, Love Trio, Electric Masada, Butch Morris, and Bill Frisell, and delivering free sonic massages with an array of one-of-a-kind handmade Wollesonic Laboratory instruments!

See Issues 1 and 2 for other performer bios

ACKNOWLEDGMENTS

Since returning to the Whitney Museum of American Art as Alice Pratt Brown Director in 2003, Adam D. Weinberg has reinvigorated the museum's mission, particularly by renewing the focus on American performance art from the past fifty years. We are most grateful for the support and encouragement he offered us as we organized *Christian Marclay: Festival*. Chief curator and deputy director for programs Donna De Salvo suggested we approach Christian Marclay to participate in the Museum's ongoing Artists Series, which highlights particular aspects of an artist's oeuvre. Her support was crucial in the planning stages and energized this collaboration between the artist and the curators.

None of this would have been possible without support from the friends of the Whitney Museum. Our sincere thanks to Bloomberg and Keds for their generous sponsorship of *Christian Marclay: Festival*. We would also like to thank the National Committee of the Whitney Museum of American Art, the Steven A. and Alexandra M. Cohen Foundation, Swiss Arts Council Pro Helvetia and the Consulate General of Switzerland in New York, and Jill and Peter Kraus. Additional support from Steve Johnson and Walter Sudol proved instrumental to publishing the catalogue. We are most grateful to Bentley Meeker Lighting and Staging and to James Steeber and Makia Matsumura of Yamaha for the in-kind support that brought outstanding professionalism to the staging of the performances in *Festival*.

We are grateful to Amanda Parmer, who, as Christian Marclay's studio assistant, helped with many of the details that arose during the development of this project. The continuing encouragement and generosity of Paula Cooper, Anthony Allen, and Steve Henry of Paula Cooper Gallery in New York and Craig Burnett of White Cube Gallery in London were critical to ensuring the ultimate success of *Festival*. And special thanks to Sarah Howard and Margaret Miller of Graphicstudio/USF for bringing Christian Marclay's print *Manga Scroll* to completion for its debut at the exhibition.

We express our gratitude to a dedicated team of sound engineers: Sascha von Oertzen of Stonefly Productions, and the team of Serena Rockower and Don Jacobs from InConcert Audio, who were dedicated in their response to Marclay's complex sound requirements, and brought every musician's individual sonic universe to life. Bentley Meeker's lighting team, Danny Slade and Zack Brown, beautifully handled the intricacies of the show's lighting needs. We would like to thank Daniel Pacheo and Livestream for providing in-kind live video-streaming, and B Productions' Alex Perlman for his sensitive videotaping of the performances.

We could never give sufficient thanks to the splendid team that helped bring this exhibition to fruition: exhibitions coordinator Lynn Schatz for her tireless coordination of the exhibition details, design/construction manager Mark Steigelman and design/construction Assistant Cara Bonewitz for their seamless handling of the installation details, associate registrar Melissa Cohen, and supervising art handler Graham Miles for skillfully leading the installation. And special thanks to acting curatorial manager Emily Russell, curatorial intern Julie Kim, and coordinator of performing arts Emily Krell for their assistance and advice as the exhibition developed.

Just as Christian Marclay's work has challenged so many preconceived notions about the aural and the visual realms, the catalogue published in conjunction with *Festival* has veered from a traditional format. We are grateful to the Whitney's head of publications, Rachel de W. Wixom, for taking on this challenge to the norm, and for enlisting a team of talented visionaries who made this three-part publication possible. Our admiration and thanks to editor Claire Barliant, designer Garrick Gott, production experts Nerissa Dominguez Vales and Sue Medlicott, as well as publications assistant Brian Reese. Manager of rights and reproductions Anita Duquette and rights and reproductions assistant Kiowa Hammons ably managed the documentation of the performances, which was essential to preserving the exhibition in the pages of *Festival*.

We are also most appreciative of the wonderful talents of director of corporate partnerships Amy Roth, manager of corporate sponsorships Maggie Ress, director of foundations and government relations Hilary Strong, and director of major gifts Mary Anne Talotta, who ensured the financial support for this complex project; the persuasive discussions with marketing and community affairs officer Rich Flood, digital content manager Sarah Hromack, and chief marketing and communications officer Jeffrey Levine, which resulted in our using Flickr to record performances and enhance the Whitney Museum's website. Audio-visual coordinator Jeffrey Bergstrom, senior technician Richard Bloes, and projectionists Jay Abu-Hamda and Ronnie Bronstein were essential to handling the manifold technical demands of *Festival*. And our thanks to Associate Director, Helena Rubinstein Chair for Education Kathryn Potts and manager of education initiatives Margie Weinstein who, with help from Pierce Jackson, Alexandra Nemerov, Sarah Meller, Heather Maxson, Stina Puotinen, and Christina Kim, extended the rich complexities inherent to this work through the educational programming of the Museum. The complexities of an intense performance schedule were smoothly managed by producing assistant Jessica Edkins who was aided by a superb team of production assistants—Zach Crumrine, Amnon Freidlin, Greta Hartenstein, Max Jhin Jaffe, Odeya Nini, Sarah Beth Percival, and Booker Stardrum.

It was the performers who brought Christian Marclay's scores to life. The Museum and our many visitors join us in thanking Cyro Baptista, Art Barcon, Steven Bernstein, Theo Bleckmann, Leila Bourdreuil, Shelley Burgeon, John Butcher, Uri Caine, Vincent Chancey, Maria Chavez, Nels Cline, Anthony Coleman, Nicolas Collins, Sylvie Courvoisier, Marilyn Crispell, Lin Culbertson, Helga Davis, Alberto Denis, The Dither Guitar Quartet, Peter Evans, Mark Feldman, Curtis Fowlkes, Miguel Frasconi, Bill Frisell, Melvin Gibbs, Rachel Golub, Mary Halvorson, Kato Hideki, Shelley Hirsch, Robin Holcomb, Wayne Horvitz, Russ Johnson, Bonnie Jones, Austin Julian, Julie Kalu, Guy Klucevsek, Nathan Koci, Briggan Krauss, Ulrich Krieger, Sam Kulik, Joan La Barbara, Alan Licht, Frank London, Tommy Martinez, Chris McIntyre, Raz Mesinai, Min Xiao Fen, Thurston Moore, Ikue Mori, Butch Morris, David Moss, Kenta Nagai, Mark Nauseef, Oscar Noriega, Esther m Palmer, o.blaat (Keiko Uenishi), Andrea Parkins, Sara Parkins, Zeena Parkins, Lee Ranaldo, Reut Regev, Vernon Reid, Marcus Rojas, Marina Rosenfeld, Ned Rothenberg, Rob Schwimmer, Elliott Sharp, Tristan Shepherd, Ches Smith, Michael Snow, Jim Staley, Tom Surgal, Dave Taylor, JG Thirlwell, Yasunao Tone, Sergei Tcherepnin, Kate Valk, Alexander Waterman, Jacob Wick, Kenny Wollesen, Nate Wooley, and John Zorn.

Above all, it is the talents and vision of an extraordinary artist, Christian Marclay, that *Festival* celebrates. We were great admirers of the artist's practice before *Festival*; now our respect for him and his work has increased a thousand-fold.

Limor Tomer
David Kiehl

85

WHITNEY MUSEUM OF AMERICAN ART
STAFF LISTING

Jay Abu-Hamda
Stephanie Adams
Adrienne Alston
Ronnie Altilio
Martha Alvarez-LaRose
Marilou Aquino
Emily Arensman
Rachel Arteaga
I.D. Aruede
Bernadette Baker
John Balestrieri
Wendy Barbee-Lowell
Justine Benith
Harry Benjamin
Jeffrey Bergstrom
Caitlin Bermingham
Ivy Blackman
Hillary Blass
Richard Bloes
Cara Bonewitz
Leigh Brawer
Rebekah Burgess
Douglas Burnham
Ron Burrell
Garfield Burton
Melissa Cacciola
Pablo Caines
Margaret Cannie
Irving Caraballo
Gary Carrion-Murayari
Michael Cataldi
Brooke Cheyney
Ramon Cintron
Ron Clark
Melissa Cohen
John Collins
Arthur Conway
Matthew Corey
Nicole Cosgrove
Heather Cox
Kenneth Cronan
Sakura Cusie
Donna De Salvo
Robert Deeds
Anthony DeMercurio
Kristen Denner
Eduardo Diaz
Lauren DiLoreto
Lisa Dowd
Delano Dunn
Anita Duquette
Jessica Edkins

Alvin Eubanks
Eileen Farrell
Jeanette Fischer
Rich Flood
Seth Fogelman
Meghan Forsyth
Carter E. Foster
Samuel Franks
Murlin Frederick
Annie French
Donald Garlington
Larissa Gentile
Robert Gerhardt
Liz Gillroy
Rebecca Gimenez
Desiree Gonzalez
Francesca Grassi
Molly Gross
Peter Guss
Kate Hahm
Kiowa Hammons
Barbara Haskell
Matthew Heffernan
Maura Heffner
Dina Helal
Claire Henry
Brad Henslee
Carlos Hernandez
Jennifer Heslin
Justine Hirshfeld
Ann Holcomb
Nicholas S. Holmes
Tracy Hook
Abigail Hoover
Sarah Hromack
Karen Huang
Wycliffe Husbands
Beth Huseman
Chrissie Iles
Carlos Jacobo
Jonathan Johansen
Kate Johnson
Bernard Johnson
Dolores Joseph
Diana Kamin
Chris Ketchie
David Kiehl
Tom Kraft
Emily Krell
Sang Soo Lee
Kristen Leipert
Monica Leon

Jen Leventhal
Amy Levin
Jeffrey Levine
Danielle Linzer
Kelley Loftus
Robert Lomblad
Sarah Lookofsky
Stephanie Lussier
Doug Madill
Carol Mancusi-Ungaro
Louis Manners
Joseph Mannino
Heather Maxson
Jessica McCarthy
Sandra Meadows
Sarah Meller
Bridget Mendoza
Graham Miles
Sarah Milestone
Dana Miller
David Miller
Christa Molinaro
Josue' Moralés
Victor Moscoso
Alissa Neglia
Graham Newhall
Sasha Nicholas
Carlos Noboa
Kisha Noel
Margot Norton
Thomas Nunes
Rory O'Dea
Rose O'Neill-
Suspitsyna
Brianna O'Brien
Nelson Ortiz
Barbara Padolsky
Alexandra Palmer
Jane Panetta
Amanda Parmer
Christiane Paul
Ailen Pedraza
Laura Phipps
Angelo Pikoulas
Kathryn Potts
Linda Priest
Eliza Proctor
Vincent Punch
Stina Puotinen
Christy Putnam
Jessica Ragusa
Brian Reese

Maggie Ress
Gregory Reynolds
Emanuel Riley
Felix Rivera
Ariel Rivera
Jeffrey Robinson
Georgianna Rodriguez
Gina Rogak
Clara Rojas-Sebesta
Justin Romeo
Joshua Rosenblatt
Amy Roth
Scott Rothkopf
Carol Rusk
Beau Rutland
Doris Sabater
Angie Salerno
Leo Sanchez
Rafael Santiago
Galina Sapozhnikova
Lynn Schatz
Brittanie Schmieder
Peter Scott
Gretchen Scott
David Selimoski
Jason Senquiz
Ai Wee Seow
Amy Sharp
Elisabeth Sherman
Kasey Sherrick
Sasha Silcox
Matt Skopek
Michele Snyder
Joel Snyder
Stephen Soba
Julia Sobol
Barbi Spieler
Carrie Springer
John S. Stanley
Mark Steigelman
Minerva Stella
Betty Stolpen
Hillary Strong
Emilie Sullivan
Denis Suspitsyn
Elisabeth Sussman
Beth Syndel
Mary Anne Talotta
Kean Tan
Ellen Tepfer
Phyllis Thorpe
Limor Tomer

Ana Torres
Alexis Tragos
Beth Turk
Ray Vega
Snigdha Verma
Eric Vermilion
Jessica Vodofsky
Farris Wahbeh
Cecil Weekes
Adam D. Weinberg
Margie Weinstein
Alexandra Wheeler
Michelle Wilder
John Williams
Natalee Williams
Rachel de W. Wixom
Ting Xiao
Sarah Zilinski

—as of October 5, 2010

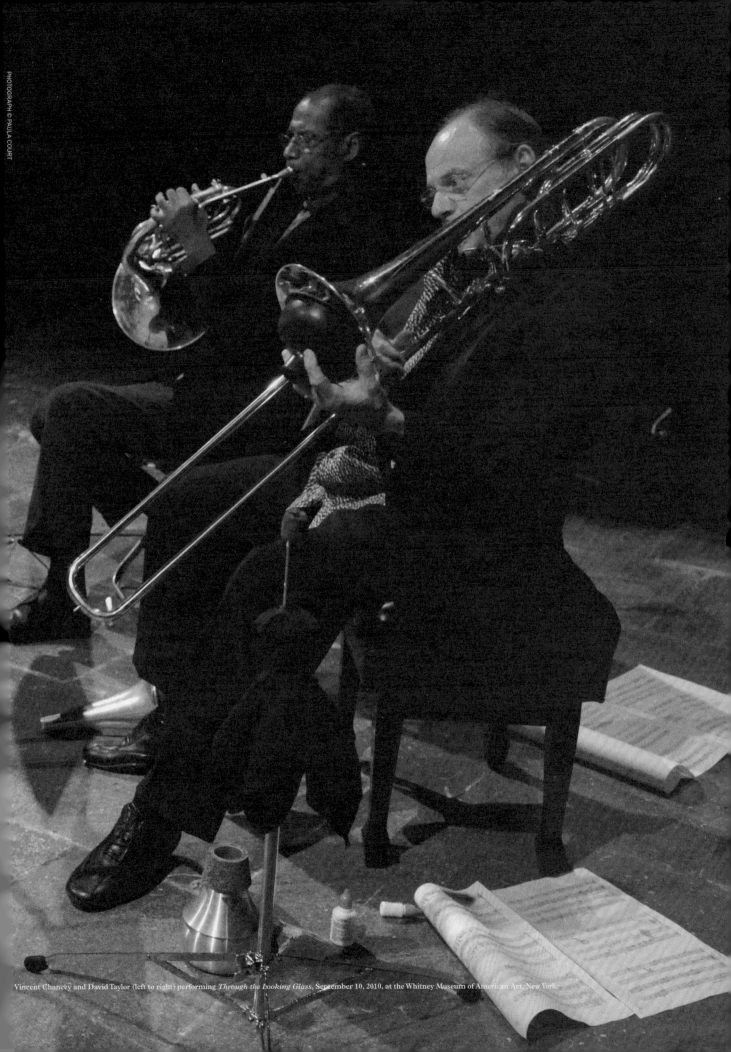

Vincent Chancey and David Taylor (left to right) performing *Through the Looking Glass*, September 10, 2010, at the Whitney Museum of American Art, New York.

FESTIVAL

This publication was created on the occasion of the exhibition *Christian Marclay: Festival* curated by David Kiehl, curator, and Limor Tomer, adjunct curator of performing arts, at the Whitney Museum of American Art, New York.

Whitney Museum of American Art, New York, July 1–September 26, 2010

Christian Marclay: Festival

Sponsored by **Bloomberg** and **Keds**

Generous support is provided by the National Committee of the Whitney Museum of American Art, the Steven A. and Alexandra M. Cohen Foundation, Swiss Arts Council Pro Helvetia, and Jill and Peter Kraus.

Lighting and audio by

**BEN-
TLEY
MEE-
KER.**

Significant support for the catalogue is provided by Steven Johnson and Walter Sudol and several anonymous donors.

WHITNEY
Whitney Museum of American Art
945 Madison Avenue
New York, NY 10021
whitney.org

Yale
Trade edition distributed by
Yale University Press
302 Temple Street
P.O. Box 209040
New Haven, CT 06520
yalebooks.com

Copyright © 2010 Whitney Museum of American Art

All rights reserved. No part of this publication may be reproduced or transmitted in any form or by any means, electronic or mechanical, including photocopying, recording or any other information storage and retrieval system, or otherwise without written permission from the Whitney Museum of American Art.

All works copyright © Christian Marclay
Unless otherwise indicated, all photos copyright © Christian Marclay and all photos of performances at the Whitney Museum of American Art were taken during *Christian Marclay: Festival.*

Essay by Ingrid Schaffner (in Issue 2) © Ingrid Schaffner and the Whitney Museum of American Art

Library of Congress Cataloging-in-Publication Data

Marclay, Christian.
 Christian Marclay : festival.
 p. cm.
 Published on the occasion of an exhibition held at the Whitney Museum of American Art, New York, July 1–Sept. 26 2010.
 ISBN 978-0-300-16900-3
 1. Marclay, Christian—Exhibitions. I. Whitney Museum of American Art. II. Title.
 N6537.M3635A4 2010
 709.2—dc22
 2010040946

Printed and bound in the United States
10 9 8 7 6 5 4 3 2 1

Cover: Audience viewing *Screen Play*, July 17, 2010, at the Whitney Museum of American Art, New York. Photograph © Paula Court.

Inside front cover: Esther m Palmer performing *Prêt-à-Porter*, August 6, 2010, at the Whitney Museum of American Art, New York. Photograph © Paula Court.

WHITNEY MUSEUM
OF AMERICAN ART
BOARD OF TRUSTEES
AND OFFICERS

CHAIRMAN EMERITUS
Leonard A. Lauder

HONORARY CHAIRMAN
Flora Miller Biddle

CO-CHAIRMEN
Robert J. Hurst
Brooke Garber Neidich

PRESIDENT
Neil G. Bluhm

VICE CHAIRMEN
Melva Bucksbaum
Susan K. Hess
Raymond J. McGuire
Robert W. Wilson

VICE PRESIDENTS
Richard M. DeMartini
James A. Gordon
Warren B. Kanders
Eric Mindich
Peter Norton
John C. Phelan
Scott Resnick
Thomas E. Tuft

SECRETARY
Joanne Leonhardt Cassullo

TREASURER
Henry Cornell

ALICE PRATT BROWN
DIRECTOR
Adam D. Weinberg

Steven Ames
J. Darius Bikoff
Pamella G. DeVos
Beth Rudin DeWoody
Fairfax N. Dorn
Victor F. Ganzi
Henry Louis Gates, Jr.
Philip H. Geier, Jr.
Sondra Gilman Gonzalez-Falla
Anne Dias Griffin
George S. Kaufman
Emily Fisher Landau
Raymond J. Learsy
Jonathan O. Lee
Thomas H. Lee
Donna Perret Rosen
Paul C. Schorr, IV
Richard D. Segal
Elizabeth M. Swig
Fern Kaye Tessler
Laurie M. Tisch
Casey Wasserman
Fred Wilson

HONORARY
B. H. Friedman
Roy R. Neuberger

FOUNDER
Gertrude Vanderbilt Whitney

As of July 1, 2010

This publication was produced by the publications department at the Whitney Museum of American Art, New York: Rachel de W. Wixom, head of publications; Beth Huseman, editor; Beth Turk, associate editor; Anita Duquette, rights and reproductions manager; Kiowa Hammons, rights and reproductions assistant; Brian Reese, publications assistant.

Creative Director: Christian Marclay
Editor: Claire Barliant
Designer: Garrick Gott
Design assistant: Eric Nylund
Production: The Production Department
Printer: The Studley Press
Typefaces: Mercury, by Radim Pesko and Adobe Plantin

88

FESTIVAL